A COLLECTORS' GUIDE TO
Judaica

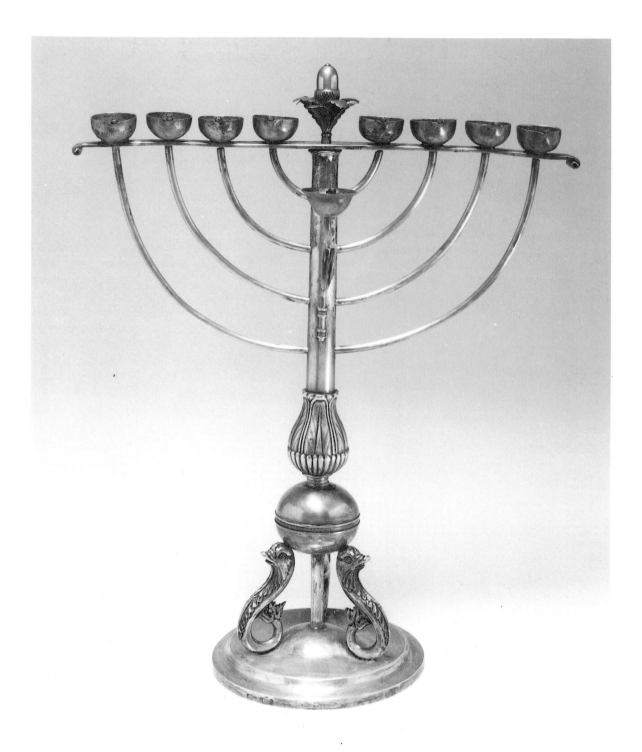

A COLLECTORS' GUIDE TO
Judaica

Jay Weinstein

with 352 illustrations, 32 in colour

Thames and Hudson

For Janet and Zachary

Acknowledgments
I would like to thank Sotheby's,
New York, for generously allowing
me to use their photographic facilities,
and the many collectors who have
allowed me to illustrate items in their
possession. Also John Calmann and
King Ltd who asked me to compile this
book. But most of all my editor,
Jeremy Schonfield, without whose
unstinting help it would never have
been written.

JW

First published in Great Britain in 1985
by Thames and Hudson Ltd, London

Printed and bound in Hong Kong

Frontispiece: German silver *Hanukah* lamp,
by Ballerman, *c.* 1825.
See illustration 151.

Contents

Introduction

The group of objects known as Judaica includes anything used by Jews for a religious purpose or having definite Jewish associations. Collectors may be attracted by the beauty and style of a piece; by the chance to use an antique in a modern Jewish ritual; by its investment value; or in order to experience some of the complex strands of cultural tradition that have formed the Jews of today. To own and use a work of art that has come from perhaps another continent, and from an earlier century, is to forge a link between far-flung Jewish *milieux*, and to reinforce a belief in the continuity of Jewish history and cultural development.

Judaica are too often valued according to their age. The older the pieces, the more 'original' they seem to be. But this attitude overlooks the great rarity of objects from earlier than the sixteenth century. Even these oldest of surviving pieces are a full thousand years later than the basic texts of Jewish life: the *Mishnah* and the *Talmud*. It is often hard to imagine the ritual items described in these works, because they are so different from those in use today. Collectors who concentrate on the question of age also risk ignoring the criteria of quality and beauty. The older pieces, like the later ones, are not invariably of the finest workmanship. In fact every period is equally important for understanding the growth of each style of object throughout the regions in which Jews have lived. Although some selection is inevitable, the argument of age alone is not a safe one to use. Far more valid would be to aim to gather examples of a certain genre of object from every known period. Alternatively, it is possible to collect all types of Judaica from a certain period or perhaps region. This will give a coherence to your collection that might otherwise be missing.

The range of historical periods open to the collector of Judaica is

narrower than the long history of the Jews would lead one to expect. But there are reliable historical reports of very early practices. From the very dawn of their history, Jews have worshipped not only in the privacy of prayer, but publicly, performing rites and ceremonies that marked them off from their neighbours. The Bible records the building of altars and later of an entire Tabernacle – a portable shrine – that the Israelites carried with them in their desert wanderings when Moses had led them out of slavery in Egypt. As the focus of a nation-state the temple of the Israelites stood in Jerusalem for a thousand years before the Romans destroyed both their sanctuary and their capital city so utterly in the first century CE that a plough could be drawn over the site. The building and its finery were lost forever: the structure was reduced to rubble, and the golden utensils carried off to Rome, where the Arch of Titus shows them being borne as booty through the streets. From this time on, Jews no longer had a central place of worship. They pray each day for the restoration of Jerusalem and the temple, but their prayers are recited in the home and in the synagogue, the twin foci of Judaism for nearly 2000 years.

This book describes objects used by Jews not only in their worship. Everyday articles are also included, because Judaism is not merely a collection of rites and ceremonies, but is a way of life that sanctifies everyday practices and routines. As the 'Chosen People', Jews see themselves as a nation of priests whose responsibilities are many but whose rights and needs are not greater than those of other groups. Their daily lives are sanctified almost as a ritual praise of God. Just as there is no area of ordinary existence that is untouched by Judaism, so there is almost no category of object that cannot be included in a collection of Judaica. For this reason the term is not limited to art or to objects of particular beauty. Indeed, it is a truism that Judaica include some objects that are almost entirely utilitarian in purpose, and which were not manufactured especially to please the eye.

Judaism has not developed as a focal point of the arts for several reasons. Firstly, the biblical interdiction of 'graven images' has steered Jews away from naturalism and towards a more ornamental approach to art. Secondly, the Jewish religion so often serves to sanctify the most everyday elements of life that rarefied environments and magnificent objects are not necessary to distract the worshipper from the ordinary world around. Lastly, Jewish objects have constantly been threatened by loss or destruction, as persecuted Jews fled across Europe, Asia and the Near East, bearing

with them only as much as they could carry. This has caused the loss of all but the smallest number of medieval buildings and larger objects, and has spared few ritual articles of a high quality.

The enforced migrations of the Jews have, however, their compensations for lovers of the arts, for they have produced a rich and powerful blend of styles. These reach back to the Late Bronze Age at least, and even now show no signs of dying out. Certain pieces can be traced to the Bible. Yet given the wide dispersion of the Jews, it is hardly surprising that the decorative traditions have evolved in different ways. It is more astonishing that communities that lived so far apart and in complete isolation have often retained almost the same ritual traditions, and have been so little influenced by the cultural environment in which they lived. From India to Northern Russia and from Morocco to China, Jews have absorbed influences from everywhere in large or small measure. The collector of Judaica must learn to recognize as many as possible of these and to be familiar with their development over the centuries.

In addition, the rituals of the Jewish home and of the synagogue need to be known at first hand, for it makes little sense to collect objects without understanding, in the deepest way possible, the reason for which they were made. A knowledge of Hebrew is also an advantage for deciphering inscriptions, and, most importantly, the dates included in them. But even those familiar with the Hebrew alphabet may have difficulty in identifying the letters that comprise the date, so a final interpretation may best be left to an expert. A note on Hebrew dates appears on page 237.

This book will focus particularly on types of Judaica you are likely to find on sale. If many of the chapters do not mention objects from a date earlier than the sixteenth century, this is not the result of laziness or oversight. In such cases, earlier examples, where they survive at all, are extremely rare and museum pieces. Several categories of far more ancient objects do survive, bearing Jewish symbols. These include pottery lamps, glass bottles and inscriptions on stone from the Roman, Byzantine and early medieval periods. But in most cases their exact use is not known and they seem to correspond to no objects employed today. The oldest Jewish remains in Europe include synagogue buildings, ritual baths and private homes; gravestones with Hebrew inscriptions; and Hebrew manuscripts. All these groups lie outside the area covered by this book, either because none are available to the ordinary collector, or because, as with manuscripts, they form an entirely separate and specialized field of study.

The relatively late date of much Judaica should not discourage the collector, however. It is true that seventeenth-century pieces have all but disappeared from the market and that eighteenth-century ones are becoming rarer. But later artists, of the nineteenth and twentieth centuries, have greatly extended the range of decoration in the field of Judaica, and have set new and higher standards of workmanship in many areas. The earlier work may possess the extra aura of age, but the impecunious collector can be assured that much of it is of poor quality and vastly overpriced. The field is moreover plagued by forgers who supply a market hungry for old pieces and whose expertise is impressive. It is now no longer enough for the collector to have a wide knowledge of the published material in order to detect the obvious fake. Counterfeiters are adept at copying objects illustrated in books. They are also eager to provide supposedly unique objects that consist in fact of features amalgamated from a number of authentic pieces. So do not imagine that the published picture of an object similar to your own is a sign of authenticity. The similarity may simply mean that the forger has seen the same picture in that very publication, and has produced a successful variant that seems to fill a gap in the evolutionary chain of styles in the world of Judaica. Most such copies, however, are not all that convincing, and no one who has handled and looked closely at a wide range of genuine examples will be easily deceived.

The market for Judaica has grown rapidly over recent years. Prices have increased dramatically, particularly following the entry of the larger auction houses into the field. These, with their publicly recorded prices, have given the market a new stability and grounding. Reactions to the price increases have been mixed. Owners who wish to sell are delighted, of course. Collectors who recognize the best and who are aware of its relative rarity go to great lengths to ensure that important pieces do not elude them. Some people yearn for the 'good old days' when the prices paid for Judaica seem, at least to us today, so reasonable. In fact the situation was less simple than it appears. Firstly, fine objects were never really inexpensive. The sums paid in the 1950s were often large, although this fact has been disguised by many years of inflation. Secondly, the lack of interest in the mass of Judaica reflected an ignorance of the field that has had a serious effect on the objects themselves: they proved unsaleable. There were few collectors and dealers, and the haphazard auctions that took place were organized for the benefit of a single owner or estate and were

accompanied by catalogues which were often sketchy and inaccurate. As a result there were bargains for the knowledgeable. But the real tragedy was that so much material was supposed to be worthless that it was lost. It was simply thrown out, given away, melted down, or abused into disintegration. I have heard many sad tales of unwanted Judaica, which no one would buy or even take away for reworking, and which were simply discarded. Now that prices have increased and there is an active market, people are beginning to value their possessions correctly.

Another realization we have come to is that there are many more pieces of Judaica available, at all levels of quality, than had earlier been believed. Collectors used to think that the vast majority of objects had been destroyed throughout centuries of persecution and displacement, and that the Holocaust had delivered the final blow to the Jewish artistic heritage. When material started to appear on the market after the Second World War, people reacted to it as though this was the last opportunity to acquire a spicebox or ceremonial cup, and thought that there were perhaps only a few hundred other examples worldwide. We now know that this is not the case, and that a significant body of material did survive, treasured by its owners. The ignorance of the art market and the resulting low prices simply kept all such pieces out of sight. Now that prices have risen and the material is actively sought, Judaica are being drawn out of their hiding places in a steady steam. They are reaching a more sophisticated and knowledgeable public. They are being bought by museums, as well as by an increasing number of people who have no intention of building up a collection, but who simply wish to own a few pieces of Judaica for their personal use, or to present as gifts.

It is for all these – buyers, sellers, institutions and dealers – that this book is written, as a useful guide to understanding Jewish ceremonial art in its broader art-historical context, and to encourage a full enjoyment of the objects themselves by identifying some of the features for which you should be looking. The book is by no means exhaustive: much remains to be learned in the field, and many discoveries lie ahead – it has been written with these future findings in mind as well. So much of our environment is looked at but not really seen, because our minds and our eyes have tended to become lazy. We simply ignore aspects of objects to which we have become accustomed. Repeated observation and judgements of quality are necessary to appreciate any art, and that of Judaica is no exception.

I

Styles in Judaica

Perhaps surprisingly, the most valuable background knowledge for the collector of Judaica, when puzzling over the origins and date of a piece, is a grounding in non-Jewish artistic styles from all the countries in which Jews have lived. Only with the help of a thorough knowledge of the arts can one hope to trace the complex strands of decorative tradition that are to be found in each type of Jewish object: for instance, spiceboxes that look similar may have been made centuries apart and at opposite ends of Europe. Far too many attributions are made on the strength of blurred photographs in out-of-date museum catalogues, instead of the well-documented work of non-Jewish craftsmen from the same time and place at which the object is supposed to have been made. For instance, the attribution of a silver ceremonial goblet to eighteenth-century Nuremberg, on the grounds of an inscription or hallmarks, must be supported by the style and workmanship of the piece. If the inscription is *earlier* than the style, then you probably have a forgery on your hands: either the inscription was added later to a non-Jewish piece in order to improve its market value, or the object is an outright fake. Unfortunately, the question of the authenticity of the piece is now one of the first that should be asked as you view an object with the aim of ascertaining its probable origins.

I have therefore chosen to present here a brief description of each of the major European decorative styles since the Renaissance. This guide will be of consistent use to the collector of Judaica, because Jewish tastes differed little from those of their non-Jewish neighbours. When they did, these departures are easy to trace: an example is the Moorish or pseudo-Oriental architectural style of the nineteenth century which was thought particularly suitable for synagogues, and which also appears in some *Hanukah* lamps.

This sudden interest in Oriental styles reflects the generally exotic, eclectic approach of many nineteenth-century artists; and although Moorish architecture is predominantly Jewish, it is not anomalous to the climate of artistic thought in the non-Jewish world.

The Jewish communities for whom ritual objects were made were not only in close daily contact with their non-Jewish neighbours and thus sensitive to the styles and tastes of the times, but the objects were often made by members of the Christian crafts guilds, and reflect artisan traditions ranging from the excellence of court circles to the lesser craftsmanship of the provinces and the simplicity of the village folk artist. But taking the international styles one by one, the following sequence can be observed.

The first illustration shows the Baroque style (1650–1730). It is characterized at first by a prodigious use of circular scrolling foliage and large flowers – usually tulips and carnations – which are sometimes interspersed with birds and cherubs. The decoration is embossed or in *repoussé*, with the design hammered through from the back of the metal until it stands out proud in front. Despite the lightness, movement and exuberance of detail, there is still a concern for symmetry. You can check for this aspect by drawing an imaginary line vertically down the centre of a piece; you will see how the design falls into two equal parts. Illustration 1 shows this equilibrium clearly. The later Baroque style, usually called after the *Régence* period in France with which it coincided (*c.* 1715–30), shows even stronger symmetry. This late style, shown in illustration 3, is characterized by the use of more formal scallop shells, foliate scrolls without flowers, tasselled fabric swags, and chequerboard or mosaic pattern.

The Rococo style (1730–70), one of the most popular and most copied of all, includes many of the motifs from the previous period. The foliate scroll now appears more often with small flowers, but there is a new interest in asymmetry. Illustrations 2, 4 and 5 show this robust, fluid style which captivated the European imagination in the mid-eighteenth century.

Discoveries of Greco-Roman antiquities in Southern Italy in the middle of the century, particularly at Herculaneum and Pompeii, paved the way for the next major style. Neo-Classicism (1770–1830). This enthusiam for the Classical, that first arose in the 1760s, is reflected in literature by works such as Winckelmann's *Laocoön* and Keats's 'Ode on a Grecian Urn', in architecture by the work of the Adam brothers, and in painting and drawing by Angelica Kauffmann and John Flaxman. The decorative details of the new discoveries

took Europe by storm and cast their influence over all the arts. Illustrations 6–8 show the range of Neo-Classical motifs, which include beaded borders, laurel and other swags, festoons, paterae and urns. Goats' heads and hoofs were also much used. The earlier period, before 1800, is characterized by lighter, chaster forms and less decoration. But as time went on the ornamentation grew heavier, particularly in Britain, where massiveness became the popular passion. The Continent copied these trends, usually in flimsier fashion.

The heavier late-Neo-Classical phase, corresponding to the British Regency and the French *Empire* styles, was more Roman in inspiration: lions' masks and paws, heavy fluting, swans, palmettes and scenes from Greco-Roman mythology. For a while, in the early years of the nineteenth century, Egyptian motifs appeared, usually in the form of sphinxes and pseudo-hieroglyphics, inspired by Napoleon's Egyptian campaign. Gilding came back into favour for silver, after half a century of comparative disuse. In the course of the first twenty-five years of the century, the metal used became less flimsy, and burgeoning ornament debased what had been a balanced, grand style, as the public tired of the Classical ideal and craved a change. Nostalgia for the Rococo period, several generations after its fading, produced the 'Rococo Revival' (1830–90 and later), a style which to a certain extent, and particularly for Judaica, has never lost its appeal.

It may at first seem difficult to distinguish mid-eighteenth-century from revival Rococo, but apart from a general decline in quality, there are distinct differences in form and the amount of ornament. Generally speaking, the ubiquitous Rococo scrolls and flowers are much more numerous on revival pieces, often covering almost the whole surface, and practically blocking out the outlines of the piece itself. The matting of the surface is less subtle on the later than the earlier pieces. One notices too a more spontaneous and robust quality in the earlier decoration; later examples are more dense and repetitive. Revival work also sometimes combines cross-hatching, trellis-work and other Baroque motifs with Rococo decoration, so look out for the mixing of styles. Illustrations 9 and 10 show some of the salient features, and need to be studied closely. Learn to look out also for the later floral chasing of pieces that were originally plain – fortunately less of a problem for Jewish than for English pieces.

The Renaissance revival style (1860–90) and the Grecian revival style (1860–80) are both relatively chaste, linear reactions to the

Rococo excesses. These – the first exhibiting Renaissance-style strapwork, masks, grotesques and fruit clusters, the second Classical medallions, beading, palmettes and other restrained foliate borders – occasionally appear on German pieces.

Moorish, Indian and Persian motifs became popular during the 1880s, generally appearing as stylized floral treatments similar to Persian and Turkish textiles. The pseudo-oriental style occurs mainly on German and Austrian pieces, but was occasionally used in America too. It was particularly influential in synagogue architecture and decoration during the last quarter of the nineteenth century. It is surprising that more ceremonial objects were not made to match.

Art Nouveau (known in Germany as Jugendstil and in Austria as the Secession) has not left a major mark on Jewish iconography, although it does appear in articles from German-speaking countries and in some from Russia or Poland. It is characterized by sinuous flowers and vines, and maidens with wind-swept hair and wavy outlines. But you are more likely to find the less fluid German equivalent. The style is a good clue to the chronology of a piece, since it flourished only from about 1895 until 1920.

The Art Déco style (1920–40) which follows it is characterized by sleek lines, geometric forms and minimal detail – again a reaction to what had gone before. Particularly in Central and Eastern Europe, however, the more formal Jugendstil and Secessionist style can easily be mistaken for it.

This brief outline of European styles since the Renaissance is intended to serve only as a rough guide. The collector of Judaica must become familiar with all this and much more; it is essential to know also how Jewish objects were used, in order to spot objects that simply cannot have been intended for ceremonial use. The following chapters examine groups of items in turn, and explain how each object evolved historically, and in all the geographical areas in which Jewish communities flourished.

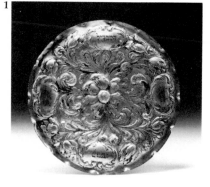

1

2

1 German parcel-gilt silver dish, Nuremberg, late 17th cent., *D*. 6 in (15.25 cm).
Probably made as the cover for an elaborate goblet. The piece was engraved later, perhaps in the second half of the nineteenth century, to serve as a dish for use in the *Havdalah* ceremony.

Nuremberg and Augsburg were major centres of production at this period. The high quality of workmanship seen here is characteristic.

The relief is fairly low, and the gauge of the metal is relatively thin to allow it to be worked. The crimped edge is typical of the time, as is the flowing quality of the flowers. The subsidiary dotted lines which circle the major leaves and flowers and add depth to the composition are a reliable indication of authenticity.

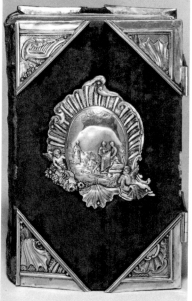

3

2 German parcel-gilt silver ceremonial cup, Augsburg, *c.* 1730, *H*. 5 in (12.5 cm).
The strapwork on this cup is typical of the late Baroque or pre-Rococo decoration found around 1700–30. Known as the Régence style, corresponding to the political period in France that followed the death of Louis XIV, it is characterized by interlacing, symmetrical designs, incorporating quatrefoil motifs in the form of flowerheads, as well as shells, cross-hatching and Classical heads.

This example is quite worn, but it is typical of the workmanship found on most metalwork and porcelain of the period.

3 Dutch gold-mounted, velvet-covered prayer book, unmarked, *c.* 1750, *H.* 8¼ in (21 cm).
The use of strongly asymmetrical shell-like motifs, referred to by their French name, *rocailles*, gave the Rococo style its title. They are abundantly visible here, particularly in the outline of the central panels, of which the symmetry has been broken at every turn. Even the oval cartouche, containing a biblical vignette, has been interrupted at the base by the imposition of an irregular shell.

I FROM LEFT Bronze bust of a Hassidic Jew, after Mark Antokolsky, the foremost Russian sculptor of the nineteenth century, on a stepped rectangular verde antico plinth, *H.* 15 in (38 cm); Italian silver hanging Sabbath lamp, maker's mark VR with an urn in a circle, late 18th cent., with ten-sided oil section typical of Neo-Classical design of this period, *H.* 28 in (71 cm); German parcel-gilt silver ceremonial cup, Hieronymus Mittnacht, Augsburg, 1763–5, *H.* 4¾ in (12 cm); English parcel-gilt silver *Torah* pointer, by Peter and William Bateman, London, who made a lot of Jewish ritual silver, 1811, *L.* 9½ in (24 cm); Continental ceramic dish, perhaps Alsace-Lorraine, early 19th cent., *W.* 13 in (33 cm); Italian brass *Hanukah* lamp, 18th cent., *H.* 10 in (25.5 cm).
II BACK, CENTRE Polish *Torah* crown, late 18th cent., made from typical low-silver alloy; sold for $13,200 in December 1984, *H.* 10½ in (26.75 cm).
FRONT, FROM LEFT Spice towers. Polish silver, late 18th cent., *H.* 11½ in (29.25 cm); East European parcel-gilt silver filigree, struck with a 13 and indecipherable maker's mark, *c.* 1800, *H.* 9½ in (24 cm); American silver, Ilya Schor, dated 1948, *H.* 8½ in (21.5 cm); silver, early 19th cent., Austrian control mark, but probably made in Holland *c.* 1775–1800, *H.* 11 in (28 cm); German silver, early 18th cent., *H.* 8¾ in (22.25 cm).

This exuberance is typical of the Rococo style practised on the Continent. English work tends to be more restrained. This example also provides an interesting comparison with the nineteenth-century Rococo revival, which was based on these elaborate motifs but which does not have their depth and detail of finish.

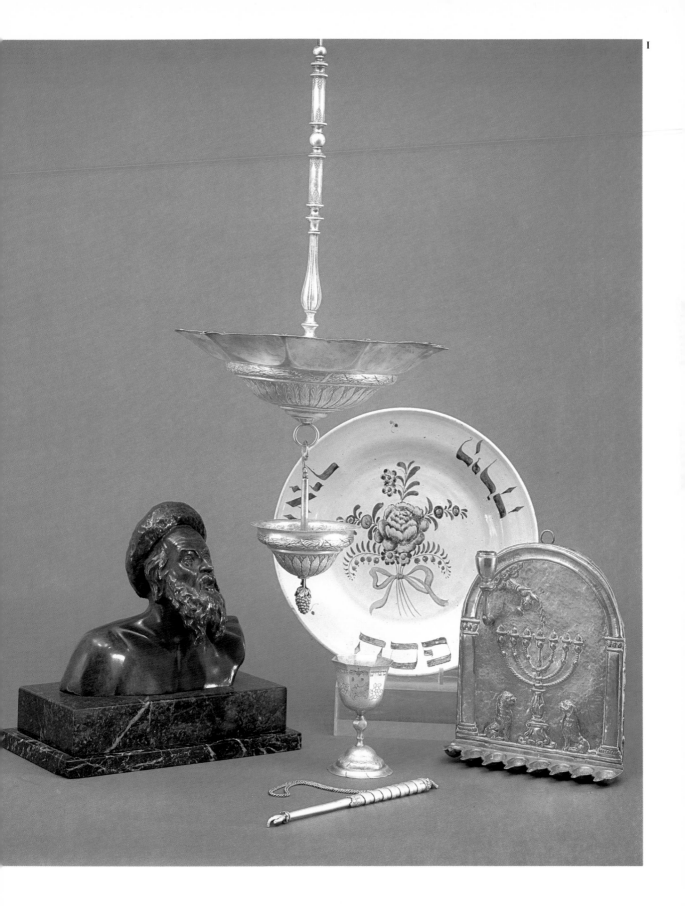

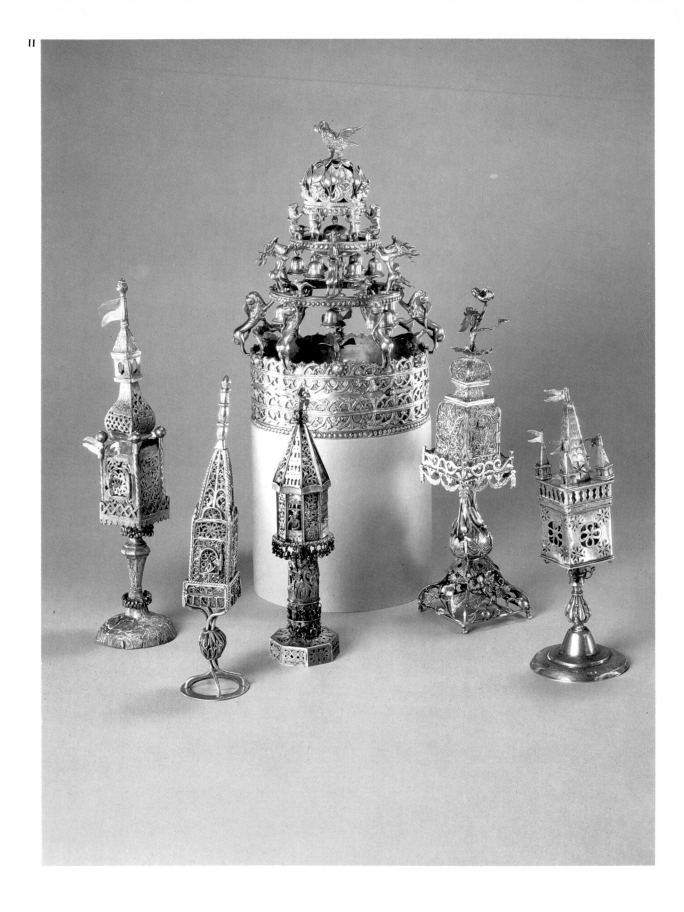

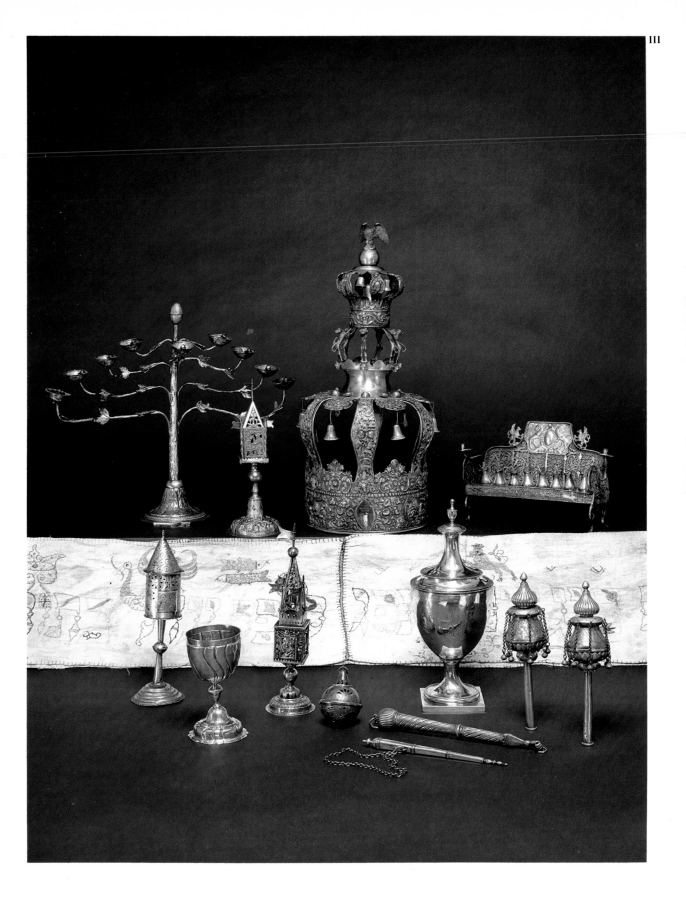

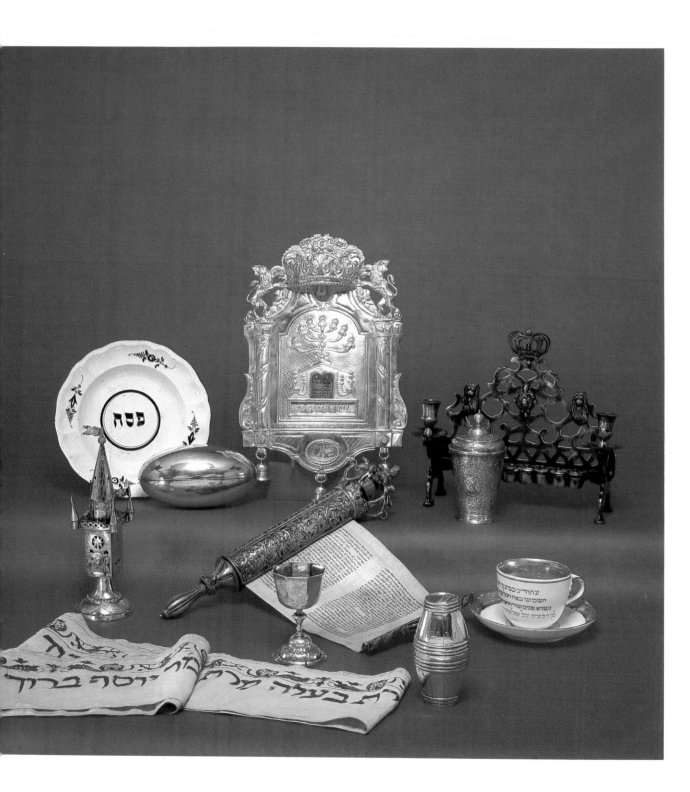

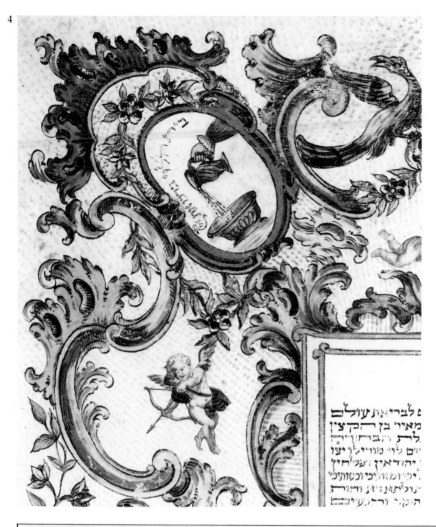

4 Detail of an Italian marriage contract, colour on parchment, mid-18th cent., *H.* approx. 23 in (58.5 cm).
This is a further elaboration of the Rococo theme, typical of Italian work and full of exuberance and vitality. These C scrolls are found in a variety of media.

5 Detail of a German parcel-gilt silver *Hanukah* lamp, Augsburg, *c.* 1765, *H.* 11 in (28 cm).
The fine lamp, of which this is a detail, is shown in its entirety in colour plate XVIII. It is typical of a more restrained version of Rococo. The C scroll is embellished with finely chased, fluted grounds, similar to those of the marriage contract in the previous illustration.

III BACK, FROM LEFT German silver *Hanukah* lamp, Muller, Berlin, *c.* 1780, *H.* 12 in (33 cm); Polish silver spice tower, late 18th cent., *H.* 9¼ in (23.5 cm); Polish parcel-gilt silver *Torah* crown, stamped 12, maker's mark PK in Cyrillic, *c.* 1825–50, *H.* 18 in (45.75 cm); Polish silver and filigree *Hanukah* lamp, *c.* 1820–30, *H.* 6¾ in (17 cm).

FRONT, FROM LEFT Continental silver spice tower, German or Polish, late 17th cent., *H.* 9 in (23 cm); German silver ceremonial cup, Rotger (Rudiger) Herfurte, Frankfurt, *c.* 1770, *H.* 5¼ in (13.5 cm); German silver spice tower, maker's mark AR in script, early 19th cent., *H.* 9¾ in (24.75 cm); Polish silver pear-form spice container, 18th cent., *L.* 3¼ in (8.25 cm); Italian silver *Torah* pointer, early 18th cent., *L.* 7¼ in (18.5 cm); Polish silver *Torah* pointer, mid-18th cent., *L.* 9 in (23 cm); American silver sugar container, Myer Myers, New York, *c.* 1790, *H.* 11 in (28 cm); Burmese parcel-gilt silver *Torah* finials, Rangoon, 1868, *H.* 7 in (17.75 cm). German embroidered-linen *Torah* binder, 1723, 110 × 8½ in (279.5 × 21.5 cm).

IV BACK, FROM LEFT Franco-German blue-painted faience, *c.* 1825–50, *H.* of plate 9½ in (24 cm); English silver-gilt *Ethrog* container, Allen Dominy, London, 1802, *L.* 9 in (23 cm); German parcel-gilt silver *Torah* breastplate, Augsburg, 1799, maker's mark SM, *H.* 16 in (40.75 cm); Polish brass *Hanukah* lamp, late 18th cent., *H.* 8¾ in (22.25 cm). Russian silver covered *Havdalah* cup, maker's mark MB in Cyrillic, Moscow, 1756, *H.* 6½ in (16.5 cm).

FRONT, FROM LEFT Italian embroidered-linen *Torah* binder, late 17th/early 18th cent., 7 × 92 in (17.75 × 233.75 cm); German silver spice tower, maker's mark JR in script monogram, Nuremberg, late 18th cent., *H.* 10¼ in (26 cm); Polish parcel-gilt silver-cased Esther scroll, *W.* of scroll 7⅝ in (19.5 cm), *L.* of case 17 in (43.25 cm); German silver Passover cup, Georg Nicolas Bierfreund, Nuremberg, 1773–6 or 1782–90, *H.* 4½ in (11.5 cm); German silver double circumcision cup, Hieronymus Mittnacht, Augsburg, 1763–5, *H.* 5¼ in (13.25 cm); German or Bohemian gilt-decorated white porcelain cup and saucer, impressed HK, and with an inscription dated 1877, *H.* 3¼ in (8.25 cm).

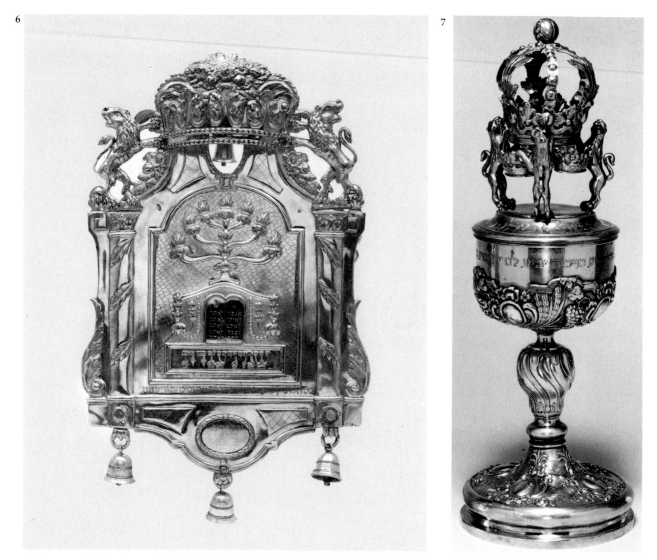

6 German silver-gilt *Torah* breastplate, Augsburg, 1799, *H.* 16 in (40.5 cm).

A breastplate of this date and origin should be completely Neo-Classical in style. It is instead transitional, reflecting a style perhaps from the 1770s, twenty-five years earlier than the fashion at the time of its making. It also contains earlier Rococo elements, that appear in the floral decorations at the centre of the top and at the edges.

The relative simplicity of Neo-Classicism is apparent here in the restrained foliate motifs around the pillars, although their carved form would seem to relate more directly to the previous style. Other indications include the wreath motifs under the base, framing an inscription, and the beading of the lower borders of the crown and under the central candelabrum, there combined with a typical bell-flower swag motif.

The positions of these Neo-Classical features suggest that they have been added to a conservative form that probably evolved in the early eighteenth century, and which survives with minor modifications. This

particular example may have been made to match a piece made in the 1770s, or to replace one which was damaged or lost. On the other hand it could reflect the conservatism of the patron, who commissioned a piece that looked old-fashioned for its time. Augsburg produced many silver objects for export, so this interpretation seems plausible.

7 Italian silver covered chalice, *c.* 1780–90, *H.* 11 in (28 cm).

The Neo-Classical vocabulary of ornament was particularly strong in Italy where important Greco-Roman discoveries had been made. It is fully developed in this piece. Gone are the curves and asymmetry. Laurel swags, leaf-tip borders, ribbon-tied oval medallions and the Greek-key around the base show a disciplined, conscious borrowing from antiquity, in an attractive balance between simple form and unadorned surface. The central knop has a later Hebrew inscription, probably added to make a Christian chalice into a *Kiddush* cup.

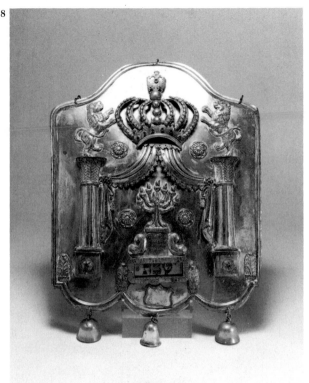

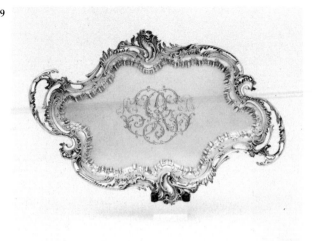

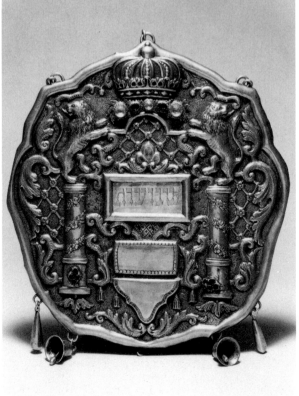

8 German silver-gilt *Torah* breastplate, Würzburg, *c.* 1820, *H.* 15 in (38 cm).
Almost all elements of the Rococo have disappeared from this piece, and German Neo-Classicism has emerged. The crown, composed of beadwork, the four applied rosettes and the Classical foliage are all of the period. The central candelabrum, however, was probably modelled sixty years earlier and remained in production. Similarly, the C scrolls flanking the Decalogue are purely Rococo, tempered by spiral chasing.

Since the Rococo revival was to begin within ten or fifteen years, these elements could as well be precocious as backward.

9 French silver tea tray, mid-19th cent., *L.* 24 in (61 cm).
A good example of fine Rococo revival in secular silver work. The exaggeration of the outline and the incisions is typical of Rococo revival, and has many parallels in Jewish ceremonial silverware.

10 French silver *Torah* breastplate, mid-19th cent., *H.* 12 in (30.5 cm).
This piece displays many features of the Rococo revival, which has played a large role in Judaica since the mid-nineteenth century and which continues to be popular today. It practically superseded all other styles found in secular silver made during the latter half of the nineteenth century, including the Renaissance, Grecian and Moorish revival styles. Distinguishing between eighteenth-century Rococo and subsequent copies is difficult at first. Hallmarks, when genuine, are an important guide. But only constant observation of the style itself enables one to distinguish between them. Even the quality of execution is not always helpful, because eighteenth-century examples from a provincial source can be rather crude, while much nineteenth-century Rococo-revival work made in the larger cities was often hand chased with great skill. The ability to distinguish between the late and early Rococo works is vital for collectors in this field.

11 American silver centrepiece, *c.* 1870, *H.* 35 in (89 cm).
A typical example of the Grecian revival, which was a reaction against the Rococo revival in its relative austerity, and recalls early-nineteenth-century design in a more consciously Classical way. The overall design is angular and plain, influenced by Grecian pottery. The hippocamps, acanthus mouldings, full-scale Greek beauties and cupids with tambourines, reflect a studied if somewhat idealized view of antiquity. Sometimes the same forms are applied with figures and masks in Egyptian taste; it is not uncommon to find the two mixed. The Grand Tours of the prosperous middle classes made such silver a fashionable reminder of foreign travels. It was never wholly adapted to Jewish ritual silverware, but elements reappear as decorative elements of a larger piece. Egyptian motifs seem even to have been mustered into service for Passover pieces!

11

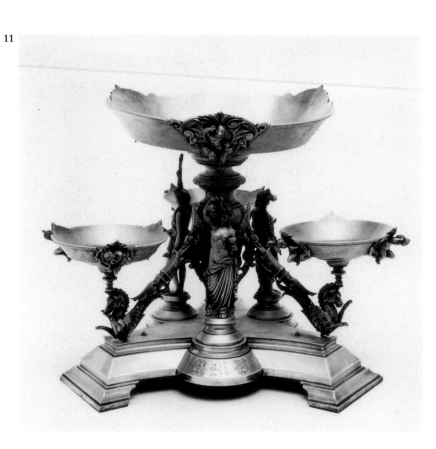

12 American silver centrepiece, Gorham Manufacturing Co., Providence, Rhode Island, *c.* 1880, *L.* 24 in (61 cm).
This piece illustrates the Moorish or Indo-Persian taste of the 1880s. Although it was popular, primarily in synagogue architecture and interior decoration, one periodically also finds design-elements of this style in ritual metalwork. Here the exotic theme is taken to its limits, even including elephants as props. The multi-layered border elements and designs are more relevant to us here, as they appear, with variations, on *Hanukah* lamps, candlesticks and *Torah* ornaments of the period, particularly in Germany and Austria.

12

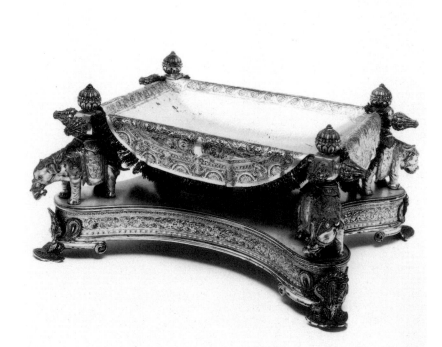

13

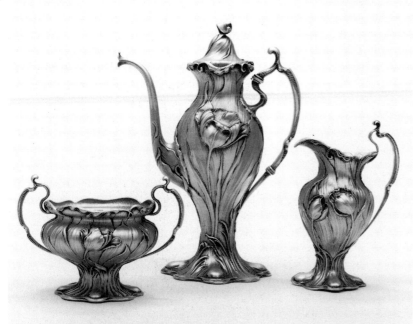

14

15

16

13 American silver coffee set, *c.* 1905, *H.* of pot 12 in (30.5 cm). A perfect example of domestic silver in Art Nouveau style. The extremely sinuous lines, employing flowers and foliage, are more naturalistic than those found in its precursor, the Rococo style, and the pieces tend to be larger in scale. There is also a preference for certain types of flowers: the iris, the poppy, and the water lily, with ripe, drooping petals. Sometimes one encounters touches of Art Nouveau in the subsidiary design of Jewish metalwork, most frequently in Germany, Austria and Russia.

14 Swedish pewter charity box, *c.* 1910–20, *H.* 4½ in (11.5 cm). This piece shows the influence of German Art Nouveau, known as Jugendstil or Secessionist. It is a more tempered version of the Art Nouveau popular in France and America, and is a forerunner of the Art Déco style, popular a few years later, in which more emphasis was placed on the geometric form and less on the sinuous line of nature. This piece is very well designed and completely in tune with the aesthetic principles of its day: a rare occurrence in Judaica of the period.

15 Wrought-iron *Hanukah* lamp, unmarked, early 20th cent., *H.* 12¼ in (31 cm). It is difficult to determine the origins of a piece such as this in the absence of identifying marks. A return to hand craftsmanship, prompted by influential figures such as William Morris in England, led to the setting up of workshops in Europe and America, between the 1880s and the First World War, championing an aesthetic later known as the Arts and Crafts Style. It was concurrent with, and formed part of, the Jugendstil and Art Nouveau movements. This attractive piece is well made and designed, and is quite rare, since the Arts and Crafts movement had a very limited impact on Judaica design.

16 Austrian silver *Hanukah* lamp, *c.* 1920, *H.* 10 in (25.5 cm). This piece is as close as one is likely to come to Art Déco in Jewish ceremonial art. The lightly hammered surface is typical, as are the simple base and thimble-form candleholders. Interestingly, the foliate decoration on the lower part of the stem derives from traditional forms of the eighteenth- and nineteenth-century styles.

II

Metalwork in Judaica

In the Jewish people's long history of persecution and flight, their homes, their treasured possessions and their public buildings have repeatedly been lost or destroyed. Of the objects they could save, the books have worn out from use; ivory, bone and wood proved breakable; and only metals, easily portable, valued for their magical appearance when polished, for their intrinsic worth and for their durability, have survived the centuries, while architecture, fabrics and other media, on the whole, have not.

Since Jews take seriously the forbidding of 'graven images' in the Ten Commandments, they have produced little in the way of graphic arts. Their creativity has instead been invested in the adornment of their ceremonies. Metals offer the flexibility to form fantastic shapes and elaborate details, and to create wonders in miniature. Just as in all other arts, Jewish ritual objects belong to traditions that reach back to antiquity. Yet however many priceless objects have been lost or destroyed, something of the old treasures found new life in later ones, in the form of copies of earlier heirlooms, lovingly recalled by craftsmen who had established new homes and were eager to remake their lives. Jewish ritual art is characterized by a continuity which it is the privilege of the collector of Judaica to trace. From land to land and century to century the ancient forms survive, gradually and lovingly changed as they pass through the hands of craftsmen.

This ability to follow the growth remains merely an intuition if the steps cannot be traced. Styles and craftsmanship are valuable guides for the collector. But still more useful are the links between the history of the economic activity of the Western world and the use of precious metals. Silver and gold are the standards by which most concepts of material 'value' are gauged. Yet pure silver or

gold are too soft to use in domestic objects that will see regular and fairly heavy wear. Both metals, it was soon found, could be hardened without changing the colour of the polished metal, by mixing in some copper. The resulting alloy would also cost rather less than the pure metal. The control of the exact proportions of ingredients in the alloys was entrusted to guilds of craftsmen in each town or principality by about the sixteenth century, who would mark pieces containing the required amount of silver so that they could be correctly priced. In order to protect the purity of bullion, stamp impressions, or 'hallmarks', were left on each piece, bearing symbols, letters or numerals indicating a town of origin, a maker, or the date of manufacture or of 'assay' – testing for metal content. In some systems, such as the British, a different stamp has been used each year for several centuries, making possible a remarkably precise degree of dating.

Knowing how to decipher these hallmarks is the collector's passport to a wealth of information about the history of any piece. Previously anonymous objects suddenly acquire a presence of their own. You may be able to trace similar objects produced by the same workshop. Once you know where the maker lived you can compare his work with the products of other workshops from the same time and place. You might be able to visit the town and discover that a local church tower provided the inspiration for a magnificent spicebox. Even more usefully, the hallmarks on one piece might help to identify a similar but unmarked object, since marks are sometimes omitted, removed or worn out. The presence of marks certainly strengthens the market value of a piece, since they ensure the pedigree and provide interesting background information.

Further data may be provided by Hebrew inscriptions. These sometimes contain the date – always counted in years since Creation – and the name of the individual or of the community for whom it was made or to whom it was given. Take care, however, that the inscription is roughly contemporary with the piece. Many were added later, either because an old and previously uninscribed object was being presented as a gift, or because a dealer or collector wished to increase the value of a plain and uninteresting object by fraudulently adding an inscription purporting to be older than it is. Look for unequal wear to the decoration or corners of the piece in comparison with the inscription. The only fairly reliable type of inscription is one that is embossed as part of the overall decoration of a piece. All others are capable of having been changed at some

time or another, although some particularly elaborate lettering may not have been worth a forger's time to copy or alter.

Occasionally an inscription is the only evidence of date available, except for the shape and decorative style, since there are many reasons for which pieces lack marks altogether. Most marking systems were introduced only by the sixteenth century, so earlier pieces were not affected. In Poland no Jews were admitted to crafts guilds until the nineteenth century, so their products were un-marked before then. North African and Near Eastern cities occasionally introduced systems still later in the nineteenth century. Even when marks were applied to the majority of pieces, some European authorities exempted small objects such as rings and amulets. In addition, many towns in Central Europe in particular were too small to maintain a guild of their own, so products were marked simply with the maker's stamp. It is further possible that an object without marks is in fact not made of solid silver or gold, but is merely plated with the precious metal, over a base of brass or copper in the case of silver, or of silver in the case of gold. Such plating was not usually carried out in order to deceive. The less expensive materials were used in order to keep down the price of an object on which the cost of labour would anyway be high.

It is often important to discover the exact metal content of a piece, if only for insurance purposes. A jeweller can identify the silver or gold content of the alloy used by subjecting a small sample of its metal to a chemical test. Quite accurate results can be obtained from the reaction of the metal to acid or to a colour-coded chemical. You must insist, however, that the smallest possible shaving is taken and that it comes from an inconspicuous place. Unless you explain very clearly what result you wish to obtain, many jewellers will assume that you wish to sell the piece for scrap. If you think that the jeweller may not have understood what you want, take the object away from him, or he may scrape or clip a sample from the most accessible and visible part of it, instead of a tiny shaving from the underside of the base. It is better not to know what metal has been used than to have your piece butchered in the process of finding out.

It is not easy for the beginner to interpret the many different types of mark and marking system that have been used. A good overall sourcebook is *Les Poinçons de Garantie internationaux*, published by Tardy in Paris. An English-language edition is also available, and there is a parallel volume for marks on gold. Its index is usefully organized according to categories of image: numbers, letters,

plants, animals and so on. Every serious collector should own a copy and should learn to recognize the main national marking systems. Begin to use your knowledge immediately by examining the marks on objects already in your possession. See if the results confirm any family traditions concerning them. Next, spend some time looking at an antique dealer's stock, checking your own discoveries against what the dealer thinks. You may be surprised to find some long-held assumptions about dates and places of origin overturned by your research.

You should learn first how some of the systems work. One of the simplest to understand is the American. Gold objects bear a 'carat' (in US, 'karat') mark, which indicates what proportion of 24 units of pure metal is present. This information may be presented in a variety of ways: '¾', '18/24', '0.75' and '75%' all correspond to 18-carat gold. The mark came into general use in the 1860s, so it indicates fairly recent manufacture. Of a similar vintage is the 'Sterling' mark on American silver. The term 'sterling' derives from medieval Britain and corresponds to a degree of purity of 92.5 per cent. The rest of the alloy consists of copper. Objects marked in this way can be difficult to place chronologically, since there is no special indication of date. The collector has to depend more on other criteria such as the style of the piece and the feel of the workmanship.

In direct contrast to this is the complexity of the Polish system, one of particular interest to collectors of Judaica. Since Jewish silversmiths were excluded from the guilds during the seventeenth and eighteenth centuries, their products of that period do not bear marks. Craftsmen sometimes inscribed their pieces in Hebrew with a name and a date, but more often the inscription will relate to a presentation. The partition of Poland towards the end of the eighteenth century led to a number of systems being introduced into the area previously united under Polish rule. Northern cities such as Breslau, Danzig and Königsberg continued to employ the marks used by the long-established guilds. Warsaw had a looser system based on the maker's name or initials in Latin characters, which appeared together with the quality mark '12'. This signified a silver content of 12 *lötig* out of a possible total of 16. The town mark varied: Warsaw was occasionally represented by an anchor, and at other times by a mermaid or an eagle. Sometimes more than one of these marks was used.

The Polish marking system was changed in 1851 when the Russian method was introduced. This remained in use until 1915. The silver standard now appeared as 84 out of 96 *zolotniks*, or 0.875

pure. The Warsaw city mark became the Imperial Russian double-headed eagle. Also included are the full date and the maker's name or initials in Cyrillic script. These marks appear on all removable parts of an object, unlike the older '12' mark which appeared only once on each piece. A spicebox, for instance, would be stamped with the '12' mark on the base alone, whereas now at least some of the relevant marks would appear on the door and the pennant as well. The system was simplified in 1896 by the introduction of a single oval punch containing the head of a girl wearing traditional Russian headdress, the '84' mark, and the small initials of the assay-master. The maker's mark appeared separately. Removable parts continued to be stamped as before.

The regions of Poland that were annexed by the Austro-Hungarian Empire employed the different Austrian system. The only unfamiliar aspect was the addition of a letter-code for the main cities: D for Lvov (Lemberg) and E for Cracow. Some small localities are now almost impossible to identify, such as the town to which the code D7 belonged. It was presumably one of the many small provincial towns in the area with a large and mostly Hassidic Jewish population. These letters appeared in a rounded punch containing a central shield with the standard-number '13'. Outside the shield were the four numerals of the year arranged to form a square; the year 1814, for instance, was represented by '18' over '14'. A separate maker's mark also appeared. Inscriptions are useful to the collector, and care should be taken over checking that the dates given in each do not conflict, or suggest some irregularity.

Marks from every region and date have been forged at some time or another, so you should treat all hallmarks as aids to identification rather than as proofs of it. Styles and workmanship are far more reliable as guides to the origins of a piece, and if in doubt you should believe these rather than the hallmarks. Do not, however, allow yourself to be convinced by a consistently accurate and beautifully made object to the extent that its late markings – scrupulously provided by the honest maker of reproductions – are classed by you as later additions. On the other hand, some magnificent and undoubtedly genuine pieces are not marked in any way. You then have no choice but to trust your instinct. You should train your eye and your taste so that markings serve only to confirm your inner feelings about a piece. If there is a genuine conflict, then you should assume that your expertise is at fault and set about correcting it.

Pewter as a whole is even less understood than are the mysteries

of silver markings. It is an alloy comprising between 80 and 90 per cent tin and perhaps 10 per cent zinc. There are usually trace elements of other metals such as copper or antimony to strengthen the resulting alloy. When it is old, pewter has a dull blue-grey sheen, and should be washed in soap or detergent and dried with a soft cloth. No abrasive or chemical cleaner should ever be used on pewter, unless it is to remove areas of corrosion. These should be gently cleaned with fine wire or nylon wadding but without touching other parts of the surface, because you will risk removing all signs of age and damaging any decoration. Pewter seems first to have been favoured as a cheaper version of silver, since it can be scoured and polished to a leaden, silvery sheen. You should never do this to old pieces, since they become indistinguishable from new pieces in traditional style.

Jewish objects include platters and bowls from Germany and Austria, often bearing inscriptions relevant to *Purim* and Passover. Many such objects bear the marks of the guilds to which their makers belonged, usually in large towns. But the marks are sometimes hard to identify, because the control of pewtersmithing was less centralized and controlled than silversmithing, and many small localities developed their own systems. Moreover, many of the marks have been worn out by heavy use and abrasive cleaning. The best source on pewter marks is the multi-volumed work by Hintze, which you will find in most good art-history libraries.

More important even than deciphering the marks on pewterware is the ability to determine the date at which decoration or inscriptions were added to a piece. There are ample supplies of undecorated eighteenth-century plates to which designs could fraudulently be added with little difficulty. The potential financial gains are such that great pains are taken to make the decoration appear convincing. More difficult to detect are the plates that were decorated perhaps only a few decades after they were made. But this category of delay seems to me to add to the appeal of a piece, and certainly does not detract from its value. You must make sure, however, that the decoration does not pretend to be *earlier* than the pewtermarks on the plate. If it does then you certainly have a forgery. You can find out more on how to date the decoration on pewter from the chapters in this book on *Purim* and Passover wares. The clearest guide, however, is a Hebrew date in the inscription, which should correspond roughly to the date of the decoration or of the entire piece.

Another area in which pewter saw widespread use was in

Hanukah lamps between the seventeenth and the early nineteenth centuries. One occasionally finds simple lamps to which decoration was later added with intent to deceive, but these concoctions are rarer than in the field of pewter plates. Complete forgeries are also known, although the gains to be made are so small that modern craftsmen have largely avoided investing time and trouble in them. The collector need worry less about the authenticity of a pewter *Hanukah* lamp than about almost any other category of festival Judaica.

Copper and its alloys – bronze and brass – form a separate groups of metalware. Bronze is an alloy of copper and tin; and brass includes copper and zinc. Copper on its own is soft and easy to work, so has been hammered out into containers and jugs such as the ewers and lavers used in the synagogue when Levites wash the hands of Priests before they deliver the priestly blessing. These finely made and often elaborately engraved objects are simple in design and very attractive. Bronze is more usually cast, in contrast to brass which tends to be wrought. No two examples of the same metal are identical in composition, especially in the Near East and North Africa. They often contain traces of iron, antimony and even gold. Nor can the composition of alloys be taken as a chronological marker: objects are often melted down to make others, so there is no really clear progression.

Brass candlesticks and candelabra were made in various centres in Eastern Europe and elsewhere, particularly around Lvov; near Tula in the Caucasus; as well as in Flanders and around the German city of Nuremberg. Most objects were produced during the seventeenth and early eighteenth centuries, particularly in Eastern Europe. Manufacture continued until well into the nineteenth century. Marks appear on very few of the Eastern European objects. Pieces are usually very difficult to date and to trace to their place of manufacture, even when they do bear marks. Some Nuremberg makers placed their stamp on the rim of Sabbath lamps and candelabra, and these are the only objects about the origin of which we can be at all certain. You should develop your feel for domestic bronze and brass of known date and provenance, with all the regional and chronological differences, and apply this knowledge to Judaica. Although the same can be said for all areas of collecting Judaica, the field of metals, do not forget, is the largest of all, so is the one you can least afford to ignore.

III

Sabbath Lamps

The Sabbath lamp is the most potent symbol of the Jewish home. Its gently diffused light emblemizes the singular peace of the Sabbath eve. The family meal on Friday evening is a time apart, when the master of each house becomes its High Priest and its table an altar. A special meal will have been prepared, the finest clothes laid out and the best tableware produced. When the preparations are complete and night is falling – since Sabbath, like all Jewish feasts, lasts from evening to evening – the holy day is welcomed into the family circle by the mother, whose work has done most to make it possible. As she lights the Sabbath lamp the sacred time commences. She covers her eyes as she says a brief prayer over it, after which a mystic poem is sung, welcoming the angels of Sabbath into the home. The father then formally blesses his children and the meal begins. Even today, when electricity has made an anachronism of oil and candles, the old lamps and candlesticks, carefully polished, shed their golden reflected aura over familiar surroundings, marking off the Sabbath-eve meal from the pressures of secular life.

There are several versions of the Sabbath-lamp custom. Some families light a pair of candlesticks; others a candelabrum; some have a hanging lamp with between six and twelve wicks; and others light one candle for each member of the family. Each number of lights has a mystic meaning: the two candles are for the double command in the Bible, to 'keep' and to 'remember' the Sabbath; the six wicks are for the working days of the week clustering around the lamp of the Sabbath; and the personal candles symbolize the angels that accompany each individual throughout the Sabbath. There seems to be little standardization in usage, except that pairs of candlesticks, which are widely manu-

factured and easy to find, have gained ground on the other forms of lighting.

Oils lamps, although they are less usual nowadays, are far more ancient than candles, so we shall look at them first. The earliest known lamps consisted of a bowl of oil with a burning wick projecting over the side. Clay bowls, some equipped with a shallow lip – to hold the wick – which has been blackened by the guttering flame, have been discovered in houses that date back to the Middle Bronze Age, when the biblical Abraham is supposed to have lived. As the centuries passed, the lip became progressively more pinched, until by Roman times the whole lamp was enclosed except for a tiny hole for the wick and a larger one for pouring in the oil. Such lamps have even been discovered on which Jewish religious symbols are moulded, but we have no way of knowing whether they were intended specifically for Sabbath use or for some other ritual, such as burial offerings, with which we are no longer familiar.

The earliest Sabbath lamps of which we know are those illustrated in medieval manuscripts, but no lamp seems to have survived from earlier than the seventeenth century. The majority of those you are likely to find are of cast brass or bronze, and have evolved from the simple hanging bowl. Originally the potter or metalworker would have indented the rim of the bowl in order to secure the wicks whose lower ends floated in the oil-filled reservoir. Another technique involved pinching the rim to produce a series of lips around the rim of the bowl. In later lamps these lips were extended into longer nozzles, particularly in Northern Europe, so that the much-reduced bowl lay at the centre of a number of radiating arms to form a star shape. For this reason they became known as *Judenstern* lamps, meaning 'Jewish star'.

Below the star hung a drip-pan, to catch any drops of oil from the wicks. The star itself was suspended from a vertical central rod or elaborately moulded tube to help reflect the light, which in turn hung from a chain, or – in the case of German lamps – from a ratchet with which one could raise and lower the lamp when it was not in use. The catch on the ratchet, usually called the pawl, was often shaped like an animal head.

You will be lucky to find a whole lamp with all its original pieces intact. Breakages have taken their toll, and many examples have been ruined by being drilled for electric light. Be on your guard also against ill-fitting sections from different lamps: the proportions should tell you if the match is a suitable one. All lamps are hard to

date and to trace to their place of origin since brass is not stamped or marked. Generally speaking, the earlier examples are larger and heavier, with more elaborately turned and finished stems. They will also tend to show signs of heavy use and of generations of regular polishing, although a little-used specimen may look almost completely new, so caution will be needed if you use this dating technique. German stars have long projections with rounded or keel-shaped bottoms, while Italian ones tend to have shorter lips spaced round the rim of a larger, deeper reservoir. Italian lamps also have thinner and more elegant hanging rods and no ratchets.

Some finer versions of the Sabbath lamp have a series of scrolling arms emerging from the hanging rod and ending in candleholders or small decorative reflectors. Larger lamps may have more than one tier of these. On eighteenth-century models the arms will have wedge-like insertion points which will often be individually numbered, since each arm will fit only into its own socket. Lamps with these additions are far rarer than those without.

There is no reason for the owner of a rich collection of Judaica not to use and enjoy the Sabbath lamps it contains. Although olive oil can be rather messy, it burns steadily and with a beautifully soft flame. A short piece of smooth string serves as an ideal wick. If you prefer electricity – which is certainly cleaner than oil, but less attractive and simply wrong for the purpose – you should buy a lamp that has already been wired for bulbs. You should certainly never ruin a good lamp by having it drilled for yourself. It is, incidentally, possible to wire one up without damaging the metal at all.

There is comparatively little danger that a brass or bronze lamp will be a forgery, since the work required to produce them is considerable and the profits not particularly high. The same is unfortunately not true of silver examples, however, which are extremely rare and consequently very expensive. The most elaborate silver lamps come chiefly from Frankfurt-am-Main and date from the seventeenth and eighteenth centuries. The central rod is adorned with ranks of tiny figurines standing around ornate galleries. Most such lamps are now in museums, but examples appear on the market from time to time. If you see one, check first of all that it is not a simple silver lamp that has been ornamented at a much later date. Check also that all the parts are genuine and that they match. A certain amount of old damage and repair, and even some later elements, are to be expected. They should be considered signs of normal use and maintenance. Some replacement pieces

may date from up to seventy-five years later than the rest of the lamp. Less elaborate German silver lamps are not so rare, but they are easier to forge. You should therefore be on your guard. The best defence is a thorough knowledge of the silversmithing techniques current at the relevant period, coupled with an acquaintance with a number of the authentic lamps in museum collections. While paying close attention to the silver marks, bear in mind that forgers are often scrupulous in reproducing these important details, so these are not in themselves proof of authenticity. This is also true of all the types of silver lamp described in the following paragraphs.

Silver lamps from Holland, dating from the seventeenth to the eighteenth centuries, tend to be less ornate, but no less splendid. They are usually closer in design to the brass lamps, and make their impact by means of the play of light on multi-faceted surfaces. Since Sephardi Jews, who came originally from Spain and Portugal, lived in the Netherlands at the same time as the local Ashkenazi Jews from France and Germany, both the Italian and the German types of lamp were manufactured there. Each piece of these lamps should be marked. Dating will be easier if there are any small applied Baroque or Rococo elements. The lamps tend to be of thick metal, which increases their value still further. A small number of a similar kind were made in England in the eighteenth and nineteenth centuries, mostly in imitation of the Dutch lamps owned by some of the earliest Sephardi immigrants. These are very rare indeed.

The Italian lamps you are likely to find on the market will mostly date to between the late seventeenth and the early nineteenth

V TOP ROW, FROM LEFT German pewter *Purim* plate, 1762, D. 9¼ in (23.5 cm); German parcel-gilt silver spice tower, maker's mark a rampant horse in a circle, Nuremberg, *c.* 1750, H. 14¼ in (36 cm); Hebrew books, the last in a German parcel-gilt silver filigree binding, *c.* 1700, H. 5½ in (14 cm).
SECOND ROW, FROM LEFT Baal Shem Tov-type silver filigree *Hanukah* lamp, Ukrainian, 1836, H. 11½ in (29.25 cm); Austrian silver-gilt *Ethrog* container, probably Vienna, 1821, L. 8½ in (21.5 cm); German silver marriage belt, maker's mark GOH in a cartouche, Frankfurt, early 17th cent., L. 32 in (81.25 cm); Continental faience festival plate, probably German, early 19th cent., inscribed in Yiddish *Gut Yontif* (Happy Holiday), D. 10 in (25.5 cm); Esther scroll on parchment with manuscript text, and engraved borders by Francesco Griselini, Venice, mid-18th cent., W. of scroll 10 in (25.5 cm); Amber-flashed glass ceremonial cup with etched Hebrew inscription, probably Bohemian, mid-19th cent., H. 4¾ in (12 cm); German silver *Torah* pointer, maker's mark IAB, Mannheim, *c.* 1750, Hebrew inscription

dated 1779, L. 9½ in (24 cm); Parcel-gilt silver *Torah* breastplate, maker SH, town mark a bear or a boar, Swiss or German, late 18th cent., H. 13 in (33 cm).
BELOW Italian embroidered-velvet Ark valance, Rome, 1938, presented to the Jews of Addis Ababa by the Jews of Rome, after Mussolini's invasion of Ethiopia, 70 × 21½ in (178 × 54.5 cm).

VI Spanish or Spanish Exile silver *Hevrah Kadishah* (Burial Society) bowl, *c.* 1550–1600, W. 5½ in (14 cm). Probably made for ceremonial drinking, this piece is similar in style to Southern French or Burgundian bowls.

VII Austrian parcel-gilt silver covered goblet, Vienna, 1697, with Hebrew inscription dated 1804, H. 17½ in (44.5 cm). Vessels such as this one, with inscriptions postdating it by 100 years or so, are common.

VIII German silver Burial Society (*Hevrah Kadishah*) beaker, Philip Stenglin, Augsburg, 1710–12, the inscription dated 1756, H. 5¾ in (14.75 cm).

V ▶

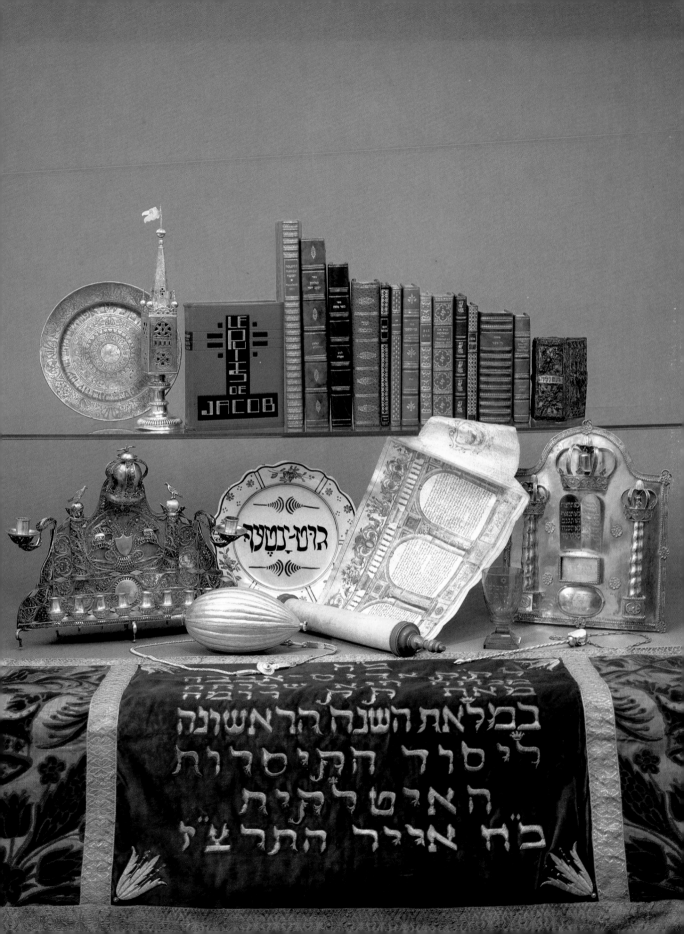

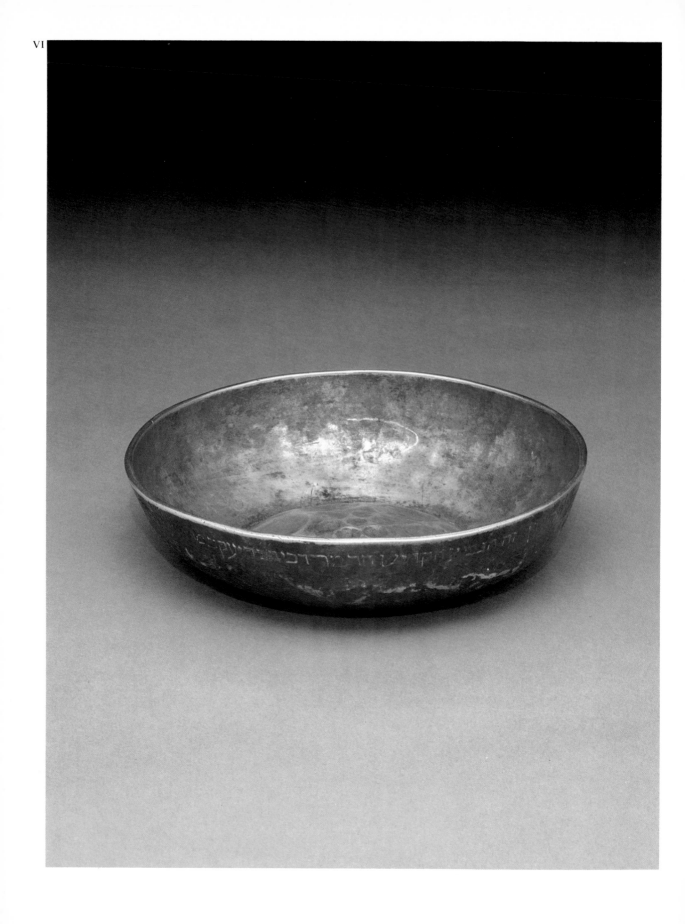

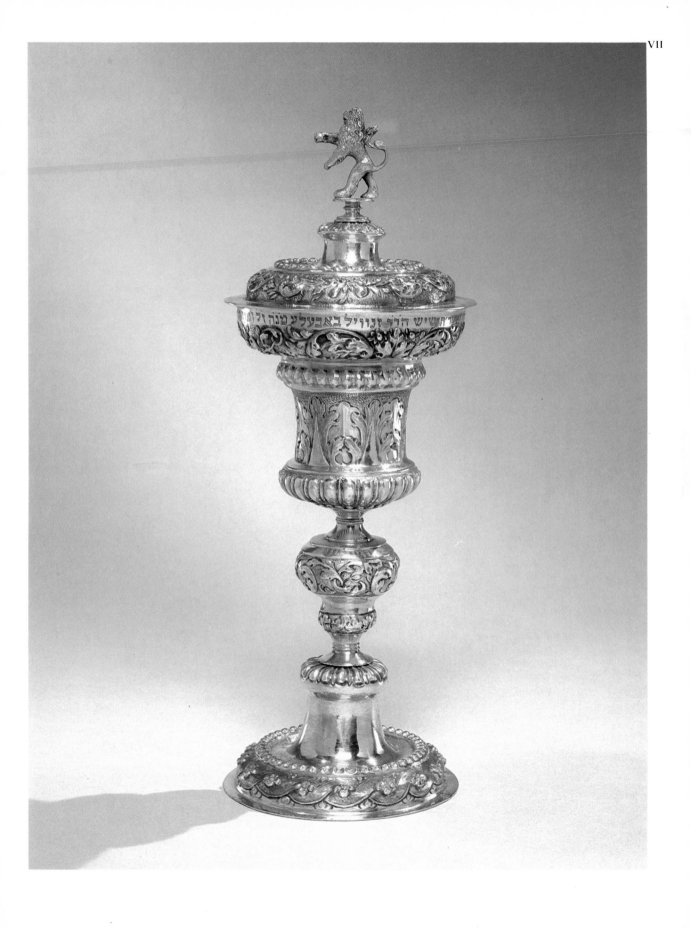

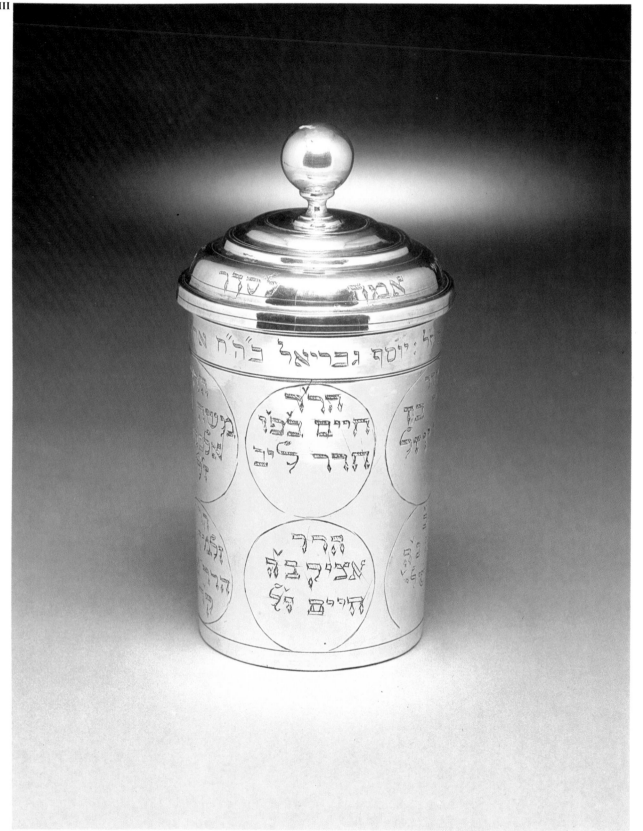

centuries. They stand midway between the heavy figural elaboration of the German pieces and the bold simplicity of the Dutch. The rim of the bowl is pinched at intervals to hold the wicks, rather than having long projecting arms to form a 'star'. The lamps are of medium- to light-gauge metal. But they make up in exuberance what they lack in weight, especially during the Baroque and Rococo periods. Separate cast figures never appear. Many of the lamps have Southern Italian markings, but as these are rather random, you should cross-check that all the pieces match in style and technique. Remember too that in Italy olive oil remained the standard lighting fuel for far longer than in almost any other part of Europe – until late in the nineteenth century – so that by no means all the Italian oil lamps you will find will be Judaic.

The style of brassware changes rather more slowly than that of other types of object, so the dating is unfortunately less precise. Candlesticks of the seventeenth and eighteenth centuries are massive and ornate, with sinuous stems, and with the sockets, pierced drip-pans and guards set at intervals in graduated tiers. The feet too are complex, and are often composed of several elements. The screws attaching the base to the stem are a reliable guide to authenticity: they should be thick and crude, often with a shallow hole punched in the centre of the base to serve as a centring point. The thread will be uneven and somewhat worn, and will fit only into the socket for which it was made. The surface of the candlestick will be smoothed by centuries of polishing, and all the sharp corners will have been worn down and gently rounded.

Candlesticks became progressively smaller and less massive and ornate during the nineteenth century. Many have stumpy, square bases and badly proportioned, bulbous stems. In the second half of the century a type produced in Warsaw takes precedence. They are of quite light-gauge metal, have domed circular bases which often stand on grapevine legs, and are chased or stamped with grapevines, foliage, and even with depictions of swans on a lake. Many were originally silver-plated, to resemble the silver candlesticks on which they were based, and which we will discuss in the context of silver candlesticks. They are often stamped with the maker's name and with the *Warszawa* provenance stamp of Warsaw. They look handsome even when the silver has worn thin, so it is usually a mistake to re-silver them; this destroys the patina and makes an old pair of candlesticks simply look new. Careful polishing brings out their rich colouring.

The brass candelabra of Eastern Europe that developed at the same time as the candlesticks usually have bulbous (multi-baluster) stems, set on broad, concave, circular bases. The earlier ones, dating from the seventeenth and eighteenth centuries, are of the same massive type of screw construction as the candlesticks. The candleholders are also attached with screws. The branches which bear these candleholders are ornately pierced with designs of inter-laced foliage, and occasionally with rampant lions and deer. On earlier examples the designs will be supplemented with engraved details. There are between two and seven candleholders; those with eight lights are for use at *Hanukah,* and are discussed separately. Large lamps were often intended for use in synagogue. Many lamps of all kinds are surmounted with an eagle knop, or even with a pair of heraldic eagles. There is occasionally a central cartouche with the Sabbath-lights blessing in Hebrew, although this is more usual in nineteenth-century examples.

We come lastly to one of the most attractive of all types of Sabbath light, which is also one of the easiest to find on the market: the silver candlesticks of Poland. They were made mostly in Warsaw from about the middle of the nineteenth century until the Second World War, and almost exclusively for Jewish use. The earliest examples date from the 1830s and 1840s and they usually have square bases and mildly bulbous stems. Later the stems swell and are embossed and chased with foliage, while a domed and tiered base appears, similarly decorated. The silver-plated examples described earlier echo these candlesticks closely. Warsaw makers produced them in great numbers, particularly prior to the First World War. The surviving quantities suggest that practically every Jewish family in Eastern Europe possessed a pair. A limited production continued between the wars in Warsaw, with little innovation or change. Later examples can usually only be identified by the lack of patina and wear; but this is a most unreliable indicator of date, since some early candlesticks have been little used. One occasionally finds pieces with both pre- and post-First World War hallmarks. This was occasionally done when pre-1914 pieces were re-assessed for tax purposes or resale. So you need not assume the piece is a forgery.

Contemporary candlesticks are mostly rather lacking in originality, and echo earlier styles in a lacklustre way. Ludwig Wolpert, Ilya Schor and Moshe Zabari of the Toby Pascher Workshop in the Jewish Museum, New York, have succeeded in creating a modern idiom. Younger artists, one hopes, will make sure that our own age is also remembered for its Sabbath lamps, as well as for collecting the masterpieces of earlier ages.

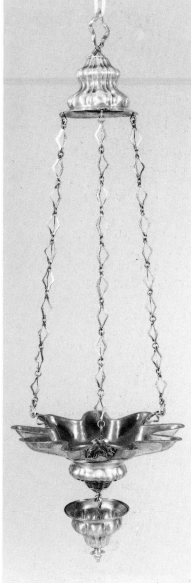

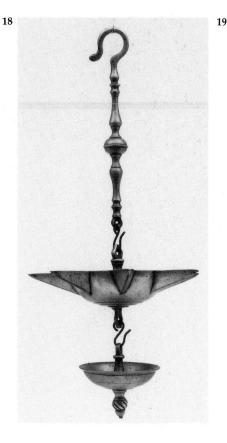

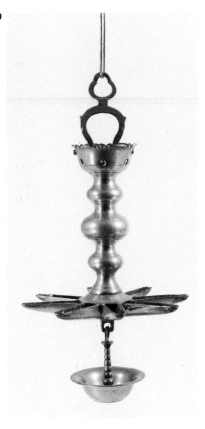

The fact that it is made of brass, and the style of the turning, suggest that it is Dutch.

19 German brass Sabbath lamp, 18th cent., *H.* 17 in (43 cm).
This type of Sabbath lamp is the one most often encountered by collectors. The shaft lacks the elegance of the Italian and Dutch forms, but many have survived, so prices are reasonable.

20 German brass Sabbath lamp, *c.* 1750–90, *H.* 35 in (89 cm).
An elaborate example with an eight-pointed-star oil section surmounted by detachable candleholders. It has flower-form reflectors and an elaborate suspension loop. The candles may have been used for ordinary lighting on weekdays. In lamps of this age, the candleholders fit into a central ring. Each one is numbered to match its slot, as they are not interchangeable. Check that the parts match by comparing the patina and colour of the metal, which should be reasonably similar.

17 Italian silver Sabbath lamp, Venice, *c.* 1770, *H.* 37 in (94 cm).
This lamp consists of a nine-pointed star-form oil section, drip pan and suspension bracket, with fluted decoration which brings out the subtle patina of the metal.

18 Cast-brass Sabbath lamp, probably Dutch, early 18th cent., *H.* 28 in (71 cm).
Although less obviously Italian than the previous example, this Sabbath lamp is related to it in form. The suspension shaft is fine, as is the finely chased knop on the drip pan.

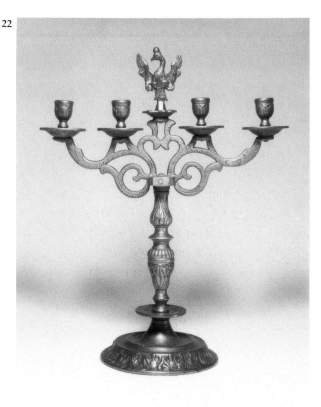

21 Polish brass 4-light Sabbath candelabrum, mid-19th cent., *H.* 17 in (43 cm).
Of heavy, roughly cast brass, this example has an unusual double-eagle motif – the four-headed bird supports the candleholders. The central, single-headed eagle is found on all types of Polish candelabra. The bold design of this piece compensates for its coarse finish.

22 Polish brass 4-light Sabbath candelabrum, *c.* 1825–50, *H.* 21 in (53.25 cm).
This example is based on a Renaissance model. It retains characteristic mask and strapwork along the base, which persisted into the nineteenth century in Poland. The eagle knop is traditional. Dating is based on the overall massiveness, the details, and especially the gauge of the screws.

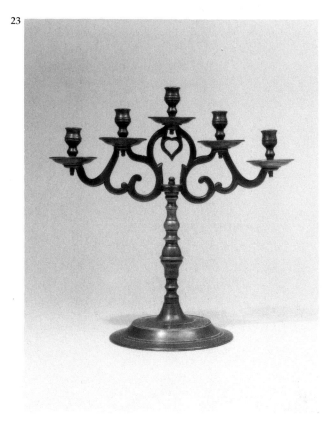

23 Polish brass 5-light Sabbath candelabrum, early 19th cent., *H.* 22½ in (57 cm).
This is a fine example of good Polish casting. It is relatively undecorated, but has a strong outline.

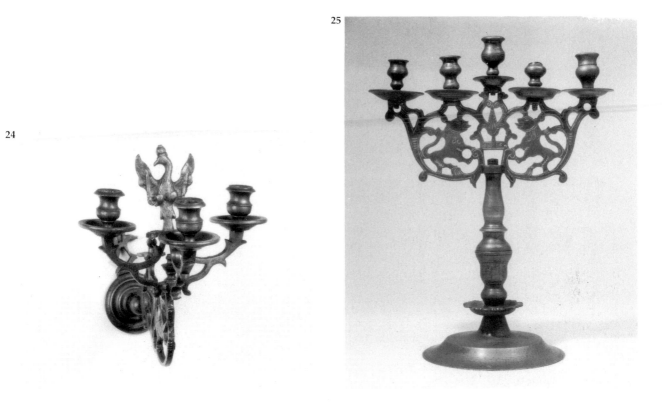

24

25

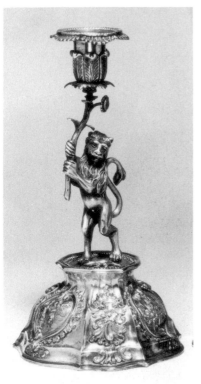

26

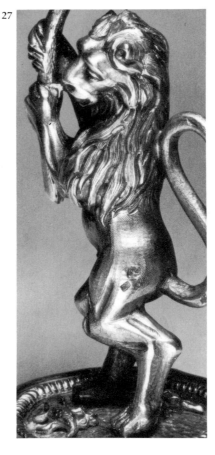

27

24 One of a pair of Polish brass 3-light Sabbath sconces, *c.* 1820–30, *L.* 16 in (40.5 cm).
The eagle knop and the three sturdy candlesockets are supported on a bracket that is pierced and chased with a lion and a bird. These are typical Judeo-Polish motifs.

25 Polish brass 5-light Sabbath candelabrum, 18th cent., *H.* 19 in (48.25 cm).
The heavy, turned stem and broad base are typical of eighteenth-century pieces. The rampant lions of the upper section are well shaded with engraved lines. The thick screws below the sockets are another reliable sign of age.

26, 27 Portuguese parcel-gilt silver Sabbath candlesticks, 1950s, *H.* 10 in (25.4 cm).
The eighteenth-century German prototypes of such candlesticks are very rare. The versions most commonly found are nineteenth-century German copies or these modern ones. Their attractive design and good craftsmanship makes even copies expensive.

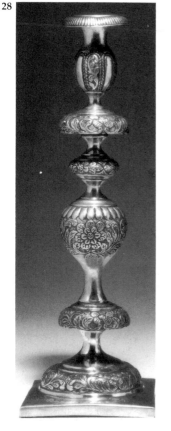

28 Polish silver Sabbath candlesticks, Warsaw, *c.* 1840, with unidentified maker's mark, 12 quality mark, *H.* 15½ in (39.25 cm). A particularly early version of this type of candlestick, these examples have heavier gauge and are better balanced than most later specimens, and are reproduced today.

29 Polish silver Sabbath candlesticks, Lobech, Warsaw, 1887, *H.* 14 in (35.5 cm). Another popular type, with characteristic vine decoration. The feet are in the form of grapevines. The piece has petal-form candlesockets.

30 Polish silver Sabbath candlesticks, S. Szkarlat, Warsaw, 1887, *H.* 13 in (33 cm). Szkarlat was a prolific maker whose mark is found on much Jewish silver from between about 1875 and the Great War.

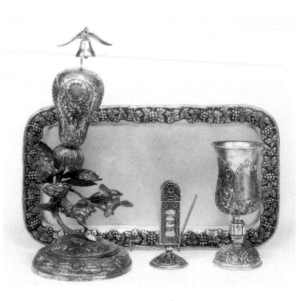

31 Silver *Havdalah* set, probably Hungarian, *c.* 1950, *H.* of cup 6 in (15.25 cm). Comprises a spicebox, a *Kiddush* cup, a candleholder and a tray. The idea of sets seems to be relatively modern, and any earlier examples have been separated or lost. This one is based on traditional designs, hand-chased in a superficially nineteenth-century style. There is a pronounced stiffness in the modern version.

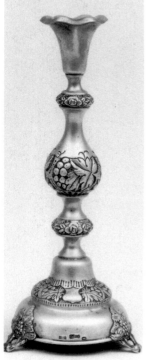

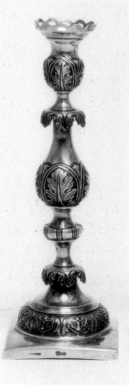

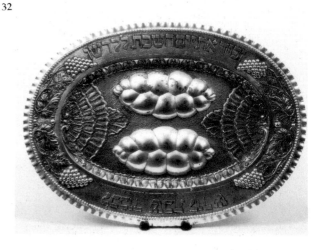

32 Hungarian silver Sabbath-loaf platter, *c.* 1950–60, *L.* 24 in (61 cm). A pleasant example of modern work in nineteenth-century style. The marks, the patina, the lack of wear and the tell-tale stiffness in the ornament all point to its modern origin. The loaves of *Challah* or Sabbath twist, commemorate the shewbread which the priests placed in the ancient Temple of Jerusalem.

IV

Ceremonial Cups

Before each main meal on Sabbaths and festivals, and at various special ceremonies such as weddings and circumcisions, a blessing is recited over a cup of wine by the senior male at the table or the Rabbi of a community before he drinks from it. The cup from which the wine is drunk is one of the most treasured of family possessions. The ceremony is called *Kiddush*, 'sanctification', because the blessings over wine and bread sanctify the meal that follows. Sabbath and festivals are also brought to a close with a ceremony, called *Havdalah*, that involves drinking from the cup. Other *Havdalah* objects are discussed in a separate chapter. But the common element to all these ceremonies is the beaker, usually made of silver, that is the most often used and perhaps the most familiar of . all the Jewish ritual objects in the home.

Silver cups and bowls have been known since antiquity as part of ordinary domestic ware. In the Middle Ages, European Jews purchased cups and bowls from non-Jewish silversmiths, the form and decoration of which varied with their date and provenance. Often it is the Hebrew inscription alone which indicates that the piece was used in Jewish rituals, so inscriptions are of primary importance for determining the origins and value of a cup.

The earliest examples a collector might encounter will probably be non-Jewish, late-seventeenth-century silver beakers or goblets with engraved Hebrew inscriptions. Discovering the age of an inscription is the main challenge. It is often easier to determine this once the date of the silver itself has been identified, which may be possible by means of hallmarks and stylistic features. Certain types of inscription, particularly those recording a presentation to a synagogue or *Hevrah Kadishah* (Burial Society), include dates, but most cups, even those with inscriptions, are undated, so their style

is the only guide. In general, the earlier the piece and the more contemporary the engraving, the finer and more elaborate the engraving will be. Thus, on a late-seventeenth-century beaker or goblet one would expect genuine early engraving to be beautifully executed, particularly if it comes, as most examples do, from Germany or Bohemia.

The letters are finely formed, usually with the central portion shaded with meticulous cross-hatching or other decorative engraving. The letters often terminate in foliate motifs or even animal heads. A good knowledge of manuscript and printed Hebrew calligraphic styles from between the seventeenth and the nineteenth centuries is vital. The inscriptions embroidered on *Torah* binders are invariably dated, so provide a useful guide to letter-styles. Lastly, the tombstone inscriptions of old Jewish cemeteries in Germany, Central Europe and Poland provide a vital catalogue of dated letter-forms. Many groups of stones have been published, so can be studied from photographs. Once inscriptions have been authenticated by museums or skilled collectors, they can be used for comparative purposes. Care is particularly important here because of the many inscriptions that have been fraudulently added in recent years to increase the value of an otherwise ordinary piece. If there is good reason for the inscription to be slightly later than the object on which it appears, the date should reflect this time-lag. In general terms, a late seventeenth- or eighteenth-century beaker will be worth 5 to 10 times more if the engraving was executed within between 30 and 50 years of the making of the piece. Nineteenth-century engraving might increase the value perhaps two- or threefold; modern engraving should not affect its value at all. In fact, a fine seventeenth- or eighteenth-century silver object can be ruined by the addition of an ugly, modern inscription.

The exact wording of the inscription also affects its value. The best Sabbath cups bear the full biblical commandment in Hebrew, to 'Remember [or "Observe"] the Sabbath Day, to keep it Holy'. Others bear only the word 'Sabbath' in Hebrew, or simply an owner's name or initials. Unless the owner achieved fame in some respect, these inscriptions add little to the value, even when they are of the right period. Other cups bear a biblical quotation relating to the particular festival on which they were intended to be used. An attractive type of festival cup has a small vignette or symbol engraved in line with the lettering, which relates to the festival in question. A small *Matsah* represents Passover, a leafy hut Taber-

nacles, and so on. One must be especially cautious in checking the authenticity of these ornaments because of the value they add to a piece.

Craftsmen in eighteenth-century Germany developed a new and popular form of *Kiddush* cup. It consists of a goblet with six or eight sides, of which the lower section is usually lobed and the upper portion chased with flowers. A Hebrew inscription appears at the rim. Its baluster stem is also lobed, and the domed circular base matches the decoration on the cup. These objects were made mainly in Augsburg and Nuremberg by a few families of silversmiths who specialized in their manufacture. In Augsburg the Mittnacht family's most active member was Hieronymus, while in Nuremberg there were the Bierfreund and Wollenberg families. Their cups should be marked on the bowl as well as on the foot, although some are marked on one or the other only. The bowl should unscrew from the stem; but in many cases the joint became wobbly and has been soldered closed. Original cups are of relatively thin-gauge metal, while later copies are cast from these and are heavier and coarser. The genuine examples often show considerable wear and may have been repaired several times. These signs of use are quite acceptable so long as the shape of the cup has not been altered. The makers of such cups tended to be somewhat conservative in their taste, so Baroque strapwork panels on the bowl and the base sometimes continued to appear during the 1750s, and Rococo foliage lingers on into the 1790s. A good German-Jewish cup, dating from between about 1720 and the end of the eighteenth century and with a matching inscription, is most desirable, especially when it also bears a festival motif.

Polish examples dating from between the late eighteenth and the mid-nineteenth century are also popular. These are cruder in form, plainer in decoration, and tend to have a Hebrew inscription that appears in a central cartouche on the side of a tulip- or bell-shaped bowl, standing on a plain cylindrical or faceted stem. They usually have a 'skirt' where the bowl meets the stem, consisting of a petal-like disc of applied silver. The cups are usually of fairly heavy-gauge metal. They are sometimes unmarked, but are more often struck with the quality mark '12'. Occasionally a maker's mark, consisting of letters or a symbol such as a leaf or a bird, will appear as well.

The most familiar form of *Kiddush* cup is perhaps the small silver beaker, usually between 1½ inches (4 cm) and 3½ inches (9 cm) in height, which was made in profusion in Poland and Russia

throughout the nineteenth century and until the First World War. The earlier examples are often Polish in origin, are of heavier metal, and are engraved with foliage and birds. They bear the '12' quality mark and perhaps a maker's mark as well. The cups usually date to about 1820-50. After this period they mostly appear with Moscow marks, until the fall of the Russian Empire in 1917. The markings include the full date of objects from before 1896, as well as the Moscow town mark of St George slaying the dragon, which is often worn down to an illegible blur. There will also be the Cyrillic maker's initials.

The cups bear engraved decoration that includes vestigial foliage alternating with a naive architectural vignette. The metal became thinner and the workmanship rougher as the century progressed. They were made originally as vodka cups, but were quickly adopted by the Jewish population. The smaller versions were used by children. Almost every Polish or Russian Jewish family, no matter how poor, managed to have at least one such cup, which they numbered among their most treasured possessions.

One version of this beaker is especially valuable: the 'Jerusalem' or 'Safed' cup. Craftsmen in Poland or in Palestine carefully engraved a typically Polish cup with three or sometimes four oval vignettes of Jerusalem or of other sacred sites in the Holy Land, including the mystic centre of Safed in Galilee. The names of the localities usually appear beside them. Such cups generally have a Polish or a Polish-type quality mark '12' and other stamps. They date from the latter half of the nineteenth century and were made until the First World War. Also popular is a version carved out of the black, so-called 'Dead Sea Stone', with similar scenes and captions.

A few other types of beaker deserve special attention. At weddings and circumcisions two people drink out of the same cup following a blessing. For these ceremonies a pair of vessels was sometimes provided, or occasionally a double cup consisting of an identical pair joined at the rim. The double examples were based on those made by non-Jewish craftsmen in the seventeenth and eighteenth centuries. They are most commonly in the form of a barrel, with the staves and tap realistically engraved and chased, and adorned with Hebrew inscriptions or abbreviations. Good double cups of this period are anyway rare and expensive, but Jewish specimens with original engraving can command many times their price, especially if they bear the name of a guild member who is known for making Jewish ritual silver. The

temptation to forge such stamps is therefore great, and care should be taken in ascertaining the date of any Hebrew lettering.

Finally, we should look at a category of cup that has attracted the attention of many collectors of Judaica: the *Hevrah Kadishah*, or Burial Society cup. The *Hevrah Kadishah* (literally 'Holy Society') is the most prestigious of the many benevolent societies that thrive in Jewish communal life. Only the most learned and observant people are permitted to perform its duties of ministering to the dying and the dead. The society's work is considered the purest form of charity, since no thanks can be expected for performing it. Burial societies hold an annual banquet for members on the traditional anniversary of the death of Moses. New members are selected and the cup passed among them. The cups are usually made of silver, although societies in Bohemia and Moravia occasionally used ceramic or glass examples. The silver ones are invariably inscribed and dated, and often record the names of the donor, the community and even of the members of the society. It is not unusual to find that the date and place of origin of a cup are different from those of the *Hevrah* by which the cup was used. Early examples with almost contemporary inscriptions are the most valuable, although the quality and the condition are important, as are any special associations of the place of origin and the presence of any famous names among the list of members. These cups, which include beakers, goblets and even tankards, are often as valued for their documentary interest as for their beauty.

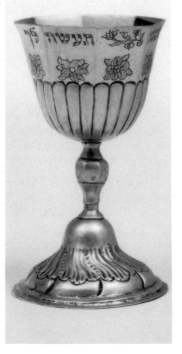

33 German silver ceremonial cup, Johann Nicolas Wollenberg, Nuremberg, 1776–80,
H. 4⅞ in (12.5 cm).
A classic eighteenth-century German cup, of the traditional form for Jewish ritual use. These cups were made in Augsburg and Nuremberg in large quantities. The bowl usually unscrews from the stem, often resulting in a loose join that was later soldered up. The soldering is usually a sign of age. There are many copies available, some quite sophisticated products of electrotyping. This can often be detected through very worn-looking marks and inscriptions, the latter having tell-tale dots raised on the surface opposite the letters on the outside. Many of the older and cruder copies are simple recasts, which can usually be detected by their excessive weight.

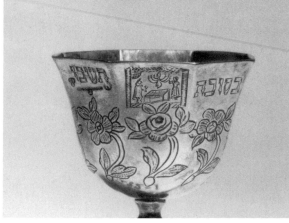

34 Upper part of a German silver ceremonial cup, Georg Nicolas Bierfreund, Nuremberg, 1787–90, *H.* 4½ in (11.5 cm).
Bierfreund was a prolific maker of such cups. Most are for the Sabbath, but here is one intended for the Feast of Tabernacles, *Sukkoth*. It has an appropriate Hebrew inscription and a rare vignette depicting figures inside a *Sukkah*, or tabernacle, kindling lights and holding a wine cup; elsewhere (not visible here) are a *Lulav* and *Ethrog* and a Star of David. Other cups of this type are engraved with a round *Matsah* for Passover, and so on.

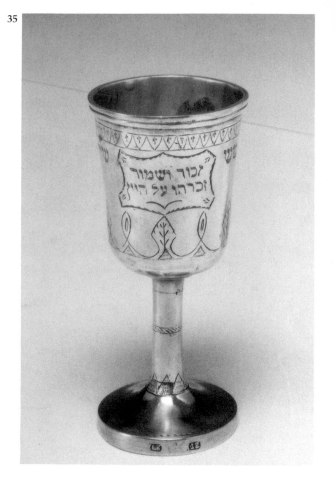

35 Polish silver ceremonial cup, early 19th cent., *H.* 4⅝ in (11.75 cm). The marks, a 12 and an indecipherable maker's mark, are clearly visible, and are typical of Polish silver at this period. Note the painted-leaf borders.

36 (left) Polish silver ceremonial cup, *c.* 1800, *H.* 4 in (10.25 cm). This piece is in German style of the early nineteenth century. The roundels relate to the *Münzenbechern*, or coin beakers, popular at the time, but they are here engraved with Hebrew inscriptions.

36 (right) Polish silver ceremonial cup, early 19th cent., *H.* 5¼ in (13.25 cm).
Another attractive Polish piece, of heavy-gauge metal, and pleasing, simple design. Note the pointed leaf-tip design where the stem joins the base, a common feature on Polish silver from this period.

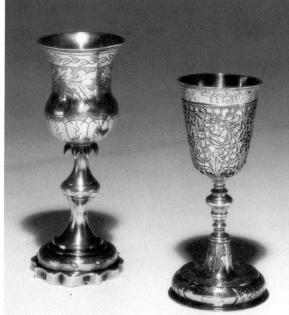

37 (left) Lithuanian silver ceremonial cup, Vilna (Vilnius), 1890, maker's mark ML in Cyrillic, *H.* 7¼ in (18.5 cm).
This cup is of good quality for its age and typical in form for the city of Vilna. The petal-base and tulip-cup are well chased with scrolling foliage. These objects come in a variety of sizes, the larger the better, and this fine, large example would command a high price. They are typically stamped with a full set of marks on the base rim, and the larger examples, as here, are also marked below the lip. The Vilna mark shows the rider of a galloping horse, holding aloft a sabre, facing left. Do not confuse it with Moscow's mark of St George slaying the dragon, which is much more common. The 84 standard mark refers to 84 *zolotniks*, out of the 96 units which made up the pre-Russian Revolution standard. The purity is 87.5 per cent, or 5 per cent below our familiar Sterling standard.

37 (right) Russian silver ceremonial cup, Moscow, mid-18th cent., dated in the Hebrew inscription 1786, maker's mark '. . . sheh' in Cyrillic, *H.* 6 in (15.25 cm).
This cup is flat-chased on the base, with entwined foliage in the Régence style, which was popular fifty years earlier in the west. This delay is typical of Moscow silver in general, which tends to be conservative. The central section unscrews to make the base and bowl detachable; this is also a typical feature of eighteenth-century cups in general. The later engraving of the cup is also a typical feature.

38, 39 'Safed' silver ceremonial cup, inscribed Safed, Galilee, 1907, *H.* 2¾ in (7 cm).
These cups, very popular with collectors, are something of a mystery. This example is decorated with three engraved architectural vignettes of the Holy Land,

titled in Hebrew. The workmanship is excellent, and collectors pay thousands of dollars for such cups, vastly more than for a similar plain Polish beaker. This piece is stamped with the quality mark 14 underneath, an anomaly in itself, though this is the equivalent of the Russian 84 standard. It was perhaps marked in an area of Poland closer to Russia proper, perhaps in Byelorussia or the Ukraine. Some scholars claim that such pieces were made in Palestine – which is unlikely as even the decoration is very Polish. Perhaps they were made by Polish emigrant craftsmen resident in Palestine, working in their natural style, using old, undecorated beakers.

40 Palestinian carved-stone ceremonial cup, late 19th cent., *H.* 3½ in (9 cm).
Carved in a blackish-brown stone called 'Dead Sea Stone', the form is Polish, but both the material and the style of carving point to an origin in the Holy Land. The body is inscribed in French as a souvenir of the region; such cups may have served as prototypes for the more elaborate silver examples illustrated previously.

41 German silver ceremonial cup, late 19th cent., *H.* 4 in (10.25 cm).
These cups depict Moses, Aaron and Solomon in reserves separated by fruit, scrolls and lions' heads. The style of the cup is late seventeenth century, but of a type greatly copied after the late nineteenth century. Earlier examples are lighter in gauge, with better chasing and background matting; later ones are cast, being heavier and coarser. Though not necessarily for Jewish ceremonial use, they are popular with collectors for their inconography and usefulness.

42

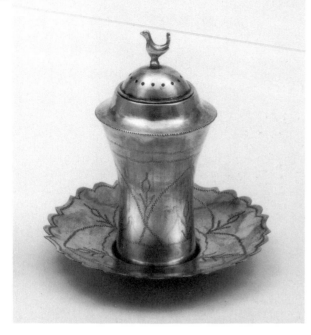

43

42 Iraqi silver covered *Havdalah* compendium, late 19th cent., *H.* 5 in (12.5 cm).

These cups, either alone or with underplates, and also as here in complete sets, were popular in Iraq for various ceremonial purposes. Very few have Hebrew inscriptions, a fact that is off-putting to European Jews who are used to heavily inscribed Judaica. There is however no doubt that such cups were for Jewish ceremonial purposes. The bird motif is found on other Jewish pieces from the region. Here the cleverly designed lid includes a spice compartment and the underplate necessary for the *Havdalah* Ceremony. Silversmithing in Baghdad was a Jewish craft, and makers took obvious pride in such work.

43 Russian silver bowl with Persian decoration, the bowl by P. Miluikov, Moscow, *c.* 1900, *D.* 7 in (17.75 cm).

An interesting 'marriage', made without any intent to deceive, this bowl was probably used for *Kiddush* in Persia. A great deal of Russian silver made its way to Persia, over their common border. The engraving is typically Persian, finely executed, with Hebrew inscriptions recounting the longing for Zion.

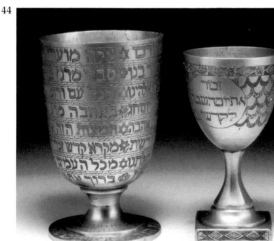

44 (left) Persian silver Passover cup, 19th cent., *H.* 5 in (12.5 cm).

An attractive piece, of simple design, engraved with a Hebrew inscription relating to Passover, and interspersed with Stars of David and flowerheads.

44 (right) Polish silver ceremonial cup, early 19th cent., *H.* 4¾ in (12 cm).

A fine piece with good engraving, including two circular reserves with Hebrew inscriptions relating to the Sabbath. Cups of this elaborateness and in this condition are rare. They command high prices, although less than eighteenth-century German examples, which happen to be more plentiful.

V

Spiceboxes, Candleholders and Havdalah Sets

As night draws in on Saturday evening and the end of Sabbath approaches, Jewish families gather for a short but richly complex ceremony, called *Havdalah*, which means literally 'separation' or 'distinction'. Just as the Sabbath was welcomed into the lamp-lit home on Friday evening, so now it is ushered out with song and candlelight. But instead of the warming, restful meal of Friday evening, there are rituals reflecting evanescence, illusion and nostalgia. No food now, only aromatic herbs scented through the filigree of spiceholders; no constant light, only the extinguishing of candles and the play of shadows. This moving ceremony has a primeval quality about it that is lacking in most other Jewish rites.

The setting itself is almost a mirror image of the Friday-night meal. In the most usual form of this ritual, one member of the family holds a lighted candle, usually a plait of three of four thick tapers, while the master of the house raises a winecup in blessing. A decorative spicebox containing scented herbs is then passed round. It may contain myrtle, eucalyptus or any sweet leaf. There follows a blessing over the lighted candle, after which everyone extends half-cupped hands towards it. The parted fingers cast bars of light on the palms of the hand, and the shadows, according to one interpretation, form the first Hebrew letter of God's name. The last drops of wine are then spilled out into a bowl and the candle extinguished in it. Some families use brandy for this ceremony, which ignites when the candle touches it. The Sabbath then fades to the blue flicker of the flame, while most families sing a prayer for the Messiah – for whom Jews still wait – in the darkening room.

The most unusual and distinctive element in this ceremony is the spice container, or *Besamim*-box. It is used for this ceremony alone, and many examples are specifically Jewish in design. Their variety

has made them more popular than perhaps any other Jewish ritual article. Ranging in shape from the smallest nutmeg-grinders to model towers up to 1 foot (30 cm) high, they have elegant stems and are adorned with bells and pennants.

The turret is the most popular form. It seems to have originated among the Ashkenazi or Northern European Jews and to have echoed in part the Christian monstrance. The central section has a small door through which the spices are inserted. On top is a tower which might contain a bell, and at the top of this a hinged pennant. The earliest examples date from the mid-sixteenth century, and are the direct models for spiceboxes still being manufactured today. They are made of filigree or of embossed sheet metal, and sometimes a combination of both.

Most tower spiceboxes that the collector is likely to find will have been made between the middle of the nineteenth century and the beginning of the twentieth. The early-eighteenth-century examples from German towns such as Nuremberg and Frankfurt-am-Main are extremely rare and have been carefully imitated in recent times. Even the town-markings are accurately reproduced, so great care is needed to distinguish forgeries from the real thing. The differences are fortunately fairly clear. The original examples are made of sheet metal that is so thin as to be almost tinny. The bases are of similar or slightly thicker metal, but are sometimes cast. The pennant on top of the spicebox is well finished, and may be decorated with chased shading or cross-hatching to give depth to the outline.

Copies of these German spiceboxes started to appear in the late nineteenth century. They contain far more metal than the early examples, and are sometimes made of thick, cast silver. This change reflects the reversed values of silver and of craftsmanship during the two periods. At the earlier period silver was the more expensive; at the later one, skilled silversmithing. The copies bear complete sets of markings, including the *Reichsmark* '800', the crescent moon, the imperial crown and sometimes some spurious marks. On originals, the base bears the town and the maker's marks, which sometimes appear on the body and the door as well. Pieces made in Frankfurt tend to be carefully and fully marked; those from Nuremberg less so. Another distinguishing sign of the copy is its rather sparse decoration and piercing. The higher cost of skilled labour led to there being more solid metal than decoration.

At roughly the same time as the early tower-boxes, craftsmen elsewhere were producing another type of container made of dense filigree. Their bases often have claw and ball feet, and the

turrets may be adorned with gilt pennants. Exactly where they were made is a mystery. They are never marked, but have been attributed by experts to workshops in Italy, Poland or Hungary. They are not as rare as the tower-boxes from Germany, so are less valuable.

Far more common, but much copied even so, are the late-eighteenth- and early-nineteenth-century spiceboxes of Poland. The central portions bear vignettes of flowers, animals and humans — the last surprising in view of the usual Jewish reticence about graven images. The forgeries are far harder to detect than are those of the German boxes. Since both the originals and the copies are of cast metal, there is little to guide the purchaser other than the ability to *feel* whether an example is authentic. This knowledge can only be acquired by examining examples known to be genuine that are now in museums.

In many cases, however, the metal itself out of which Polish ritual silver is made provides the unmistakable evidence the collector needs. Polish craftsmen often used a low-silver alloy containing 50 per cent copper. With the colour of pewter, softened by rosy copper highlights, this alloy was never made outside Poland and hardly at all after the early nineteenth century. Although it was never marked, it is a good indication of date and provenance. It seems never to have been successfully copied. In order to be sure that you recognize it, you should look closely at examples of pewter on the one hand and of silvered copper on the other, to learn the feel of both. Silvered copper was an early form of silver plating in which a copper or brass object was dipped in a mixture of mercury and ground silver and then fired. This too is frequently encountered.

There is direct continuity between the spiceboxes of the eighteenth and of the nineteenth centuries. But the later ones are far easier both to date and to trace to their places of origin. They are also far less frequently copied, with the possible exception of those from Warsaw. Hallmarks are the first aid to identification; also useful is the new tendency for bells to appear on the outside.

One important type comes from Berlin. It made its appearance in about 1810 and continued to be made until the end of the century, although with decreasing skill. The later the example the more spindly it will be. Also look out for the *Reichsmark* '800' of the late nineteenth century, which will confirm this general rule. The base of Berlin spiceboxes is domed and circular, and of sheet metal. It may be ringed with a high-relief stamped leaftip band. Other such

bands may appear along the edges of the filigree sections of the spicebox itself. There may be two or three superimposed filigree sections – generally circular – the lowest and largest of which will contain a door for inserting the spices. Occasionally the lower section will detach from the rest, and no door will be needed. The lower section of the spire on top of the spice container may be decorated with patterned, engine-turned bands. There may also be an appliqué stamped panel showing lions flanking the Ten Commandments. In earlier examples the spire may contain a bell. Later on, the spire is replaced by an open columnar section. On top of all these spiceboxes is the typical ball-and-pennant finial.

A second important category of nineteenth-century spicebox comes from the Austro-Hungarian Empire, mainly from Vienna and Prague. It is made almost entirely of filigree, and has bells and pennants along the sides. The spice container itself is square, and is the lowest of several graduated sections of the same general shape. The filigree stem is also square in section, often with a thicker element in the centre. Its complex base stands on domed circular supports. Such spiceboxes are seldom higher than 10 inches (25 cm). They were made in large numbers between the middle of the nineteenth century and the First World War, so are neither rare nor particularly sought after, unless the metal is thick.

The most exciting group of nineteenth-century spiceboxes, however, comes from Warsaw. The base is either circular and domed or square, and of sheet metal. Early-nineteenth-century examples have a skirted knop mid-way up the stem. The square or octagonal spice container has filigree sides, usually of rather coarse, thick wire, worked into round patterns. This is set into solid-silver borders, and equipped with a strong door, bells and pennants. On top of the sheet-metal spire is a ball-and-pennant finial. All spiceboxes bear a maker's mark and a quality stamp '12', usually on the base. Russian marks were introduced in 1851, and, although they were slightly less copious after 1896, continued in use until the First World War. These include the double eagle of Warsaw, the full date, the assay-master's initials or full name in Cyrillic, and the maker's initials or full name in Cyrillic or Roman lettering on the base. Some of the same marks also appear on the door and the pennant. If these are not marked you should check if they are replacements. Should they appear to be original, the whole piece may prove to be a copy. In cases of doubt you should look for signs of age and authenticity, such as wear, repairs and dents. The best guide is the workmanship of authentic examples that can be

examined in museum collections.

Also from nineteenth-century Warsaw is a group of spiceboxes with a solid-metal spice container, waisted like a spool. This often has grapevine decoration, and stands on a domed, circular base with grapevine supports. The marks are similar to those of the other categories of Warsaw spicebox.

Polish boxes are so popular that they have continued to be copied to the present day. Their modern makers do not necessarily intend to deceive, but dealers are not always aware of the provenance, so collectors may find themselves being misled. Since the copies rarely have false markings, you need only check that the stamps are consistent in order to be reasonably sure that the piece is authentic. More confusion surrounds the apparently genuine objects that bear both the number '84' and the word 'Sterling'. It has even been suggested that these were Polish products exported to America and stamped there. The problem is not a small one, because almost every type of Polish silver object is found with these marks. In fact they were produced by Polish craftsmen living in America between about 1900 and the First World War. Their immigrant customers were used to seeing the '84' stamp on their silverware and were not familiar with the American 'Sterling' mark. So although the '84' standard is equivalent only to 87.5 per cent pure silver, whereas sterling is 92.5 per cent pure, the mark was included for their benefit, mainly, one imagines, to indicate that that the piece was indeed of solid silver and not merely plated.

We have so far spoken only of tower-shaped spiceboxes. Those shaped like fruit were also popular mainly from the late eighteenth century, although they were known from the mid-eighteenth century or earlier, and were made until the late nineteenth century. They were common in Poland, Lithuania, the Ukraine and White Russia, until they were replaced by the tower-shape.

The most familiar version is in the form of an apple or a pear. It is set on a stem in the form of foliage, and the base may be shaped like a section of pear. The cap, which may be perforated, screws off to reveal the spice container. These boxes are often made of the low-silver alloy from Poland that has been discussed in connection with Polish tower-boxes from the later eighteenth century. The older types consist of the fruit itself, about 1½ or 2 inches (4 or 5 cm) long, and a pierced lid which screws onto the end of a vertical rod that runs from the base to the top of the box. The spiceboxes are often adorned with various beasts in typical Polish-Jewish style, showing boldly schematic serpents, birds, deer, lions and so

on. The piercings in the lid sometimes echo these motifs. Many copies have been made of these popular objects, some even bearing the correct '12' standard mark. Genuine examples have rather higher-quality chasing and shading of the design, and contain metal of medium gauge. They should also have a fine patina, and some damage and dents to the pierced areas as a result of long use. Take care too not to buy filigree perfume and incense burners from Central and South America. They feel quite different from Jewish examples, but are often sold as such.

A similar group of spiceboxes includes all those shaped like flowers. Sunflowers are the most usual, and the lid of the spice container is located among the petals in the centre. The stem is leafy and the base decorative. Russian stamps and dates on these boxes tell us that they were made in Novgorod, Zhitomir or Vilna between the 1830s and 1850s.

Italian silversmiths produced a slightly different tradition of spiceboxes. They were responsible, during the late eighteenth and early nineteenth centuries, for elegant spherical or ovoid containers that are now becoming increasingly rare. The container, finely pierced and chased with foliate designs, stands on a narrow stem with a circular base. The finial on top of the container is often in the shape of a rampant lion holding a palm frond. The lion figurine screws onto the end of the vertical central rod that holds the top half of the container closed.

Related to these are the miniature containers, shaped like an egg or an acorn, that have occasionally been used by Jewish travellers even though these were not initially manufactured for the *Havdalah* ceremony. They are rarely more than 1½ inches (4 cm) long, and unscrew at two or three places. They are covered with engine-turned or chased designs and are usually unmarked. Perhaps they were made to contain ground spices for seasoning drinks, or maybe pins and needles. The ground spices may have suggested the Jewish use.

A particularly popular field for the collector is the figural spicebox, and especially those shaped like fish. These were probably first made as novelty containers for spices or as small ornaments. Although the symbolism of fish is strong in Judaism, there is no connection with the end of Sabbath that would identify these objects as uniquely Jewish. Collectors should make sure that the head is hinged to reveal the lid of the spice container, or that the mouth opens. If there is no container the object clearly has no place in a collection of Judaica. The body may be fully articulated, with

carefully chased fins and scales and with stone-set eyes. The fish were originally made in Holland and Germany from the early nineteenth century. The Dutch examples are fully marked, although the stamps may be hard to find, and later nineteenth-century pieces are often supplied with spurious hallmarks to make them look older than they are. Most specimens available today date from the last quarter of the nineteenth century. Similar objects are being manufactured even today in Mexico and elsewhere. Many are inlaid with coarse abalone shell. The lengths of all types of fish vary between 1½ and 12 inches (4 to 30 cm). Many are delightfully realistic.

Another favourite shape for spiceboxes is the steam locomotive. These date from the late nineteenth century and were manufactured in Poland, Russia and Austro-Hungary. They comprise a horizontal filigree 'boiler', with two pairs of wheels that turn, and up to three chimneys on top. One end of the boiler can be removed to open the spice container. Forgers have taken to this style of spicebox almost as intensely as have collectors. Check to see that the marks are authentic. If there are no markings the piece is probably a copy. Locomotives vary in length from 2 to 6 inches (5 to 15 cm). A more recent variant of this group is shaped like an aeroplane, but make sure that it contains a spice container before making an offer. Other boxes come in shapes as varied as storks, roosters, windmills and coaches, although these are not so frequently associated with *Havdalah*.

Lastly we come to some of the simplest but most classically striking of all spiceboxes: the traditional German style. They were made between the late seventeenth and early nineteenth centuries in Frankfurt-am-Main and other cities and are now most rare and sought after. The square or rectangular box is between 3 and 6 inches (8 and 15 cm) long, and has a sliding lid and usually four compartments. It stands on a stump foot, or sometimes on animal-shaped legs such as rampant lions. They are usually made of silver, but sometimes of pewter. They rarely have much decoration, so their strong, simple lines remain uncluttered. Always check that the markings that appear on the body and sometimes on the lid are authentic. The price will vary according to size and decoration, but also according to the interest of the inscription that is often found on them. The names of known individuals are occasionally encountered and these raise the value dramatically.

German spiceboxes sometimes have a candleholder built on the lid for the *Havdalah* light of woven tapers. Examples come from

small towns as well as major centres such as Nuremberg and Frankfurt-am-Main, and date to the eighteenth and early nineteenth centuries. Like the ordinary German spicebox, these stand on a square or circular base, or sometimes on lion feet or finials. The spicebox itself contains a drawer divided into the usual four compartments, which often has a leaf-shaped pull. The shallow candle-socket on the lid is sometimes supplemented by tall posts or supports inclining slightly inwards from the outer edges of the box, which hold the candle from higher up. The total height of the spice-box and candleholder is usually between 7 and 10 inches (18 to 25 cm).

Other types of combined spicebox and candleholder are rather more rare. On some examples of both Berlin and Warsaw tower-boxes the spire, ball and pennant are replaced by a candleholder. But their filigree is hard to clean of dripped wax and such pieces are far less popular than the German box-type.

Candleholders on their own are also occasionally seen, mostly of German manufacture and dating to the early twentieth century. A socket is usually set on a short stem with a round base. There may be a handle at the rim, rather like that of a cup. Above the socket there may be a vertically sliding ring to hold the candle further up. It is surprising that more candleholders are not known. Perhaps it was considered more suitable to hold the candle while it was lighted, and when it was extinguished to put it down. In addition, it would be difficult to use a holder while turning the candle upside down to douse it in the bowl.

No survey of *Havdalah* equipment would be complete without mentioning the matching sets of objects made in Germany during the late nineteenth century. These were manufactured by the firm of Posen in Berlin, who also provided fitted cases. The set included a cup and underplate, spicebox and candleholder, all simply but well crafted out of silver. These groups have been much imitated during the twentieth century. But the originals are all hallmarked, so the imitations are easy to detect. Be suspicious of matching sets that date to before the late nineteenth century. They are extremely rare, and well worth the forger's time and attention.

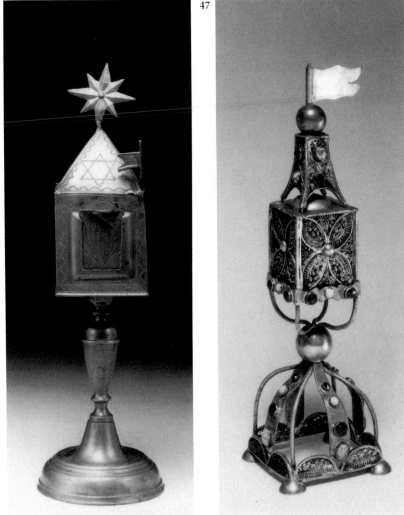

45 (left) German silver spice tower, dated 1731, *H.* 13 in (33 cm).

This spicebox has particularly attractive pierced decoration, including Stars of David, birds, lions, and the Hebrew date corresponding to 1731. Two similar pieces, also pierced and dated, are recorded. The mermaid finial is often found on Polish spice towers, so it is possible that this served as a prototype or was made in Germany near the Polish border.

45 (right) German silver spice tower, Rotger (Rudiger) Herfurte, Frankfurt-am-Main, mid-18th cent., *H.* 11½ in (29.25 cm).

A classic eighteenth-century-type tower, hexagonal, with an elaborate door and bolting mechanism. The gauge is sturdy but light. It is marked, as is typical with pieces from Frankfurt, on the base, body and door. Herfurte is recorded as having made many pieces of Jewish silver, including ceremonial cups, and *Torah* breastplates and pointers.

46 German or Austrian pewter tower-form spicebox, early 19th cent., *H.* 11¾ in (30 cm).

Rare in pewter, this tower-form example had pennants on its four corners of which only one has survived. The wriggle-work engraving is typical of the medium, and the Star of David is a sure sign, should any be needed, of Jewish ritual use. The snowflake – like a star – on top, is found engraved in the centre of pewter plates of the period.

47 Austro-Hungarian parcel-gilt silver spice tower, unmarked, *c.* 1870, *H.* 9½ in (24 cm).

This piece, set with cabochon turquoises and garnets, is typical of work produced in Vienna in the Hungarian taste, and relates to the jewellery of the period. The stones enliven a typical if not particularly interesting Austro-Hungarian spice tower, and probably at least double the price over that of a plain example.

48 Continental parcel-gilt silver-filigree spice tower, *c.* 1750–1800, *H.* 14½ in (36.25 cm).

The origin of these towers, which have survived in considerable numbers, is not completely clear. The uppermost, large pennant, often takes the form of a fanciful figure: a sea serpent or maiden, an elephant or exotic bird. The filigree is tightly curled. There is a bell in the open tower, and often a bell inside the spice section itself, which is generally a good sign of age in tower-form examples. The locking mechanism of the small door is also of better quality in earlier examples. The use of gilding to highlight the details is another reliable indication of age. Expect a certain amount of irregularity in the filigree and minor damage and loss.

49 Polish silver spice tower, *c.* 1830, *H.* 7⅛ in (18 cm).

This example has a pull-off lid, which when held upside down could have been used to hold the *Havdalah* candle. The filigree is handmade, but is coarser and less complex than that found in earlier examples.

50 Three Polish silver spice towers, 19th cent., *H.* of the tallest, 10¼ in (26 cm).

The piece on the left is stamped 12, and dates to around 1820–40. It is unusual for its shape, with its hexagonal mid-section and its sliding door, capped by a rosette. The urn-shaped upper section is pierced and engraved.

In the centre is an example by M. Khorlap, Warsaw, 1888, a prolific maker of Jewish silver. The filigree is coarser and simpler, but the overall quality is still good. Such pieces should be marked on the foot rim, door and pennant. Those marked 'sterling' on the foot only, or with an 84 alone, are American copies from the early twentieth century.

On the right is a Polish box from around 1840. It is indistinctly marked, but was probably made in the Prussian sector of Poland, as the overall style is reminiscent of the Berlin types, although the filigree, the octagonal form and the base are all typically Polish.

48

49

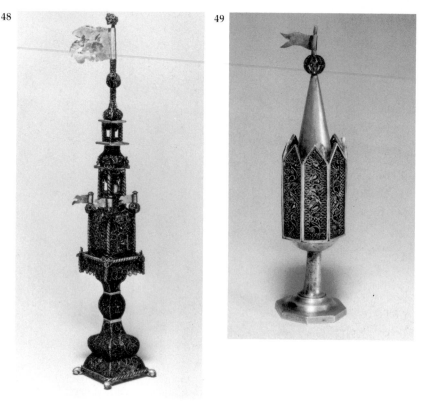

50

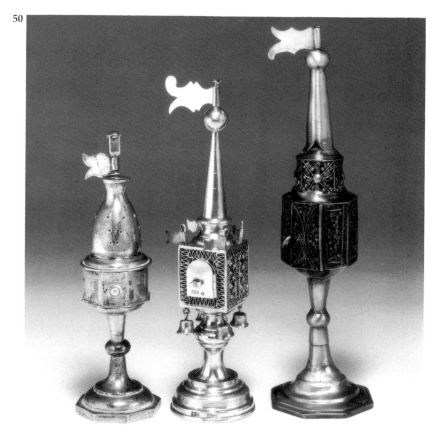

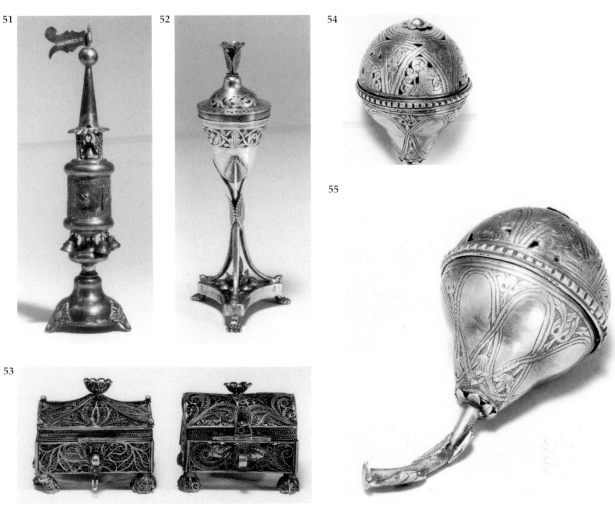

51 | 52 | 54

55

53

51 Polish silver spice tower, maker M. Khorlap, Warsaw, *c.* 1900, *H.* 10½ in (26.5 cm).
This spool-form spice tower is again by Khorlap, a prolific maker. The solid mid-section is set on a knopped stem and circular base, with grapevine supports. The latter are often found on the base of Sabbath candlesticks, for which these were made to match. Again, looks for marks on the base, door and pennant. If they are lacking on the door or pennant then these are replacements.

52 Italian silver spicebox, maker's mark BZG, *c.* 1800, *H.* 6¾ in (17 cm).
This charming piece, with an urn-form container set on three snake supports and animal-paw feet, owes its design to Neo-Classicism. This was particularly strong in Italy, where the style originated following the excavation of Roman cities. The overall finish is more sophisticated than that found on Polish examples of the period.

53 Two Russian silver-filigree spiceboxes, Moscow, late 19th cent., *H.* 1¾ × 2¼ in (4.5 × 5.75 cm).
Such pieces were made as small souvenirs by Moscow silversmiths, and adapted soon after by Jews as spice containers, particularly for travelling purposes. They are attractive and completely suitable for this purpose. One often finds, instead of the usual Russian 84 standard, the higher standards of 88 or 91 out of 96 parts, because filigree is easier to work if it is in a purer alloy.

54, 55 Polish silver pear-form spicebox, 18th cent., *H.* 4 in (10 cm).
A particularly well-detailed example of a popular form, executed in the typical naive style of Polish eighteenth-century silversmiths. The real clue to its age and quality is the lines giving depth and detail to the foliate and figural designs. The lion, deer and bird motifs are pierced for inhaling the spices. As usual, it is constructed with a central shaft which fastens together all the separate elements.

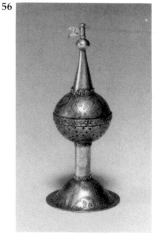

56

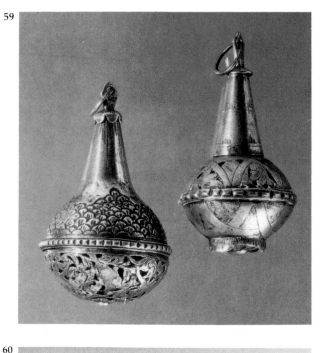

59

58

57

60

56 Polish silver fruit-form spicebox, late 18th cent., *H.* 5¼ in (13.25 cm).
This piece illustrates how pear-form spice containers were sometimes mounted to make them upright and free-standing. The piercing on the lower section of the pear is in keeping with the unmounted examples.

57 Polish silver fruit-form spicebox, maker's mark a stag, also marked 12, early 19th cent., *H.* 5 in (12.75 cm).
A style of which to be wary. The veining on the leaves and the minute serrations on the leaf edges and base are signs of quality and age. The mark of a stag probably refers to a Jewish maker's name, the German and Hebrew equivalents being 'Hirsch' and 'Tsvi'. The container is pierced at the top and is connected to the leaf clusters which surround it by a central stem.

58 Polish silver figural spicebox, stamped 84, *c.* 1830, *H.* 6¼ in (16 cm).
A popular form that has been much copied, this type of spicebox is suspect because of the 84 mark. However, its wear, patina and method of construction all indicate its authenticity. The spices are placed inside the flowerhead, the lid of which can be pulled off.

59, 60 (left) Polish silver pear-form spicebox, late 18th cent., *H.* 3½ in (9 cm).
A classic Polish form. This is an early example of the type. The chasing and piercing are well done, with an attractive forthrightness and excellent shading. Depicted running around the foliage on the base are a rabbit, a horse, a dog and an eagle – not all traditional Jewish elements, and doubtless influenced by European folk art. The piece comprises two sections held together by a central stem.

59, 60 (right) Polish silver pear-form spicebox, marked 12, *c.* 1800, *H.* 3¼ in (8.25 cm).
This piece is less fine than the previous example. Here the piercing appears on the upper spherical section, and consists of a Star of David on a foliate ground. The motif is repeated unpierced underneath. This use of the Star of David motif is significant, because it is rarely identified, before the mid-nineteenth century, as a specifically Jewish symbol; here, then, is a fairly early example of the use of the Jewish star motif. The construction is identical to the previous example, although the gauge of the present one is less heavy.

61

62

63

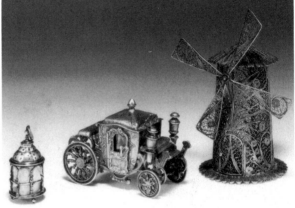

61 German or Austrian silver spiceboxes, 18th cent., *H.* of flask 2¾ in (7 cm).

These small containers were probably intended for smelling salts or condiments. Jews used them as travelling spice containers. Many are decorated with engine-turning, a series of repeated geometric patterns. Most of them also unscrew in several places, with miniature 'secret' compartments, making them both amusing and technically remarkable. The many variations make possible an interesting and compact collection.

62 Four spiceboxes, 18th/19th cents., *L.* of larger locomotive 3⅛ in (8 cm).

The two oval spiceboxes date from the eighteenth century, and relate to the examples in the previous illustration. The Rococo engravings place the left-hand example in the mid-eighteenth century. The locomotive-form spicebox is mostly Austro-Hungarian or Russian, and was made in the latter half of the nineteenth century. These novelty pieces were inspired by the railways making their way through the provincial regions. Because of the popularity of such boxes and the relatively small number that were made, many have been faked. The collector should be especially

careful. Most German pieces are marked, but so are the fakes. One favourite false mark is a large 84 on the round door closing the cylinder. Looking closely at the filigree and the general wear should help you avoid the copies.

63 Three silver spiceboxes, late 19th cent., *H.* of windmill 4¾ in (12 cm).

The lantern and coach are Dutch and nineteenth century. The filigree windmill is probably from Palestine and was made early in the twentieth century, based on a Dutch model. These were made for a variety of purposes, often simply as models, but they were adapted, if they happened to be hollow and equipped with an appropriate opening, for use as spice containers. Purists rail against these pieces, but if spices fit in, there is no way, or need, to prohibit their use in Jewish ceremonies.

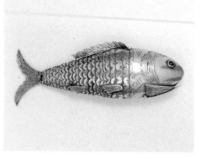

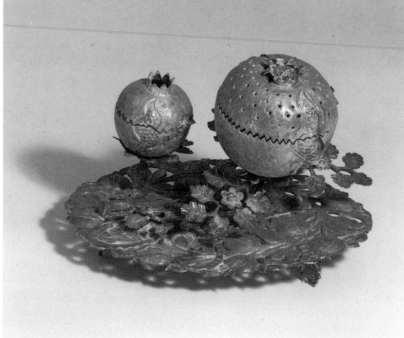

64 Dutch fish-form spicebox, late 19th cent., *H.* 4¼ in (10.75 cm).
Fish-form spiceboxes were popular in.northern Germany and Scandinavia in the eighteenth and nineteenth centuries as ornaments or decorative pieces.

The majority of those found are of the late nineteenth or early twentieth centuries; examples from Holland and Germany often have pseudo-hallmarks.

65 Turkish parcel-gilt silver fruit-form spicebox, 18th cent., *H.* 7 in (17.75 cm).
These pieces are the subject of some controversy. Many authorities maintain that spices in Turkey were kept in the hand for inhalation during *Havdalah*, or that rose-water sprinklers were employed in the rite. Others claim that this type of box was used for spices. In any case, these pieces are of fine quality, and eminently suitable for use as spice containers. The pomegranate is a traditional Jewish motif.

66 German silver spicebox, unmarked, *c.* 1700, *H.* 1⅝ in (4 cm).
This box-type container is distinguished by the high legs on which it is set, and by the figure on the sliding lid which depicts a man in traditional Jewish garb. He holds a cup and a twisted *Havdalah* candle.

This four-compartment box with sliding lid is typically German, but they are usually rectangular, on short legs and with a fairly simple knop. The square proportions of this example give prominence to the knop, which increases the interest and value of the piece. One should check that such a knop is original, as many recast examples exist.

67, 68 Two German pewter spiceboxes, late 18th cent., H. 4¼ × 3½ in (10.75 × 9 cm).
These boxes are of quite a common type: the poor relations of the silver examples. The interiors are divided into four compartments; the sliding lids have acorns or other simple knops; Hebrew inscriptions are quite common. The more interesting examples have animals, birds or plants in thick wriggle-work interspersed with inscriptions. They are analogous in design to the *Torah* binders of the period.

69 German silver *Havdalah* candleholder and spicebox, late 19th cent., H. 6 in (15.25 cm).
This is a late version of the German *Havdalah* candleholder with spice drawer. It is rarer than the earlier varieties, though not necessarily as valuable. The sleek lines and strong design prefigure the twentieth-century Art Déco style. The Hebrew inscription is of the period.

VI

The Torah and its Ornaments

Synagogue buildings reflect complex geographical and architectural ideas. The eastern wall is the direction of prayer – towards Jerusalem – but it is also where scholars and rabbis have their seats, facing outwards towards the congregation. So although the focus of attention might seem to call for a long narrow building aligned towards the east, synagogues are often broad, to provide seating for the many scholars on whom communities so pride themselves.

The eastern wall also contains the main point of focus of the whole synagogue: the Ark of the Law. This large ornamental cupboard, called the *Aron* in Ashkenazi synagogues and the *Hechal* in Sephardi ones, contains manuscript parchment scrolls of the *Torah.* On Sabbath, festivals, and every Monday and Thursday a text is recited from a scroll in the course of a service. With song and solemnity the curtain hanging in front of the Ark is drawn back and the doors opened, to reveal the magnificently attired ranks of scrolls, crowned and emblazoned with their sumptuous ornaments. In Sephardi communities the curtain hangs inside the doors, but the symbolism remains the same: it derives from the curtain of the Holy of Holies that lay at the centre of Solomon's Temple in Jerusalem. The rabbi, the cantor and a helper from the congregation then remove one or more of the scrolls – depending on how many portions are to be read – and process round the synagogue, with the scroll cradled upright in the rabbi's or the appointed layman's arms, towards the central reading desk on its platform, called the *Bema* in Ashkenazi communities, and the *Tevah* in Sephardi ones. The congregation bow as the scroll is carried past them. At the reading desk the scroll is carefully unwrapped, and laid on the table. The cantor then reads from it using an ancient form of cantillation reserved only for reciting from the Law. The

lesson finished, the scroll is borne back to the Ark, passing round the other half of the synagogue, while the remainder of the congregation bow as it passes.

The scrolls used in the Ashkenazi communities of Northern Europe are usually about 3 feet (1 m) long and a maximum of about 12 inches (30 cm) wide across both rolls of parchment. The lettering is arranged in columns, without any punctuation or vowels, in a style of presentation that has not changed since antiquity. The ink, quills and parchment are all ritually prepared. The scribe devotes a year or more to writing one scroll while observing a strict rule of devotion. Little wonder that they are the most treasured possessions of a Jewish community, that Jews risk their lives to save them, and that when they are worn out or damaged they are buried with the same respect and care that is shown to human beings. The parchment is mounted on a pair of wooden rollers, which project below in the form of handles, and above as short protrusions that may be decoratively turned and ornamented with bone. The rolls of parchment are protected at the top and bottom by wooden discs, sometimes inlaid with bone, mother-of-pearl, silver or gold. Each roller is symbolically called an *Etz Hayim* or 'Tree of Life', a phrase used to describe the *Torah* in the liturgy. When the scroll is not in use, the rolls are bound together with a long wrapper, and a mantle passed over the whole length. The rollers project through the mantle on top, while the bottom is open, to leave the handles free for carrying. The history of the fabrics is discussed in the chapter on textiles.

The scroll is hung about, when not in use, with a number of ritual ornaments. The smallest but most important of these is the pointer, consisting of a short handle with a model hand at the end, its index finger extended. The pointer is used by the person who recites from the scroll in the synagogue, so that the lettering is not worn or damaged by being constantly touched. This ancient conservation measure shows admirable understanding of how harmful the natural oils and acids present on the finger-tips can be to delicate manuscripts. When it is not in use, the pointer hangs from a chain passed over the projecting rollers on top. The other ornaments for the Scroll of the Law allow more scope for fantasy. The breastplate or *Tass* is also hung by chains from the rollers on top. It covers perhaps half of the front of the scroll and is embossed and engraved, and sometimes decorated with appliqué ornaments. The symbolism of the object is derived from the breastplate of the High Priest in the Temple. Lastly come the elaborate finials or

Rimmonim, 'pomegranates', which are fitted over the projecting rollers on top. These are usually a pair of tiered towers hung with bells. Their bases are in the form of sockets which pass over the ends of the rollers. They probably represent the 'fruit' growing from the 'Tree of Life' rollers. A variant of the *Rimmonim* is a decoration in the form of a crown that fits over both projections at once, called a *Keter*, or 'crown'. The symbolism here is of the regal *Torah*, crowned as monarch. It may be related to the headpiece once worn by the High Priest in the Temple. Indeed, the *Torah* ornaments and fabrics all tend to reproduce the ritual garments of the Temple of Jerusalem, as though to recall that the synagogue has now fully replaced all its functions in Jewish life.

Sephardi communities in North Africa and the Near East have preserved a slightly different form of casing for their scrolls. Occasionally, the reddish leather of deerskin is used instead of parchment. The casing is of wood or metal, and consists of an upright cylinder or polygon called a *Tiq*, from an ancient Greek word. This encloses the scroll mounted on its two rollers. In order to read the scroll the case is opened vertically into two halves, with hinges along the joint at the back, leaving one roller in each half of the casing. Most examples date to the turn of the century. The pointer will be hung from the outside of the casing, while the breastplate may be represented by inscriptions or by small plaques inscribed with prayers or a dedication set into the woodwork. The *Rimmonim* fit over projections on the top, rather than on the rollers themselves, and are angled slightly outwards. The scroll in its casing is not laid flat to be read, as with Ashkenazi *Torah*-scrolls, but is left standing on the flat-topped *Tevah*.

Scrolls of the Law rarely appear on the market since they are usually commissioned by an individual or a family and deposited with a synagogue for use. Some homes contain a miniature scroll as a gesture of special piety by a scholar perhaps, but the room in which the Ark stands then becomes practically a synagogue, which somewhat restricts the uses to which it can be put. Scrolls have less sanctity if they are found to contain a scribal error, or if letters begin to become worn. A scroll that is *Passul*, or 'invalid', should

IX Ivory-mounted miniature *Torah*, with English parcel-gilt silver finials, the scroll Dutch or German, 18th cent., the finials London, 1812, *W.* of scroll 4½ in (11.5 cm), *H.* of finials 4⅛ in (10.5 cm).

X American silver *Torah* finials, *c.* 1825–50, *H.* 6½ in (16.5 cm); German parcel-gilt silver *Torah* breastplate, J. Rimonim, Fürth, *c.* 1770, *H.* 7 in (17.75 cm).

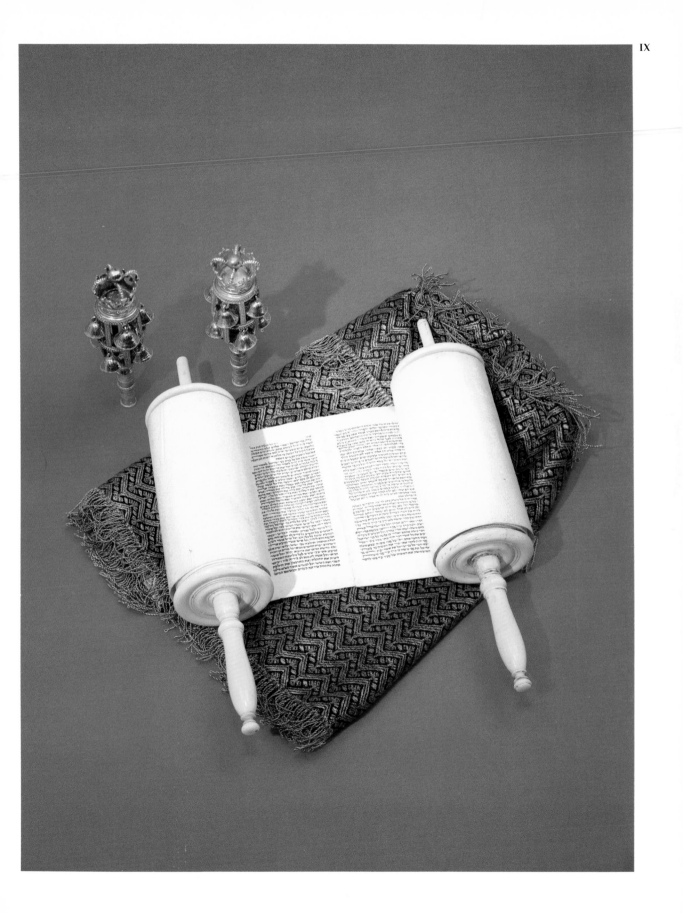

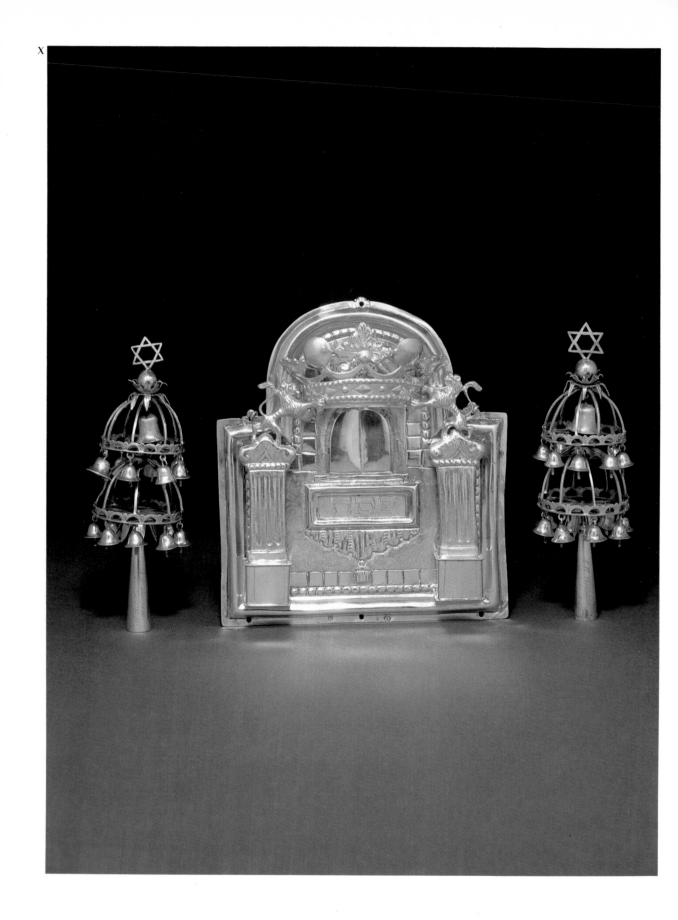

either be repaired, to make it *Kasher*, or 'valid', once again, or is respectfully buried in a special plot in the cemetery. An invalid scroll may be kept so that readers can practise their cantillation, but it should still not be disposed of on the open market. It is unusual to find collections of scrolls in the hands of practising Jews, although some museums hold a selection in order to show regional variations in script and materials used.

There are very few obvious signs of date and provenance on most scrolls. The writing surface bears only the unadorned text, without a date or scribal colophon, and there is no writing on the back. One of the discs that protects the parchment from slipping over the projections of the rollers may contain an inlaid plaque, inscribed with the date of its writing or repair, and perhaps with the name of the scribe or the donor. On North African and Near Eastern scrolls an inscription may appear on the casing. The Sephardi communities of Europe, however, use scrolls mounted on rollers, like those of the Ashkenazi Jews, but the parchment will be backed in silk or satin throughout. Sephardi and Ashkenazi scribes use a different number of hair-strokes on top of certain letters; Ashkenazi letter-forms also tend to be more angular. But such differences are not easy to spot for the untrained eye.

Of all *Torah* ornaments, finials are perhaps the most varied. The earliest known examples date from the seventeenth century, although similar ones are still being made today. Most of those you will find for sale date from the nineteenth century. The majority of all seventeenth- and early-eighteenth-century examples come from Italy or Holland. Italian finials include filigree work and are often multi-tiered and elaborately constructed. They tend to be fairly large, sometimes over 18 inches (45 cm) long. The bells are typically suspended from long chains or twisted silver supports. Marks generally appear for the city in which the piece was made, for the maker and for the assay-master. Filigree is harder to mark than sheet metal, so the marks may be sparse or even absent. Dating these finials will be easier if they include motifs in Baroque, Rococo or Neo-Classical style. Their stems may be very long, since they were often intended to be used together with a crown.

It is not always easy to distinguish between Italian and Moroccan examples. Those from Morocco are more simply and crudely decorated, and are usually between 50 and 100 years later than Italian examples of similar style. But North African decorative motifs should be easily recognizable. The nineteenth-century marks that appear on many Moroccan pieces tend to be very small, but

these are often complemented by Hebrew inscriptions containing references to people with typically Moroccan names. Although such finials are often delightfully elegant, prices tend to be as little as half or one-third of Italian examples.

North African and Near Eastern examples sometimes appear in brass. Those from Iraq and the Yemen are often the smallest, since they, in particular, were intended to fit over pegs projecting from the top of the *Torah*-case rather than over the rollers themselves, and to project slightly outwards. Their sockets are therefore narrow and shallow, and the base may be trimmed at an angle. The entire finial may be as little as 3 or 4 inches (8 or 10 cm) long. But care must be taken not to mistake these Oriental examples for miniature European ones, made for the private scrolls owned by scholars or for travel purposes. These are simply scaled-down versions of the European finials that will be discussed here in the context of the relevant country of origin.

The finest of all early finials are probably those from seventeenth- and eighteenth-century Holland. They are of heavy cast silver, and their design is bold and finely executed, often with parcel gilt (partial gilding) on the bells or elsewhere. They comprise three graduated tiers hung with bells in architectural arches. Examples from the late seventeenth and early eighteenth centuries are usually of hexagonal section, with the bells closely lodged in balustraded arches. They are surmounted usually with a crown or with a pineapple-shaped knop. Some filigree work may appear. There are usually marks to help with the dating. But motifs characteristic of Baroque, Rococo or Neo-Classical style are also useful guides, because they are generally contemporary with similar details in secular objects. Bear in mind, however, that there may be some delay before the styles reached localities remote from the main centres at Amsterdam, Rotterdam and The Hague. These finials are now rather rare.

In checking such pieces for authenticity you should make sure that a mark appears on each part, including the stem and every tier. The best evidence remains the quality of the workmanship, which should be superb, including the knops and the balustrades. Since fakers often work from casts of original objects all the elements will be present, although the finish will be inferior. Some copies are even supplied with crudely decorated additions in sheet metal, intended to lend an air of age to an otherwise fairly crisp design.

German finials rarely survive from before the seventeenth century. The style prevalent in the secular arts tended to be used in

Jewish pieces made in the large centres of Augsburg, Nuremberg, Frankfurt-am-Main and Berlin. All production was controlled by powerful craft guilds whose wares were often distributed far from the region in which they were made. Jews were not permitted to become members, but their needs were satisfied by craftsmen who specialized in Jewish ritual objects. A family might approach the craftsman who had supplied their domestic silver to commission a spicebox, over whose design they might provide some help. You should therefore look out for points of similarity between Jewish ritual objects and the domestic wares produced at any period. These provide the only sound evidence of date.

There may have been one Jewish member of a craft guild: a man called 'J. Rimonim' who lived in Fürth in the later eighteenth century. His output seems to have consisted mainly of Jewish ritual silver, including many *Torah* ornaments. It is possible that the name by which we know him was an informal one, based on the number of *Rimmonim,* or finials, for which he was responsible. But this point remains to be proven, and is certainly worth further study.

German *Torah* silver of the late seventeenth and early eighteenth centuries often includes applied figures of a heraldic nature. Eagles symbolize the family name of 'Adler', stags symbolize 'Hirsch', and so on. Inscriptions are common, and may include the name of the community for which the object was made, the name of the donor, and the date of manufacture. In far more cases, however, the date will be that of the presentation of the piece, which may be long after it was actually made. If the inscription and the marks do not agree, you should rely on the marks. But make sure that the inscription is not *earlier* than the marks, for if it is, the piece is a forgery. Inscriptions that are embossed into the design are generally reliable. Indeed, if the marks do not correspond to the date in the inscription, you should inquire further into the authenticity of the piece.

Complete sets of German *Torah* ornaments are known from the early eighteenth century. They should include the pointer, finials and breastplate, all of which should have the same decorative motifs, and usually matching inscriptions. Some inscriptions may be complementary rather than matching, so you should check that the style of lettering is similar.

Torah crowns were not common in Germany until the nineteenth century. Early examples are so rare that any you see should be checked for evidence of date. They were not, like the Italian ones,

intended to be used together with separate finials, so are more massive in design. Polish crowns, however, were common in the seventeenth and eighteenth centuries, but less so from the 1850s. The later examples are still being rather crudely copied in America. The originals were grandly adorned with lions, birds, eagles and griffins in Polish folk style.

Torah breastplates are largely European in origin, since the wooden cases of North African and Near Eastern scrolls tend to have dedicatory plaques set into their cases. Breastplates are not universally used even in Europe, but were particularly popular in Germany and Poland. They are usual in contemporary communities. The most common form consists of a sheet-metal plaque with engraved or appliqué symbols such as a pair of lions, the Decalogue, a crown, or a pair of columns. There is often an open display-frame into which one slides a small metal plaque engraved with the name of the festival for which the scroll has been prepared – since scrolls are rolled to a certain text before the service for which they are to be used – or bearing the name of the text to be read on a certain Sabbath. It is lengthy and cumbersome to locate a text in a heavy scroll while the congregation waits, and it is important to remove the correctly prepared scroll from the Ark – which may contain a dozen or more scrolls – when the rabbi opens the doors in the course of the ceremony. Some Sephardi communities in Europe use only a small plaque bearing the name of the relevant festival or text, and do not have elaborate breastplates.

Some of the finest breastplates were made by craftsmen in large urban centres such as Augsburg, Nuremberg, Frankfurt-am-Main and Breslau. In the smaller provincial towns of Germany and Poland it was occasionally possible for Jews to work as craftsmen, and their products are often charming, although less sophisticated in many cases.

One nineteenth-century German design consists of a rather laboured imitation of the breastplate worn by the High Priest in the Temple. It features twelve stones arranged in a rectangle in the centre, each of which symbolizes a different tribe of the Israelites. Most of these pieces date from the nineteenth century, and contain large tawdry 'stones' of paste in an assortment of clashing colours.

Breastplates from Poland resemble those from Germany in style, although most datable features appear between 50 and 75 years later than the same elements in Germany. The workmanship is also less fine. Filigree was popular, often in the form of figures bolted to the surface of the plate. Marks are occasionally missing,

especially from the work of Jewish craftsmen prior to the nineteenth century. But inscriptions are more common in Polish pieces than German ones. Jewish workmen sometimes included their own names, in addition to those of the donor, the recipient and the date of presentation.

Torah pointers include an unusually wide range of styles, covering several centuries and continents, and a profusion of media. Silver is the most common material, but all metals are used, with the exception of iron and steel which are considered too closely associated with war and violence for use in Jewish ritual. Ivory, bone and wood are all occasionally used, either on their own or as components of more elaborate compositions.

Italian pointers survive from the seventeenth and eighteenth centuries. They resemble Near Eastern pointers in two respects: some have a pyramidal or faceted point instead of the conventional hand; and Southern Italian examples are known which have a small spice container built into the handle. The spice is doubtless to remind the reader of the subtle pleasures of learning.

Particularly elaborate Sephardi pointers come from Turkey, Morocco and India. These may be studded with diamonds or other gems, with turquoise, pearls and semi-precious stones. The pointer itself may be of gold. Less flamboyant examples in filigree occasionally have gilded highlights. The simplest pointers from this region are of base metal or even of wood. Near Eastern pointers tend to have flat shafts with Hebrew inscriptions along both sides. They are also notable for their length – up to 18 inches (45 cm). The end may be in the form of a pyramid or a faceted point, or, more usually, the profile of a flattened hand with the index finger extended. The marks that are sometimes found on Moroccan and Egyptian pieces are unfortunately so small that they are often difficult to read and even to locate.

European *Torah* pointers are usually of silver and sometimes gilded. But their true variety is to be found in their decoration. On Dutch and Italian examples of the seventeenth and eighteenth centuries the index finger of the finely modelled hand at the end sometimes wears a jewelled ring. There may be an elaborately ruffled cuff at the wrist. Examples of such pointers are known from English workshops of the same period, produced for the Spanish and Portuguese Sephardi community in London, on the basis of Dutch and Italian models.

German pieces of the time tend to have twisted shafts. At the handle-end of the shaft there may be an inscribed cartouche

containing the Hebrew date. The hand, at the other end, will be finely worked and may have a cuff at the wrist. The chain by which the pointer is suspended from the rollers when it is not in use, and by which it is held when it is, should be considerably worn from long use.

Polish pointers usually have a circular central shaft which tapers down from the handle-end towards the hand. At intervals along the stem there are round knops. These are either decoratively pierced with depictions of foliage or animals, like the small pear- or fruit-shaped spiceboxes of the period, or they are ribbed. Many such pointers are made of the low-silver alloy typical of the earlier period. The extended index finger of the hand may be sharply arched, and have a hole drilled between the arched finger and the thumb that supports it. The end of the finger will be worn from use.

Copies have been made of most types of pointer during the nineteenth and early twentieth centuries, generally without intent to deceive. The markings will be complete and will serve to distinguish reproductions from the real thing. Less innocent are the large quantities of parasol, umbrella and cane handles that have been cut down and converted into *Torah* pointers by the addition of a crudely modelled hand. The handle-end of the ivory, shell and gold handle will have a relatively large knop, shaped so that it can be comfortably held upside down – clearly superfluous for a pointer that is small and light, and which is anyway more conveniently held along the shaft. The new hand will not only be of inferior quality, it will be roughly attached with glue.

Be on your guard against an unusually long type of pointer that is manufactured in Spain and Israel, and which measures between 18 and 24 inches (45 to 60 cm) in length. It is decorated with crudely chased flowers and foliage, and has at the handle-end a revolving spherical compartment containing a bell. The puny, ill-finished hand is obviously modern, and you should avoid being taken in by such pointers.

Lastly a word on how best to display your collection of *Torah* pointers. Laying them flat in a showcase is both wasteful of space and tends to conceal one side of each example. Far more attractive and effective is a glass or perspex cube in which the pointers can be hung at various heights so that none is obscured. Since most pointers are in any case made to be hung by a chain from the top of a scroll when not in use, this form of display also coincides with the makers' intentions.

70 Italian miniature *Torah* scroll, 18th cent., *W.* of scroll 4¾ in, columns approx. 2⅜ × 3⅞ in (6 × 10 cm).
Torah scrolls for use in synagogue are far larger than this: between 30 and 50 in (77 to 127 cm) in width. A few smaller examples were made for travel or as special presentations. To write such a scroll in miniature demands great skill, and few scribes are prepared to undertake it. Collectors prize them for this reason. Most scrolls that appear on the market are *Passul*, or not fit for ritual use, because the lettering is worn. This keeps their value down and also reduces their sanctity. A *Kasher*, or ritually fit *Torah*, has to be treated with particular reverence and care.

71 Near Eastern fabric- and silver-decorated wooden *Torah* case, with associated *Torah* scroll, 19th/early 20th cent., *H.* of case 24 in (61 cm).
The case and finials suggest how elaborate this type of *Torah* housing can be. The scroll, of typical white parchment, is European, so cannot belong with the case. It also fits poorly.

72 Italian silvered-brass *Torah* crown, *c.* 1825-50, *H.* 4⅝ in (11.75 cm).
Chased in Régence-revival style, this open-work design is typically Italian. Since finials were intended to be used in conjunction with the crown, it is open at the top. The velvet lining is a later addition. The lettering of the inscription is also typically Italian.

71

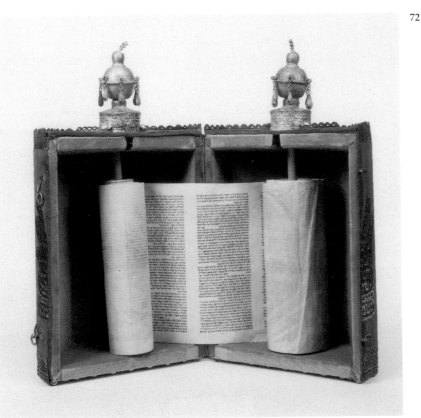

72

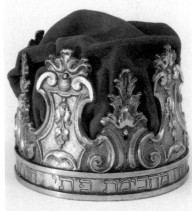

73, 74 Moroccan parcel-gilt silver and coral *Torah* crown, mid-19th cent., *H.* 6½ in (16.5 cm), *D.* 10 in (25.5 cm).
There is clear Arab influence in the filigree bosses and arched panels, while the delicately pierced tracery is borrowed from the Rococo scrollwork of Italy; both traditions share a belief in the protective powers of coral. The crown is of heavy-gauge metal, covered with Hebrew inscriptions. The top is pierced for inserting the *Torah* finials, a form borrowed from Italian practice.

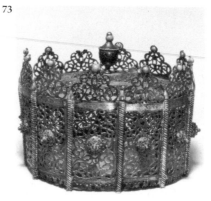

73

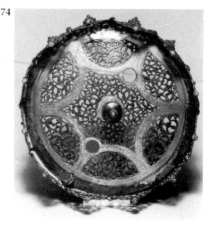

74

75 Italian silver *Torah* crown, maker's mark Agnelli (?), Naples, *c.* 1830, *H.* 12 in (30.5 cm).
Torah crowns are often hard to distinguish from those made for Christian religious effigies. The type presented here is not specifically Jewish. Most Jewish examples from Italy are oval, with *Torah* finials used together with them. One also likes to see convincing Hebrew inscriptions, and some Jewish

iconography chased into the design. This has only a small band of Hebrew presentation-inscription around the spherical knop, which seems later than the crown itself. It is possible that the crown was adapted sometime after its manufacture for Jewish ritual use. One would therefore expect to pay considerably less for a piece of this type.

76 English parcel-gilt silver *Torah* crown, Aaron Teitelbaum, London, 1928, *H.* 19 in (48.25 cm).
This crown was part of a three-piece set, consisting of a matching *Torah* breastplate and a pointer. Based on a German nineteenth-century model, the weight and workmanship of the crown are first-rate. It is characteristic of the work carried out in England well into the twentieth century.

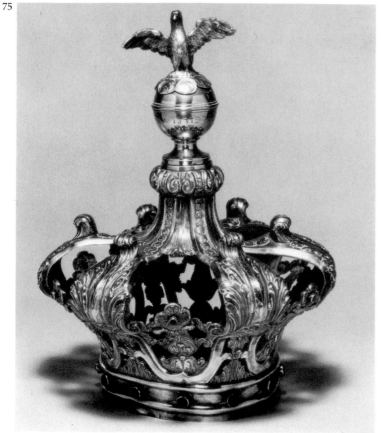

75

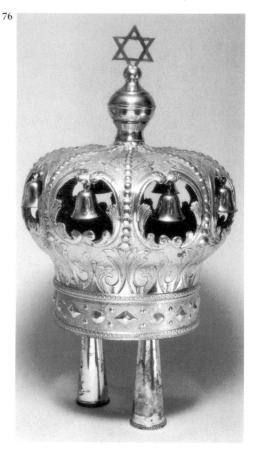

76

77

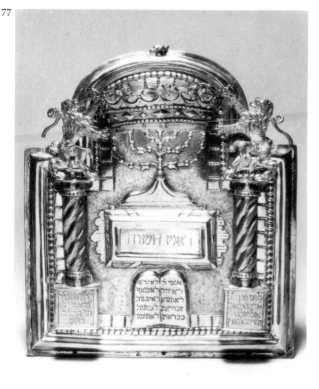

78

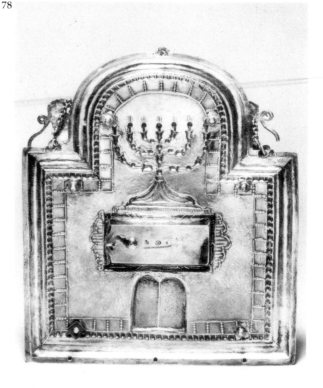

79

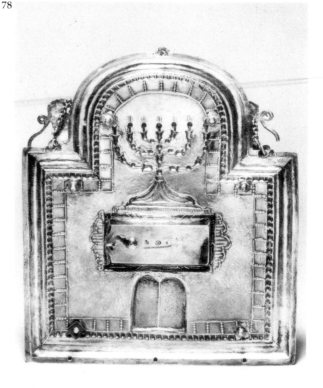

77, 78 German parcel-gilt silver *Torah* breastplate, made by Master I. Rimonim, Fürth, late 18th cent., incised date-letter I, *H.* 8¾ in (22.25 cm).

Fürth had a prominent Jewish population from the Middle Ages until the Second World War. This shield is by one of the few German masters who may have been Jewish, and who was a member of a German guild. Rimonim, who worked between about 1760 and 1790, seemed to have specialized in *Torah* silver. His name is the Hebrew for '*Torah* finials'. Here the classic elements of *Torah* breastplates – lions, pillars, a crown, the Decalogue, candelabra – are chased and applied. The only datable style is found in the Rococo-style scrolls flanking the portion plaque; stylistic characteristics such as this were normally adopted twenty or thirty years later in small towns than in larger centres. A presentation inscription is dated 1792. The marks are visible on the base, on the base of the crown and on the reverse, which also shows two assay scrapes. On the reverse, the lock of the portion-plaque door has been replaced and one bolt is new. But the high quality of the workmanship can clearly be seen.

79 Baltic silver *Torah* breastplate, maker's mark Klost (?), Breslau, late 18th cent., *H.* 9 in (23 cm).

This is one of the finest examples of Breslau silversmithing, a town noted for its fine craftsmanship. The low-relief chasing of Moses and Aaron on a matted ground is as good as the work found on Renaissance and Baroque plaquettes. The three heart-shaped plaques below are engraved with Hebrew presentation inscriptions. This piece could hold pride of place in many important collections.

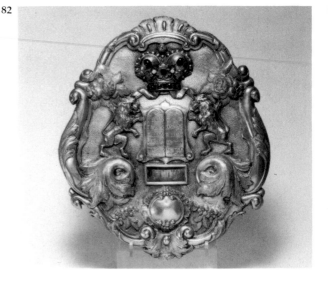

80, 81 Continental silver *Torah* breastplate, maker's
mark Burcard, perhaps Swiss or Franco-German, mid-
19th cent., *H.* 8⅞ in (22.5 cm).

This intriguing breastplate exhibits late-Classical motifs
in the foliate swags and rose clusters, which are a
popular feature of the Rococo revival of between the
1840s and the 1860s. The names Alexandre Dreyfus
and Brindel Weil, the former repeated in French, are
inscribed along the sides in Hebrew. There is also a
Hebrew date, corresponding to 1858, and a placename,
probably Schlitstadt. The piece was probably presented
to mark a wedding or wedding anniversary.

82 Austro-Hungarian parcel-gilt silver and gem-set
Torah breastplate, late 19th cent., *H.* 12 in (30.5 cm).
This Rococo-revival-style breastplate is typical of its
time and place; well chased in low-relief on a contrasting
matted ground, and in its use of roses showing another
Viennese feature. The crown is set with cabochon
garnets and turquoise – a combination often found in
jewellery of the region.

83 Austro-Hungarian *Torah* breastplate, late 19th cent.,
H. 15 in (38 cm).
This breastplate incorporates many traditional features,
but interpreted in a novel way. The rising sun in the
background is an allusion to the concept of the *Torah* as
the source of light. The Tablets of the Law supported
by the lions create a dramatic tension. All this is set
within the usual Rococo-style framework. Flowers,
scrolls and a shell form the border.

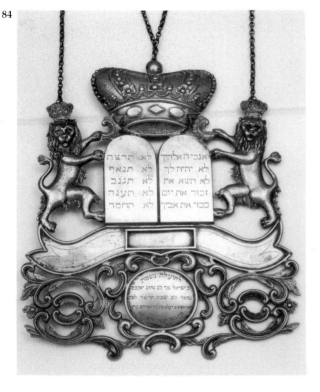

84 Dutch silver *Torah* breastplate, *c.* 1900, *H.* 11 in (28 cm).
This breastplate is probably Dutch, since the lions and crown resemble the Dutch royal arms. The open foliate and flower decoration is also typical. The Hebrew presentation inscription is dated 1904. The shield was cast and then, unusually, hand-finished. This is a good although not particularly fine piece.

85 Dutch parcel-gilt silver *Torah* breastplate, Rotterdam, 1891, *H.* 17 in (43 cm).
This is superior to the previous example. The vertical design is more effective than the horizontal plan, and the pendant charms and the pinecone add a touch of lightness. The Hebrew inscription commemorates its presentation in honour of Queen Wilhelmina of the Netherlands, who had recently ascended the throne. This example, with its beautiful chasing, is worth between three and five times as much as the simpler version shown in plate 84.

86 Polish silver *Torah* breastplate, *H.* 8½ in (21.5 cm).
This is a fine example of workmanship and design, although the end result is somewhat crude. It was probably made in a provincial Jewish workshop, outside the main guilds. The design derives from early-eighteenth-century German silver, in particular the flowerpots, shells and symmetrical scrolls. The lions, double eagle and crown are local heraldic devices that have been adapted to fit Jewish symbolism. Such crowns are usually set with coloured glass. Even though it lacks the portion plaques and the door to their compartment, this is a fine Polish piece that would be an asset to any collection.

87 Polish silver *Torah* breastplate, mid-18th cent., *H.* 7 in (17.75 cm).

This eloquently demonstrates the late arrival in Poland of fashionable stylistic features. It is chased with Baroque foliage, in vogue over fifty years previously. It has undergone extensive repairs. This, coupled with its small size, makes it relatively inexpensive.

88 American silver *Torah* breastplate, *c.* 1900–10, *H.* 12½ in (31.75 cm).

This piece, stamped 84 and Sterling, illustrates the Polish style carried to America by immigrants, keen to preserve the taste of their homelands. It was probably made in Baltimore, where the tradition of Neo-Rococo silver was very much alive. Similar designs continue to be made today, but the craftsmanship becomes coarser as time passes, and casting replaces hand-chasing and finishing.

89 Mediterranean region silver *Torah* breastplate, marked 16 and inverted U, late 19th cent., *H.* 14 in (35.5 cm).

This intriguing piece has a Turkish-style, bold central floral basket, and a Moroccan-style date, '5554' in Arabic numerals at the top in an oval cartouche. The *Tiq,* or wooden case for the *Torah,* is used in Turkey and Morocco, so perhaps an Ashkenazi community in Turkey – one originally from Northern Europe – commissioned the piece. It might otherwise come from somewhere in the Balkan area, particularly Bulgaria or Greece, or an island, such as Rhodes, with a large Jewish community and strong Turkish influence.

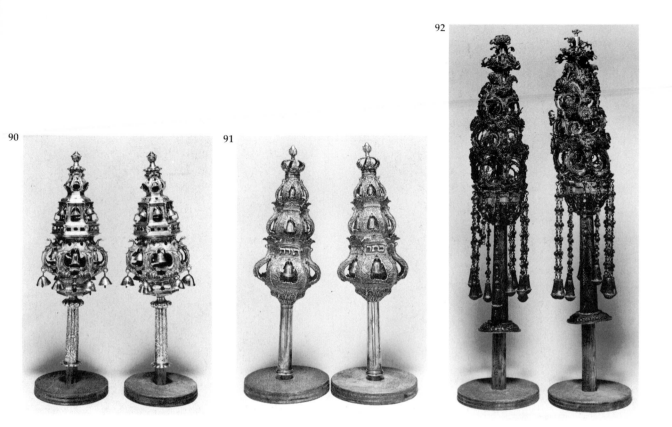

90 Dutch silver *Torah* finials, apparently unmarked, probably Amsterdam, *c.* 1700, *H.* 16 in (40.5 cm).
These forms are known from the late seventeenth century and continued to be made throughout the eighteenth century. Most examples are marked, and one should be most wary of unmarked ones. Some are found with genuine nineteenth-century marks. Such finials should be of cast metal and finely hand finished. Decorative details which help date the pieces include late-Baroque foliage on the stem, and especially the scallop-like scrolling visible where the lower row of bells joins the body. These pieces unscrew into separate sections; the threading, when visible, is uneven. Assay scrapes – the zig-zag lines so often found on old silver – are visible in these examples and are a reassuring sign. They tend to be heavy because of the casting, but not as massive as some later copies, which are not hand finished. The lack of marks, even in genuine pieces, can deduct up to 50 per cent from their value.

91 Dutch parcel-gilt silver filigree *Torah* finials, 18th cent., *H.* 14 in (35.5 cm).
Filigree is commonly found in silver from Italy and Poland, but was also a feature of some work in Holland. The fineness of the wire and the precision of the work are such that a close examination is necessary to differentiate between filigree of this quality and later, machine-made pieces. The solid parts were cast and hand-finished, and these should be closely inspected for quality of finish. The finials are clearly based on solid-silver models, but have a light and airy look. They are applied at intervals with Hebrew plaques inscribed 'Crown' and 'Torah'. Extra bells were suspended from small rings visible at the top of each tier.

92 Italian silver and filigree *Torah* finials, mid-18th cent., *H.* 14 in (35.5 cm).
Pieces composed largely of filigree are more likely to be unmarked than others. These pieces are of swollen triangular section, with filigree of fairly thick gauge. They show considerable wear and numerous minor losses. The rim from which the bells are suspended has the filigree Hebrew inscription 'Crown in Honour of the *Torah*'. The long chains for the bells are typical of Italian finials. The Rococo scrolls and scalework on the lower section are the best evidence of dating. The style of the filigree upper section originated in the seventeenth century, and was based on even earlier prototypes. The large size is typical of Italian finials of this period.

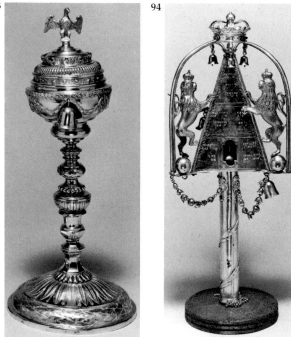

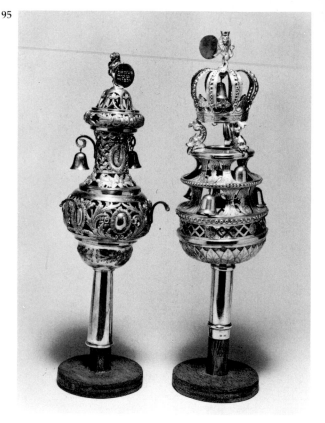

93 German silver-gilt *Torah* finial, made by master I. and S., Augsburg, 1783–5, *H.* 14 in (35.5 cm).
This one of a pair of finials exhibits judicious recycling of styles. The basic form here is late Baroque, dating to the early eighteenth century. The baluster form of the stem is typical of this period; even the laurel banding around the base, which was a feature of Neo-Classical work, harks back to the earlier style. The most clearly Neo-Classical element appears in the upper section near the bells: the laurel swags, hung at intervals with flowerheads, which give a clear indication of the date. Notice as well the hole in the base of the stem which is a feature of many eighteenth-century German finials, and served as a means of fastening the finial to the wooden stave of the *Torah*.

94 German parcel-gilt silver *Torah* finial, marked with an acorn in a trefoil, and with master's mark IS in an oval, both untraced, *c.* 1780, *H.* 16 in (40.5 cm).
The rarity of this form, though the piece is one of a pair, would give it a place of honour in any collection. The bell-flower swags hung along the lower rim, as well as the foliage wrapping around the stem itself, proclaim the Neo-Classical origin of the piece. The rampant lions are typically German and are probably modelled on a contemporary coat of arms. Locating this would help identify the region of manufacture. The Hebrew inscription records that it belonged to the congregation of 'Treiglingn', perhaps a small town. Notice the hole in the stem, and the chain below it, with a pin at the end. The pin attached the finial to the stave of the *Torah*.

95 Two single Augsburg *Torah* finials, the smaller by Unsin, 1781–3, the larger by maker IM, 1804, *Hs* 14½ and 16 in (36.75 and 40.5 cm).
The smaller finial, though made in the Neo-Classical period, shows the lingering influence of the Rococo style. The delay is not uncommon in ritual silver, which was often made for conservative patrons, or to match existing examples. A date perhaps ten or fifteen years earlier would have been expected in view of the style. Evidence here of Neo-Classical influence includes the piercing, which lends it an overall lightness, and the oval bosses and symmetrical foliage surrounding them. Rococo lingers on in the embossed flowers along the lower section, and especially in the flower and latticework in the upper section near the tier of bells.

The larger finial is more clearly Classical – as can be seen from the leaf-tip, beaded borders and dolphin supports. Single *Torah* finials are worth less than half as much as a pair, but this does not detract from their documentary interest or intrinsic beauty.

96

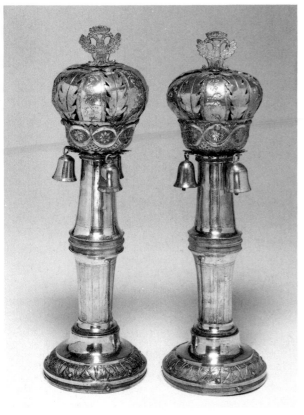

97

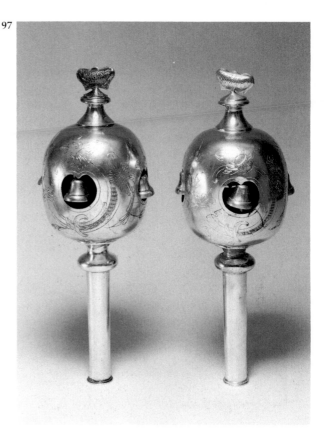

98

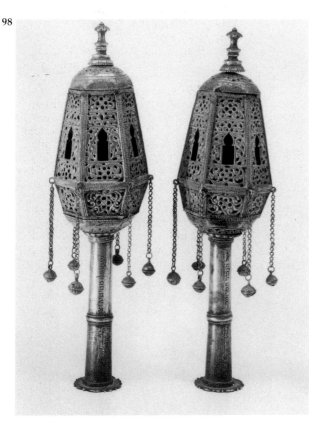

96 Bohemian silver *Torah* finials, maker's mark FB, Pressburg (Bratislava), 1800, *H.* 13 in (33 cm).
Of heavy-gauge metal and solidly constructed, these pieces are less ostentatious than usual. The ornament is concentrated in the complex upper section. They are surmounted by the crowned double-eagle symbol of the Holy Roman Empire, of which Pressburg was an important city.

97 Russian silver *Torah* finials, Moscow, *c.* 1910, *H.* 11 in (28 cm).
Finials made in Moscow are unusual, as Jews required special permission to live there prior to the Revolution. The pomegranate is surmounted by a version of the Russian Imperial crown, but without the cross. The lightly engraved foliage is in the Art Nouveau style.

98 Moroccan silver *Torah* finials, 19th cent., *H.* 15 in (38 cm).
These illustrate many standard features of Moroccan finials. They are usually hexagonal or octagonal, chased with foliage, and pierced with arches, often in the form of *Mihrabs,* as in the second pair. The long, hanging bells are derived from Italian examples. Hebrew inscriptions, which usually commemorate a presentation, are engraved on the staves.

99 Southern Italian or Moroccan silver *Torah* finials, mid-19th cent., *H.* 19½ in (49.5 cm).
The cross-cultural influences between Italy and North Africa were strong. This pair of finials seems to be more Italian. The flower urn and the star motif, applied separately, are typical of the period between 1820 and 1840; while the Rococo-revival stem decoration seems to be a few years later. The inscription, freely written with open letters, could be either southern Italian or Moroccan, although it is more likely to be the latter. Perhaps it was inscribed in North Africa on a pair made in Italy.

100 Mediterranean region silver *Torah* finials, probably Gibraltar, mid-19th cent., *H.* 16 in (40.5 cm).
These finials show a variety of influences; Spanish architecture predominates, harking back to Moorish design. The scrolling flowers and foliage which frame the 'windows' echo the 'perfumed garden' theme suggested by the tower form.

101, 102 Two Turkish silver *Torah* finials, inscriptions from Gallipoli, both 19th cent., *Hs.* 10¾ and 9¾ in (27.25 and 24.75 cm).
Style is a poor guide to the date of objects from this region. Dated inscriptions, workmanship and wear are the only reliable indicators. The hand-form is an ancient talismanic theme found in many Mediterranean cultures. In Islam it is called the 'Hand of Fatima', invoked for protection. Gallipoli had an active Jewish community for many centuries, its inhabitants increasing rapidly in number after the expulsion from Spain in 1492. The back of the larger example is chased with a Star of David within a circle with a Hebrew inscription.

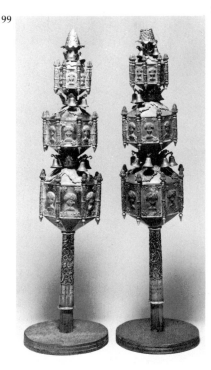

99

100

101

102

XI Three *Torah* breastplates (*from left*): German parcel-gilt silver, *c.* 1650–1700, *H.* 10½ in (26.75 cm); Bohemian silver, maker's mark AR conjoined, Bratislava (Pressburg), 1813, *H.* 18 in (45.75 cm); Polish parcel-gilt silver and filigree *Torah* breastplate, late 18th cent., *H.* 12 in (30.5 cm).

XII Polish parcel-gilt silver, filigree and gem-set *Torah* crown, with niello maker's inscription, dated 1796, *H.* 10½ in (26.75 cm).

XIII Austrian or Polish gold and gem-set *Torah* crown, *c.* 1825–50, *H.* 9 in (23 cm). One of the very few gold and jewelled articles of Jewish ritual art, this was probably made for the court of the Ruzhiner Rebbe.

XIV German silver-gilt *Torah* breastplate, maker's mark HLV, Stuttgart, *c.* 1800, *H.* 12 in (30.5 cm). The piece uses a crown and *Menorah* motif which could have appeared at any time during the last half of the eighteenth century.

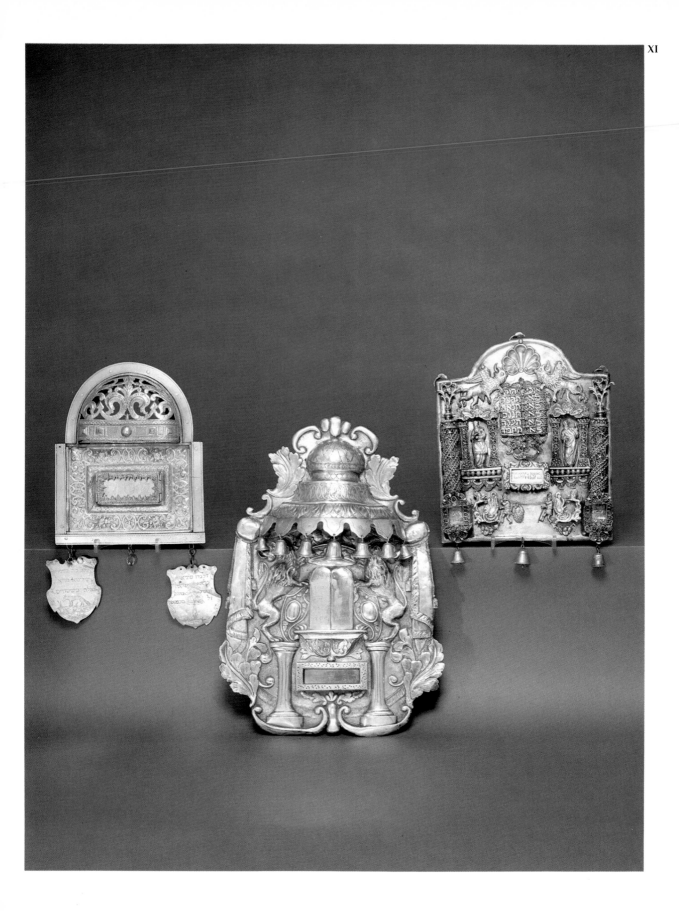

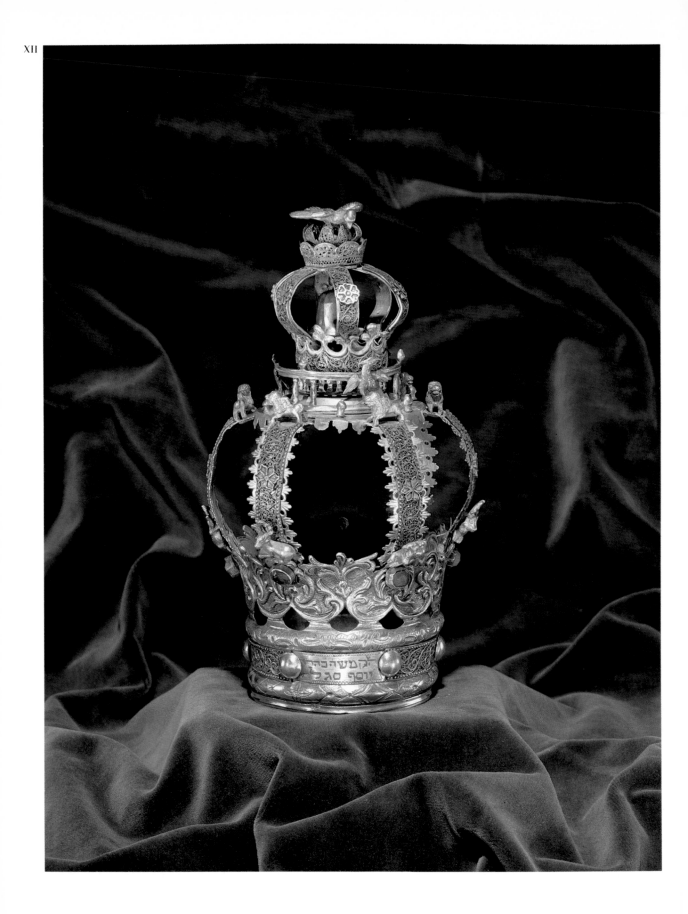

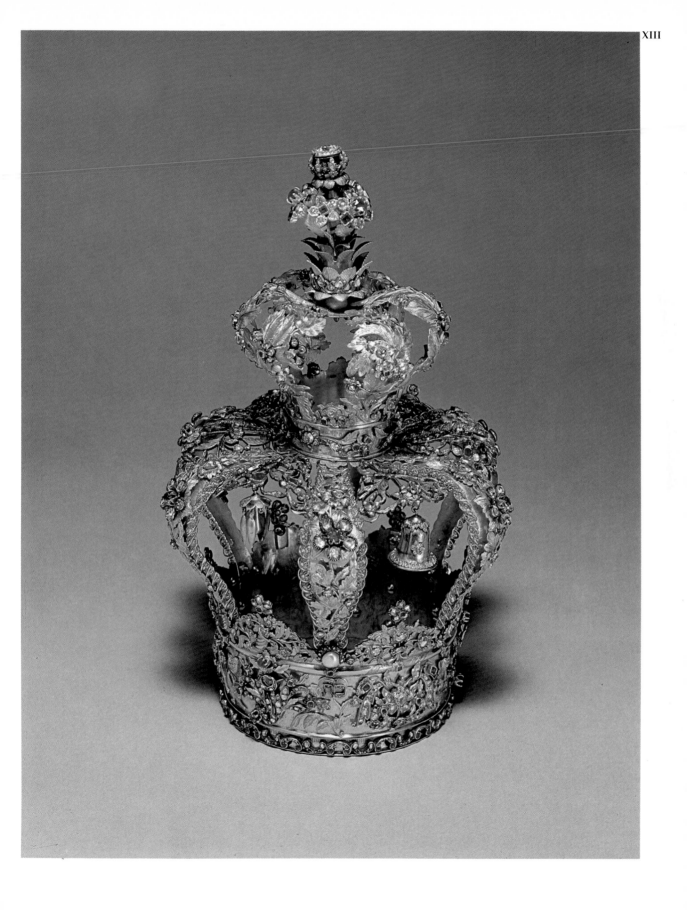

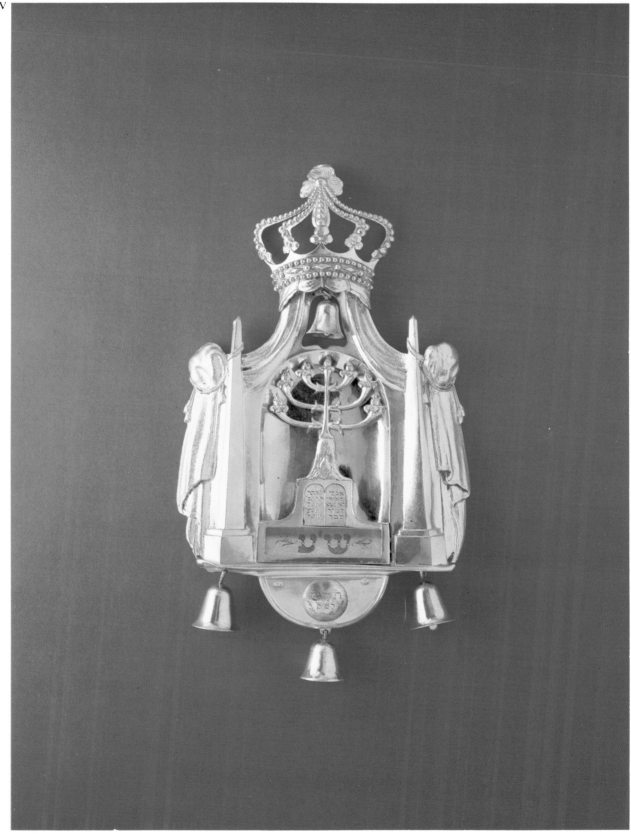

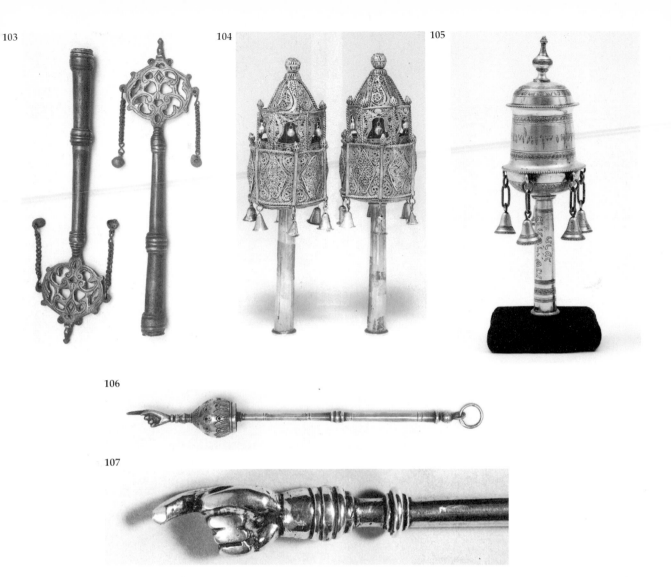

103 Near Eastern brass *Torah* finials, possible Yemeni, 19th cent., *H.* 6½ in (16.5 cm).
Typical of finials created by the less affluent communities of the region. Their simplicity attracts many collectors.

104 Near Eastern silver gold filigree *Torah* finials, 18th cent., *H.* 10 in (25.5 cm).
It is hard to trace the origin of these finials because so few parallels exist. They may be Afghan or Balkan, perhaps from Greece or Bulgaria. The filigree is obviously old, and is of complex design. The diamond-shaped plaques are of solid gold, and have been applied with silver wire. In addition, the wear and repairs also suggest an eighteenth-century date.

105 Egyptian silver *Torah* finial, *c.* 1900, *H.* 9 in (23 cm).
Hallmarks confirm the identification of these finials. The spool form, hung with bells and stamped with palmette bands, derives from Italian examples. Even the Hebrew inscription, with its open letters, derives from an Italian source.

106 Italian silver *Torah* pointer, Naples, maker's mark SP, early 19th cent., *L.* 8¾ in (22.25 cm).
This pointer is unusual for the spice section included just above the hand, serving as a decorative 'cuff'. It is pierced for the aroma to escape, and can be opened by turning the long handle. This use of spices is a Sephardi practice that occurs in North African and Near Eastern examples. It doubtless relates symbolically to the 'sweet fragrance' of the *Torah*.

107 Detail of a Dutch silver *Torah* pointer, Amsterdam, mid-18th cent., *L.* 8¾ in (22.25 cm).
The detail shows the fine finish of the hand, and the considerable wear to the underside of the pointing finger, where it passes over the parchment line by line, during the reading of the Law.

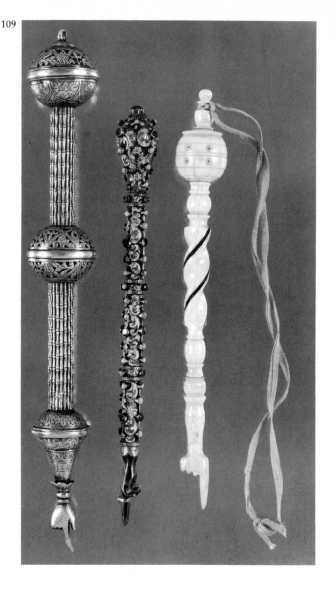

108 Russian provincial silver *Torah* pointer, maker's mark HL in Latin letters, unidentified town mark, *c.* 1880, *L.* 11 in (28 cm).
This pointer, probably made in a Russian town close to Poland, shows strong Polish influence in its twin bulbous knops and Rococo-revival-style chased flowers and foliage. The hand and the cuff have been simplified. This served as a prototype for the late-nineteenth-century or twentieth-century model which is still made today in America. Recent copies are usually cast and finished rather poorly.

109 Three *Torah* pointers, *L.* of the example on the right, 9 in (23 cm).
On the left is an extraordinary Polish silver pointer, of the mid-eighteenth century. Its ribbed stem, with an unusual, bamboo-like pattern, connects one pear-form and two spherical and pierced knops, all chased with foliage. Such elements were used interchangeably to form the small pear- and other fruit-form spice containers typical of the period. This example is of heavy weight, and is most desirable. The pointer in the centre is Austro-Hungarian, and of the late nineteenth century. It is of silver-gilt and is characteristically set with turquoise and garnets. This type is often cut down from a cane or parasol handle. On the right is one of carved bone. It probably dates to the early nineteenth century and is Turkish or Near-Eastern in origin. It is rare to find a bone pointer that is genuine, as almost all started as handles of one sort or another. Its proportions are good and hand fits plausibly.

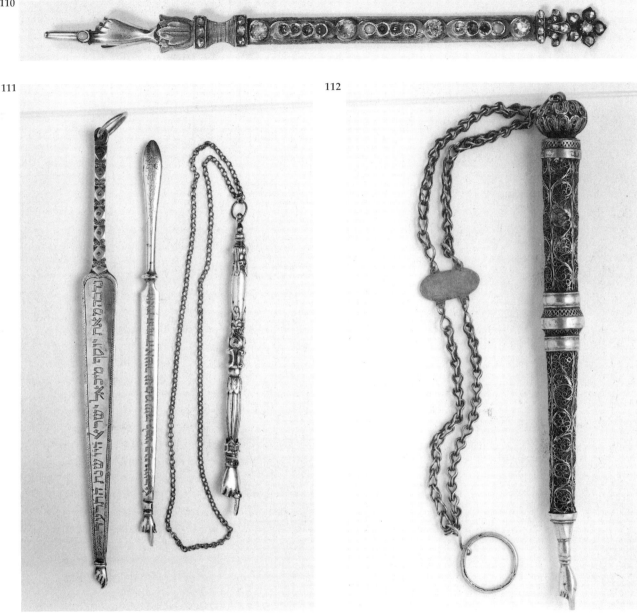

110 Silver-gilt and jewelled *Torah* pointer, probably Turkish, 19th cent., *L.* 7 in (17.75 cm).
The use of precious stones makes this pointer unusual. It is made from a flat piece of silver, set with rose diamonds (typical of Turkish jewellery), rubies, emeralds and turquoise. The flower-form knop is complemented by the tulip design of the 'cuff'. The pointing finger is set with a ring containing a further turquoise, a feature found particularly on Dutch examples.

111 Three silver *Torah* pointers, *L.* of longest 12½ in (31.75 cm).
The example on the left is Near Eastern, possibly Moroccan, and made around 1900. The flattened mid-section, the faceted square handle and the small hand are all typical. That in the centre is Egyptian, similar to the first but slightly more recent, its handle made from a model that would serve for tableware. On the right is a good reproduction of an earlier piece, probably Dutch in origin and mid-eighteenth century. Here, the entire object has been cast. The photograph shows the crude treatment of the scrollwork in particular.

112 Moroccan parcel-gilt silver *Torah* pointer, early 19th cent., *L.* 10¾ in (27.25 cm).
Without the hallmarks it would be hard to identify this piece as Moroccan. The filigree, and particularly the spherical knop at the end, have a strong Polish flavour, as does the suspension chain. The metal under the filigree has a greenish cast, perhaps from old fabric.

VII
Charity Boxes

The good luck of the rich and the misfortune of the poor are major themes of that favourite Jewish genre: the joke. The rich man pays for his fame and standing by being besieged by beggars; the beggar's only hope is the rich man. The need for charity is shame enough in itself: no pains must be spared to protect the poor from exposure to ridicule. In a fine grading of types of charity, Maimonides, the great medieval rabbi, defined the noblest act as one in which neither the donor nor the recipient were aware of each other's identity. This depersonalizing is emphasized by the Hebrew word for charity: *Tsedakah*, 'correct behaviour', in which there is no sign that it is especially good or kind to give alms. It is shameful, on the other hand, to be unable to give to others. So even the recipient of charity passes some on to others still less fortunate.

Friendly societies and social assistance agencies are set up in almost every community. Schools, hospitals, care for the aged, aid for distressed communities abroad: all are provided by enthusiastic volunteers. But the most distinguished association of all is the *Hevrah Kadishah*, the 'Holy Society', membership of which is reserved for the most learned, pious and respected members of the congregation. They care for the dying and perform burial rites. This holy work is accompanied by seminars and group study, and by an annual day of fasting followed by a banquet – paid for by leaving a charity box in each house of mourning for the seven days during which formal visits of condolence are made. Other charities use more active methods. Some of the opprobrium of the beggar, a *Schnorrer* in Yiddish, adheres to the charity collector, who uses almost any methods to achieve his ends.

The box itself is usually shaped rather like a tankard, with a slot

in the lid, and a hasp and staple for a padlock. The finest examples are in silver, but far more common are those in pewter, copper, brass, tin, iron, or even wood. Some communities, usually in Italy, use fabric bags for collections in synagogue, a style adopted directly from the church. Near-Eastern communities in particular use simple metal bowls, occasionally inscribed with the name of the society to which they belonged.

The earliest known charity boxes from Europe are of wrought iron, and are equipped with complex locking systems and usually with a means of attaching them securely to a wall or to the top of a post. These are not uniquely Jewish in design, so you should make sure that any Hebrew inscription is both contemporary and authentic. Some bear the names of donors, of communities, or the date of manufacture or of presentation – by no means always the same. Early inscriptions sometimes also appear on normal domestic bowls, which were originally used for collecting charity in both Ashkenazi and Sephardi communities. Not all such bowls were inscribed, but an inscription is the only means of identifying a Jewish example among the fairly common group of pre-eighteenth-century vessels. An inscription may have been added up to 100 years after the bowl was made. Indeed, a longer interval is probably a sign that all is not well. Keep a look-out for forgeries in this area, because the rewards for successful faking are considerable.

Charity boxes of the eighteenth century tend to be of the handled variety. These are mostly of pewter or copper, but silver examples occasionally appear. The ones that look like mugs were probably converted from tankards by the very craftsmen who made them. Some bowls continued to be used for charity collecting during the eighteenth century, as the inscribed examples show. But the grandest charity boxes of the time were made for wealthy communities for whom the simple tankard shape was too modest. Forgeries of these, which are produced in considerable quantities in Spain and Israel, can be distinguished by the large number of inscriptions and figures engraved and applied on them, including, occasionally, what appears to be the entire cast of *Fiddler on the Roof*. These monstrosities have dark, chemically obtained patinas. They occasionally bear genuine Russian marks of the nineteenth century, cut from the stem of a Russian spoon of the right period. By including this in the hasp of the charity box the forgers have successfully taken in a significantly large number of people. Be careful, therefore, in buying elaborately decorated charity boxes. It is best to examine genuine examples in museums before purchasing

one yourself, so that you become familiar with the workmanship of the time.

In the nineteenth century there were fewer pewter boxes and rather more tin ones. Silver and copper maintained the popularity they had gained during the previous century. The silver ones are quite plain. Inscriptions tend to have been added to these in order to improve their value, so examine inscriptions carefully for signs of authenticity. Another type of charity box became popular for use in Ashkenazi homes during the nineteenth century. These miniature boxes were shaped like small tankards or barrels, with a slot in the lid or the handle. Although they were made for use by children, they were adopted by Jews who wished to give charity before lighting the Sabbath lamp. You will rarely find Hebrew inscriptions, so it may be necessary to rely on family traditions in identifying the examples used by Jews.

Lastly, mention should be made of the fabric containers used in some Italian communities for collecting charity, that were adopted in the last century from those used in churches. They consist of a turned-wood handle with a circular metal frame at the end to hold open the mouth of a fabric bag. Jewish examples will always have an inscription engraved into the metal frame or embroidered into the bag, and you should only consider including a charity container of this design in your collection if it is inscribed in Hebrew. There is otherwise no difference between those used in synagogues and those in churches.

113

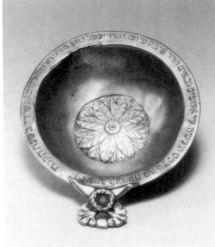

113 Hungarian silver charity bowl, Budapest, 1792–6, inscription dated 1798, *W.* 5 in (12.75 cm).
Bowls were originally, and sometimes also at later periods, used to collect charity. This example, inscribed in Hebrew: 'For Charity in Pest, by the Gabbis [Beadles] Itzig Pihm, Jakov Cohen and Rabbi Mordecai Leib Bogardi, 1798', is a rare specimen of Jewish silver from Buda or Pest. The community of Pest was rather small until the second half of the nineteenth century. The style of writing is typical of that found on Ashkenazi pieces of the late eighteenth and early nineteenth centuries. The correspondence of the hallmark with the inscribed date makes the piece still more attractive. This fairly simple object sold for nearly $10,000 in 1984.

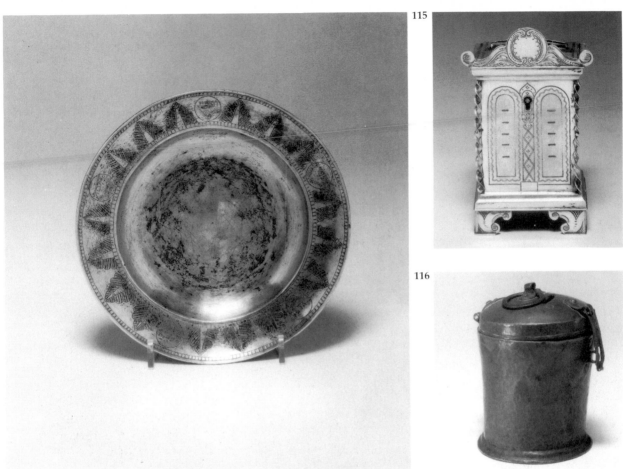

114 Polish silver charity dish, early 19th cent., with inscription dated 1861, *W.* 7¾ in (17.75 cm).
A fine piece with interesting inscriptions, of great interest to collectors. The Hebrew name 'Shlomo ben Frieda' is inscribed in the roundels which appear on the rim, and a further inscription: 'For healing in body and soul'. This piece may either have been used to donate money to a society for visiting the sick and for helping those in need of funds, or to receive donations from those who wished to be healed. A combination of these purposes, and others too, have been proposed, giving this piece an almost magical presence. The back contains the Hebrew date in another roundel, written in unusual fashion with, according to some authorities, Kabbalistic overtones.

115 German silver charity box, Brahfeld and Gutrub, Hamburg, *c.* 1860, *H.* 4 in (10 cm).
So many charity containers are humble, plain boxes, that it is most rare to find a piece such as this, in the form of a miniature *Torah* Ark.

116 Continental sheet-copper charity box, early 19th cent., *H.* 5½ in (14 cm).
A simple piece that has a certain presence. It will appeal to the serious collector who understands that many charity containers were quite humble. The copper work is hand-hammered and executed in a craftsmanlike, almost artistic, manner. This is quite possibly the work of a Jewish maker, employed outside the guild, and is likely to have been made in Poland.

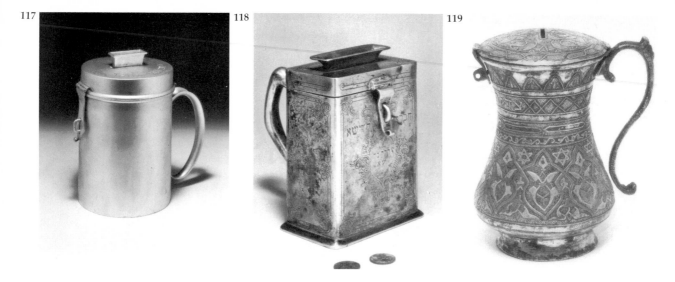

117 118 119

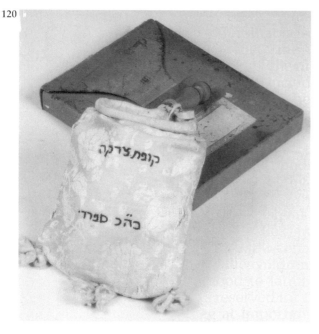

120

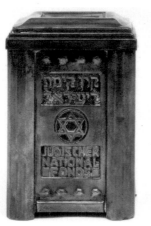

121

117 Austro-Hungarian silver charity box, maker's mark M.J. Leibach, late 19th cent., *H.* 5¼ in (13.25 cm).
This piece is typical of the silver charity boxes of this area and period. They are quite plain and functional, and are devoid of the 'Fiddler on the Roof' ornamentation found on so many later copies. This is a beautiful piece of silver, well engraved at the time of making with the Hebrew inscription: 'Burial Society of the Nadifolo Community'.

118 Austro-Hungarian silver charity box, late 19th cent., *H.* 5 in (12.75 cm).
This charity box is typical of institutional varieties: basically plain, here with some decoration and engraved in Hebrew.

119 Syrian inlaid-brass charity box, late 19th cent., *H.* 6½ in (16.5 cm).
This is an unusual form of charity container. The damascene work of silver and copper on a brass ground contains Stars of David and the ubiquitous Hebrew inscription found on charity containers (originals as well as fakes): 'Charity averts Death'.

120 Italian fabric charity-collection bag, early 19th cent., *H.* 6 in (15.25 cm).
This piece is particularly charming for its unusual materials. The Hebrew inscription documents its use as a charity receptacle. Of attractive yellow wool, woven with floral designs, the base is applied with three tassels and the top attached to a turned-wood handle. The original paper box is visible in the back of the photograph.

121 German or Austrian brass charity box in Secessionist style, Leopold Fleischhacker, *c.* 1910–20, *H.* 6 in (15.25 cm).
This piece is stamped with inscriptions in Hebrew and German recording its use for the Jewish National Fund, an organization supporting Jewish life in Israel. This piece is of interest for its stylishness.

VIII

Ethrog Boxes

The *Ethrog* or citron is a key symbol of the autumn festival of *Sukkoth*, or Tabernacles. Following the harvest, as the nights draw in, Jews commemorate their survival during years of wandering in the wilderness by building a hut with a leafy roof in which to eat their main meals. Orthodox families live entirely in their *Sukkah*, or Tabernacle, throughout the eight days of the festival. Maybe this home-making recalls how, at the coming of the winter months, Israelites would repair their homes against the rain and cold. Leaves and ripe fruit are the themes of this pastoral, thanksgiving feast. Its main, impassioned prayer, is that the rains will not fail.

The synagogue service has its own symbols: the *Lulav* and *Ethrog*. At the high point of the ceremony, when a group of Psalms is being read, each member of the congregation takes a *Lulav*, a young palm-branch, the leaf still tightly closed, and at whose base are bound some sprigs of myrtle and willow sprays. This is held in one hand while in the other, close to it, is the *Ethrog*, a lemon-coloured, strongly scented citrus fruit, grown mostly in the Near East. This bouquet is raised in blessing and shaken at key words, so that the dry rustle of winds in the palms is heard in the synagogues of every land.

The palm-branch can be carried from home to synagogue wrapped in a cloth, and when not in use is left standing in water. Moreover, a carrying case that would hold the largest branches would have to be over 3 feet (1 m) long, and would be more cumbersome than the *Lulav* alone. But the *Ethrog* is smaller, need not be left in water when not in use, and is far more delicate than the *Lulav*. Its budding end must remain intact and its skin perfect if it is to be fit to use. So containers are often provided for each fruit when it is sold. These are nowadays of card or wood. But

decorative containers have been produced in various countries to house the *Ethrog* in greater style.

The finest examples of such boxes are of silver. Some are gilded. They tend to echo the shape of the fruit, which is set horizontally on a stem in the form of a branch, and provided with a base in the form of a leaf or of a section of a larger branch. The container on top of its stem opens horizontally at its midpoint and is hinged at the back. Both halves of the container may be lined and padded in order to cushion the fruit and protect its delicate end from breakage. The earliest and most valued boxes were produced by craftsmen in Augsburg and other German cities in the course of the seventeenth century. Simpler versions continued to be made in Germany until the end of the nineteenth century, both in silver and in brass plated with silver.

A more common type of *Ethrog* box, but one that is very difficult to distinguish from the secular sugar containers to which they were identical, is known as the 'Zuckerdose'. These oval or rectangular containers, some decorated and some not, began to be used by Jews in about the early eighteenth century. It seems likely that they were in regular use throughout the year as sugar containers, and were pressed into temporary use for the *Ethrog* at Tabernacles. But the only examples that can safely be included in a collection of Judaica are those with an inscription. Uninscribed pieces are not particularly rare and are far less valuable than those bearing a Jewish inscription, so you should expect the forgers to have been active in this area. Recently inscribed pieces are, in my view, less attractive than the genuinely uninscribed ones apparently never used in a Jewish ceremony. Secular boxes from eighteenth-century Germany are more valuable than nineteenth-century examples from Poland, Austria or Germany. The forgeries are in any case rather over-elaborate in style so are not difficult to detect.

The sugar containers of Eastern Europe and Russia have experienced precisely the same type of use and re-use by Jews as those of Germany. Some of these oval-shaped, heavily ribbed boxes with squash flowers and leafy bases have been clearly identified as Jewish by means of Hebrew inscriptions, but the vast majority have not. The melon box is to be avoided by collectors of Judaica unless there is an authentic inscription. They tend to date from between the middle of the eighteenth and the end of the nineteenth centuries, and many collectors mistakenly believe them to be typically Jewish.

Craftsmen in the Holy Land have produced *Ethrog* boxes since

the late nineteenth century. The most interesting were produced by the Bezalel School of Arts and Crafts, and have a variety of Art Nouveau and Biblical Revival vignettes embossed in the metal or carved into the wood. Olive-wood boxes carved or painted with panoramic views of Jerusalem or other holy places are not rare. They are sometimes also decorated with Tabernacles symbols and inscribed with the names of the sites depicted on them. Modern Israeli silversmiths have now established another type of box, in which the oval container is set upright on a low base. They are often decorated with filigree and with semi-precious stones and turquoise. Such examples are certainly more conveniently portable than the older types, with their legs and stems, but one cannot help noticing that some of the sheer splendour has gone out of this particular genre of Judaica. This fact can only make us value the early pieces more.

122

123

122 Continental silver *Ethrog* container, town mark below a sunray, maker's mark IML, probably German, mid-19th cent., *L.* 5½ in (14 cm).
It is impossible to be certain that this box was used for sugar or for an *Ethrog*. The size and form are ideal for an *Ethrog*. It is of great simplicity, a testament to the skill of the silversmith, who raised this piece from flat sheets of plate. The owner might have felt that such an object would have been wasted if used for only one week a year to hold an *Ethrog*, and that it should be used for sugar throughout the year.

123 German silver *Ethrog* container, stamped 750, late 19th cent., *H.* 5½ in (14 cm).
Pieces such as this, clearly made for containing an *Ethrog*, originated in the middle of the nineteenth century. The early examples are quite light in gauge, as is this example which dates to 1860–70. The chasing is quite good, the basic form being achieved by stamping, and later finished off by hand. There are also silver-plated brass versions of slightly later date. These pieces are great favourites with collectors.

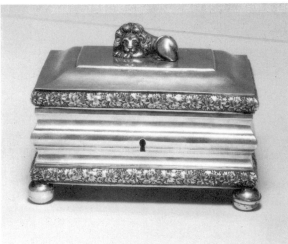

124

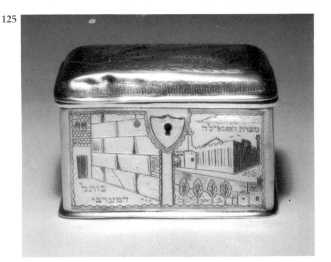

125

126

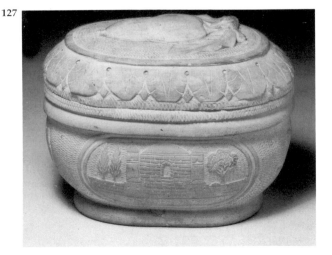

127

124 German silver *Ethrog* container, Johann Georg Wilhelm Herniche, Berlin, *c.* 1830, *H.* 6 in (15.25 cm).
A handsome piece, clearly meant for a variety of uses. Collectors are attracted by the grapevine and lion motifs, which are considered 'Jewish'. In this context neither is particularly relevant. Such pieces can be bought in ordinary silver sales for a fraction of their cost in the context of a Judaica sale.

125 Austrian silver *Ethrog* container, with later Palestinian decoration, the box 1818, the decoration 20th cent., *L.* 6 in (15.25 cm).
This is an interesting example of an old piece being adapted for specific religious use by later decoration. Often this is done with intent to deceive. The scenes of Jerusalem on this container are difficult to date exactly, but are well executed and enhance the value of the piece rather than detract from it, as do so many examples of later decoration.

126 Palestinian painted-olivewood *Ethrog* container, early 20th cent., *L.* 6¾ in (17.25 cm).
The box is painted with an *Ethrog* and *Lulav*, making it indubitably Jewish. There is also a Hebrew inscription relating to the holiday, a depiction of Rachel's tomb, and a stylized Hebrew monogram spelling 'Jerusalem'. It is quite likely that this is an early, unsigned work from the Bezalel School, perhaps at one time identified by a paper label which has since been detached.

127 Carved-stone *Ethrog* container, probably Jerusalem, *c.* 1900, *L.* 7 in (17.75 cm).
Of whitish stone, the body is carved with two Jerusalem scenes amid foliage, and the lid with an *Ethrog* fruit. The matted background leads to the conclusion that silver examples provided the model for this piece, which is much rarer and more interesting.

128 Syrian inlaid-wood *Ethrog* container, *c.* 1900, L. 7¾ in (19.75 cm).
This box, typical of Near Eastern work, is inlaid with pearl and bone in star and other patterns; the interior is lined with silk and inscribed in Hebrew in ink with a biblical verse relating to the festival of *Sukkoth*. This is an interesting local version, as intriguing as the phenomenon of the sugar box doubling with the *Ethrog* box in the West.

129 Near Eastern parchment *Ethrog* container, 19th cent., D. 5 in (12.75 cm).
This is a charming piece, made rare by the perishability of the material. For purists, the *Ethrog* on the cover should dispel all suspicions of secular use. This example illustrates the diversity of materials used and their adaptation to Jewish observance.

130 Contemporary silver *Ethrog* container, made by 'Tzvi', a Russian émigré craftsman working in London, H. 7 in (17.75 cm).
This example illustrates modern work in a traditional style, and is similar to that done by Ilya Schor. It is not to every taste; some prefer contemporary work to be Modernist in the style of Wolpert and Zabari. The work here is good, better in the sculptural detail than in the engraving. Its recent date is evident even from its traditionalist vein. Such new pieces are often expensive, and many collectors are able to buy old examples for less; others enjoy commissioning new pieces to their own taste, and in this way encourage artists to carry on the tradition of ceremonial art.

IX

Hanukah

Hanukah is a mid-winter festival of warmth and light, celebrating the rededication of the home environment at the darkest time of the year. It commemorates the victory of the oppressed Judaeans, under their leader Judas Maccabaeus, over the Greeks who had conquered the Jewish homeland and had set up a pagan cult in the Temple of Jerusalem. The beginning of the feast marks the day the victorious Maccabees entered the cleansed Temple for the rededication – which is the meaning of the word *Hanukah*. It lasts eight days because the single cruse of consecrated oil that they found was miraculously sufficient to light the large Temple candelabrum for eight days, until more special oil could be prepared by the priests. The idea that the home is a sanctuary, and that it survives hard times unscathed, is crucial to this festival. The main activities are the exchanging of gifts and the kindling of candelabra with eight lights both in the synagogue and in the home after nightfall on each evening. A single light is lit on the first night, and another added each evening until all eight are burning. A ninth flame is set slightly apart from the others and is used to light them.

There is a brief but moving ceremony for lighting the lamp, which is called a *Menorah* ('lamp') or in Modern Hebrew a *Hanukiyah*. In most families each person has his or her own lamp to light. Everyone stands holding the servant light (called a *Shammes* by Ashkenazi Jews, or a *Shammash* by Sephardis), while blessings over the festival and the lights are recited. There follows a brief prayer as the lamps are lit. Most families then sing a hymn of thanks for the struggles of liberation fought by Jews throughout their history. The candelabra are usually lit in a window, so that they can be seen from the outside.

The *Hanukah* lamp is a favourite genre among collectors for a

number of reasons. When it is not in use, the *Menorah* is often kept on display in the home, so it is a familiar object and has acquired considerable symbolic importance. Collectors are perhaps most attracted, however, by the sheer variety of styles available from almost every region of Europe and Asia. Lamps are made in materials as varied as silver, brass, bronze, copper, pewter, ceramics and glass. They also survive from almost every period, and collectors have no difficulty finding examples from the late Renaissance – the sixteenth or seventeenth centuries – and gradually purchasing a series including specimens of each type dating from then until the present day. Contemporary artists are still producing interesting pieces.

Most lamps from Mediterranean countries are fuelled by olive or other vegetable oils. Candles have been increasingly popular since the seventeenth century in Northern Europe, and are now the most common form of lighting, although some modern makers have chosen to return to oil. The revival of old methods has been matched by a trend towards innovation in materials, such as new heat-resistant forms of glass.

Such is the popularity of *Hanukah* and its ceremonial lamps, that several monographs and catalogues have been produced on them. Best known is the work of the famous scholar Mordecai Narkiss, whose illustrated publication appeared in Hebrew in 1939. But all such works should be treated with discretion, since they have been plundered in recent years for designs to reproduce. The resulting copies are often hard to distinguish from the authentic objects, all the more so since many bronze and brass designs were themselves manufactured over a long period between the mid-eighteenth and the nineteenth centuries, so show many slight variations. It is therefore essential to resist the temptation to use published photographs as evidence that a piece is authentic, for the similarity may in fact prove the opposite of what is hoped: you may have a copy taken from the very photograph you believe establishes the authenticity of your piece. Similarly, the fact that examples of a style are absent from the published literature has been used to show that the style is simply not genuine. Many rare and interesting objects have been rejected because of this over-reliance on published material. Every collector should remember that a description and a photograph are no substitute for real expertise.

A few genuine lamps have survived since the Middle Ages, but are extremely rare. They are usually identified as Franco-German, and are dated to between the twelfth and the fifteenth centuries.

They are typically of bronze, with a triangular backplate pierced in a motif that resembles a Gothic rose window. The style was widely reproduced in the late nineteenth century when the demand for medieval objects of all kinds was met by a prodigious amount of copying. If you wish to be sure about the authenticity of a piece, have the wear, patina and construction examined by a specialist in metalwork of the medieval period. Every major museum employs one on its staff. Genuine examples have not appeared on the market for many years, but some no doubt lie unrecognized in dark cellars. It would be a major achievement to discover one.

The earliest pieces available to the collector come from Italy. Fine bronze castings played a major role in Italian art of the sixteenth and seventeenth centuries, and lamps were cast there in considerable numbers. They have a cartouche-shaped backplate with pierced and chased decoration. Popular themes include elaborate scrolled foliage, occasionally inhabited by putti, or just by their heads, by fantastic monsters and grotesques, herms and fruit clusters. All these are borrowed from the Renaissance ornament of the period. One particularly popular scene, often found on European lamps of this type from the seventeenth and eighteenth centuries, is Judith holding the head of Holofernes. Judith was a biblical heroine who beheaded a Babylonian general while he slept. She was included on *Hanukah* lamps perhaps because her name is the female form of 'Judah' or 'Judas' – the guerrilla leader who provides the focal point of the festival. She usually appears standing, with the sword in her right hand and a severed head in the left. A little dog that appears in the story is also sometimes included.

These backplates are lit by a row of eight oil pans, each with a circular well and a protruding lip to receive the wick. The row of pans is cast separately and is secured by projections which fit into slots in the backplate. The projections are locked into place by pins. One sometimes also finds the single matching pan for the servant light, which fits into a slot situated near the top, either in the centre or to one side, and is pinned in a similar way. More often the slot alone remains, although when the servant light is lost it is frequently replaced with a copy. This is a common and quite

XV German silver *Hanukah* lamp, George Wilhelm Margroff, Berlin, *c.* 1776, *H.* 26in (66 cm). This large Rococo lamp is one of the finest eighteenth-century examples.

XVI Italian silver *Hanukah* lamp, maker's mark GV in an oval, Rome, mid-18th cent., *H.* 11 in (28cm). Early-Rococo – style C scrolls feature in this architectural lamp.

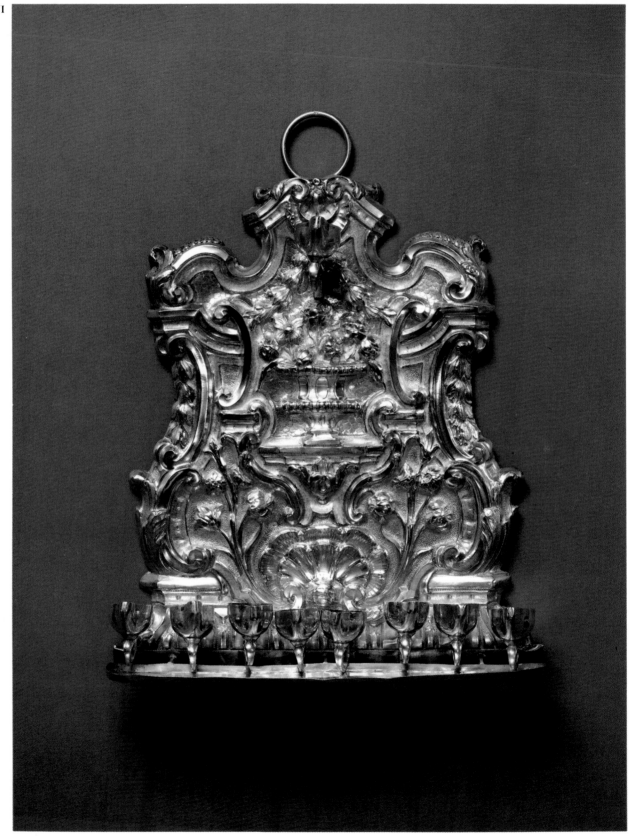

acceptable repair. More radical modifications than this, however, tend to reduce the value of a piece. It is important to check the colour of the bronze from which the oil pans are made, and to make sure that the patina and wear match that of the backplate. The row of pans may have been taken from another lamp of the right period, but this is very hard to detect. It is not as damaging to the value of a piece as a completely modern replacement. The dating is made harder by the fact that most lamps were cast from a common model and sometimes from each other, without any marking, as was the case with silver examples. Old lamps seem to be dated almost randomly to the sixteenth and seventeenth, or the seventeenth and eighteenth centuries. Many of them are in fact later. Only a thorough knowledge of the bronzework of Italy at this period can guide you through the problems of dating. If you do not know the field you should go to someone who does. A knowledge of the secular prototypes is extremely important.

By the late seventeenth century another type of lamp had appeared. It was made of sheet brass, with a rectangular backplate whose top was arched. It was embossed and chased with a variety of motifs, including the lions of Judah and the crests of the family to which the lamp belonged. One distinctive motif is a hand appearing from a cloud and holding a jug from which oil is being poured – a reference to the *Hanukah* story of a miraculous supply of oil. These sheet-metal examples often have a wood or cast-metal backing. Their oil receptacles are also cast, and are mostly circular and set in twos. They stand on curved supports, with a matching servant light above them. The lamps were made throughout the eighteenth and into the nineteenth centuries, and incorporate the decorative motifs common at the time.

Silver examples of the same type of lamp are also known, made in eighteenth-century Italy, mostly in Venice or Rome. They are stylistically of their time, with a cartouche-form backplate chased with Baroque, Rococo or Neo-Classical motifs. It is interesting to compare the decoration of these lamps, which are now quite uncommon, with that of the Italian silver bookbindings of the same period. Both tend to be of very high quality and are flamboyantly characteristic of eighteenth-century Italian craftsmanship. Silver lamps are always hallmarked, unlike the base-metal versions, so are easy to date and to trace to their place of origin.

Italian work had a profound influence on Jewish art elsewhere around the Mediterranean, and particularly in Morocco. Brass *Hanukah* lamps there have pierced backplates and cast oil pans

similar to the Italian examples. But the Moroccan versions have a few characteristic features. The piercing is often in a simple geometric style, and includes the ubiquitous *Mihrab* or Islamic arch motif. Stylized cockerels and other birds often appear as well. Moroccan craftsmen tended to be conservative and produced the same models by the same methods for generations, continuing into the twentieth century. Lamps can therefore only be dated according to very broad time-bands. Older lamps can be recognized by their weight, their fine detail, their smoother patina, and by the quality of the design or the assembly. Modern examples, which are still being cast in Israel, are coarsely finished, with edges sometimes so rough and jagged that careless handling can leave you with a deep cut. North African lamps are less valuable than they might be were it not for this widespread reproduction, although in general the styles have been little understood and enjoyed in the West, so prices tend to be low even for quite early eighteenth- or nineteenth-century examples.

Lamps made in Germany tend to be of pewter or silver. The large communities in centres such as Berlin and Frankfurt-am-Main favoured the candelabrum type of lamp in which four branches flank a central stem fitted with a matching servant light. Good examples survive from the late seventeenth century. They are commonly decorated with a figure of Judith or with lions and other traditional symbols. Other figures from the *Hanukah* story appear more rarely. Workshops in Berlin particularly favoured the form of a tree with spreading branches. Backplate varieties are also known, decorated simply but finely in the prevailing style. They are usually fairly small – between 5 and 8 inches (13 and 20 cm) high, decorated with lions flanking a crowned Temple *Menorah* amid Rococo scrollwork. In front is a rectangular box-like structure with a hinged lid, from which eight tube-like wick-holders protrude. The lamp is often set on a rampant lion or bear support. It has a fairly large servant light with a stem which is set in a loop at the side. Such lamps come mostly from Frankfurt-am-Main, Hamburg or Nuremberg, and date to the late seventeenth or eighteenth centuries. Check that all the components are marked and that these stamps match. The backplate will be thin and quite simply decorated. The cast oil box will often be marked inside on the bottom, and the hallmarks may be covered by the wick-holders. These lamps are rare and have become a favourite of the copyists so you need to inspect them carefully. There is a related version without the backplate, but with a lower section set on similar

supports, and the same type of servant light. Forgers of these have even copied the eighteenth-century hallmarks quite satisfactorily, so special care is needed in dealing with them.

Pewter lamps were also made throughout Germany and in Bohemia and Moravia. These all include a backplate, and appear in styles ranging from the most simple, with sparse decoration, to far more complex ones in which the backplate, shaped like a florid cartouche, is chased with cherubs and lions' heads, and with dolphins holding oil-jugs. These are usually struck with a pewterer's touchmarks which help to place them; but pewter marks can rarely be dated precisely, and decorative styles tend to change more slowly than do those in silver, partly because the moulds for pewter and brass were expensive to make and were changed less frequently.

Poland and the Prussian and Baltic regions of Germany are famous for their brass lamps. Free-standing examples survive from the seventeenth century, although there is some doubt about their dating, as there is for all base-metal examples. They are decorated with elaborate scrollwork on the upper sections – most are of the branch-and-stem type – and the scrolling terminates in prickets or candleholders often of large size and huge weight. Those up to 5 feet (1.5 m) in height must have been intended for use in a synagogue. They were influenced by Christian candlesticks of the same periods. An eagle is a common decorative motif, as are lions sejant which often serve as supports for the stepped or domed circular base. This form of lamp was made throughout the eighteenth and nineteenth centuries and was copied in the twentieth century. The best signs of age are the degree of wear due to cleaning, and the size and quality of the screws that join the separately cast parts. The earlier screws tend to be large, with irregular, hand-filed threads, and often have a dot punched in the end in order to centre the screw itself. This in particular is a reliable sign of age. Lamps from the first half of the nineteenth century are recognizable by the simplicity of the design and the thinness of the connecting screws. All these lamps are beautiful and significant, but they are not easy to house, so their very size keeps the prices relatively low.

The chief glories of Polish brass *Hanukah* lamps are of the backplate variety. The plates themselves are cast and pierced. The lamps were made from the late seventeenth until the early nineteenth century. Age can be detected by the overall massiveness of the construction, by the degree of elaboration, by the wear, and by the size and precision of the joining screws. Copies can be spotted by the sharp edges and pitted surfaces, especially on the back. The

backplate tends to be of delicately scrolled tracery including a variety of motifs. Most popular are stags, lions, griffins, crowns and birds – particularly eagles. Meandering branches are even likely to end in serpent heads. Most lamps also have decoratively pierced side panels, usually in a latticework style. Sometimes there is a pierced gallery of similar design in front of the oil fonts or candleholders. The servant lights, in the form of large candle-holders, appear at each end, or more usually slightly above the others. It is useful, in the case of such complex models, to check your piece against published examples to see if there are any sections missing. The front gallery or servant lights have often disappeared. These lamps are a firm favourite of collectors, who recognize their solid dignity and the wealth of variety in design.

Polish silver examples are also much sought after. A particularly popular version was made in the region of Lvov (Lemberg) during the first half of the nineteenth century. It is known as the 'Baal Shem Tov' type, after the charismatic founder of the mystic Hassidic movement who was said to have owned one. The backplate is shaped like a broad cartouche. Its thin silver is sometimes gilded, but usually decorated with filigree motifs including scrolls containing either a double-headed eagle or an arched double doorway that sometimes opens to show a miniature *Torah* scroll. Other motifs include open flowers, pillars, crowns and birds. The front is set with eight oil-containers in the form of miniature jugs, and there is usually a pair of servant lights, each with a scrolling filigree stem supporting a candleholder. The lamp stands on a number of spindly scroll supports. The front section supporting the oil-jugs is always engraved with a diamond-shaped pattern, and hallmarks may be found there also. These lamps come in a number of sizes, and range from about 8 inches (20 cm) to about 20 inches (50 cm) in length. Their value depends on their size, ornateness and condition – they are far more fragile than the brass versions, so are less often in a perfect state. There are a number of variations in the basic design, most of them fairly straightforward. One model, however, has a watch-face in the centre, and can range up to 4 feet (1.2 m) in height. These are a great rarity and command very high prices.

A classic style of lamp was produced in Warsaw, mostly between about 1830 and the end of the century. Its backplate is in the shape of a squarish cartouche, and is generally of solid metal, without any piercing or applied filigree. It is often embossed with a vignette of a bird sitting in a bowl of fruit. The upper section bears a crown

flanked by birds and flowers. To either side is a pillar or a palm tree, close to the servant light on one side and to an oil-jug on a similar stem on the other. The oil-containers are shaped like inverted pears and sometimes have covers. The supports are usually small panels with decorative foliage.

Examples of the 'Prague' lamp are still occasionally found for sale. These brass lamps originated in the eighteenth century and continued to be made during the nineteenth. Their horizontal rectangular backplate is pierced with scrolling foliage among trelliswork. The top or the sides bear a Star of David, at the centre of which appears a hat. This detail may pass unnoticed unless you are looking for it, but the motif has an interesting history. The badge was granted for use by the Jews of Prague by the Habsburg Emperor Ferdinand II, when the Jews helped to defend the city against an invading Swedish army. The hat is in the style of those of the enemy soldiers. The sides of the lamp bear depictions of Moses and Aaron. Between them is the row of oil-pans, shaped like spoons. The age of these lamps can be discovered using the same criteria as for the Polish brass lamps.

Austrian lamps are usually of silver and made in Vienna. The most characteristic forms, which were made throughout the nineteenth century, have a hemispherical backplate which is pierced and chased with Rococo-style flowers and foliage. At its centre a pair of lions flanks the Decalogue. The detachable row of oil-pans is shaped like a series of spoons – in fact spoons were often used in making the earlier examples. The whole lamp is set on high, Rococo-style scroll supports. There are a number of interesting variants, including one with a peacock motif which is most rare, and another, which is less so, whose backplate is pierced with Gothic arches and trelliswork, at the centre of which is a crowned Decalogue.

Holland is famous for its brass lamps, much sought after by collectors. Most are of sheet brass, unlike the Eastern European types which are usually cast. They have squarish backplates with scalloped tops, and are decorated with piercing, punchwork and embossing in a variety of designs. These include tulips and other flowers, birds, Stars of David, candelabra and the word *Hanukah* in Hebrew. They often have a splendid patina, built up by regular polishing ever since they were made between the mid-seventeenth and the end of the eighteenth centuries. The metal may have worn quite thin in places, and holes may even have been left in raised parts of the design. They range in size from about 8 inches (20 cm)

to 16 inches (40 cm) in length. The oldest of them have the most complex and delicate decoration.

Dutch craftsmen also produced a lamp of cast brass, the upper section of which terminates in a graduated row of stylized tulip heads, and with a rectangular plaque cast with the Hebrew word *Hanukah.* A row of eight pointed oil-pans is cast in a line and fits into slots along the bottom. A single pan above them serves as the servant light. The base is usually enclosed in a sheet-brass housing to catch any spilled oil, especially useful when the lamp is hung from a wall. These lamps have been made in considerable numbers ever since the late seventeenth century and continue to be cast today. Late-nineteenth-century examples are particularly common, and seem not to be much poorer in quality than the original pieces. The more worn examples are assumed to be the earliest, and these command the highest prices.

Some particularly attractive lamps have been produced in the Near East. Reflectors in the form of glass set into brass rings are characteristic, as are backplates decorated with stars and crescents, and with the *Hamsa,* the sign of the hand which is an important symbol of Islam. These are characteristic of both Syria and Iraq. Iraqi ones tend to be entirely of brass, while Syrian examples are often of brass decoratively inlaid with copper or silver – a technique known as Damascus work. The cross-cultural borrowing in Near-Eastern lamps is particularly complex, making their date and place of manufacture difficult to trace.

The twentieth century is notable for the work of the Bezalel School in Jerusalem, which operated between 1909 and 1926. Their lamps are in stamped brass and silver, with backplates often decorated with attractive vignettes from the *Hanukah* story. The designs are mostly by Raban and other artists. Other modern work is covered in my discussion of Bezalel and other modern artists, such as Schatz, Wolpert and Zabari, whose output draws on the full range of traditional themes and styles.

A last word of warning. Candelabra are occasionally found which have only seven lights – three on each side and one in the centre – and these should not be mistaken for *Hanukah* lamps. They are imitations of the Temple lamp portrayed on the Arch of Titus in Rome and are purely for decoration. It is unlikely, in addition, that they were manufactured by or for Jews, and since they do not have sufficient lights for *Hanukah* they cannot be included in a collection of Judaica.

131 Franco-German bronze *Hanukah* lamp, 14th–15th cent., H. 6¾ in (17 cm).

Here, in a medieval example, we find a prototype for Italian and North African lamps of the following 300 or 400 years. This type is among the earliest and most coveted examples known, and is rarely obtainable in its original form. Many copies were produced in the nineteenth century by skilled forgers working with early bronzes. The present oil pans are clearly not original, since they are out of proportion to the backplate. They are probably seventeenth century. It is essential to consult a specialist in medieval and Renaissance metalwork before accepting one as genuine. Only a handful of complete, genuine examples have so far come to light. The backplate reflects the Gothic architecture of the period.

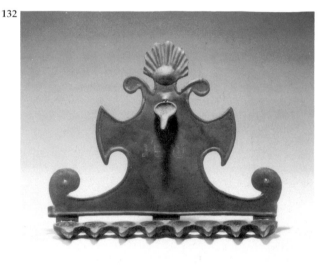

132 Italian bronze *Hanukah* lamp, late 17th cent., H. 8½ in (21.5 cm).

This lamp exhibits classic Baroque exaggerated scrollwork and a scallop shell. The small holes in the lower section may show that it was once mounted on a wooden backing. The owner's initials in Hebrew are well engraved and shaded, indicating that they are approximately of the same period as the lamp.

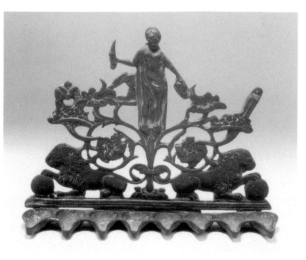

133 Italian cast-bronze *Hanukah* lamp, 17th–18th cent., H. 6½ in (16.5 cm).

The triumphant Judith holds aloft her sword and the head of Holofernes. Below her are foliate scrolls and flowers, all resting on recumbent-lion supports, behind a row of eight oil pans. The servant light, now lost, would have fitted into the heart-shaped opening on the left. This particular model is executed in a fairly thin-gauge, yellowish bronze, rather later in date than the sixteenth-century design. It is also possible that the piece was made in Southern Germany, where this type of metal was more likely to be used and where Italian influence was strong. The lions are characteristic of Italian Renaissance work.

135

134

136

137

134 Italian brass *Hanukah* lamp, 18th cent., *H.* 8½ in (21.5 cm).
Composed of graceful branches centering on a rampant lion of a kind that features in the crests of many Italian-Jewish families and several Italian cities. The fineness of the casting and finish identify this as Italian work.

135 Italian brass *Hanukah* lamp, early 19th cent., *H.* 4½ in (11.5 cm).
The griffins and flaming urn are finely cast and chased. They are typical of Italian work of the 1820s, and could appear as readily on a clock or mirror of the period. Such borrowing from Greco-Roman antiquity was especially common in Italy at this time.

136 Dutch bronze *Hanukah* lamp, early 18th cent., *H.* 11½ in (29.25 cm).
A variation on the form in plate 135, this time depicting two exotic beasts in a tree. It is decorated with the usual piercing and bead work, and with the ubiquitous heart.

137 Dutch brass *Hanukah* lamp, 1750–1800, *H.* 8½ in (21.5 cm).
Years of careful polishing have worn away the raised surfaces of the embossing and completely removed the metal. This degree of wear is excessive, although a moderate amount is a sign of age. It is a good idea to hold sheet-brass lamps up to a strong light to check for minute holes which are an indication of authenticity.

XVII Polish silver *Hanukah* lamp, late 18th cent., apparently unmarked, *H.* 9 in (23 cm).
XVIII German parcel-gilt *Hanukah* lamp, maker's mark H, Augsburg, 1765/7, *H.* 11 in (28 cm).
XIX Isidor Kaufmann, *The Descendant of the High Priest*, oil on panel signed, 16 × 12 in (40.5 × 30.5 cm).
XX Isidor Kaufmann, *Sohn des Wunderrebbe von Belz*, silver panel, 6 × 7¾ in (15.25 × 19.75 cm).

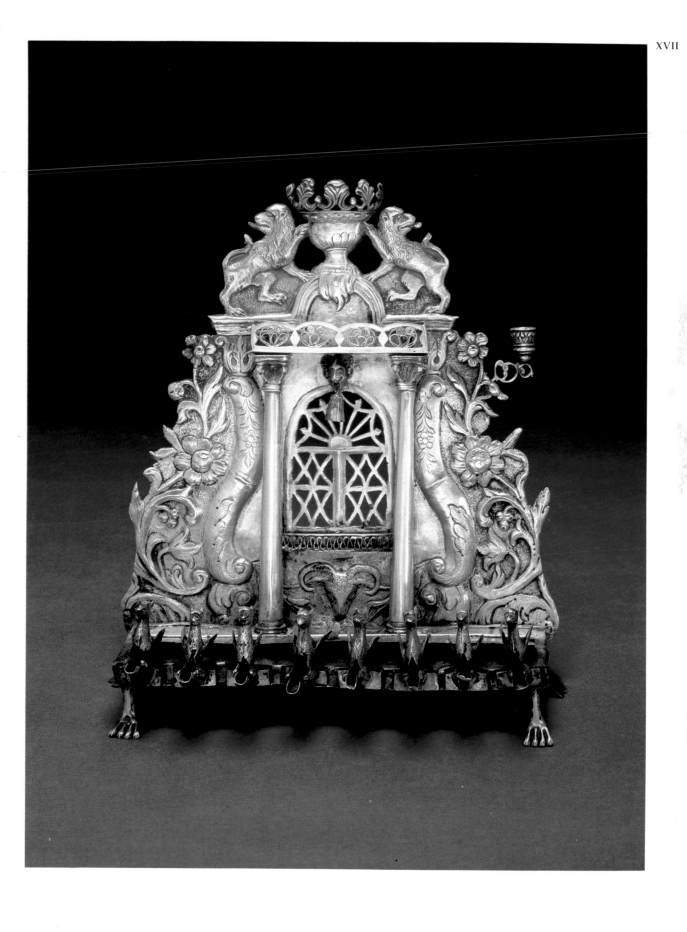

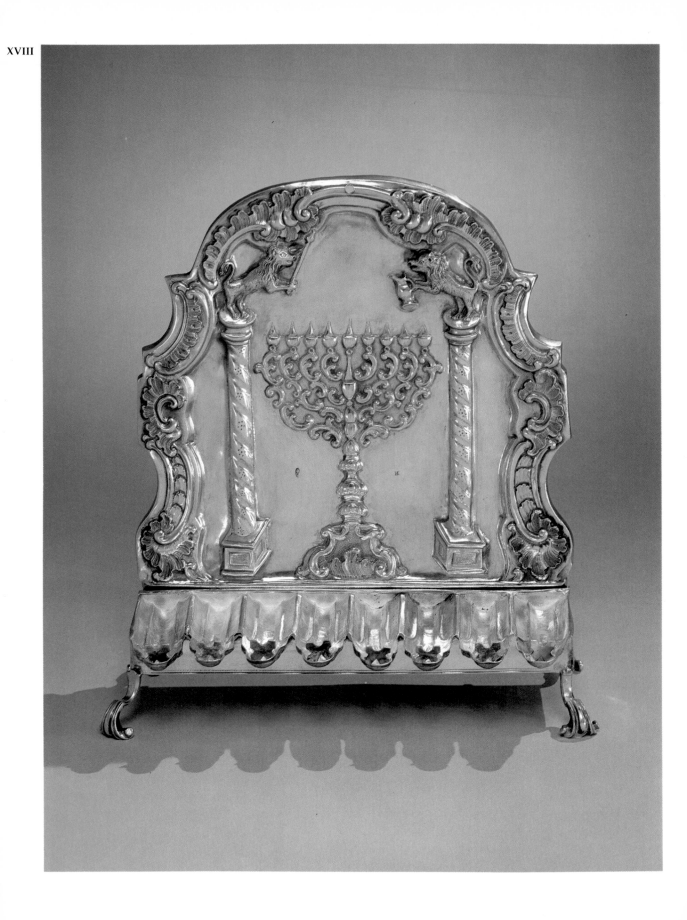

138 Dutch sheet-brass *Hanukah* lamp, mid-18th cent., H. 9¾ in (24.75 cm).
This lamp is decorated in Rococo style, rather less finely than one would expect in a silver example of the period. It shows the spies from Canaan, carrying the bunch of grapes. The background texturing is so poor that it was probably intended merely to obliterate a previous decoration. In fact the scene was probably added in the twentieth century to a plain but genuine lamp. Care was taken to dress the characters in vaguely eighteenth-century style, but the crudeness is too evident.

139 Dutch cast-brass *Hanukah* lamp, late 18th – early 19th cent., H. 11½ in (29.25 cm).
Lamps of this type are usually enclosed in a sheet-brass casing helping it to hang and to catch oil spills. These lamps, first found in the seventeenth century, have been much copied. Most belong to the late nineteenth and even the twentieth centuries. This example shows patina and wear. Screws connecting the two candlesockets are also typical for the period.

140 Brass *Hanukah* lamp, Dutch, 18th cent., H. 13½ in (34.25 cm).
An unusual variant of the sheet-brass lamp common to Holland. The double-pitcher motif in the upper section is a clever reference to the oil miracle in the *Hanukah* theme; the crown is borrowed from Dutch heraldry; the nine bosses echo the nine lights which burn in the lamp. The star motif appears as part of Dutch and German folk design – the Jewish Star of David rarely appears before the nineteenth century. The row of oil pans is lacking; there are two holes into which they would fit. The embossed beading adds depth to the design.

141 Dutch brass *Hanukah* lamp, *c.* 1800, *H.* 11 in (28 cm).
A simplified version of the earlier sheet-brass lamps, this example has circular bosses and chasing that contrast with the plain surface. The oil pans and servant light are cast and in a heavier gauge, that is also typical of the later lamps. The Star of David in the centre is unusual and may have been added in the second half of the nineteenth century, perhaps to replace a worn central circular boss.

142 German or Czech pewter *Hanukah* lamp, mid-18th cent., *H.* 13 in (33 cm).
Fairly elaborate for a pewter lamp, this probably reflects a design of the 1730s in silver. Its date would be 1750–70. The oil pans are set on high supports, directly below a lion's head and Hebrew owner's initial. The servant light on the right is probably a replacement for an oil jug. The inverted-scroll feet were often used by silversmiths and pewterers of the period on coffee pots, teapots, and so on. They also appear on tankard lids as thumbpieces.

143 Dutch brass *Hanukah* lamp, *c.* 1700, *H.* 14 in (35.5 cm).
A classic Dutch *Hanukah* lamp, cut from sheet brass, decorated with hearts and tulips, traditional Dutch folk-motifs and larger circular bosses, all of which reflect the light. These were made throughout the eighteenth and early-nineteenth centuries. The earlier models, such as this, tend to be larger in size and more intricately pierced and chased. The secondary decoration – the lines of beading which add depth to the design – are of high quality. The front is usually quite worn from years of polishing; the back was normally not cleaned, so is a deep brownish-black. Small repairs are not uncommon. They do not detract from the value, as they are a sign of authenticity.

144

144 Bohemian pewter *Hanukah* lamp, mid-18th cent., *H.* 13½ in (34.25 cm).
This classic type of pewter lamp was made from about 1750 until the 1780s. The angels on the cartouche-form backplate could be adapted to both Christian and Jewish designs. The inverted-heart piercing contrasts with the central engraved flower, which is commonly found on these lamps. The row of oil pans is fastened through a hole in the centre and secured by a pin on the reverse. The hooks below commonly hold buckets to catch oil overflow, but they were probably more decorative than useful. The scalloped front rests on 4 ball-and-paw supports. The servant light, set on a tall stem, is often balanced by a similarly stemmed oil jug. The material is quite soft, so a small amount of wear and tear is to be expected.

146 German pewter *Hanukah* lamp, mid-19th cent., *H.* 7¼ in (18.5 cm).
This unusual lamp exhibits, in the pierced central rosette and the arched backplate, elements of the Gothic design popular in the 1830s and 1840s. This style rarely appears in Jewish ceremonial art. The Hebrew letters form the name 'Maccabee', the Jewish heroes of the *Hanukah* story. They are the initials of the Hebrew words for 'Who is like unto Thee among the gods, O Lord'.

147 Austro-Hungarian silver *Hanukah* lamp, mid-19th cent., *H.* 8 in (20.25 cm).
Although it is not clearly marked, this lamp is typical of those made in Vienna throughout the nineteenth century. The heart motif recalls those found on Dutch brass lamps, while the lions and crown are more Viennese, as is the matted ground with prominent dots. The detachable lights are often in vase form, as here, or are shaped like spoon bowls. They should be marked to match the body. The high strapwork supports are stamped. They are borrowed from the Viennese silversmiths' repertoire, where they were often arranged round a circle or oval with a glass liner, to form open-spoked sweetmeat dishes and baskets.

145 German or Austrian pewter *Hanukah* lamp, *c.* 1750–1800, *H.* 5¼ in (13.5 cm).
This simple pewter model is functional but attractive. The proportions are good, and the base is not overloaded as in some larger, more elaborate examples. The drain-spout is sometimes equipped with a bucket to catch oil drips. The servant light would rest on the ledge at the side. The graceful outline is enhanced by a simple wrigglework border, outlining the body and supports.

145

146

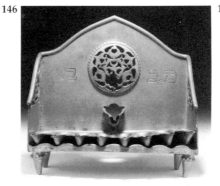

147

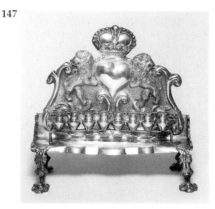

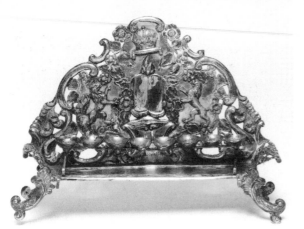

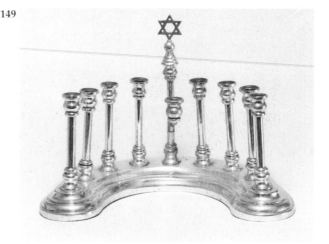

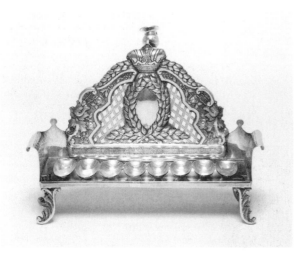

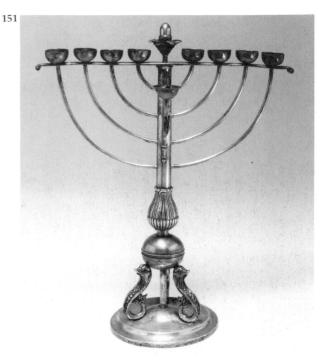

148 Austrian silver *Hanukah* lamp, Vienna, 1856, *H.* 8 in
(20.25 cm).
A typically Viennese lamp, with strongly Rococo legs
formed of bold scrolls. The traditional motifs have been
incorporated into a riot of further scrolls and foliage.
The gauge of the metal is not heavy, so it has suffered
some minor damage and loss.

149 Austro-Hungarian silver *Hanukah* lamp, Vienna,
late 19th cent., *H.* 9½ in (24 cm).
This interesting variation on the more usual straight-
columned arrangement, is set in a semicircle. The
design is architectural and relates to a balustrade. The
ritual requirement, which is not always observed in
Hanukah lamps, to have all eight lights on the same
level, is accomplished here in a novel and pleasing
way.

150 Austro-Hungarian silver *Hanukah* lamp, probably
Vienna, 1870, *H.* 7 in (17.75 cm).
The upper section of this well-made lamp is hand-
worked in heavy-gauge metal. The traditional Rococo-
style flowers and scrolls, the trellis and the laurel-
wreathed oval cartouche, are presented here in an

unusual and attractive way. The simplicity of the lower
section, with the spoon-form oil pans, lends grace to
the overall design.

151 German silver *Hanukah* lamp, Ballerman, *c.* 1825,
H. 15 in (38 cm).
This lamp, which is of heavier-gauge metal than normal
for its period, illustrates the late-Neo-Classical and
Empire styles. The circular base bears three scrolling
dolphin supports, which are surmounted by a sphere
and a foliate-chased knop. The arms of the candelabrum
and the top bar are based on Roman inscriptions. The
acorn-shaped oil pan echoes similar motifs, either in
relief or in the round, common on German silver of this
period. Similar knops occur on teapots, coffee pots and
other lidded containers.

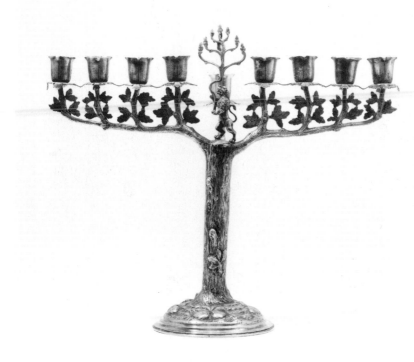

152 German silver *Hanukah* lamp, apparently unmarked, *c.* 1870, *H.* 13¼ in (33.75 cm).
This lamp is related to other examples from Berlin, to judge by the leafy stems, the tree-trunk base and even the small candelabrum-knop. The rampant lion is also a popular motif, found most commonly on *Torah* breastplates flanking the Decalogue. The base is applied with a salamander, a naturalistic element found earlier on Mannerist pieces of the sixteenth century. Marks are often missing in pieces made during the 1860s and 1870s, when the guilds ceased to function in many German towns, and the unified German Imperial marks of 1882 were not yet established.

153 German silver *Hanukah* lamp, Posen, Berlin, early 20th cent., *H.* 9½ in (24 cm).
This simple model is in a Neo-Classical style which prefigures the Art Déco period. Posen, a German-Jewish firm of silver and goldsmiths, produced both ordinary domestic and Jewish ceremonial silver, generally of good quality and conventional design. The carefully hand-hammered oil pans reflect the influence of the Arts and Crafts movement. No servant light was found with this lamp, and there is no evidence of one missing, so a separate candle and holder must have been used.

154 German silver *Hanukah* lamp, *c.* 1900, *H.* 9 in (23 cm).
This lamp, basically Neo-Classical in inspiration, reflects the increased interest in Classical antiquity around this time. The base of the model is particularly high, and once enclosed a musical movement which is now missing. Those that survive, and still work, play *Ma'oz Tsur*, the traditional *Hanukah* hymn.

155 German silver *Hanukah* lamp, late 19th cent.,
H. 45 in (115.25 cm) without wooden stand.
This magnificent lamp must have been made for a
synagogue, or for a similar institution. It is finished in a
variety of geometric and foliate patterns, that match
the Neo-Classical themes of the time. The gauge of the
metal is high without being too heavy, and the details
are finely worked. It sold for more than $60,000 in a
Judaica sale in December 1984.

156 Austrian silver *Hanukah* lamp, maker's mark AK,
Vienna, 1857, *H.* 13 in (33 cm).
Viennese lamps of the mid-nineteenth century often
have adventurous designs, with exotic birds, including
the eagle and the peacock, playing a large role in their
decoration. Here an eagle makes an appearance in an
amusing manner, set above typical Rococo-revival
ornament, fronted by oil jugs. Unusual lamps like
these are much sought after; one should take extra care
to see that all the parts match and that the marks on the
larger components are identical.

157 Austro-Hungarian parcel-gilt *Hanukah* lamp,
probably Vienna, *c.* 1870, *H.* 11 in (28 cm).
This type of lamp originated in Vienna in the 1830s or
1840s, during the Gothic revival, and continued to be
made for several decades. The overlapping arches of
the backplate terminate in Gothic-style fleurettes, two
of which are now lacking. The conventional lions,
crown and Decalogue appear in the centre. The base
too is characteristic. The oil pans, of exceptional weight,
were discovered to be of silvered brass, probably
replacing the missing original silver set.

158 Eastern European silver *Hanukah* lamp, marked with crossed swords and 13, perhaps Polish or Hungarian, late 18th cent., *H.* 11½ in (29.25 cm).
A splendid lamp, with a mark often encountered on Jewish silver, but never traced. The bird-and-crown motif on top seems to be Polish, as do the pierced, foliate-chased lions which hold the oil. The wicks protrude from their mouths. The pierced flowers, foliage and scrollwork flanking the sides and front are in Rococo style, which appears rather late because of the provincial origin of the piece. Their elaborateness makes such lamps much sought after.

159 Polish brass *Hanukah* lamp, late 18th cent., *H.* 9¾ in (24.75 cm).
A classic Polish type, of heavy cast brass, attractively designed with opposing deer and birds. The high, arched side pieces and front grill are pierced in a simpler, geometric pattern. In general, the more massive the lamp, the earlier the date. Check the thread of the screws which secure the candlesockets – they should be of different lengths and uneven. Recasts betray themselves by insufficient wear on the surface and in the openings in the design. These lamps usually had circular drip pans under the candlesockets for the servant lights, which are lacking here – a minor fault in what is otherwise a fine example.

160 Polish brass *Hanukah* lamp, late 18th – early 19th cent., *H.* 9 in (23 cm).
This model, the backplate of which is composed of a simple frame terminating in birds' heads, contains a variety of favoured motifs. These include a double eagle perched on top of a seven-branched candelabrum, that is flanked by lions, birds, columns and flower-filled urns. There are also the standard pierced side panels, front panel and servant lights. The central decoration is one of several commonly used.

161 Polish brass *Hanukah* lamp, *c.* 1800, *H.* 8¾ in (22.25 cm).
A variation on the lamp shown in plate 160, attractively pierced with lions flanking a flowering urn, birds, crown and foliage – all traditional motifs, harmoniously employed.

159 **160** **161**

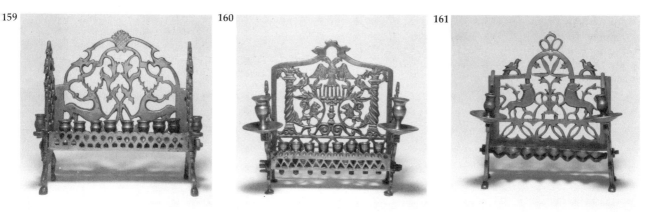

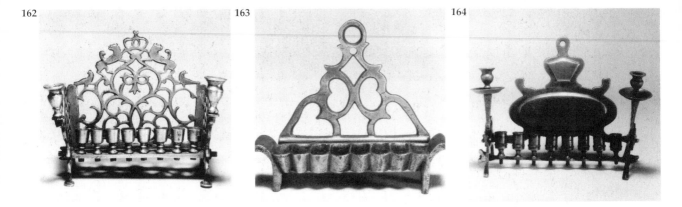

162 Polish brass *Hanukah* lamp, *c.* 1750–1800, *H.* 8 in
(20.25 cm).
One of the major Polish types, with entwined foliage,
lions, crown and birds. One can clearly see the thread
of the screws, their thickness and unevenness. These
are good signs of age, as is the general massiveness
and wear. The double servant lights could be used for
the Sabbath as well: they probably had disc-like wax
guards which are now lacking.

163 Polish cast-brass *Hanukah* lamp, 18th cent., *H.* 4¾ in
(12 cm).
This type of lamp is generally regarded as Polish,
though there is little evidence to support the view. It
can be hung from a wall, or stand on a surface. The
servant light is now lacking. These may have served
travellers, their size and sturdiness making them
suitable. They have survived in large numbers, and are
not expensive.

164 Central European brass *Hanukah* lamp, early 19th
cent., *H.* 8¼ in (21 cm).
The origin of these lamps is something of a mystery;
the unusual backplate does not relate to other types.
There are elements of Polish design with Germanic
influence in the candlesockets: a severe design which
appears on silver candlesticks of the period.

165 Polish brass *Hanukah* lamp, early 19th cent., *H.* 10 in
(25.5 cm).
This is one of the most desirable models of brass
Hanukah lamp. It is based on an architectural façade –
perhaps that of a synagogue – with a balustraded roof,
arched windows and door. It is surmounted by the
bird and crown motifs. The side panels, partly visible
here, depict rampant lions and foliage. There is a row
of pointed oil pans, the ends of which protrude from a
pierced gallery secured to each side by two birds. The
servant lights have the usual twin sockets and drip
pans. These lamps fall into three chronological types:
eighteenth-century examples are larger, massive and
elaborate; nineteenth-century varieties are slightly
simplified and smaller; and recent fakes which are
obviously unworn and which are quite common. It is
sometimes difficult to differentiate between the copies
and the genuine nineteenth-century examples which,

because they are legitimately later, many people mistake
for copies. The eighteenth- and nineteenth-century
varieties are generally pitted on the surface, both front
and back; the open sections are very rough to the
touch; and the screw threads are also quite pitted and
scratchy.

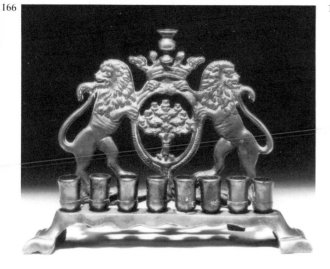

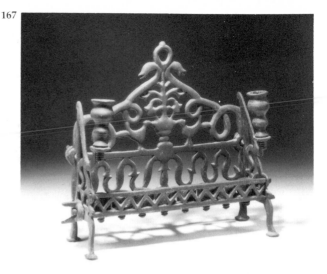

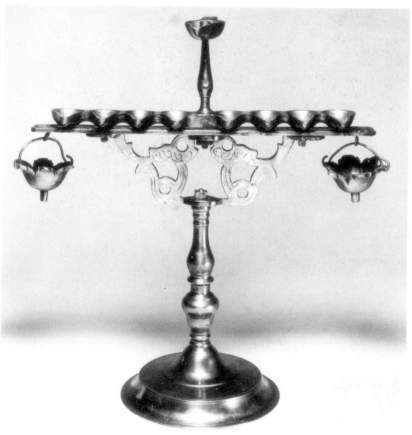

166 Polish brass *Hanukah* lamp, probably Danzig, *c.* 1820, *H.* 8½ in (21.5 cm).
The backplate on this lamp is identical in design to the arms of the city of Danzig, except that a candelabrum has been substituted for the original two crosses. This model, which seems to have originated in the late eighteenth century, may include oil pans in the earlier examples. It was made from the early eighteenth century and up to the First World War, becoming progressively thinner and coarser. The candlesockets also shrank. Mid-nineteenth-century examples incorporaqte Rococo scrolling in the backplate.

167 Polish brass *Hanukah* lamp, late 18th cent., *H.* 10¾ in (43.25 cm).
This lamp has distinctive winding-serpent motifs in the backplate, terminating in serpents' or birds' heads on the top. The flowering urn in the centre is often found, in smaller scale, mounted on silver lamps and *Torah* breastplates.

168 Polish brass *Hanukah* lamp, early 19th cent., *H.* 17 in (27.25 cm).
The broad circular base and baluster stem is found on a variety of candelabra. It is adapted here, more unusually, as a *Hanukah* lamp. These were made throughout the eighteenth and nineteenth centuries. The overall massiveness and the thickness of the connecting screws are the best signs of its age.

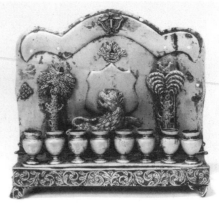

169 Polish silver *Hanukah* lamp, maker's mark IIN, early 19th cent., *H.* 6¼ in (16 cm).
The Baroque-style cartouche-form backplate is chased with a diamond-shaped pattern popular in Poland and the Ukraine, enclosing a laurel wreath and a crowned monogram, which is in the latest of the several styles found here. It was probably added some time after the lamp was made. The style is German, similar to the Frankfurt-style lamps with the hinged lid in the front. Here, the oil spouts are in the form of dolphins' heads, a more Polish feature. The maker's mark has been struck twice, flanking a 12 for the quality mark. The formation of the 2 is typically Polish, of the late eighteenth or early nineteenth centuries.

170 Polish silver *Hanukah* lamp, *c.* 1840–50, *H.* 6¾ in (17 cm).
This is an early version of the backplate variety, which became loaded with applied ornamentation later in the nineteenth century. At this period they are fairly simple in design, the backplates reminiscent of *Torah* breastplates. The birds in a palm tree flanking a fierce lion are all hand-chased from sheet silver and then applied. In later examples these elements were pre-stamped in large quantities and applied as required by the silversmith and his client.

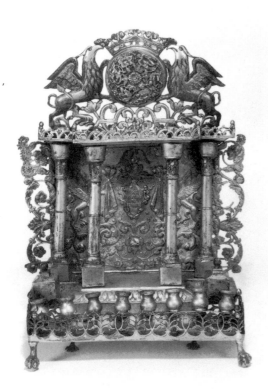

171 Polish silver *Hanukah* lamp, early 19th cent., *H.* 16½ in (42 cm).
This is a classic Polish type in silver. It occurs from the eighteenth to the mid-nineteenth centuries, when it was superseded by simpler varieties. The griffins flanking the crowned shield are found on all types of Judeo-Polish art. In fact the whole backplate is modelled on a *Torah* ark, which would have been executed in carved wood. The galleried platforms, the pillars and foliage are all architectural borrowings. Lamps of this size, quality and age are rare, and may cost more than $50,000.

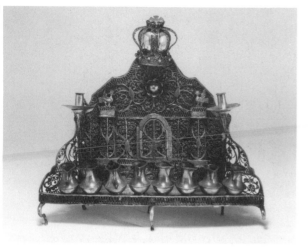

172 Polish parcel-gilt silver and filigree *Hanukah* lamp, maker's mark a leaf, Lemberg region, *c.* 1830, *H.* 9½ in (24 cm).

This lamp is of the *Baal Shem Tov* type, named after the founder of Hassidism who by tradition owned one of this type. It is very popular with collectors. Its filigree and worked surface has an airy feel. This type of lamp has a door representing a miniature Ark; columns, foliage and flowers; as well as double-headed eagles, lions, griffins and the whole panoply of Polish *Hanukah*-lamp decoration. The oil receptacles are usually of the jug variety, and there are also two servant lights for candles. An interesting feature on almost all these lamps is a depiction of the ground on which the oil jugs sit, in the form of a diagonal parquet pattern. A later mark was added on a diamond-shaped panel, perhaps to avoid some duty.

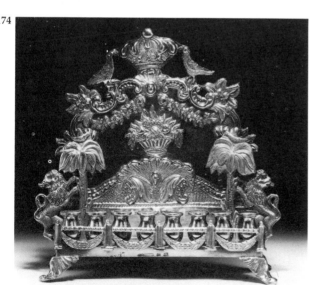

173 Polish silver *Hanukah* lamp, I. Szekeman, Warsaw, 1890s, *H.* 10 in (25.5 cm).

This is a fine and detailed example of a later lamp, not too light, and with considerable chasing. Elements of Rococo, Classical and folk art are combined in a pleasing mélange.

174 Polish silver and filigree *Hanukah* lamp, *c.* 1825–50, *H.* 9¼ in (23.5 cm).

A variation on the *Baal Shem Tov* type, here with a double-headed eagle in the centre, and an attractive floral bouquet above the central crown. The feet are usually higher, and closer inspection shows that these have been clipped, probably in a poor attempt to even out some that had broken off. This reduces the value by 10 or 20 per cent, whereas repaired or replaced feet, if only one or two are involved, do not usually affect the value.

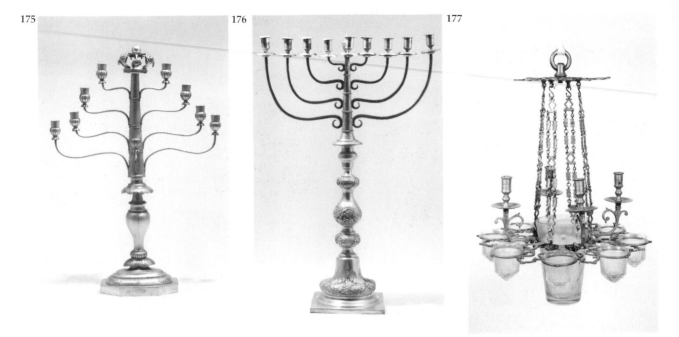

175 **176** **177**

175 Polish silver *Hanukah* lamp, maker DRT, probably Warsaw, mid-19th cent., *H.* 20 in (50.75 cm).
An attractive variation on the candelabrum form. The sturdy, low-set base is surmounted by a solid upper shaft with delicately set candlesockets, all capped by a crown. The ruffled section above the base is typical of Polish silver. The arms are all moveable.

176 Polish silver *Hanukah* lamp, Lejzer Majerowicz, Warsaw, 1873, *H.* 26½ in (67.25 cm).
Another candelabrum, rather later than the preceeding example. It is well made, is of good weight, and has a typical candlestick base. It is important to check that the upper and lower sections match. The highest prices are paid for those with identical marks on both the base and the upper section. They should be marked fully on the flange that fits into the candlesocket, and partially on the stems as well, since at this time Warsaw was subject to the Imperial Russian hallmarking system, which tended to be thorough.

177 Indian brass and glass *Hanukah* and Sabbath lamp, 18th cent., *W.* 18 in (45.75 cm).
This finely cast and chased brass piece bears a close resemblance, particularly in the candlesockets, to Polish work of the same period. The lamp would have been a major investment for a family, and is a multi-purpose piece. The glass receptacles would have served for *Hanukah*, the candlesockets for Sabbath. The whole lamp could have been used for general illumination when required. Circular arrangements for *Hanukah* lights appear most commonly in Iraqi and Indian lamps.

178 Iraqi silver *Hanukah* lamp, probably Baghdad, late 19th cent., *H.* 11 in (28 cm).
The circular form often found in Iraqi and Indian Judaica is evidence of the close ties between the two communities. On some examples the upper section is hinged, allowing the candleholders to be fixed at an angle and the base to be hung on a wall.

178

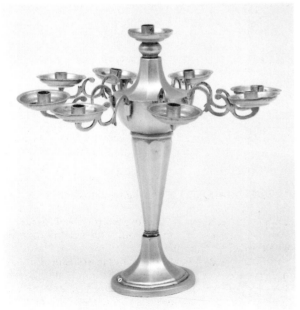

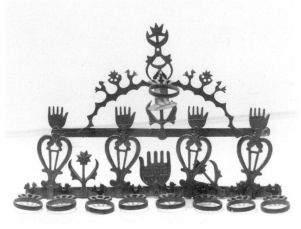

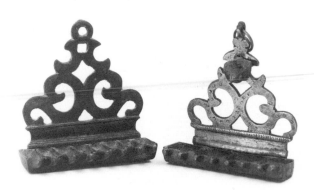

179 Iraqi brass *Hanukah* lamp, Baghdad, 19th cent., *H.* 12 in (30.5 cm).
This piece is covered with motifs typical of Iraqi Judaica, including cocks flanking a crescent and star, and the hand of Fatima, a traditional symbol used in the Near East to ward off evil. The rings along the base, and above in the centre, hold glass oil-receptacles which are usually lacking or at best replaced.

180 (right) North African brass *Hanukah* lamp, possibly Moroccan, 17th–18th cent., *H.* 5¼ in (13.25 cm).
This lamp can be usefully compared with the Italian models on which it is based. The patina and design are less fine, and there is a star-form panel design on the surface of the upper section, a popular motif in North Africa. Most telling are the four double oil pans instead of eight separate ones; these double pans are the surest sign of North African as opposed to Italian origin. The metal too is more brassy, and different from the Italian Renaissance bronze with its typical weight and patina.

180 (left) Italian cast-bronze *Hanukah* lamp, 16th–17th cent., *H.* 5⅜ in (13.75 cm).
This simple model is elegant in outline and finish; the stepped pediments connecting the upper and lower section are typical of the Classical nature of Renaissance bronze work. Knowledge of patina and casting techniques is necessary for a complete evaluation of lamps of this type. More elaborate models are embellished with cupid's masks.

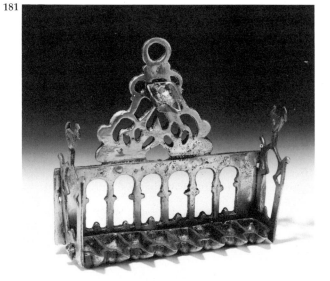

181 Moroccan brass *Hanukah* lamp, 18th cent., *H.* 8½ in (21.5 cm).
Of heavy cast brass, this example has typical North African cocks on either side, and *Mihrab* piercings. The oil pans derive from Italian lamps, and often feature on Moroccan work. The wear and quality of execution are a guide to dating, as is the heavy bolting that secures the components. This type of lamp probably continued to be produced throughout the nineteenth century.

184

182 Moroccan brass *Hanukah* lamp, late 19th cent.,
H. 17½ in (44.5 cm).
Of sheet brass, this example continues the use of birds,
beading and *Mihrabs* typical of lamps from the region.
The lengthy Hebrew inscription is in a Moroccan
script, and the oil pans are once again of Italian type.

183 Near Eastern brass *Hanukah* lamp, probably Syrian,
19th cent., *H.* 13 in (33 cm).
This type is of sheet metal. The finely pierced rosette in
the centre is a direct borrowing from window design in
Islamic architecture. The background is finely chased
and punched, a sure guide to age in a model that
continued into the twentieth century.

184 Near Eastern brass *Hanukah* lamp, probably Syrian,
19th cent., *H.* 11 in (28 cm).
This lamp is attractively pierced, with a central rosette
within further piercing, and with applied and cast
spiral columns. The design is more abstract than in
North African examples, without any direct
representations of animal or human forms. The
decoration relies on purely geometrical designs.

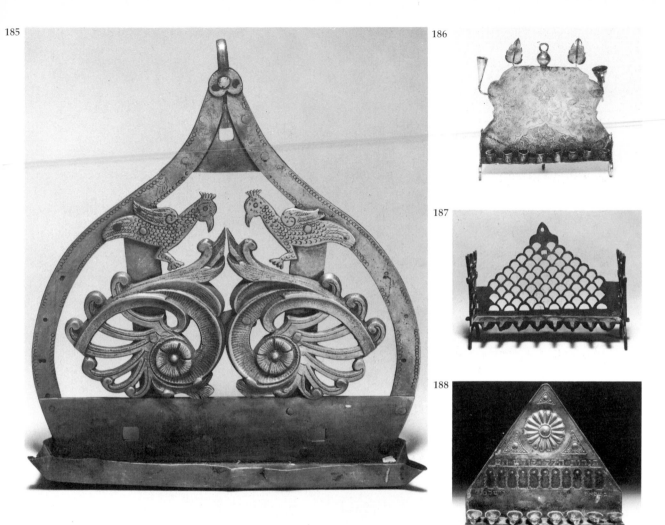

185 Brass *Hanukah* lamp, probably Near Eastern, *c.* 1800–50, *H.* 10½ in (26.75 cm).
The birds on this example are the clearest indication of origin, for they are related to lamps found in North Africa; the lower part is typical of Dutch examples. The lamp could be a hybrid, with elements put together from different lamps.

186 Persian silver *Hanukah* lamp, mid-19th cent., *H.* 8¼ in (22.25 cm).
This piece is unusual for its separate traditional elements combined in one lamp. The backplate, with Persian floral and foliate decoration, was probably cut from a larger, earlier piece, such as a tray; the candleholders are thimbles; the feet are mother-of-pearl discs set in silver rims, which were probably buttons. This curious combination forms a pleasing piece. Its construction might seem unorthodox to the inexperienced collector, but the piece is quite authentic.

187 South Italian or North African cast-brass *Hanukah* lamp, 18th cent., *H.* 9 in (23 cm).
An attractive backplate deriving from medieval examples, pierced in a semicircular pattern terminating in a fleur-de-lys. The oil pans are well formed and finished. There is a dark patina which bespeaks age and use. The row of oilpans matches the rest of the lamp, an important point in models such as these. Nor are the areas inside the semicircles jagged and sharp to the touch.

188 Palestinian bráss *Hanukah* lamp, Bezalel, *c.* 1920, *H.* 7⅞ in (20 cm).
This example, based on a medieval model, is attractively decorated with a rosette and with archways flanking a Hebrew inscription. The front section is gently fanned, and is fitted with oil receptacles similar to those found on Polish lamps. This model was also produced with simple candlesockets.

X

Purim Objects

The festival of *Purim,* which takes place in early spring, seems to have little about it that is 'sacred'. It is a self-indulgent, noisy time, that seems to reflect the lightening of winter darkness and the gradual shortening of the nights. All the ingredients of the European carnival are there: fancy-dress, banqueting, gifts and hilarity. It celebrates the events in the *Book of Esther,* including the foiling of a plot to kill the Jews of ancient Persia. The book is read in synagogue from a handwritten scroll, but the reading is no time for respectful attention. Each time that Haman, the leader of the anti-Jewish plan, is mentioned in the text, the congregation explodes with a roar of fists banging on pews, feet stamping, the blowing of horns and whistles, and a volley of rattles, all intended to 'blot out his name'. It is a festival of reversed fortunes – the Jews were endangered but rescue came; Haman enjoyed royal favour but was overthrown – and Jews enact this in their customs. Charity is given to the poor, while children dress up as characters from *Esther* and take gifts of food to family friends. The food is often carried on special plates reserved for the occasion. As in all carnivals, children enjoy playing at important roles, while adults are encouraged to indulge in buffoonery. Even excessive drinking is likely to be forgiven.

The scroll of Esther used in the synagogue is one of the most elaborately decorated objects that the average Jewish family is likely to possess. So popular is the text that a copy is usually simply called a *Megillah,* 'scroll', and is rarely given its full title of *Megillat Esther,* 'The Scroll of Esther'. Collections of these are particularly enjoyable to own. They represent the Jewish love of the written word in its most ancient form – the scroll – combined with an often splendidly ornamented casing. The scroll either fits end-wise into

the casing tube, or is mounted onto a roller and is fed through a slot in the side of the case so that it can be pulled out in order to be read. The variety in the form and decoration of the casings is matched by the range of treatments of the scrolls themselves, which tend to cover the whole gamut of recent artistic styles. But the greatest motive of all for owning and collecting these scrolls is the pleasure of reading a work of literature in a physical form – handwritten on parchment – very close to that probably known by its original writers. Other than for Scrolls of the Law, this is a privilege almost unknown in the modern world. The scribal techniques are similar to those used in a *Torah* scroll: the text must be written by hand on parchment or leather, in black ink and without punctuation. But there the similarity ends. The scroll has only one roller, and sometimes has no roller at all. It may have an elaborate case, but it never has separate ornaments such as breastplates or finials. Most distinctive of all, its margins are sometimes peopled with ornamental motifs and with illustrations such as are never encountered in *Torah* scrolls. In some examples these decorations are printed onto the parchment before the scribe begins to work – colouring in the printed design and writing the text itself – since the words may only be handwritten for use in the *Purim* ceremony.

Most of the scrolls available today date from the eighteenth or the nineteenth century. Many of them are finely written, onto parchment if they are from Northern Europe, and darker skins or leather if they are from the Near East. Scrolls are usually un-decorated, but even one on a simple wooden roller, with either a close-fitting fabric cover or a wooden case, will attract a high price if the scribe has spaced the text so that each column – except for the very first one – begins with the word for 'the king', *Ha' Melech*. So difficult is it to plan out the writing of a scroll with this precision, that *Ha' Melech* examples cost between a half and a third more than the ordinary ones.

The most valuable scrolls of all are those that have an ornamental case or that are decorated. Of the illuminated ones, the finest were produced by two Italian artist-scribes: Shelomo Italia and Francesco Grisellini, who worked in seventeenth-century Holland and Italy. Examples of their work are extremely rare and command the very highest prices. Scrolls of the same period and provenance but of slightly lower quality and by unnamed artists tend to be less sought after. Examples from the sixteenth century are not difficult to find. Whatever the quality of the workmanship, a colophon with

a name and a date adds considerably to the price. But the decoration in itself is not difficult to date, since European motifs usually relate to the decorative style of the period. In other words, birds and scrolly tulips tend to indicate Baroque work, while scrolls and flowers in asymmetrical arrangements will be Rococo.

A great many scrolls, however, were ornamented a long time after they were written. You should be on your guard against eighteenth-century originals with later crude, brightly coloured illumination between the columns. These confections are still being produced today, mostly in the Holy Land, and the earliest examples date from the nineteenth century. Consignments of scrolls seem to have been shipped there from Europe in order to be decorated and equipped with decorative cases. Only the larger scrolls are selected for this treatment: examples are often up to 24 inches (60 cm) tall. They certainly make interesting decorations, but I do not think they belong in a collection of Judaica. Your money would undoubtedly be better spent on a really fine but undecorated scroll with an interesting case. Such pieces are not difficult to find; many will be found to date from the nineteenth century and to have been made in Turkey or Italy.

Turkish examples are particularly attractive. Their silver or ivory rollers tend to have top ends shaped like a triple crown, surmounted perhaps by a crescent. These fine scrolls were popular as gifts from the family of a bride to a new husband, so they survive in fairly large quantities. The silver examples tend to have sheet-metal handles but filigree covers. A hinged jacket may clip over the scroll itself when it is rolled closed. Or the handle may revolve within the casing to wind the scroll into it as far as a bar at the end of the parchment, which prevents the end of the scroll from disappearing inside the case. Craftsmen in the Holy Land tended to place greater emphasis on sheet metal. Those produced by the Bezalel School of Arts and Crafts are usually marked with the Bezalel stamp, so are easy to identify.

A style of decoration developed in Central and Eastern Europe that was remarkable for its use of figural decoration. Polish examples of the eighteenth and nineteenth centuries, with floral and animal decorations of this kind, are very rare and command high prices. Scrolls from Vienna are often cased in silver with elaborate engraving and embossed work. There may be very little decoration to disturb the fine lines of an early-nineteenth-century piece, while later ones are encrusted with garnets and turquoise.

So many different styles of scroll casing are known that it is not

possible to describe them all here. The usual problems regarding markings remain true, as well as many of the dangers of forgery. The undecorated scroll, however, is a relatively safe commodity. Indeed, old scrolls are often less expensive than even poorly written modern ones, because of the high cost of the scribe's time and of his skill in preparing the skins, pens and ink. This disparity of price is almost unique in Judaica. But care is needed in choosing an old scroll, not only because wear and fading detract from the value, but because tiny cracks in the thick ink tend after a while to become much worse. Once the ink starts to lift and break off, your scroll will deteriorate quite quickly each time the parchment is unrolled. A well-decorated scroll may be best preserved by keeping it open although shielded from all direct light so that it does not fade. Undecorated scrolls are perhaps best enjoyed by being handled as scrolls. The pleasure of unrolling the parchment to reveal the simple lettering in its regular columns has been familiar for thousands of years. It is a rare privilege to be able to share the sensation. Other important criteria in choosing old scrolls are the degree of wear to the parchment – the amount of scuffing and creasing to the skin – and the quality of the lettering. Although the regional and chronological variations of letter-forms are not subjects that can be covered here, anyone familiar with the Hebrew alphabet can recognize the regularity of penmanship of the master-scribe. The thick horizontal lines should be absolutely straight and without wavers, and the thin ones as fine as possible and identically angled. You will very rarely see the best of work for sale, although parts of any one scroll may be nearly perfect. One distinction may help you in identifying a place of origin: the letters tend to be more angular and to have greater contrast between thick and thin lines in the Ashkenazi scrolls, and to be more rounded and flowing in Sephardi ones. But you should consult an expert if you wish to be absolutely sure of a provenance.

After the reading of the *Book of Esther* in synagogue on *Purim* morning, the traditional gifts of food are sent to friends and neighbours. The sweetmeats or nuts and dried fruit are placed on a dish or platter reserved for this purpose. The action, as well as the objects sent, are named after the order in the *Book of Esther*: 'Send portions of food', *Shlach Manot*. Pewter plates are usual, especially in Central Europe, although silver or ceramics are sometimes used. The pewter examples often bear the coat of arms or the name of the family by whom the gift is sent, surrounded by quotations from the *Book of Esther* concerning the rescue of the Jews, or, more particu-

larly, referring to the feasting and celebration that followed the foiling of the plot. There may be an illustration from the story in the centre, such as Mordechai the Jew being led in state by his defeated and disgraced enemy Haman, who is on foot beside his horse, or the feast of Esther with King Ahasuerus of Persia.

The dating of plates of this kind is fraught with problems. An inscription, even one containing a date, can have been added to an older plate at almost any time. Even pewter marks can be forged, so that the age of the plate itself may be in some doubt. However, since pewterers were rarely Jews, inscribed scenes which seem slightly unsuitable, or even errors in the Hebrew inscription, are not necessarily indications that the piece is a forgery. On the contrary, a modern forger would fear that such an 'authentic touch' might jeopardize his chances of being believed. In addition, the lack of wear on a plate that appears to be old need not indicate that it is modern, because *Purim* plates are used only once a year, so are rarely scoured. A further consequence of so few Jews being involved in pewter engraving is that the style of lettering current at any one time in Hebrew manuscripts need not be that which appears on a plate, because the whole inscription might have been copied from an earlier example. Therefore, the elaborate letter-forms of the seventeenth century occasionally appear in plates of the nineteenth. Most confusing of all is the copying of an earlier inscription complete with its date onto an obviously later plate. Check that the pewter marks are not much later than the date in the inscription. If there are no marks, check the back of the plate for signs that the marks might have been removed. But only a feel for the workmanship of authentic plates will guide you through this difficult area.

The final category of *Purim* objects of interest to the collector is the rattle, sometimes combined with a whistle, that is used in synagogue during the reading of the *Book of Esther* when the name of Haman is mentioned. This is called a *Gregger* in Yiddish. It is usually of wood, but occasionally of silver, and consists of a short handle with a ratchet and a flexible strip of wood or metal to act as a clapper set at right angles to it in a frame. It can make a frighteningly loud noise when it is swung round in the air. Rattles have been made since at least the mid-nineteenth century, and have been used ever since both for play and as primitive signals. Jewish examples can be identified only by their Hebrew inscriptions or *Purim* designs. But many of these have been added at a later date in order to increase the value of an otherwise ordinary rattle.

The silver examples seem invariably to be Jewish, however.

I have never seen a silver rattle from before the middle of the nineteenth century, although it is probable that they existed earlier than that. If you do find one with an early date, make sure that it is not the product of a forger attempting to make a common rattle into a rarity. The gain would be large and the effort not great. As ever, a knowledge of genuine examples will help you avoid the fakes.

189

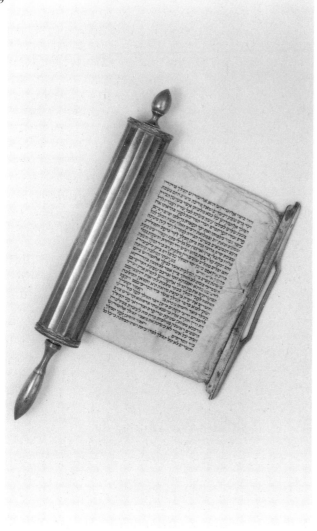

189 Silver-cased Esther scroll, unmarked, probably Vienna or Prague, *c.* 1800, *L.* of case 8¾ in (22.25 cm), *W.* of scroll 4½ in (11.5 cm). A very attractive example, both for the finely written parchment scroll (note the correct proportion of the width of the scroll to the thumbpiece and the opening in the case) and the case. Its simplicity is typical of early-nineteenth-century silver, relying for decoration on the fluting of the case and the brightly-cut engraving in bands at each end. The acorn-form knop and elongated handle are also typical of the period.

192

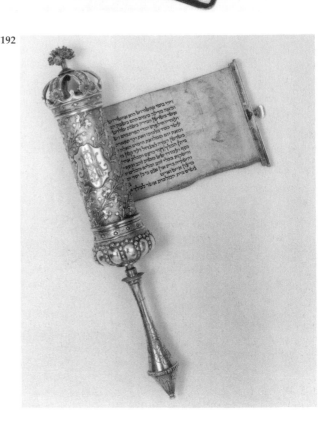

190 German parchment book-form Esther 'scroll', Germany, mid-19th cent., *W.* of scroll 5 in (12.75 cm). Rare and distinctive in form, since the *Book of Esther* is almost always presented as a scroll. This example is in book form, but folded in such a way that the entire text can be opened out into a single band. Such an object, being undecorated with illumination, should cost relatively little.

191 Persian silver-filigree-cased Esther scroll, 18th cent., *W.* of parchment scroll 3⅞ in (10 cm).
This piece has an attractive, complicated filigree case that is obviously handmade and old. The scroll has illuminated columns, is worn, and fits the case.

192 Austro-Hungarian parcel-gilt-cased Esther scroll, *c.* 1870, *W.* of scroll 2¾ in (7 cm), *L.* of case 9 in (23 cm). This case is particularly attractive, delicately embossed with clover on a matted ground, enclosing a monogram, typical of the period between 1875 and 1900. The parchment scroll is of small size, finely written, and is original to the case. The miniature bouquet on top of the case derives from Turkish examples, an influence which is often seen in Viennese pieces.

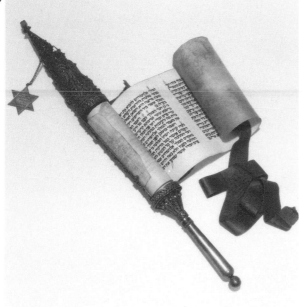

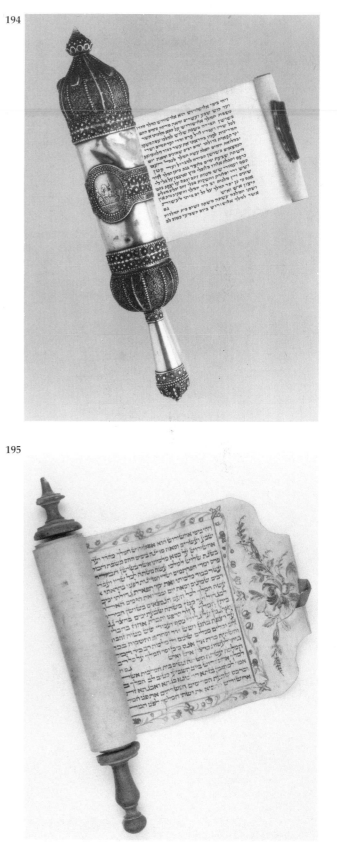

193 Turkish silver-filigree-cased Esther scroll, mid-19th cent., *W.* of scroll 6 in (5.25 cm), *H.* of case 19 in (48.25 cm).
This is a typical Turkish scroll, with the triple-crown upper-section surmounted by a coral bead, a hinged, removable mid-section and a parchment scroll. Visible in the photograph is the embellishment of certain Hebrew letters in the text, with delicate flame-like motifs written above them – another feature of Turkish Esther scrolls.

194 Palestinian silver-cased Esther scroll, attributed to Bezalel, *c.* 1925, *W.* of scroll 3 in (7.75 cm), *H.* of case 8¾ in (22.25 cm).
This is a good-quality twentieth-century Esther scroll and case. The scroll itself is a *Ha' Melech* example; the case is applied with filigree and a vignette depicting Mordecai riding in triumph. Bezalel examples usually have the full name applied to the case or stamped on the thumbpiece. As the thumbpiece is lacking, and there is no mark, one must be careful in attributing it to Bezalel, though it is in many ways typical of their work.

195 Italian illuminated parchment Esther scroll on wooden roller, 1750–1800, *W.* of scroll 8⅜ in (21.25 cm).
Such scrolls, with simple floral and foliate decoration, were made in Italy and the rest of the Mediterranean throughout the early twentieth century. Dating and tracing their origins is difficult, as they changed very little stylistically. The only guide is the quality of the painting and the writing. Here the rose on the initial panel lacks the stiffness of later work. The roller appears to be original, though the lack of figural decoration and the relative simplicity of the illumination keeps the value of such examples down.

196

197

198

199

196 American silver-cased Esther scroll, designed by Gerald Leslie Brockhurst, executed by Herman Garfield at the Cranbrook Academy, 1946, *H.* of case 10½ in (26.75 cm).
This is an important and rare example of contemporary Judaica made at the Cranbrook Academy, a prestigious American art school in Michigan, specializing in modern design. This piece was commissioned by a pioneering Judaica collector, and is inscribed on the base. The hexagonal case is chased on each side, in ascending order, with vignettes illustrating the Purim story. The lid is embossed in high relief with Mordecai in triumph, being led on horseback by the villain Haman.

197 Central European pewter *Purim* plate, late 18th cent., *W.* 11½ in (29.25 cm).
A wonderful, classic *Purim* plate. The Hebrew inscription around the edge refers to the custom for which the plate was made – sending portions to one's neighbours; there is even a depiction of food engraved between the words. In the centre are three fish entwined, symbolizing the zodiac sign of Pisces for the month of Adar in which *Purim* falls.

198 German pewter *Purim* plate, dated 1770, *W.* 9½ in (24 cm).
Such plates were used on *Purim* to send gifts of food and money to one's family and neighbours. Here a charming, naive representation of 'Mordecai's triumph' is engraved in the centre, with an accompanying Hebrew text; some of the letters have engraved dots above them, which yield the date.

199 Design for a *Purim* plate, ink and metallic foil on paper, by Ilya Schor, signed in Hebrew and English, *c.* 1960, *W.* 8 in (20.25 cm).
This design is included to show the continuity of traditional Jewish ceremonial art into the twentieth century. Schor employs traditional imagery, depicting the three principals, Esther, Mordecai and King Ahasuerus. The background shows the piercing and chasing that will appear in the finished piece, so typical of Schor's work. The Hebrew inscription, a quotation from the *Book of Esther*, is finely written, in eighteenth-century style.

XI

Passover Objects

Passover is the most important family event of the Jewish year. The festival revolves round the celebration of the Exodus from Egypt, which took place several thousand years ago when the enslaved Israelites were led to freedom by Moses. It is also, on a symbolic level, a springtime feast, with an emphasis on house-cleaning and on preparations for a season of work in the fields. The dominant motif of the eight-day festival is the eating of *Matsah* – unleavened bread – which replaces all forms of food containing yeast or raised dough. This dry wafer was all the Israelites were able to prepare in the short time before they departed to wander in the wilderness. But it also suggests the hardships endured during their centuries of slavery, and the hard labour required each year in order to plant and harvest their crops. It is also a thoroughly enjoyable time, and tends to remain among the earliest of childhood memories.

All the symbols of the festival are explored during the Passover-eve ceremony – called the *Seder* – which is conducted in almost every Jewish home around the dinner table. Various ritual foods are eaten, besides the *Matsah:* sour horseradish roots; a paste of apples, wine and nuts; and hard-boiled eggs. The ancient ceremony during which they are eaten is a rich blend of songs, question-and-answer games, history and legend, that involves children as much as the adults of the family. The text, known as the *Haggadah*, literally 'narration', is embellished by spontaneous talk about the major themes of the *Seder*, that lasts long into the night. Manuscripts of the liturgy are the most profusely illustrated of Hebrew books, playfully expanding on the ideas in the text.

During the ceremony, the celebrant – usually the senior male of the family – sits at the head of the table with a dish before him bearing several symbolic foods. Special bowls might be provided,

each with a relevant inscription: *Maror* for the bitter herbs representing suffering; *Charoset* for the apple, wine and nut paste representing the bricks and mortar used by the slaves; *Pessach* for the roasted egg and shankbone representing the original Paschal offering of the Israelites in Egypt; and *Karpas* for the lettuce that contrasts with the bitter horseradish. There is also a bowl of salt water to recall the tears of the slaves. But the point of focus is the three wafers of *Matsah*, either wrapped in a cloth beside the dish or displayed on the shelves of a three-tiered rack that stands on the table before the celebrant, with the Passover dish on top. A ewer and laver may stand beside the celebrant's chair for him to wash his hands at various points in the ceremony. A decorative towel may be reserved for the *Seder*, bearing Passover inscriptions. Participants are also supposed to lean at ease while celebrating this festival of freedom, so special pillows with inscriptions and motifs are supplied for the celebrant, and sometimes for everyone at table. All the fabrics for use at Passover – the *Matsah* cloths, towels and cushion covers – are discussed in the chapter on textiles. Each participant will need a winecup, for the four ritual cups to be drunk during the ceremony. The celebrant may have one that is specially inscribed for Passover, although some multiple sets are known, which include one for each member of the family. An additional cup of wine is filled and left in the centre of the table. This is called the 'Cup of Elijah', and is intended for the Prophet Elijah, the precursor of the Messiah, who is expected to come in the guise of a traveller on Passover eve. From this stems the custom of inviting outsiders to the *Seder*, and of providing special hospitality on that evening. All the ceramic tableware is reserved for Passover, and is not used during the rest of the year in case it comes into contact with leavened products, all of which are forbidden during Passover. These ceramics may have a suitable design to distinguish them. Even the knives, forks and spoons may be inscribed, although in other respects they will be conventional domestic utensils. Ceramic plates of the eighteenth and nineteenth centuries may have the Hebrew word for 'Passover' – *Pessach* – painted or glazed on them.

The pewter plates with engraved Passover designs are for use by the celebrant, and tend to be large and ornately decorated. The simplest of them bear the word *Pessach* and the name, initials or crest of the family to which it belonged. But many examples are inscribed with texts or key words, and with some simple Passover scenes. They are satisfying to own and easy to display, so tend to be hung on a wall throughout the year and taken down only to be

used at Passover. Workshops in as wide an area as Austria, Germany, Bohemia and Switzerland seem to have produced them, although it is common to find that the engraving was added at a different time and place from the making of the plate itself. The pewter marks and the design on the plate sometimes show a timelag of several decades. The pewterer may in any case have handed the plain plate to an engraver – perhaps a craftsman attached to a guild of silversmiths – for decoration. Since no engravings bear names it is difficult to be certain that a craftsman other than the maker of the plate was responsible for the design, but it seems likely.

The scenes and motifs on Passover platters are modelled on those in manuscripts of the *Haggadah*, especially those from eighteenth-century Moravia. They also resemble the woodcuts in early printed *Haggadot* from Prague and Amsterdam. But pewter is notoriously difficult to date; it is still harder to be sure that the decoration is roughly contemporary with the plate on which it is engraved. Undecorated plates of the eighteenth century are not expensive, and the temptation must be strong to increase the value of an ordinary platter by adding some convincing engraved ornamentation. The cost to the collector who finds that an expensive piece is in fact a recent forgery can be rather high. A recently decorated piece is worth only slightly more than an unornamented one, and a great deal less than the real thing. As with *Purim* platters, you should bear in mind that engravers were often illiterate in Hebrew and would copy the engraving on an older piece letter by letter, complete with the older Hebrew date. Make sure that the inscription does not pretend to be older than the plate. If it does, you may have a later copy – or worse. But do not be alarmed by errors in the Hebrew. This is almost evidence of authenticity, since few modern forgers would risk having their work detected by introducing such a genuine touch. The finest examples of the pewter-engraver's art are dated to the end of the eighteenth and the beginning of the nineteenth centuries. At their best, the engravers achieve a wonderful balance between lettering and ornamentation, and fill the surface of the plate without either of these elements becoming dominant.

Finer still than the Passover platter is the three-tiered rack on which to display the three wafers of *Matsah* and on top of which the symbolic foods are set in bowls. This consists of three trays supported by vertical rods at the sides and with a decorative plate on top. The open sides may be provided with shutters, for the

moments in the ceremony when the *Matsot* are to be covered, or there may be rings along the upper edge for fine lace curtains that fulfil the same function. Some examples may also have candlesticks to light the top of the rack, and these tend to predate the invention of gas and electrical lighting. The finest plates of this kind are made of silver. They may have doors to close the sides, and be profusely decorated with free-standing figures dressed in the style of the period. Most can be dated by this means to the late seventeenth and the first half of the eighteenth centuries. The silversmiths of Frankfurt-am-Main were interested in this technique of decoration, and applied it also to Sabbath lamps and spiceboxes. As in the case of the other categories of Frankfurt figured workmanship, these Passover plates have been copied ever since the late nineteenth century. Copper examples are fairly common, but the most familiar Passover plates are made of wood. The top is either painted or carved with Passover symbols or with vignettes of Holy Land life or landscapes. Wooden as well as metal examples may have fitted bowls to contain the symbolic foods.

One category of *Seder* plate is worth acquiring even though it is in no sense an antique. Hungarian workshops still manufacture plates in silver or ceramic, intended for export, which are based on nineteenth-century designs. These are as successful as their Sabbath platters embossed with two plaited loaves. Both types of plate are marked 'Sterling/.925', and 'Made in Hungary', although forgers occasionally remove these stamps and substitute older-looking ones. Check plates carefully for signs of tampering, and avoid any that you think are doubtful.

The winecups used at *Seder* are often of ordinary domestic design, and not even marked with a Passover inscription. This is because, unlike ceramics which may not be used for both Passover and everyday use, silverware need only be scalded in order to render it suitable for Passover. But cups for use at *Seder* are found sometimes as parts of sets and sometimes alone. They are engraved with inscriptions or with motifs that single them out for Passover use. Silver goblets tend to have six- or eight-sided bowls and a prayer or biblical quotation engraved on the side or round the rim. Some have a *Matsah*-shaped design on the side, that might have served to identify the cups for servants who read no Hebrew. Glass beakers may be similarly decorated. Elaborate scenes of family *Seder* gatherings are found usually on late-nineteenth-century glass and silver.

Larger than any of these is the Cup of Elijah, whose size is a

mark of respect to the prophet who it is hoped will appear before the coming of the Messiah, and who is expected to arrive in the form of a guest at a *Seder*. The cup may be engraved with scenes from the life of Elijah. Many of those engraved with suitable inscriptions are not of Jewish origin. These magnificent silver and gilt vessels from eighteenth- and nineteenth-century Germany were often adapted as soon as they were made. Others are still being modified now, and supplied with Hebrew inscriptions that are intended to appear contemporary with the cups themselves. Only experts are able to distinguish early from recent engraving and letterforms, so you should hesitate before committing yourself to a purchase. There is no real need to use specially made and inscribed objects for the *Seder*, however, and modern families should feel that they continue a long tradition if they adopt non-Jewish pieces for ceremonial use.

200

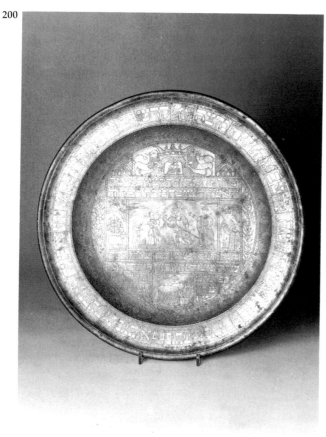

200 Continental pewter Passover plate, the plate probably Dutch, 18th cent., the decoration Prague, dated 1770, *W.* 17 in (43.25 cm). Of unusually large size, this example is also noteworthy for the quality of its engraving, combining excellent pictorial and calligraphic decoration. The rim is engraved in Hebrew with the sequence of the Passover service, alternating with vignettes derived from contemporary manuscript *Haggadah* liturgies, illustrating the Hebrew texts. The centre is engraved with the 'four sons' of the *Haggadah*, flanked by Moses and Aaron, as well as the binding of Isaac and lions flanking the Pascal lamb, here closely modelled after the 'Agnus Dei'. The plate is particularly interesting for bearing the name of the family that owned it – Gruenhut – the placename Prague, and the date 1770.

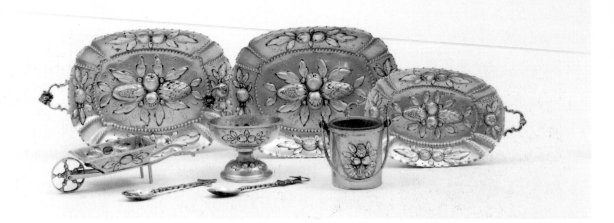

201 German silver Passover condiment set, Posen, late 19th cent., in fitted case, *W.* larger dish, 8¼ in (21 cm).
Posen, a German-Jewish silver manufacturer, made a full range of Jewish and other domestic silver. Their work is popular with Judaica collectors both for the design and for its fine quality. Here, dishes for the Passover *Seder* plate, including a wheelbarrow for the *Charoset*, which represents mortar, are stamped with typical German Baroque fruit and foliage. The oval dishes were sold separately by Posen, as well as by many other manufacturers of the time, for sweets and nuts. A set such as this, in its box, is worth considerably more than the separate items.

202 German pewter Passover plate, late 18th cent., *W.* 9½ in (24 cm).
Attractively decorated in a naive style, this plate depicts a central six-pointed star together with birds and flowers that would be equally at home on Pennsylvania Dutch pieces. The border is decorated with Hebrew words from the *Haggadah* alternating with further flowers.

203 German silver *Matsah* plate, *c.* 1900, *W.* 18 in (45.75 cm).
Ceramic prototypes for this plate are known from Holland and Italy, made in the seventeenth and eighteenth centuries. Silver pieces like this one were first made in Germany from about 1850. Similar modern examples are made in Hungary today, usually with a frilled rim and stamped 'Made in Hungary' and 'Sterling'. They are of quite good quality. The earlier, German examples are worth approximately twice as much. They are usually lighter than the Hungarian ones, and bear the German 800 *Reichsmark*. This type of plate is popular with those who want an attractive Passover plate of useful size.

202

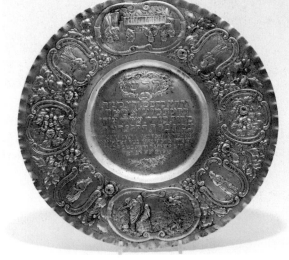

203

204 Palestinian carved, inlaid and painted olivewood *Seder* tray, *c.* 1910, W. 15 in (38 cm), H. 8¼ in (21 cm).
Possibly from the Bezalel School, though unsigned, this example is well carved with Jerusalem vignettes, and painted and inlaid with relevant Hebrew inscriptions. The three lower trays are for the three pieces of *Matsah* placed on the table. They are correctly labelled *Cohen, Levy* and *Israel* in Hebrew, the traditional subgroups of the Jewish people and the names of each *Matsah*. An attractive, usable piece.

205 Persian brass Passover plate, late 19th cent., W. 24 in (61 cm).
Charmingly engraved with fish and paisley motifs alternating with the names of Passover foods in Hebrew, this large, deep dish is rare and attractive. It is both useful and decorative, adding an exotic touch to a European collection, and showing a local interpretation of a Jewish feast and holy day celebrated all over the world.

206 Near Eastern silver Passover plate, possibly Syrian, *c.* 1920, W. 13 in (33 cm).
Decorated with a foliate scroll ground in relief, this plate resembles brasswork of the region, the more usual medium of such plates. The traditional order of the *Seder* is inscribed along the interior in Hebrew, and six depressions hold the symbolic Passover foods.

XII

Textiles and Rugs

Ritual garments, covers for sacred objects and magnificent cere-
monial curtains – Jews use textiles on every day of the year. Some
of them are modern in concept and richly embroidered, and others
serenely simple. Textiles now permeate every type of ceremony at
home and in the synagogue: many are so familiar that their forms
have become standardized, while others retain the freshness and
originality of works of art. We will look at each group of objects
here in the order in which they are normally seen in the course of
the day, and according to the yearly cycle of festivals. Finally we
shall come to the real glories of Jewish textile work: the synagogue
fabrics. This will take us into a wide range of ceremonies and
events which will throw light not only on the significance of each
group of textiles, but also on the texture of Jewish life as a whole,
its habits and values.

Throughout the day, the orthodox Jewish male keeps his head
covered. He usually wears a skull-cap, called a *Kappel* or *Yarmulka*
in Yiddish or a *Kippa* in Hebrew, which may be quite small and is
usually undecorated. On Sabbath and festivals he will use a far
more elaborate one, while a white one will be reserved for New
Year, Day of Atonement and Passover eve. Eastern European caps
are ornamented with gold or silver thread and are sometimes
covered with *shpanyer* work: stylized foliate designs in silver or
gold. Most of the available *shpanyer* now is of base metal thread
plated in the precious metal; the earlier examples, in which the
pure precious metal was used, have fallen victim to *parfillage*, the
ancient amusement of picking out the metal to sell as bullion.
When you are building up your collection of skull-caps, take care
not to mistake nineteenth-century smoking-caps for Jewish exam-
ples. The surest guide is the fact that Jewish skull-caps never have
hanging tassels.

For morning prayers, which take place in synagogue, Jewish men wear a prayer-shawl, which derives directly from the everyday outer clothing of ancient nomads and farmers of the Near East, so must have been familiar to their remotest ancestors. This square or rectangular *Tallit*, predominantly white, is worn by every worshipper, so that when the synagogue is in use it can have a mysterious ghostliness. The Ashkenazi Jews of Northern Europe wear shawls of fine white woven wool with occasional black bands, while Sephardi Jews of the Mediterranean and the Near East wear ones of white silk with occasional blue bands. The shawl is worn over the shoulders and sometimes over the head, and the top edge, at the collar, is often decorated with a band of *shpanyer* work or of silver links. This collar is called an *Atarah*, examples of which are sadly almost unsaleable at the moment. Some are made into caps – you should be on your guard against such conversions – while others are simply discarded. Fine *Atarah* collections could now be formed at little expense; if they are not, few may survive. (A similar area of heavy loss in recent years is the Eastern European bodice made of *shpanyer* work. This *Brusttuch* is seldom recognized by collectors, although several appear in portraits of well-dressed women by Maurycy Gottlieb, who is discussed in the chapter on painting. Because of this lack of recognition it is now quite rare.) A special effort, therefore, should be made to save the *Atarah* from extinction.

The prayer-shawl itself is in no such danger. Old ones wear out from regular use, or are used as shrouds for the dead, and new ones are constantly made. Very few are decorated, other than some Italian examples of woven silk or cream linen which have embroidery on the headpiece or the corner-patches, and occasionally all over. The corners of all shawls should be pierced, and some are also reinforced, to take the knotted tassels or 'fringes' – called *Tsitsit* – prescribed in *Numbers* 15:37. But you should not worry if the tassels are missing, since all four *Tsitsit* are changed whenever they become even slightly worn, and your example will not be marred if it is given a new set.

Far more commonly available on the market are the often beautifully embroidered velvet, silk or tapestry bags in which the *Tallit* is kept when it is not in use. You will also find the sometimes matching bag for the phylacteries or *Teffilin* that Jewish men also wear for weekday morning prayers. *Teffilin* consist of a pair of small black parchment boxes, containing manuscript biblical texts. One of them is attached with leather straps to the left arm, binding

it metaphorically to the heart, while the other is fixed to the forehead as a symbolic crown with a leather strap circling the head. Pictures of Jews praying often show both the prayer-shawl and the phylacteries in use. The bags in which they are kept are often the gifts of women relatives to a boy on his thirteenth birthday – his *Bar Mitsvah* – when he first puts on *Teffilin*. Some are therefore quite simple, decorated only with initials or a religious symbol, but fine examples with elaborate designs expertly executed are not hard to find. At earlier periods such bags were similar to the purses and holdalls in which one kept sewing equipment or personal belongings. It was only towards the end of the nineteenth century that Hebrew dates and formulae began to be added to Jewish examples. If you find a matching pair, the *Tallit* bag will be the larger one, and will be closed with a flap and perhaps also buttons, while the *Teffilin* bag may have a drawstring.

All weekday ceremonies take place in the synagogue, with a congregation of at least ten men without whom the full liturgy may not be recited. But on Sabbath the focus momentarily shifts to the home. On Friday evening, after the service in the synagogue, the Sabbath is welcomed into the family circle with a festive meal. In the flickering light of the Sabbath lamp, the master of the house blesses and then passes round a ceremonial cup of wine, and next blesses two loaves of plaited bread – called *Challah* – covered with a decorated cloth, before distributing pieces of it. This same ceremony is repeated at Saturday noon and on all the major festivals. The *Challah*-cloth, with which the bread is covered before it is blessed, is often embroidered with flowers, scrolls or birds that should be carefully examined for any datable stylistic elements. Some cloths are themselves inscribed with a date, and this can be helpful for identifying otherwise undated pieces. If there are no clear indications of date, remember that earlier examples tend to be decorated freehand, and that from the middle of the nineteenth century stencilled patterns became popular, over which one embroidered. Such work is characterized by the use of cross-stitching and by designs showing the *Challah* and the Sabbath lights. Hebrew lettering can also be a useful guide to date, because earlier letter-forms tend to be more elaborate and to be decorated with leaves and foliage.

By far the widest range of textiles made for the home – much greater than those for the Sabbath – are those reserved for a single festival: Passover. The Passover-eve ceremony – the *Seder* – is perhaps the most important family event of the Jewish year. With

songs, a meal and question-and-answer games, it involves every member of the family and lasts long into the night. It includes an ancient liturgy describing the Exodus from Egypt, that revolves round the eating of the symbolic *Matsah* – the dry unleavened bread which was all the Israelites took with them into the desert after their escape. On this occasion, the *Challah*-cloth is replaced by a *Matsah*-cloth or bag, which resembles the *Challah*-cloth in decoration, except that the inscriptions are usually Paschal in theme. Some German-Jewish families also use a ceremonial towel at table, to be employed when the celebrant washes his hands before distributing ritual foods. When this is not in use the towel serves as a wall-hanging, since it is often decorated, sometimes also embroidered with a family name or a date. Usual motifs include a star, a Paschal lamb, lions or the Decalogue, all rendered in needlework onto the unbleached linen. These German towels are now rare and valuable. Italian towels and *Matsah*-cloths are unfortunately less popular. Finely embroidered in white on a fine linen ground and often trimmed with lace, they are less obviously colourful and decorative. But their craftsmanship and understated charm deserve far more attention. One last group of Passover textiles includes cushion covers. These are used mainly by the celebrant at a *Seder*, since the story of the liberation from slavery is to be recited while leaning at ease. Such covers may have some decoration, but they usually lack a Hebrew inscription. For this reason they tend to pass unidentified unless they form part of a Passover set.

Undoubtedly, however, the chief glories of Jewish textile work are not to be found in the folk art and personal charm of the home, or in objects for private use. The best work is reserved for the synagogue, where the intimate gives way to a splendour that matches the often grandiose architecture of the modern synagogue. Inside, the focus of worship is the Ark. This is a cupboard along the wall nearest to Jerusalem, containing parchment scrolls of the *Torah* or Pentateuch. Each manuscript scroll is elaborately wrapped in a fine fabric mantle or *Me'il* and adorned with various types of silver ornament. In front of the cupboard doors (or inside them in Sephardi synagogues) is an ornate curtain or *Parochet*, that corresponds to the veil before the Holy of Holies in Solomon's Temple. Standing just in front of the Ark, or sometimes in the centre of the synagogue, is the platform – called the *Bema* in Ashkenazi synagogues, or the *Tevah* in Sephardi ones – from which the scrolls are read in the course of public worship. A fabric-covered lectern stands on the *Bema*, forming the second point of focus of the

synagogue. At the high point of Sabbath and festival services, the Ark is ceremonially opened to remove scrolls, which are then carried to the *Bema* to be read, and later borne back again in procession. The curtains, scroll-mantles and lectern-covers all stand out brilliantly against the white prayer-shawls of the Rabbi and Cantor carrying the scrolls. At this moment all the focal points in the synagogue are marked by sumptuous fabrics.

The finest synagogue textiles contain exquisite needlework on superb materials. Many examples can be dated by inscriptions on them that include the names of donors and of the communities for which they were made. Germany, Bohemia and Italy have left the greatest legacies of these. The decoration usually reflects the motifs current at the time, particularly if the piece was made in one of the larger urban centres. Those from smaller towns are often less influenced by current fashions. Many *Torah*-mantles and some of the smaller Ark curtains contain 'recycled' materials. Rich silks, embroidered or woven in floral or foliate patterns, were employed as ground or as decorative piecework. Hebrew inscriptions are often rendered in appliqué in this way. The floral-decorated fabric was usually taken from gowns or waistcoats which were either no longer in fashion or which were worn out. Many of the resulting pieces are of superb quality. Ark curtains of the seventeenth and eighteenth centuries, well decorated and in good condition, command very high prices. The larger ones are usually bought by museums, although smaller ones, which are easier to display in the home, remain the most popular.

The easiest of all synagogue fabrics to display, however, and often the most touchingly personal in origin, are the long binding wrappers used to secure the two rolls of each *Torah*-scroll when it is stored upright in the Ark. They are hardly ever seen, for they are covered by the ornate mantle when the scrolls are in the Ark and folded ready for re-use when the scrolls are open, but they are often painstakingly decorated. The binders are of undyed linen, and measure about 6 inches by 100 inches (15 × 250 cm). They are traditionally made out of the swaddling cloth used at the circumcision of a baby boy. It would later be decorated by his mother or his sisters with his name, date and place of birth, and with the prayer that his life should be devoted to good deeds, study of the *Torah*, and that he should pass under the marriage canopy. The adorned wrapper was then presented to the synagogue as a 'swaddling cloth' for the *Torah*. Examples are common after the eighteenth century from Germany (where it is called a *Wimpel*), and after the

seventeenth from Italy (where it is called a *Mappa*). Italian pieces are finely embroidered, with a pomegranate or floral border in silk, and with an inscription in a strong colour, often a deep pomegranate hue. But pride of place must go to German pieces. These tend to be of slightly coarser material than the Italian ones. They are decorated in colourful, vigorous folk-style, with animals, birds and foliage, and also with vignettes based on the themes of the inscribed blessings. One sees weddings in progress under their canopies, depictions of *Torah*-scrolls to symbolize learning, and signs of the zodiac. There are even occasional family symbols, such as raised hands with fingers parted in priestly blessing if the family name is Cohen, or a ewer and basin if it is Levi. The letters of the inscription often terminate in animal heads or foliage. Towards the middle of the nineteenth century the materials used in the decoration of the wrappers changed dramatically. The needlework was entirely replaced by painted decoration. This did not however lead to a change in the style of decoration, the subjects depicted or the colours used. Some of the earlier examples in particular are quite attractive. You should be on your guard against forgeries in this area, since today's printing techniques make mass reproduction relatively simple. Look for the tell-tale flaws that denote genuine handwork, the gentle fading inevitable in an older piece, and, of course, signs of wear. In general, avoid any bright, new-looking examples, for they are likely to be forgeries. Check also that parts of two binders have not been incorrectly joined – this should be clear from the design – and make sure that sections are not missing.

Lastly we come to non-ceremonial textiles. In this category it is often difficult to distinguish articles made for or by Jews from those hangings or rugs in which Old Testament scenes and symbols just happen to appear. We will take the main areas of Jewish interest one by one. A small number of Persian rugs were produced from the late nineteenth century onwards, containing Hebrew quotations, symbols of the twelve tribes of Israel, and depictions of Moses and Aaron and of the Ten Commandments. The designs are naive and often somewhat crude, but the silk examples – rather than the wool ones – remain popular with collectors. Before investing large sums in this field, however, you must obtain the advice of a rug-expert. You can yourself check that the rug is not machine-made – as are many sold as antiques – by looking at the back and checking for the knots typical of hand-made carpets. The colouring of the back will also reveal the delicacy of the design, and you will find out

whether any worn patches on the front continue right through the carpet. A worn area on the front will not affect the interest of the rug so long as the backing remains intact. Indeed, the softening of the colours through careful use and slight general wear was foreseen by carpet-makers, and forms part of their products' appeal.

A less bewildering field for the collector of fabrics is the output of the remarkable Bezalel School of Arts and Crafts in Jerusalem. This workshop functioned between 1909 and 1926, and was intended by its founder to produce a renaissance in Jewish artistic creativity. It generated a distinctive Art Nouveau style based on Jewish and Holy Land motifs, that was applied to ritual as well as decorative objects. Many elements were drawn from the archaeological and ethnographic collection in the school building, which has since formed the core of the present Israeli national museum. Its variety and sheer wealth of reference make Bezalel work one of the most satisfying fields for the collector in this area.

Some of the earlier products of their textile department are adorned with architectural vignettes or panoramas of Jerusalem and with Hebrew inscriptions. There was a particular fondness for a view of the city through the branches of a *Menorah* – a seven-branched candelabrum. These rugs were intended as wall-hangings and measure some 3 feet by 5 feet (1 × 1.75 m). Some have the name 'Bezalel' worked into the design in Hebrew, but many are unmarked.

Later examples of Bezalel work fall into two main categories: geometric and pictorial. The predominantly pictorial examples show animals or vegetation and tend to have narrow formal borders. One very popular series shows a tree and elegantly leaping gazelles surrounded by a quotation from the *Song of Songs* in the border. Such rugs tend to command high prices, all the more so since they are of convenient size. In comparison to these, the geometric rugs of the same period are far less expensive. Their stylized foliate or floral decoration is no less splendid in execution, and many of them reproduce an ingenious mosaic effect that is attractive and memorable. A fine example is quite as good an acquisition as one of the pictorial specimens. The later rugs of both kinds are marked with the Hebrew words *Marvadia* and *Jerusalem* flanking a camel.

A brief word is necessary on the subject of samplers, a category that collectors of Judaica often avoid since there is so little to connect them with Jews or Judaism. These charming and often

exquisite specimens of needlework were produced throughout the eighteenth and nineteenth centuries all over the world, by young ladies training in essential household skills. Samplers are usually now found framed, and include embroidered scenes and designs together with biblical quotations and religious rhymes and mottoes. But Old Testament inscriptions are not themselves conclusive proof of Jewish manufacture. Some doubtless were produced by Jews. But only ones containing Hebrew inscriptions, or with Jewish associations, really deserve a place in a collection of Judaica.

All collectors of fabrics should have the conservation and proper care of their holdings uppermost in their minds. Fabrics are perhaps the most vulnerable type of Judaica you are likely to collect, and can be irreparably damaged by exposure to direct sunlight or even to normal atmospheric changes. Many pieces are also extremely delicate and easily torn, so should be handled as little as possible and never used roughly or negligently. It is arguably better to hand on a fine *Tallit* or *Torah*-binder to future generations than to use it a few times ourselves and to destroy it. In all cases you should be guided by a specialist who will advise you on conservation and use, on where to keep your collection and how to clean it. Specialists also know how to spot forgeries, should you be contemplating a major purchase. But do not forget that the true quality of a collection need not lie in the amount of money you invest in it. The field of fabrics has areas that are unjustly neglected by collectors. Whether you are interested in the whole range of fabrics – the regional variants of the skull-cap as well as the special white synagogue fabrics used on the New Year and Day of Atonement – or just in a single category of object such as the *Atarah*, you should be able to build up an interesting and worthwhile collection for comparatively little investment. All you need is patience, time and good taste. Be generous with these, and your good luck will follow.

207 Near Eastern skull-cap, perhaps Bukhara, late 19th cent., *W.* approx 7 in (17.75 cm).
Worked with geometric designs in gold-coloured thread and lined with red, such pieces appear periodically on the market. Skull-caps in general, particularly European examples, are rare from before the late nineteenth century. Some appear in *shpanyer* work of gold and silver metallic thread. They are expensive, unlike the neckpiece in the following illustration.

208 (left) Polish *Shpanyer* prayer-shawl collar (*Atarah*), 19th cent., *L.* 30 in (76.25 cm).
The technique is known as *Shpanyer Arbeit*, Yiddish for 'Spanish work'. Silvered metal is wrapped around thread which is then sewn in decorative patterns – here in a tight foliate and star motif. They are not rare and many old examples are still in use today.

208 (right) Blue-silk prayer-shawl bag, probably Far Eastern, made for the Russian market, late 19th cent., 8½ × 11 in (21.5 × 28 cm).
Another inexpensive piece, attractively worked with flowers and a Star of David. Because they have survived in large quantities and are not particularly old, such pieces are an ideal starting ground for the collector.

209 Continental velvet *Matsah* cover, dated 1858, 20 × 20 in (50.75 × 50.75 cm).
This possibly Bohemian piece is typical of the mid-nineteenth century. The decoration is executed in heavy gold metallic thread. In the centre is the name 'Joseph Pollack'. The words in the corners indicate that it was intended for Passover: 'For seven day shall you eat *Matsah*'. The date appears as the four letters under the bow. The monogram below it is transliterated as *l'fak*, which indicates that the letters above it are to be read as a date.

210 Near Eastern embroidered table cloth, early 20th cent., *W.* 35 in (89 cm).

The decoration on this piece relates closely to that on the Russian bowl with Persian decoration in the ceremonial cup section (plate 43). In the centre is the Hebrew word 'Zion', and, repeated round the edge, the word 'Jerusalem'. These do not identify the occasion for which this piece was intended. It may have been used to cover the Sabbath loaves.

211, 212 German painted-linen Passover towel and pillowcase, *c.* 1825–50, hanging 48 × 15 in (122 × 38 cm), pillowcase 31 × 29 in (78.75 × 58.5 cm).

Such sets are now quite rare. The lions flanking the *Seder* scene on the towel may be derived from the arms of the town from which it comes. The floral decoration symbolizes springtime, when Passover occurs. The star motifs on the pillowcase (used by the person leading the *Seder*), also occur on pewter Passover dishes. Painting on cloth is common on *Torah* binders from the early 1800s onwards, replacing traditional embroidery.

213 German or Italian embroidered-silk *Torah* mantle, 18th cent., *H.* 29 in (73.75 cm).
This piece was probably assembled from discarded older items. It is worked with flowers and foliage on a medium-green ground, and hung with two rows of gilt-thread fringe. Superior to most modern examples, such objects are quite reasonably priced.

214 Near Eastern embroidered-velvet *Torah*-case mantle, 19th cent., *H.* 25 in (63.5 cm).
This mantle, applied with gold thread on a pomegranate velvet ground, was meant to cover a *Tiq*, the wooden case used in the Near East to cover the scroll. The stylized ornament consists of hearts, stars and a wheel on a zig-zag ground. It comes possibly from Morocco, since it resembles bridal textiles from the Atlas mountains.

215 Polish or Balkan Ark curtain, early 19th cent., 68 × 61 in (172.75 × 155 cm).
Such pieces often have a contrasting panel applied to the upper centre, perhaps bearing an inscription. The initials for 'Crown of *Torah*' (the first now lacking) were also applied. The panel is in a Turkish design, popular in the Balkans, Poland, Hungary and Austria.

215

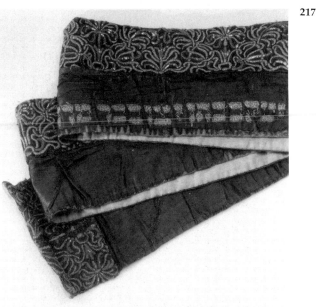

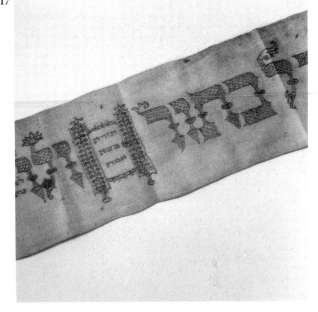

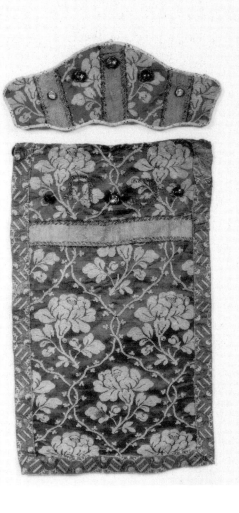

216 Continental embroidered-silk *Torah* binder, 18th cent., 116 × 6½ in (294.75 × 16.5 cm).
The green-silk ground is finely embroidered with an inscription in Ashkenazi script below an elaborate, metallic-thread foliate border. This rare form of binder may have been made from an older piece of fabric. The lettering resembles that on *Torah* mantles and Ark curtains from around Prague, pointing to a similar origin for this example.

217 German embroidered-linen *Torah* binder, 18th cent., 120 × 6 in (304.75 × 15.25 cm).
This typical German example is worked in coloured silks on an undyed linen ground. The letters resemble those on pewter and silver objects of the period. The foliate embellishments on the tops of the letters are typical, as is the *Torah*, symbolizing a wish often embroidered on German binders – that the son shall grow up to follow the *Torah*.

218 Czech or German miniature Ark curtain and valance, silk, 18th cent., curtain 18 × 10¾ in (45.75 × 27.25 cm).
The curtain includes fabrics from other articles. The upper section is applied with the initials of the words: 'Crown of *Torah*'. It is notable for its quality, its condition, and especially for its small size. Many Ark curtains are too large to display outside a synagogue or a museum.

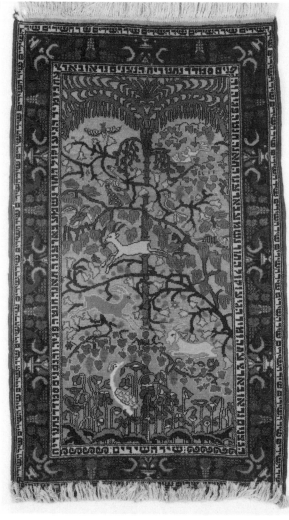

later, from around 1920, signed with the Bezalel rug-weaving trademarks 'Marvadia' and 'Jerusalem', in Hebrew flanking a camel. One shows a scene from the *Song of Songs* and is framed in a quotation from the text. The other is an abstract design, of unusually large size, reproducing a Roman mosaic floor, with tulip heads and overlapping scalework in wonderful tones of pomegranate red, grey and beige. Condition is important in these rugs, though more latitude is given to the earlier examples, many of which have suffered considerable wear. Higher prices are paid for the pictorial examples, in particular the *Song of Songs* type, though the geometric and patterned varieties can be particularly attractive.

219–221 Three Bezalel pile rugs, 1910–20, 66 × 17¾ in (167.75 × 45 cm), 31½ × 67 in (80 × 170.25 cm), 68 × 40 in (172.75 × 101.5 cm).
The first example is the earliest, from around 1910, decorated with a view of Jerusalem and signed 'Bezalel' in stylized Hebrew script within the border. A highly stylized *Menorah* is superimposed on the silhouetted vignette. The second and third examples are somewhat

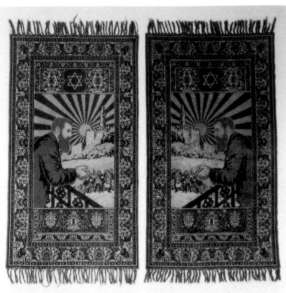

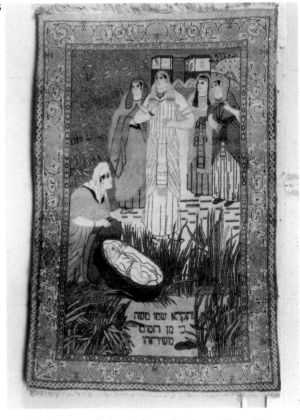

222, 223 Two Bezalel wall hangings and a Bezalel silk *Matsah* bag, 1920s–1930s. Hanging on left 20 × 35 in (50.75 × 89 cm), *Matsah* bag 16 in (40.75 cm).
Three further examples of Bezalel textile work, providing a glimpse of the broad range of material produced. The wall hangings are embroidered and appliquéd, and were designed by Shmuel Ben-David. The *Matsah* bag is painted and printed with vignettes relating to the Passover story and with Hebrew inscriptions. Such textiles are still quite modestly priced.

224 Two Palestinian cotton wall hangings, early 20th cent., 40 × 21½ in (101.5 × 54.5 cm).
These examples are machine woven and mass produced. With unashamed sentiment they show Herzl on a balcony, the sun rising over Jerusalem, and pioneers below. They closely echo Zionist posters of the period.

225 Persian wool pictorial rug, Kashan, 1920s, 79 × 50½ in (200.75 × 128.25 cm).
Such rugs were often woven in either wool or silk for the Jewish market in Persia and elsewhere. This example shows a favourite scene: Moses in the bullrushes. The accompanying Hebrew text quotes *Exodus* 2:10: 'And they called his name Moses, for he was drawn out of the waters'. The bright tones give an Art Déco feeling to the piece.

XIII

Ceramics and Glass

Objects of ceramic and glass are seldom used by Jews for ceremonies, unless each meal, with its grace before and after, can be called a ritual rather than an everyday event that happens to be sanctified by a holy rite. Only on Passover are special sets of ceramic ware used, and some of these are identified by glazed inscriptions. Otherwise, ceramic and glass objects appear simply as decorative items, or as humbler versions of pieces which more usually appear in metal.

A second reason for their rarity is their comparative fragility. Indeed, perfect examples are often of suspect origin, and small signs of wear and damage serve as useful indications of antiquity. You should check that the base-rim of each piece shows plenty of multi-directional scratches from being placed on hard surfaces. Fresh abrasions aligned identically have probably been made quite recently on a machine and are the mark of a forgery.

A common class of glass objects is from Bohemia, in which the clear object is dipped in red and then decoratively cut, although some are left uncoloured. They were made in factories there during the nineteenth century. The surface is often etched with floral designs, or with forest and wildlife scenes. The Jewish pieces bear an inscription or a recognizably Jewish vignette, most commonly showing a Passover or a Sabbath scene including a laden table and the participants seated around it for the festive meal. A *Judenstern* Sabbath lamp might hang overhead. Some such designs were doubtless executed at the factory in which they were made. Others, often cruder, seem to have been added in an amateurish way later on, perhaps after their purchase by a Jewish family or society. Unfortunately, quality alone does not provide a certain guide, since the early etching, particularly of Hebrew inscriptions,

is occasionally quite crude, having been done perhaps with a diamond ring held in a shaky hand. Some of the late copies are technically more competent, but might either be in the wrong style for the period from which they pretend to be, or lacking in depth and shading. Vignettes are a better sign of quality and period. Superb work appears only on fine-quality early glass, and crude vignettes on pre-nineteenth-century pieces are most suspect.

The finest specimens of Jewish glassware are usually those associated with the *Hevrah Kadishah,* or Burial Society. The few great surviving examples are now in museum collections. These large glass beakers are of Bohemian origin and date to the seventeenth century. They are usually decorated with polychrome enamel painting that incorporates figures and inscriptions. Because they are so valuable these objects are highly attractive to fakers, so it is most important to exercise caution when thinking of buying one – as is true, in fact, of all valuable *Hevrah Kadishah* material.

Ceramics are also often faked, particularly pre-nineteenth-century examples. High-quality forgeries are still being produced in Eastern Europe, some of which are completely new Passover or *Hevrah Kadishah* plates, while others are old ones which have been freshly inscribed or decorated to make them more valuable. New painting has occasionally been applied over the old glaze, although elsewhere the fakers are more thorough and the entire piece has been reglazed. It is important to consult a ceramics expert who understands Central European faience if one is to avoid deception.

Ceramic presentation pieces are sometimes also found, mostly in the form of inscribed cups and saucers or tobacco pipes. The lettering is often beautiful and sometimes includes a date. Most are of German, Austrian or Czech origin, although the exact location is usually difficult to determine as marks rarely appear. They were generally made around the middle of the nineteenth century, and occasionally bear interesting vignettes of the period.

Related to this group of objects are the decorative ceramics that have formed the core of many older collections. These include figures of Jewish types and biblical characters. Many English Staffordshire pieces of the late eighteenth and early nineteenth centuries depict Old Testament scenes, or caricatures of Jewish pedlars and moneylenders. Potters began in late nineteenth-century Austria and Germany to produce large quantities of caricatural groups, ranging from the mildly amusing to the downright offensive. Anti-Semitic examples are avidly collected mainly for the light they cast on contemporary Jewish dress.

Domestic wares were made particularly in Austria and England, and are still available in abundance and are hardly ever faked. Many attractive Passover plates have survived from this period, the most common being those of the Tepper factory in England, which, although transfer-printed and mass-produced, are popular with collectors.

A useful indication of date in ceramics is the 'Made in . . .' stamp on the base of a piece. This was included in accordance with a US Government regulation passed in 1890, requiring any imported item to bear an indication of its country of origin. This was so strictly adhered to that an origin mark, or simply the word 'England' or 'Germany' on a piece, dates it to later than 1890.

Value is partly dependent on whether a piece is hand-painted or transfer-printed. Hand-painted pieces, when examined under a magnifying glass, reveal brush-strokes that consist of a broad sweep of paint. Printed decoration consists of groups of minute dots of colour which, to the casual glance, appear as a block of solid paint. This printed decoration is found mostly on domestic wares and not on figurines. It originated in England in the late eighteenth century, so cannot be used in order to date a piece precisely. Most Central European workshops continued to decorate ceramics with hand-painting throughout the nineteenth century. Some fine makers, such as Meissen and Berlin-KPM, never used transfers at all. Hand-painted pieces tend to be far more valuable than printed ones, reflecting the prestige of craftsmanship over mass-production.

Despite the relative rarity of ceramic ceremonial wares they are little favoured by collectors, whose attention is drawn far more to objects in metal. Recent examples of Passover and *Purim* plates are not difficult to find. They provide collectors with an attractive variant on the more usual themes, one that they should welcome and foster. Here, then, is an area for investment and expansion, especially suited to those seeking to form their first collection of Judaica.

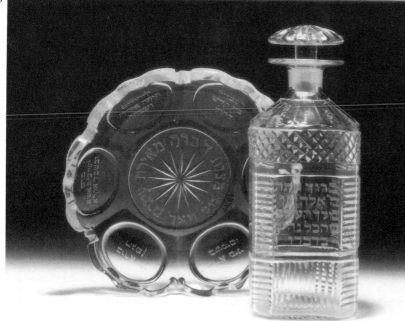

226 Bohemian glass *Havdalah* dish, mid-19th cent., *W.* 6¼ in (16 cm); and Continental wine decanter, *c.* 1820, with later engraving. These clear-glass pieces frequently appear for sale. The dish seems to have been engraved close to its time of manufacture. Its form is typical of Bohemia, where the Jewish population commissioned or adapted other such objects. The decanter is earlier, and more Anglo-Irish or American in style. This makes it more likely that it was engraved later.

227 Bohemian clear- and ruby-glass beaker, *c.* 1850, *H.* 5½ in (14 cm). The beaker is engraved with a Star of David above a Hebrew blessing for *Kiddush*. The engraving is so primitive that this piece must have been 'home-decorated' shortly after it was made. The inscription was added without any intent to deceive.

228 Bohemian flashed ruby-glass decanter, late 19th cent., *H.* 9¾ in (24.75 cm).
A late example of Bohemian glassware. With its thin flash of red, this piece has a long inscription that appears right for its period. The grapevine motif is appropriate. Filled with wine, this would be an attractive object to use at table.

229 English pressed-glass plate, *c.* 1875–1900, *W.* 10½ in (26.75 cm).
A commemorative plate portraying Sir Moses Montefiore in his old age, probably on the occasion of his 100th birthday in 1884, or to mark his death in 1885. They were made in large numbers, and many have survived. A good example should be included in every collection of Judaic glass.

229

230

231

230 Central European painted and gilt porcelain pipe bowl, mid-19th cent., *H.* 6¼ in (16 cm).
The form of this pipe is typical for its time and place of manufacture. It is inscribed in Hebrew: 'Six days shall you work and on the seventh shall you rest'. Originally set on a long wooden stem, these pipes were specially commissioned and decorated to order. Smoking is forbidden to observant Jews on the Sabbath, and this admonitory message was intended as reminder.

231 Dutch Delft plaque, mid-18th cent., 5¼ × 7¼ in (13.5 × 18.5 cm).
Old Testament scenes, so common on Dutch wares, occasionally find their way into Judaica sales and collections, although they fall outside the canon of Judaica. In puce, is Moses presenting the Decalogue.

232 German painted-terracotta group and painted Baroque group, mid-19th cent., *L.* of larger group 8 in (20.25 cm).
The first, larger group is titled in German and Hebrew: 'The Children of Israel'. It depicts a group in conversation, meant to represent 'Jewish types', and is mildly caricatural in intent. This is part of a series of scenes similarly modelled and coloured, which appears on sale from time to time. The smaller group also depicts two 'Jewish types' in conversation. It is difficult to know if such pieces were to be enjoyed by Jews as mild self parodies, or if they were meant for a satiric market whose taste included political and other ethnic commentary.

232

233 Austrian painted-creamware *Seder* set, Vienna, mid-19th cent., *W.* of central dish 5¼ in (13.5 cm).
Simply painted in russet, with Hebrew inscriptions referring to the traditional Passover foods, the central dish has an inscription from the *Hagaddah*. This attractive dish is as practical and useful today as when it was first produced. The beaded border relieves the otherwise complete plainness, and nicely sets off the outline.

234 French porcelain Passover plate, Jh. Klotz, Paris, *c.* 1870–80, *W.* 16½ in (16.5 cm).
The blue ground and inscription are painted, while the central roundel with Moses parting the Red Sea is transfer-printed, in a mixed technique typical of the period. This is an unusual and decorative model. Although mass produced, few examples have survived.

235 Austrian painted-ceramic group, late 19th cent., *H.* 11 in (28 cm).
This group, more accomplished than those in illustration 232, is also more strongly caricatural. The two men, one in traditional dress, the other in checkered trousers and spats, are recognizably Jewish, and their whisperings might have been seen as having sinister overtones, especially in view of the impressed German caption: *Auch ein Geheimnis* ('Another Secret'). An interesting yet somewhat disturbing piece.

236 Austrian porcelain gilt-metal wall sconce, late 19th cent., *H.* 12 in (30.5 cm).
This interesting sconce consists of a hand-painted platter, entitled *Die Juden Braut* ('The Jewish Bride'). It was made in Vienna-factory style, based on an old master painting of that title. It has been skilfully mounted through the holes in the handles as a wall sconce. Though questionably Judaic, such pieces are popular with many collectors.

237 Paired porcelain cup and saucer, early 19th cent., *H.* of cup 3 in (7.75 cm), *W.* of saucer 5¼ in (14.5 cm).
The cup and saucer are painted with scenes of the Jerusalem Temple *en grisaille*, within claret and gilt borders. Though strictly more biblical than Judaic, such pieces are in demand. The cup and saucer were bought, in the sale of the Zagayoki collection, for an amazing price of $4400, in December 1984.

238 Ethiopian stained-earthenware bowl and figure, 20th cent., *W.* of bowl 7 in (17.75 cm).
These pieces were made by the Black Jews of Ethiopia, commonly known as 'Falashas', a term originally of opprobrium. They are probably sun-baked, and are both decorated with the Star of David. The figure represents King Solomon, the 'Lion of Judah'.

239 American ceramic New Year's (*Rosh Hashanah*) plate, Alice and Celia Silverberg, Elmira, New York, early 20th cent., *W.* 9½ in (24 cm).
The Silverberg sisters made charming, Pennsylvania Dutch-style Jewish ceramics in New York in the early 1900s. Several of their pieces have appeared at auctions. They are characterized by a naive, folkish style and execution. Most pieces are of terracotta dipped in a white slip, with the design cut away. This is one of their loveliest pieces, emphasizing the traditional wish for a 'Sweet New Year', when, as part of the holiday ritual, an apple is dipped in honey and eaten with accompanying greetings.

XIV

Paintings and Prints

Jewish involvement in the graphic arts has tended to be comparatively slight over the centuries. The Bible forbids 'graven images' in order to discourage idolatry, and Jews have gone to extremes to avoid illustrating even the Bible and other religious texts with human figures. The prohibition of representations in Islam further debarred Jews in Muslim lands from realistic portrayals, while the domination of the Church as patron of the arts in the West provided a barrier to Jews with artistic abilities. Yet Jews in modern times have been almost as distinguished in the graphic arts as in music, usually considered the more traditional field of Jewish achievement. Modigliani, Pissarro, Soutine, Chagall and Liebermann have all excelled as artists of worldwide stature, although their output ranges in style from the international and secular to the most specifically Jewish of approaches. Collectors of Judaica are torn here between two strategies. Are they to collect works of art because these happen to be by Jews, or must they insist on the Jewish subject-matter of a work, be the artist Jewish or not? The answer is usually provided by the economic factors involved. It makes little sense for a collector of Judaica to spend vast sums on works without direct relevance to Jewish subjects, especially when pictures imbued with Jewish spirit and full of ethnographically valuable detail can be had for far less.

Medieval Hebrew manuscripts with illustrated scenes are mostly now in museums. Later examples, from the seventeenth and eighteenth centuries, are charming though rare. They contain the grace after meals, the wedding ceremony or the circumcision liturgy, and usually include naive vignettes from everyday life.

Most material available today dates from the nineteenth century, during which there was a vast increase in the production of Jewish

genre scenes. Rabbinic condemnation of graven images, always somewhat variable in severity, became progressively more elastic in the second half of the century, so much so that pious or genre pictures soon became acceptable even to the more traditional and conforming of Jews. The availability of artistic training was an important determining factor of this growth, as was the increasing fashionability of art and the power of the growing middle classes to purchase it. Works of social realism were popular, as were the portraits rich in psychological insight. Jewish artists were quick to supply large numbers of Rabbinic portraits and group scenes from Eastern Europe to a burgeoning market.

The most important of Jewish genre artists was Isidor Kaufmann. He was born in Hungary in the middle of the nineteenth century, studied in Vienna, and died shortly after the First World War. He travelled throughout Eastern Europe in search of material in Jewish townships and villages, sketching as he went. His secular scenes, including both landscapes and portrayals of peasant life, command roughly a quarter of the price of his *shtetl* paintings. These are characterized by an exhaustive attention to detail and an acute sense of the psychological authenticity of his models. His panels are small, measuring between 5×7 inches (12×18 cm) and 9×12 inches (23×33 cm), only occasionally extending to 20×30 inches (50×77 cm). His brushwork is so precise that it is visible often only under magnification, and the photographic realism of many of his works leads some people to believe that they are not in fact painted. Some pictures are more impressionistic and softer in tone, but no less precise in execution.

He usually signed his paintings in reddish-brown paint, using his full name written from bottom to top up one side. His Jewish subjects command the highest prices, and the secular ones roughly half as much. This has led to three main categories of deception. The first is the incorrect cataloguing of secular or Christian topics as Jewish ones, such as the description of a traditional village girl in a white communion dress as a *Bat Mitsvah*, although this *Bar Mitsvah* ceremony for girls is of comparatively modern and usually non-orthodox origin; or the inclusion of a scene showing chess-players who need not be Jewish in a Judaica collection. The second trap is the addition of a forged Kaufmann signature to a painting by another artist, whose name may even appear elsewhere on the work. The third involves the imitation of Kaufmann's style, often carried out in his own lifetime by inferior painters whose work can easily be spotted by a practised eye. The collector should also be

aware of a portfolio of prints of Kaufmann's work produced in Vienna in 1925 shortly after the artist's death. These are of extremely high quality and are especially difficult to distinguish from genuine paintings when they are found mounted on canvas and varnished over, as was occasionally done in the 1930s and 1940s. The complete collection of prints is itself worth collecting.

A second major painter of Jewish scenes was Maurycy Gottlieb, who was born in Poland in 1856 and died aged only 23 having produced works that have ensured him a favoured reputation in both Poland and Israel, where there are important collections of his output. Less photographic than Kaufmann, his paintings are suffused with a delicate light that gives depth to their rich tones. Portraits both Jewish and secular, and a famous view of a synagogue on the Day of Atonement from the centre of which the artist gazes intensely, are typical of his works. He was asked by the German publisher Beckmann to illustrate Lessing's play *Nathan der Weise,* but anti-Semitic pressure caused the project to be abandoned when only seven plates were complete. Imitations and forgeries continue to be made in response to the heavy demand for his works in both Poland and Israel, so specialist advice is essential if a collector contemplates buying one.

Earlier than both these artists is Moritz Oppenheim, who worked within the German genre tradition and under the influence of the Nazarenes, who were famous for their biblical subjects. Oppenheim's realism is tinged with romanticism, mainly because his paintings recall scenes common in his childhood, but which were already old-fashioned when he painted them. Happy family gatherings are portrayed in typical settings, complete with hanging Sabbath lamps and silver *Kiddush* cups. He occasionally worked *en grisaille* – in various tones of grey – for reproduction in prints. The popularity he won by his paintings and prints during his lifetime has hardly faded, and his Jewish subjects in particular are much sought after.

The works of a highly popular Polish-born artist, Artur Szyk, who worked during the first half of the twentieth century, are steeped in both Polish and Jewish folklore. He left Lodz in the 1930s for London, later moving to the United States. Szyk produced miniatures and book illustrations in ink and gouache on paper, evolving a jewel-like precision of colour and a uniquely exact calligraphic style. Szyk's Jewish and Polish interests led him to a series of anti-Nazi and Axis caricatures. But his greatest work is the *Haggadah* for Passover, published in London in 1939 in a limited

edition printed on vellum and elaborately bound. Reproductions of this have been appearing ever since, and the *Szyk Haggadah* is now firmly established as a classic. The original works of art from which the book was printed were sold by Sotheby's in New York in 1984 for $209,000. Copies and forgeries are common, many of them bearing an official Polish export stamp which I have never yet seen on a genuine work by the artist. Szyk's political caricatures are far less valuable than his Jewish subjects, so are more rarely forged.

Two artists who worked in Palestine in conjunction with Boris Schatz, whose Bezalel School of Arts and Crafts is discussed in a different chapter, are Abel Pan and Ze'ev Raban. Their watercolours, oil-paintings and etchings of biblical themes exemplify the blending of Near-Eastern and European styles of the Bezalel School, expressing the ideas in fine pastel shades. Both artists worked in other media, such as textiles and metalwork. These are only two of many artists from whom it is hard to choose a representative number for adequate discussion. Most will be found in standard works of reference such as those of Bénézit, and of Thieme and Becker, but other artists were too little established or produced too few original works of their own, as opposed to copies, to be easy to document.

Collectors of Judaic art need not confine themselves to original works of art. There is no lack of prints from which to choose, most of them far less expensive than the output of the artists discussed above. Bernard Picart produced seven volumes of *Ceremonies and Religious Customs of the Various Nations of the Known World* in French and later in Dutch during the eighteenth century, the first volume of which covers Judaism and Catholicism. Many copies of this work have been plundered and the prints mounted and framed. Nineteenth-century reprints of the set are less expensive than the originals and are no less fine.

Later in the eighteenth century, Dutch and English print-makers depicted synagogues, Jewish personalities and ceremonial scenes with vigour and originality. Pedlars, the London-Jewish boxer Mendoza and political satires all appear in their work, which is of interest to serious collectors of Judaica mainly for its documentary content. Care is needed to see that the colouring is original, since

XXI Isidor Kaufmann, *The Chess Player*, oil on cradled panel, signed upper right, Isidor Kaufmann, Wien, 10¼ × 8½ in (26 × 21.5 cm).

XXII Isidor Kaufmann, *Portrait of a Rabbi in a Fur Cap*, on panel, signed lower left, 7⅛ × 6¼ in (18 × 16 cm). The painting shows Kaufmann's sensitivity to character and expression.

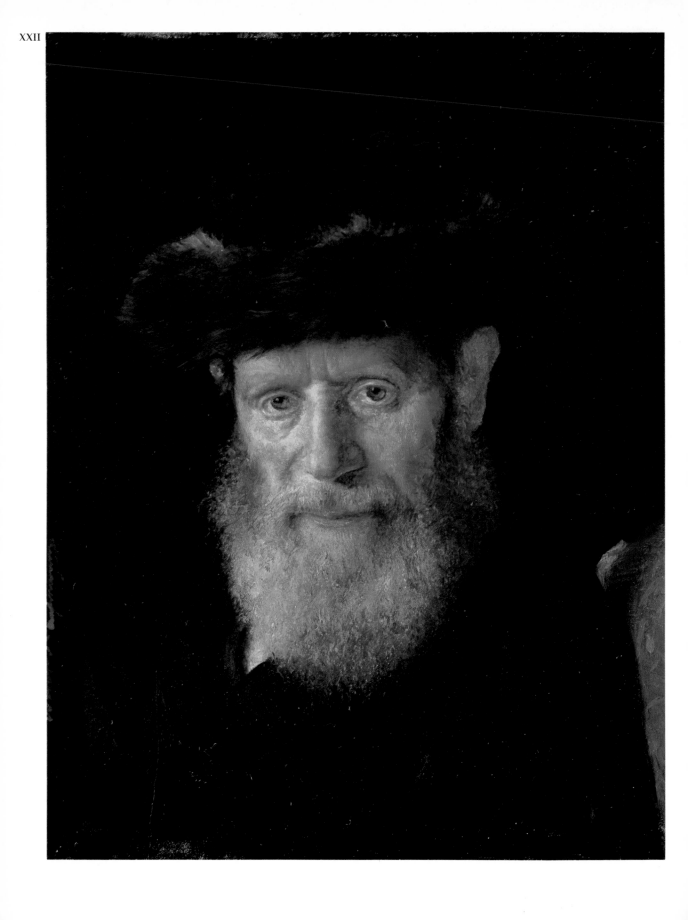

uncoloured versions are less valuable than others, and apparently genuine effects are not difficult to forge.

The second half of the nineteenth century saw an increased production in prints of Jewish interest which matched the greater output of paintings at the same time. A major artist of this category was Hermann Struck, an orthodox Jew from Germany who moved to Palestine after the First World War to teach in the Bezalel School, where he died in 1944. He worked in copper-plate etching, aquatint and lithography, capturing the psychological essence of his subjects in a powerful manner. Struck's long and productive career has left behind so many works that even good examples are not expensive, and these make a worthwhile addition to any collection. Each original etching should be signed in pencil and is usually numbered. They are dated on the plate itself. Unsigned copies are of identical quality, but are worth rather less.

Other artists roughly contemporary with Struck and also worth collecting include Joseph Steinhardt, Lazar Krestin and Joseph Budko. Ilya Schor also made some charming etchings and woodcuts, although he is more famous for his metalwork. These and other artists produced works which are distinguished for their quality and dignity, and which can be obtained for a fraction of the price one usually pays for oil-paintings, many of which are of frankly dubious quality and scarcely do credit to the taste and discrimination of their owners. The print is long overdue for rehabilitation as worthwhile art.

Perhaps less serious than prints, but just as interesting and often more entertaining, are the posters produced mostly in America for the immigrant population around the turn of the century, illustrating their fears, dreams and fantasies in the service of advertising. Passover *Seder* scenes are used to sell wine and tea; images of war are displayed to solicit charity for those left behind in Europe; and more lively designs are used to sell tickets for Yiddish theatre and concerts. These are very reasonably priced, as are the varied types of greetings cards and institutional letter-heads popular in the early twentieth century. Some pop-up examples are quite expensive, but all have the flavour of Jewish communal life, vividly portrayed at perhaps its most vital period. Much of this ephemeral material is to be found in business and personal archives that are now being discarded and destroyed as their owners retire and grow old. The preservation of such collections should be one of the dearest aims of anyone interested in Judaica and in the texture of recent Jewish history.

240

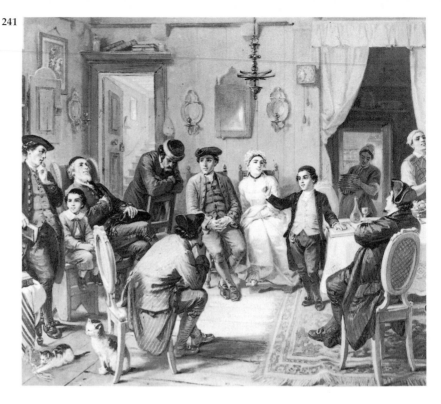

241

242

240 Continental School, *Painting of a Rabbi,* 18th cent., *H.* 4 in (10 cm) excluding frame.
This miniature on ivory depicts a Rabbi in Oriental or Sephardi dress, seated by a pillar indistinctly inscribed in Hebrew with a name. He holds a scroll containing the opening lines of the *Book of Genesis*. Depictions with Hebrew writing that verify the religious identity of the sitter are most uncommon at this date.

241 Print after Moritz Oppenheim, one of a series of 12, *c.* 1880, 6¾ × 5½ in (17 × 14 cm).
Oppenheim became famous for his paintings *en grisaille* – tones of white and grey – made specifically for reproduction. They depicted the idealized Jewish domestic life of the late eighteenth century, seen through the nostalgic eyes of an artist working half a century later. The idyllic depiction of a family amid traditional objects, such as the silver *Kiddush* cup on the table, made such works instantly popular, and they remain so today. Paintings by Oppenheim, who depicted a variety of specifically Jewish scenes, are rarely offered for sale. The prints, issued at various times through the mid- to late-nineteenth century, are widely available and make charming additions to any collection, since they show many of the objects treasured by collectors today actually being used.

242 Central European School, Jewish still life, late 19th cent., oil on board, 21 × 16 in (53.5 × 40.5 cm).
This painting, unsigned, is similar in style to the work of Alois Priechenfried and his followers. The appearance of Jewish articles, a prayer shawl and a *Streiml* (the fur hat worn by Hassidim) without people is rare.

243

243 Isidor Kaufmann, *View of Gutshof in Neubadt, Slovakia,* signed and dated 1916, with dedicatory inscription in German, oil on cradled panel, 15½ × 12 in (39.5 × 30.5 cm).
A seemingly typical Kaufmann, from relatively late in his career. This is nevertheless one type of painting he worked on when not painting traditional Jewish subjects – views of the countryside around Vienna. The palette is quite light, with tones of grey and mauve.

244 Saul Raskin, *View of Synagogue Interior in S'fad,* pastel and watercolour on paper, signed lower right, dated 1923, titled in Hebrew, 20 × 24 in (50.75 × 61 cm).
Raskin, an American, spent some time in Palestine early in his career, painting famous Jewish sites and genre scenes. The subject is rendered in pink and purple, giving an ethereal quality to this synagogue, located in the traditional centre of Jewish mysticism, the town of Safed in Galilee.

245 Mané-Katz, *Supplication,* gouache on paper, 12 × 16 in (30.5 × 40.75 cm).
Mané-Katz does not regularly feature in Judaica sales, as he has been adopted by the broader collecting public. But when the subject is specifically Jewish his work cannot be excluded from Judaica collections. Here the artist successfully depicts a powerful image in a few broad strokes.

244

245

246 Leopold Pilichowski, *Two Jews Praying on the Day of Atonement*, oil on canvas, signed, 20 × 21½ in (50.75 × 54.5 cm).
Pilichowski (1869–1933), a Polish Jew who settled in England, painted several versions of this theme. This piece is a study or detail taken from the larger version, which depicts a crowded synagogue interior with these figures in front, serving as the composition's focal point. His powerful style captures the emotional and spiritual turmoil of the worshippers on the most solemn day of the Jewish year.

247 Indo-Persian painting, one of a pair, oil on canvas, mid-19th cent., 20 × 16 in (50.75 × 40.75 cm).
The illustrated example depicts Moses with his attributes. The companion piece shows Aaron, the High Priest. Moses is painted on a flower-strewn ground, holding the Tablets of the Law. He stands below a Star of David under a Persian crown, held by two cherubim with distinctly Persian faces. The figural iconography is typical of Persian religious art in general, so it is possible to trace such borrowings as they appear in Jewish art of the region. These pieces were probably meant for use in a synagogue or religious building.

248 S. Shurtzman of Safed, *The Story of Esther*, gouache on paper, signed in Hebrew, 26½ × 17½ in (67.25 × 44.5 cm).
Shurtzman works in the style of Shalom Moskovitz of Safed, his better-known contemporary. The naive style is appealing, and the story it tells, built up in several registers, is reminiscent of Russian icons. Such work presents biblical and other religious subjects in a pleasing, light way, and is popular with collectors.

249 Bernard Picart, one of 13 etchings, from *Cérémonies et Costumes réligieuses*, Amsterdam, 1725, image size 8¼ × 6 in (21 × 15.25 cm).
Picart's etchings are from one of seven volumes dealing with the religions of the world. The Jewish and Catholic religions are discussed in the first volume, which, if sold alone, costs as much as the entire set. Often the plates are cut out and framed. They offer a fascinating glimpse of Jewish life and ceremony at the time, including details of some ceremonial objects.

250 Hermann Struck, *Skizzen aus Russland*, a portfolio of prints, executed 1919–20, 16 × 12 in (40.75 × 30.5 cm). These early works of Struck, a German Jew working at this time for the Prussian army, document Jewish life in Western Russia. His sensitivity to the subject matter, and the resulting psychological insight for which he was later famed, is already evident. Struck was one of the masters of the etching process in this century. Never a popular artist, his work can be purchased for quite modest prices.

Old Clothes to sell?!

251 *Old Clothes to Sell*, coloured print, English, *c.* 1810–20, approx. 7 × 5 in (17.75 × 12.75 cm).
The 'Old Clothes Man' figures prominently in English topical prints and literature of the late eighteenth and nineteenth centuries. It always depicts a Jew, probably of German or Eastern European origin, in dress ranging from the traditional to the outlandish, and in a variety of English urban and rural settings. In this example the caricatural elements have been kept to a minimum and attention has been paid to the neutral depiction of the participants.

252 Anna Tikho, etching, 16 × 12 in (40.75 × 30.5 cm).
Anna Tikho depicts the country around Jerusalem in
this series of etchings. The feeling of a parched, sun-
baked landscape is achieved with great attention to
detail.

253 L. Reiss, *Lublin Ghetto,* charcoal on paper, 20 ×
15 in (50.75 × 38 cm).
Another sombre view of Jewish life in Poland before
the Second World War. As a record of *shtetl* life such
sketches are invaluable, although their dark qualities
may not appeal to all collectors' tastes. The quality of
the work is excellent, and such a piece would be
particularly appropriate for a museum, synagogue or
other institution.

THIELMANN: AUS DER SYNAGOGE.

254 W. Thielmann, *Aus der Synagoge,* set of 10 prints,
with foreword by Dr A. Sulzbach in portfolio,
Frankfurt-am-Main, *c.* 1900, 9 × 12½ in (23 × 31.75 cm).
This Thielmann series does not appear for sale often; it
offers an interesting and well-executed glimpse of
German-Jewish life at its high point. Here the Rabbi or
cantor is lighting the *Hanukah* lamp in the synagogue.
The remainder of the work concentrates on other
dramatic moments in the synagogue ritual throughout
the year.

255

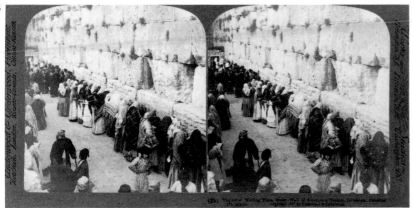

255 Stereoscoptic views of the Holy Land, American, late 19th cent., 6½ × 3 in (16.5 × 7.5 cm).
These views were presented side by side to achieve a three-dimensional effect when viewed through the special stereoptic device supplied. Sets were to be found in every home across Europe and America. Views of the Holy Land depicted points of Jewish, Christian and Moslem interest, so were probably meant for travellers of all religions. They offer the collector of Judaica many interesting points of comparison between the photographs and the Holy Land views depicted in paintings, prints, textiles, silver and other media.

256

שניאור זלמן

256 Micrographic print of Rabbi Schnur Zalman, copyright 1924 by Nathaniel Chasin, Washington DC, approx. 18 × 12 in (45.75 × 30.5 cm).
Such prints were based on hand-written originals in which biblical and other religious texts were written out to form a portrait of a spiritual leader. They were popular from the late nineteenth century. The art of micrography goes back even further, having originated in the Middle Ages. Original micrographic works occasionally appear for sale. Their value far exceeds the few hundred dollars which a reproduction print such as this might command.

257 French election poster, lithograph on paper, *c.* 1889, 55 × 39 in (139.75 × 99 cm).
An example of the anti-Semitic material often printed during the nineteenth and twentieth centuries. This example attests to the precarious status of Jews in France, which culminated in 'L'Affaire Dreyfus'. It depicts 'Frenchmen' dominating the 'Jews' depicted in the centre. The 'Talmud' on the ground presages the virulent racism that became persistently stronger throughout Europe, resulting in large emigration to America, Britain and elsewhere.

257

258 Chromolithograph of the Passover, American, early 20th cent., approx. 16 × 24 in (40.75 × 61 cm).
Probably based on a commissioned work, this piece depicts Russian immigrant families at the Passover ceremony. The costumes, faces and furnishings are all evocative of the period, and are charming, warm-hearted documents of a brighter moment in the difficult life of the recent arrivals to the new land.

258

XV

Marriage

Despite the crucial role that marriage plays in Jewish communal life, it is less a sacrament than a contractual agreement between a man and a woman and their families. Special attention is paid to the legal rights of the wife. A contract, signed by the bridegroom and two witnesses, known in Hebrew as a *Ketubah*, is given to the brother of the bride to ensure her financial protection. The traditional *Ketubah* demonstrates Jewish sensitivity to the status of women long before most other communities became aware that male dominance should be limited in any way. The document itself follows a formula established by Jewish Law centuries ago. But important personal details find their way in: the exact date of the wedding; the city in which it was held; and the name of the bride and groom are all included. Then, besides the formal promises of support and devotion, there is often a list of *Tana'im*, 'conditions' covering special dowry arrangements, provision of housing and other material matters.

Many *Ketubot* are now of interest only for this ethnographic information. All Jewish communities use *Ketubot* in one form or another, so varied collections can be built up of examples drawn from every continent in the world, and from most periods since the Middle Ages. But we will focus here on the two most popular sources from an artistic point of view: Italy and Persia.

Italian scribes and illuminators produced the finest surviving marriage contracts. Written usually on fine parchment or vellum, they have exquisitely decorated borders. Wealthy communities in Venice, Rome, Padua, Mantua and Ancona commissioned decoration in styles specific to their city and time. Dates are provided in the course of the text, so each *Ketubah* provides excellent evidence for the dating of its decoration. There are of course many problems:

some contracts have been trimmed, perhaps because the owners wished to re-use the decoration on a new document. It is sometimes worth collecting fine decorations, even when the texts have been replaced. Many fine examples have fallen victim to damp and flooding, and some of these have been further damaged by clumsy restoration and overpainting. Other specimens are complete re-fabrications, painted in the style of an older but poorly preserved example. New painting feels stiff, the colours are wrong, and the text is poorly written. Compare these with authentic examples and you will soon come to recognize the over-restored ones. It is advisable to consult an independent expert when large sums are at stake, since seventeenth-century documents in good condition are valuable enough to be worth forging. Many lovely *Ketubot* of the early nineteenth century, however, are far more reasonably priced and are therefore not generally faked. In some workshops, such as those of Ancona, decoration remains remarkably consistent through the eighteenth and into the nineteenth centuries, showing only a gradual decline in quality. The collector with limited funds will therefore lose little by buying a later and cheaper example.

Turning to the Near East, the most interesting examples are from Persia, where Isfahan developed its own distinctive style. The documents are on paper, perhaps because skin was too expensive, and they are attractively decorated in panels of birds and flowers arranged in a carpet-pattern. There may also be two rampant lions from whose back the sun rises, each of the yellow circles being painted with a human face. Most examples date from between 1850 and 1930 and their value depends mostly on their age. They are invariably colourful and large, although some creasing and perhaps even slight tears along the folds are to be expected in the older examples.

Jewish ceremonial marriage rings from Italy, Germany and the Near East were intended for ceremonial use only. They belonged to a community or family which lent them for the bride's use on her wedding day.

Italy produced the loveliest examples, of gold and enamel. The classic type, which emerged in Venice during the sixteenth and seventeenth centuries, is a broad band, chased and enamelled all round. On top is a pitched roof, usually hinged, which opens to reveal the Hebrew words *Mazal Tov*, 'Good Fortune', or its Hebrew initials. The older examples tend to be in medium-weight metal of fairly thin gauge, and to include some filigree. The gold is particularly pure and soft, so the ring will be bent and dented from

use. The enamel will also show signs of wear, and in places may be missing. For this reason a pristine example should be treated with suspicion. The rings are unmarked, except for later control stamps which are generally a reliable sign of age when all the other elements look authentic. Copies, on the other hand, may have modern gold marks such as '750' or '18K' inside the band. Another popular Italian type, made in the seventeenth century, consists of a broad band with twisted wire borders to which decorative circular bosses have been applied all round. The interior often bears the inscription *Mazal Tov*. Sometimes a small plaque with these words appears among the bosses.

Marriage rings are found in single, double and even triple widths, with the same motifs repeated. It is harder to identify them when there is no enamelwork, but the rather uneven filigree details and the wear to the goldwork will be comparable to those described above.

Marriage rings from other sources are rare. German craftsmen produced some tower-form rings at an early date, using styles found in spiceboxes, and resembling Central European towers of the late Middle Ages. These silver and bronze rings are dated to between the fourteenth and seventeenth centuries, but so little is known about them that even genuinely old ones are hard to date with certainty. Some North African examples are also known, which are usually of silver or silver-gilt, and are based on Italian models. Broad bands are surmounted by pyramid-shaped towers, often of granular composition. Dates are given from the eighteenth or nineteenth centuries, and the workmanship and degree of wear seem to confirm this assumption.

The marriage rings you are most likely to find, however, are forgeries. Some small examples are of solid gold, although most are silver or silver-gilt. The latter are quite large, and measure between 2 and 4 inches (5 and 10 cm) in height, including a thick ring attached to an elaborate, tower-like upper section composed of several turrets. This part accounts for more than three-quarters of the object's height. The outside is sometimes engraved with Hebrew inscriptions, including traditional wedding quotations as well as fictitious names and dates. The roof of the turret is hinged and opens to reveal miniature models of a table with a *Torah* scroll, a ceremonial cup, or a pair of gold wedding rings. These extraordinary confections are of cast metal, and despite their faults still command quite high prices. They are certainly attractive possessions, provided you do not delude yourself that they are old.

An additional ceremonial object sometimes used for marriages is a pair of wedding belts intended to be worn by the bride and groom and connected during the ceremony. Known as the *Sivlonot gertel*, they were most popular in Germany during the sixteenth and seventeenth centuries. They are usually of silver or gilt and are made up of massive links, elaborate buckles and circular rings applied at intervals. Most belts were made by non-Jewish craftsmen for use as adornments. Only when a Hebrew inscription or Jewish symbol appears can one be certain of its use for Jewish weddings. Since the price of a Jewish example is so much higher than that of a non-Jewish one, care should be taken to check the authenticity of the engraving. The belts themselves are often marked, so their date and place of manufacture can be traced without difficulty. But many genuine examples are not marked, so you will have to rely on your knowledge of provincial craftsmanship.

Belt buckles also were made in the Near East for use at wedding ceremonies. Like the German examples, many would have been made for non-Jewish use and would only later have been adopted by Jews. Distinguishing those that have simply been 'improved' at a later date by having an inscription added is difficult, since the craftsmen of Turkey and Afghanistan are conservative in their tastes. But Jewish or not, the buckles make fine decorations.

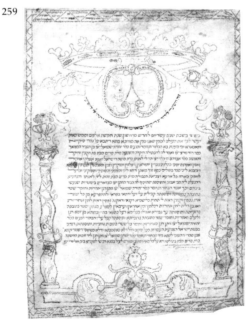

259

259 Italian parchment marriage contract, Modena, dated 10 Marcheshvan 5510 (1750), uniting Yehudah Shemuel ben David Nursi with Miriam bat Avraham Halevi.
This contract is unusual for its micrographic decoration, which is here in more than one colour. It forms the whole design, including the coats of arms in a crowned double cartouche at the top.

50

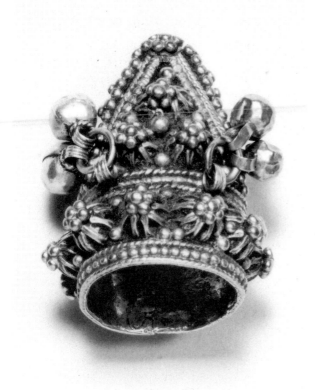

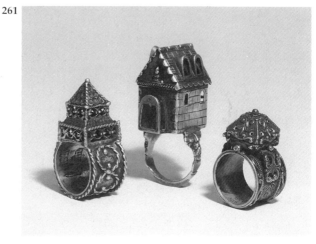

261

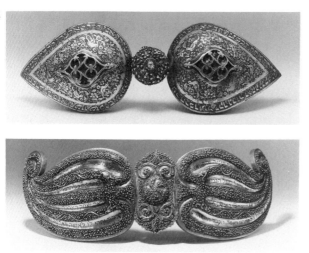

260 Near Eastern silver wedding ring, 18th–19th cent., *H.* 1⅞ in (4.75 cm).
Such rings are obviously modelled on earlier Italian pieces. Compare this example to the one on the left in colour plate XXIV which is similar, though without the painted section and the bells, which are borrowed from indigenous Near Eastern jewellery. Very little is known of this type of ring. Collectors cautiously prefer to pay modest sums of a few hundred dollars until more is known.

261 Three silver marriage rings, 20th cent., *H.* of the largest 2½ in (6.5 cm).
Although these are replicas of earlier rings, they are among the more attractive examples of their kind. Others are included in the chapter on forgeries, but the better specimens deserve to be seen as works of art in their own right. The words *Mazal Tov* are engraved inside the bands of the rings appearing to the left and the right.

262 Near Eastern silver marriage buckle, probably Persian, 19th cent., *L.* 9 in (23 cm).
The twin paisley-form sections are engraved with Hebrew inscriptions enclosing finely worked bird and flower motifs, typical of Persian silver of the period. Such buckles were worn by the groom at the wedding ceremony in Near Eastern countries.

263 Near Eastern parcel-gilt silver and niello marriage buckle, possibly Afghan, 18th cent., *L.* 12 in (30.5 cm).
A very elaborate piece, finely chased and applied with granulation. The Hebrew inscription is from the *Song of Songs*, a common source for marriage-related pieces. It is difficult to trace the engraving of such pieces to their place of manufacture and date of origin, but this piece looks sufficiently good to be authentic.

195

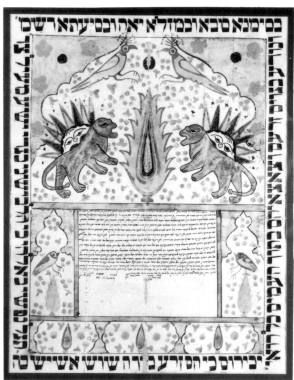

264 Indian parchment marriage contract, Cochin, dated 1939, 12 × 16 in (30.5 × 40.75 cm).
Written in purple ink, the layout represents a heavenly body on the horizon, in a simple but bold design. Documents relating to this community are particularly interesting, as it was largely dispersed between the end of the Second World War and the founding of Israel. The recent date of this piece will keep the price low enough to appeal to any collector.

265 Persian paper marriage contract, Isfahan, dated 1914, 20 × 20 in (50.75 × 50.75 cm).
A popular piece, deserving a place in any broad collection. Isfahan contracts are collected for their decorative and attractive use of colour. They invariably include, as here, lions, suns, exotic birds and flowers. They commonly range in date from the mid-nineteenth century to the 1930s, with minor variations of quality. Prices range from $1500 for early varieties to about $500 for twentieth-century examples.

266 Persian paper marriage contract, Teheran, 1854, 13 × 24½ in (33 × 62.25 cm).
The colourful illumination of this example resembles decorative patterns popular in the Islamic arts of the period.

267

267 Three pieces of gold jewellery, 19th–20th cent., *H.* of bracelet 1⅝ in (4 cm).

On the left is a Victorian 'Mizpah' ring, London, 1874. Favoured not only by Jews, such rings, and similar brooches as well, were based on that Hebrew word, commonly translated as 'May the Lord guard us whilst we are separated one from another'.

The piece in the centre is a modern gold bracelet, in two colours of 18 carat gold, bearing the Hebrew woman's name 'Bracha', which also means 'blessing'.

On the right is an Italian gold and enamel marriage ring, made recently in seventeenth-century style. It is a good reproduction, the 'tower' opening to reveal the Hebrew word *Shaddai* ('The Eternal One'). The band is engraved on the outside *Mazal Tov.* It has modern gold marks.

268

268 Yemeni silver, amber and coral necklace, 19th cent., *L.* approx. 20 in (50.75 cm).

Necklaces such as this were made by Jewish Yemeni silversmiths, and would have been used throughout the region by Jews and non-Jews alike. The lower tubular case is hollow. These are often found to contain a manuscript amulet. If the scroll is in Hebrew one can be sure that the example is Judaic.

269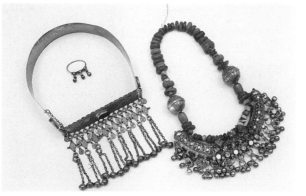

269 Two Near Eastern bridal headdresses, late 19th cent., *W.* of each band approx. 6 in (15.25 cm).

The example on the left, with its matching ring, is of a type worn over the forehead by Jews as well as non-Jews. There is a Hebrew inscription on the reverse that points to its Jewish origins. A carnelian is set in the centre. The example on the right is composed of amber and silver beads.

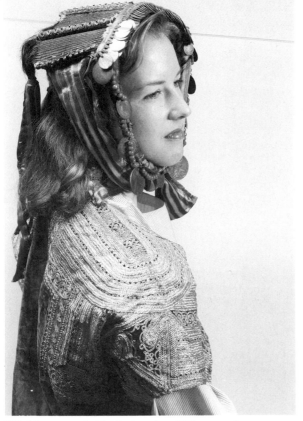

270 Moroccan bridal jacket, late 19th cent., *L.* approx.
30 in (76.25 cm).
The jacket is of green velvet, applied with gold metallic
thread. The decorative patterns used here occur in
other media, including metalwork, as well as on fabrics
such as prayer-shawl bags.
 Moroccan bridal headdress, 18th-19th cent., *W.*
approx. 12 in (30.5 cm).
This piece is composed of silver and of enamelled
strips coloured in orange and green, favourite colours
of the region. The body consists of tightly wrapped
horsehair woven inside metal strips. The front is hung
with a variety of coins, including examples in gold,
silver and copper.

271 Yemeni silver necklace, 18th-19th cent., *H.* 4½ in
(11.5 cm).
Delicate work of this kind, with linked plates, drops
and bells, would be worn by a bride under her chin.

XXIII Artur Szyk, *The Hagadah Shel Pesach,* 48
watercolours, 1935–6, 11 × 10 in (28 × 25.5 cm).
Szyk excelled at both calligraphy and painting. His
scenes capture the whole world of Jewish Poland.
The watercolours sold for $209,000 in 1982.

XXIV Three gold marriage rings.
TOP LEFT: Italian, 16th cent., *H.* 1½ in (3.75 cm). An
exceptionally fine example.
TOP RIGHT: Italian, 17th cent., *D.* 1¼ in (3 cm).
BELOW: Italian, early 17th cent., *D.* overall 1³⁄₁₆ in
(3.5 cm).

XXV Italian illuminated parchment marriage
contract, Mantua, dated 7 Tishri 5426 (1666),
uniting Yehoshua ben Yitzhak Mahalalel Nursi
and Hava bat Moshe Gentili.

XXVI Italian illuminated parchment marriage
contract, Rome, dated 14 Tishri 5543 (1783),
uniting Shabbati ben Avraham Fino and Patienza
bat Jacob Torazino. The pointed base is typical of
Roman marriage contracts. It has a micrographic
border.

XXVII Italian illuminated parchment marriage
contract, Vercelli, dated 4 Sivan 5560 (1800),
uniting Samuel Haim ben Yitzhak Shlomo Lublin
and Simcha Malkah bat Rafael Yehuda Jacob
Trevish. The upper and lower cartouches enclose
family crests.

XXVIII Italian illuminated parchment marriage
contract, Turin, dated 1 Adar Sheni 5535 (1775),
uniting Menachem ben David Todro and Leah bat
Joseph Grigo. It includes secular and biblical
scenes, and a springtime landscape reflecting the
date of the marriage.

XXIX Italian illuminated parchment marriage
contract, Ferrara, dated 1 Adar Sheni 5567 (1807),
uniting Benjamin Shlomo ben Mordechai Shalom
Hezekiah Pizzaro and Grazia Simcha bat David
Ha-Cohen. The Cohen crest shows hands raised in
priestly blessing.

XXX Italian illuminated parchment marriage
contract, Casale Monferrato, dated 1 Adar Sheni
5532 (1772), uniting Meir ben Yochanan
Shelomoh, called Yonah Zalman, and Zipporah
bat Shimon Chaim Levi Morillo. The two family
crests are on the upper corners.

XXXI Italian illuminated parchment marriage
contract, Rome, dated 30 Tishri, Rosh Chodesh
Marcheshvan 5642 (1882), uniting Shabbatai ben
Eliezer Efrati and Channah bat Gershon Makkai.

XXXII Near Eastern illuminated parchment
amulet, 19th cent, *H.* 12 in (30.5 cm). Two braided
bands enclose florettes around the name of God.
Hebrew inscriptions are written in a *Menorah* form.

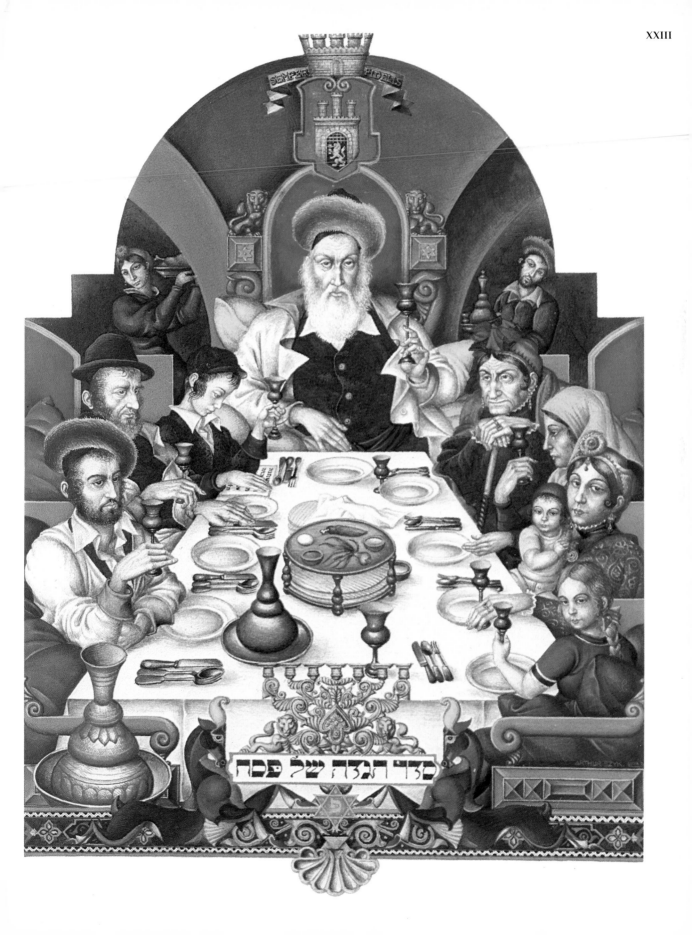

SEMPER FIDELIS

סדר הגדה של פסח

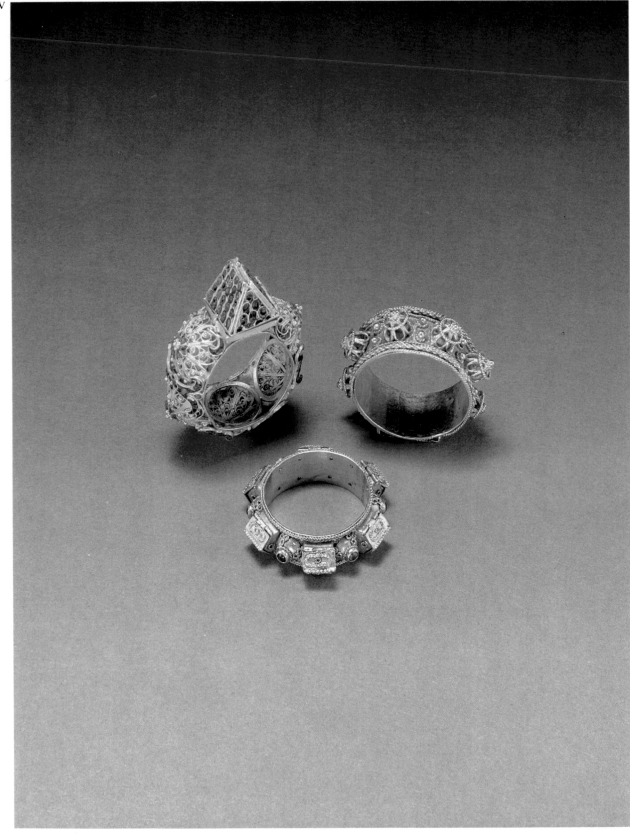

ברביעי בשבת ארבעה ימים לחדש סיון שנת חמשת אלפים וחמש מאות ושש'ים לבריאת עולם
למנן שאנו מנן פה ורצילילי מתא דתבא על נהר סירטו וסידזיא הבחור היקר והמשכיל שמואל חיים
יצו בן הקצין המפואר יצחק שלמה לבלין יצו אמר להדא בתולתא היקה והצנועה שמחה
מלכה בת הק' המפואר רפאל יהודה יעקב טריויש יצו הוי לי לאנתו כדת משה וישראל ואנא
אפלח אוקיר איזון ואפרנס יתיכי נהלכות גוברין יהודאין דפלחין מוקירין זנין ומפרנסין ית נשיהון
בקושטא והיבנא ליכי מהר בתוליכי כסף זוזי מאתן דחזו ליכי מדאוריתא ומזונכי וכסותכי וספוקיכי
ומיעל לותיכי כאורח כל ארעא וצביאת מ' שמחה מלכה מנבה בתולתא דא והות לה לאנתו ודא נדוניא
דהנעלת לה מבי אבוה סך עשרים לט' כ"ץ מלבר כולבוש ה תכשטטיה וצעיפיה השייבים לגופה וצבי
כ' שמואל חיים לבלין יצו חתן דנן הנל והוסיף לה מדיליה סך עשרה ליט' כ"ץ כהיכי דליהוי להנן כתובה
דא נדוניא ותוספתא סך שלשים ליט' כ"ץ מלבר מדבושיה תכשטטיה וצעיפיה הנל כל וכך אמר אסר לנא כ'
שמואל חיים לבלין יצו חתן דנן הנל אחריות וחומר שטר כתובה נדוניא ותיספתא דא
עלי ועל דתאי בתראי לותהפרנא מן כל שפר ארג נכסין וקנין ראית לי תחות כל שבניא וקנא
ורעתיד אנא למקני נכסין דאית להון אחריות ואנבי וזלית להון אחריות כלהון יהון אחראין ערבאין
ומפותקאין למזפרע מנהון שטר כתובה נדוניא ותוספתא דא וצבילין מן גלימא דעל כתפאי בין ב
בחיי בין במותא חו מן יומא דנן ולעלם ואחריות וחומר שטר כתובה נדוניא ותוספתא דא קבל
עלוי כ' שמואל חיים לבלין יצו חתן דנן הנל כאחר ותוקמר כל שטר כתובות נדוניות ותוספתות
דנהוניג ובישראל העשוים כתיקון חכל דלא כאסמכתא ודלא כטופסי דשטרי וקנינא מיד הבחור היקר
והמשכיל שמואל חיים יצו בן הק' המפואר יצחק שלמה לבלין יצו חתן דנן הנל ליד חכמת הכבודרה
כלהון מ' שמחה מלכה מנבה בת הק' המפואר רפאל יהודה יעקב טריויש יצו בתולתא דא ובכ יא-
על כל מאי דכתיב ומפרש לעיל במנא דכשר למקנאביה והכל שריר וקים

[חתימות]

מצא אשה מצא טוב

יהי
מקורך ברוך ושמח מאשת
נעוריך

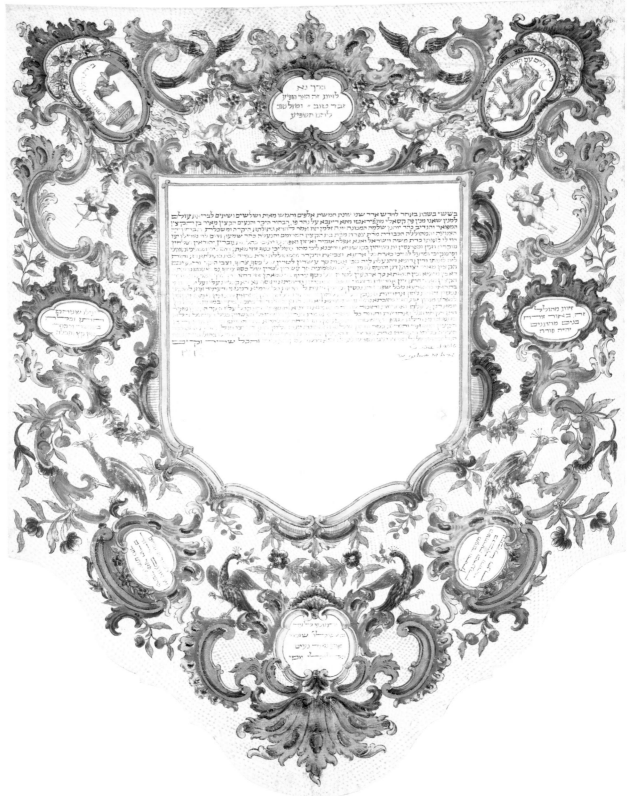

XVI
Amulets, Mezuzot, Teffilin and Watches

Magic amulets or charms are mentioned by Rabbis in the *Mishnah* and *Talmud* written 2000 years ago. They treated them with complete seriousness as instruments for intervening in the natural course of events. The user hoped for good fortune or health, in exchange for wearing this holy symbol or document. Amulets usually include inscriptions, such as Hebrew prayers, single words, or letters and emblems, to provide protection for travellers, for the ill, for pregnant women or for young children. The gold necklace charms so often worn today, featuring the word *Chai* ('Life') or a Star of David, are an integral part of this tradition.

Amulets fall into three broad categories. In most examples the inscription or symbol appears on a plaque of silver or gold. In others it is written on parchment or paper, and is enclosed in a special case of precious metal. Sometimes it is hung round the neck in a small cloth sack. The metal examples are the easiest to find, most attractive to display, and therefore of most interest to the collector.

Such talismans are popular around the Mediterranean and in the Near and Far East, where they are used also by the non-Jewish population. The few German amulets that survive are so tiny that they are rarely marked, which makes it difficult to trace the date and provenance of a piece. It is often the calligraphic qualities of the Hebrew script that are the best aid to identification.

Italian craftsmen produced the most attractive European amulets. They date from the seventeenth and eighteenth centuries and were made in and around Venice. Their maker and town marks need to be checked carefully for forgeries. The amulets are usually quite large, around 4 inches (10 cm) in height. They are in the shape of elaborate cartouches, decorated on both sides with embossed

decoration in high relief, which includes scrolls, grape clusters, crowns, beasts, Hebrew letters which are often applied, and motifs such as the Decalogue, Aaron's mitre and censer, and a *Menorah*. This elaborate container holds a parchment scroll with a short Hebrew text. The case needs to be openable so that this can be inserted. Early examples have an elaborate door or lid skilfully concealed behind a decorative motif, while in some cases the two halves are detachable. These early examples are made of fairly thin-gauge metal, either gold or silver, and sometimes gilt. Copies tend to be cast, so the metal is heavier and the detail far less precise. Since it is difficult to provide an opening, this is often omitted in copies, making nonsense of the amulet because to the original wearer it was the scroll inside that was of primary importance. Smaller Italian examples are made of filigree, and specialist knowledge is essential for dating them. Many have a Divine name applied to the centre, but take care that the wear and patina to the letters is the same as to the rest of the piece, or it may be a forgery.

The vast majority of available amulets were made in the Near East, and particularly in Persia. Craftsmen worked mostly in silver, but also in gold, base metal and stone. As with most metalwork from this region, precise dating and identification of provenance are often impossible, although most date from between the eighteenth and the twentieth centuries. The best indications of age and origin are the overall wear and the quality of the engraving. There has been some copying, but this mostly involves legitimate reproduction of early pieces, rather than deliberate attempts to deceive. Prices of these pieces have never been as great as for European ones, so the temptation to forge them is smaller. They come in a variety of types, but most are pendants. These may be square, round, rectangular, scalloped, cartouche or pear-form and so on. Many were part of whole necklaces. Others are curved in profile, to be worn on an arm at the wrist or above the elbow. Many of the Hebrew inscriptions are either illegible or contain unintelligible repetitions of magic names such as 'Joseph ben Porat' – a particularly common talismanic inscription in Persia. Some are very attractive, incorporating birds and foliage in their design. There is a considerable literature on Near Eastern amulets, explaining their texts and uses. The *Encyclopaedia Judaica* gives a good bibliography.

Two of the most important objects of everyday Jewish life are closely related to the amulets described here. They reach back to

the earliest antiquity and still today have considerable symbolic power. One of them is the *Mezuzah,* or doorpost amulet, and the other is the pair of *Teffilin* or phylacteries – the blackened leather cases containing biblical texts which Jewish males tie to their head and left arm for morning prayers. The *Mezuzah* and *Teffilin* derive from the principal declaration of Jewish faith, used at most services, taken from *Deuteronomy* 4: 4–9, and called the *Shema.* Jews are commanded in this text to bind the Law of God 'on your doorposts and on your gates', and 'as a sign upon your hand, and as frontlets between your eyes'. To fulfil this, the text in question was written on parchment by a scribe and fixed to the right-hand post of every door as you enter. *Mezuzah* boxes are long and narrow, 2–6 inches (5–15 cm) in height. Fine *Mezuzot* from before the nineteenth century are rare. Most surviving cases are of wood or silver and come from Poland or elsewhere in Eastern Europe. The elaborate silver ones in particular have been widely copied by making casts. Some have modern marks which should help the buyer. Portuguese examples are usually well stamped. Many are quite simple with a minimum of carved decorative foliage. In North Africa, particularly in Morocco, embroidered flat pouches are used to fix the *Mezuzah* scroll to the door. A Hebrew inscription is worked, often in metallic thread, onto the front, and there is a long, narrow niche in the back where the scroll is inserted. The inscription on the front often includes a woman's name and is sometimes also dated.

Teffilin consist of the same text as the *Mezuzah,* together with some similar ones mentioning the same commands, contained in two leather boxes with a loop on one side through which a strap passes, for fixing them to the forehead and the left arm, as the Bible prescribes. The boxes are sewn closed and then blackened to protect the delicate parchment from wear. They are treated with special respect and worn for weekday morning services. Sizes vary with the date and place of origin. Eighteenth-century pairs seem to be the smallest, although miniature travelling sets are still made. The largest are of the late nineteenth century. The boxes of the smallest may be ½ inch (1 cm) across, and the largest 2 inches (5 cm) across. Those made today are slightly smaller than these large ones. Additional leather or metal cases were made to protect the boxes when they were not in use. Silver boxes were made primarily in Poland, decorated with simple foliage or with more elaborate eagles, lions, stags and so on. The cases should have silver marks, and they usually date from between the late eighteenth

and the late nineteenth centuries. A good pair of early-nineteenth-century boxes with elaborate decoration and interesting inscriptions can attract a high price. Be sure that if they form a pair, one is for the arm and the other for the head. They are generally inscribed or initialled in Hebrew to indicate which is which. Similarly, the decoration may be varied in order to differentiate them. Quite simple versions exist for those who wish to spend less on their collection, and tin or tooled leather examples are quite common.

Watches with Hebrew dials date back to the eighteenth century, although most available examples date from the end of the nineteenth or the beginning of the twentieth centuries. These white-metal pocket watches have open faces, Hebrew lettering painted on porcelain dials, and stamped portraits of Moses and the Decalogue on the backs. Some higher-quality Swiss pocket watches and wrist-watches were made in the 1920s and 1930s with attractive Art Déco styling. Most are in gold-filled cases. Small mantel-type clocks are also known, with a watch movement and a Hebrew-numeral dial set in a bronze case between pillars. The cases are variously decorated with lions, the Decalogue, a Star of David, and even with a small portrait medallion of Herzl. These clocks were made in Vienna from the late nineteenth century until the First World War. The earlier ones have a dark patina and are well cast and finished. Later ones tend to be coarser. In many examples the base is fitted with a musical movement.

275

272 Italian silver amulet case, probably Venice, unmarked, 18th cent., *H.* 3½ in (9 cm).
These early amulet cases are occasionally unmarked, as is this. The style is much copied, so it is important to be cautious. Many of the copies are carefully marked as well, so the only secure criterion of age is quality. Early examples are generally light and three dimensional in look and feel, with bold embossing, and with good and complex matting. The front and the back usually unscrew. The thread will be handmade and turned, as are all old screws.

273 Venetian parcel-gilt silver amulet case, 18th cent., *H.* 4 in (10 cm).
Similar to the preceding amulet case, but of a type more commonly faked. The applied elements of candelabrum, Decalogue, mitre and censer were cast separately.

274 Continental parchment manuscript amulet, 18th cent., approx. 4 × 4 in (10 × 10 cm).
Pieces like this were commonly folded and placed inside silver cases for protection.

275 Group of Near Eastern silver amulets, probably Persian, 18th–19th cent., *H.* of top left example 3 in (7.75 cm).
Amulets like these have survived in great numbers, bearing various Hebrew inscriptions to provide health, to avoid the 'evil eye', for help in childbirth, and so on. The age is best determined by the quality of the inscription and by the wear.

276

276 Egyptian or Syrian silver-inlaid brass box, late 19th cent., *L.* 3½ in (9 cm).
The Hebrew words on this piece are often found on Near Eastern amulets and objects, and are a name, Joseph ben Porat. It is often repeated on such pieces, to increase the efficacy of the charm.

277 Syrian or Balkan silver- and copper-inlaid brass wall plaque, 18th or 19th cent., 10¼ × 8½ in (26 × 21.5 cm).
Inlaid brass plaques like this one are generally Syrian or Egyptian. This piece is unusual for its fine workmanship and European motifs; the lions, birds, deer and especially the double-headed eagle, seem to be borrowed from Polish-Jewish iconography. A Balkan origin would explain the combination of Syrian technique and Polish design.

278 North African silver and wood *Mezuzah* case, 18th or 19th cent., *H.* 10 in (25.5 cm).
The wooden case is covered with a thin sheet of silver, which has been worked in relief with traditional symbols including a *Menorah*, a laver, a basin and an altar. The reverse is hollowed out to hold the parchment scroll. A charming piece, different from European *Mezuzah* cases.

277

278

279

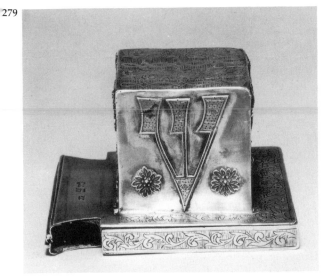

279–281 Russian silver *Teffilin* cases, Zhitomir, 1868, assay-master A. Arzhannikov, Master ZTP in Cyrillic, untraced, 3½ × 4 in (9 × 10 cm).

These are among the most elaborate *Teffilin* cases extant. Traditionally made for the son of the Ruzhiner Rebbe, a noted Hassidic spiritual leader, they are decorated with a variety of techniques and motifs, including elaborate engraved bands, applied Hebrew letters, and grapevine motifs. The base of one has a Hebrew inscription, and the other a running stag. It is not unusual to find different decorations on each of a pair, as this helps differentiate the arm piece from the head piece. These ones are particularly large.

280

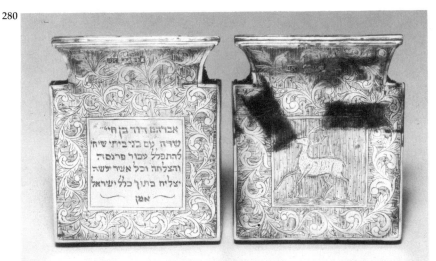

אברהם דוד בן חיי'
שריה עם בני ביתי שיחי
להתפלל עבור פרנסה
והצלחה וכל אשר עשה
יצליח בתוך כלל ישראל
אמן

281

282 Continental silver *Teffilin* cases, unmarked, probably Polish, early 19th cent., *H.* 2½ in (6.5 cm). Embossed cases are rare. Both of these are engraved in Hebrew with the owner's name, 'Yehoshua ben Ari', and they are differently decorated to differentiate the arm piece from the head piece.

283 Italian parcel-gilt silver-covered prayer book, Venice or Padua, maker or assay-master's mark a tower flanked left by '2' and right by 'C', *c.* 1650–1700, *H.* 7½ in (19 cm).

This fine binding, worked in high relief with scrolls, flowers and fruits on a matted ground, is typical of the robust silverwork found in Italy at the period, and also demonstrates why the later Rococo style was to emerge from Italy. Here, all is still symmetrical. The central cartouche depicts a rampant lion, the crest of an unspecified Italian-Jewish family. The cover is marked on all its sections with the town mark, the head of San Marco prominent on the spine. The prayer book inside is earlier, dated 1626 – not an uncommon practice – though one should still check that the book fits the cover. These seem to have been made for each other, and the Venice cover, with a printed Venice title, adds credence to the whole. This type of silverwork has commonly been faked, although this can generally be detected by the clumsiness of the workmanship.

284 Austrian gold pocket watch with silver dial, Vienna, *c.* 1825, *W.* 2¼ in (5.75 cm).

Hebrew-dial watches are known from the eighteenth century, although examples from before the late nineteenth century rarely appear on the market. This example is therefore quite early.

XVII

Bezalel and the Modern Arts

Collectors too often overlook the work of twentieth-century craftsmen, in the mistaken belief that value and artistic worth are determined by age alone. The collector who falls into this trap not only misses many important pieces, he also endangers the continued survival of those very art forms he claims to cherish. Fortunately, the trend is now being reversed, and more attention is being paid by collectors not only to works produced in this century, but to the output of artists living now.

The first modern movement that aimed to create a contemporary Jewish style of art was led by the Bezalel School of Arts and Crafts, founded in Jerusalem in 1906 by Boris Schatz. He, in his early twenties, had abandoned his traditional Jewish studies to work with the sculptor Antokolski in Paris. In 1895 he became court sculptor to Prince Ferdinand of Bulgaria, and founded the Royal Academy of Art in Sofia. In 1903 he met Theodore Herzl, whereupon he became an ardent and idealistic Zionist. Schatz proposed the establishment of a Jewish art school, outlined in a plan which he presented to the 1905 Zionist Congress. Soon after, in 1906, he moved to Palestine and established a school of art in Jerusalem. The name 'Bezalel' recalled the craftsman whom Moses had instructed to build the sacred Tabernacle in the desert. The first Jewish artist thus gave his name to the first Jewish art school.

Schatz aimed to unify the arts and crafts, and to create a valid artistic style for the modern Jewish nation. He grafted indigenous European techniques onto Near Eastern, traditionally Jewish inconography. Schatz's European training shows in the Jugendstil or Art Nouveau flavour of his flamboyant creations. The school produced an unusually wide range of objects in many media: gold, silver, bronze, copper and brass in various combinations; textiles,

including hand-woven carpets, woven and painted or printed fabrics; paintings and prints; postal and greetings cards; wood-work and enamelling; photography; and sculpture in metal and stone. Despite problems of finance the school survived even the death of Schatz in 1932 while on a fund-raising mission abroad. In its prime it produced a felicitous blend of good design and fine workmanship, turning out thousands of articles ranging from elaborate synagogue and ceremonial pieces to jewellery and even cigarette-holders. Most pieces are marked 'Bezalel' and sometimes also 'Jerusalem' in English or Hebrew. Some are signed by the artist. Bezalel products were generally ignored and even scorned until only some ten years ago. They are now far more in favour, partly as a result of the current popular interest in Art Nouveau, and the Israel Museum has recently organized a major exhibition accompanied by a catalogue outlining the history of the Bezalel output. Seen in its full context, Bezalel was a daring and original attempt to provide an artistic renaissance to match the rebirth of Jewish national consciousness. The distinctiveness of its style, even to us today, is the measure of its success.

Bezalel's influence was strongest in Palestine, where Near Eastern motifs were everywhere to be found and easily recognized. European craftsmen who went to America, however, chose different modes for expressing the Jewishness of their art. The most important artist was Ilya Schor, who enjoyed little success in his lifetime, but whose work is now much sought after. He was inspired by the Bible, by Jewish folklore and by *shtetl* life in the Eastern European Pale of Settlement, and produced an evocation as potent as Chagall's of the spiritual dreamworld of that now lost society. Schor worked by hand, using traditional methods and tools. His hand-wrought decoration includes human figures, birds, animals and fish, and he often incorporated Hebrew or Yiddish inscriptions in his designs. He frequently worked on special commissions for jewellery, which he produced mainly in silver, though a few were in gold, or in a combination of silver and gold. The patrons of these works may have suggested motifs that were of personal significance to them. Many of his pieces feature small pendants. Larger ceremonial objects are primarily of silver and contain a wealth of detail. His workmanship is as pleasurable to touch as it is to see, since the craftsmanship is unusually fine. His works are almost always signed in English or Hebrew and some-times both. All are engraved with his artistic symbol, a dove in flight. Some very small or fragile pieces are unsigned. Many are

also dated. Sadly, a certain number of fakes are known in this area, although Schor's technical mastery is not easy to imitate, and the forgeries will immediately be spotted by anyone who knows genuine examples of his output. Schor was also a painter and graphic artist; but his chief achievements are to be found in his metalwork.

Another vital force in twentieth-century Judaica was Ludwig Wolpert, born near Heidelberg at the turn of the century. He studied sculpture and then metalwork at the Frankfurt-am-Main School of Arts and Crafts, emigrating to Palestine in 1933, where he became Professor of Metalcraft at the New Bezalel School for Arts and Crafts in Jerusalem in 1935–6. He left in 1956 for New York, where he established the Toby Pascher Workshop in the Jewish Museum. There he taught a new generation of craftspeople, working in a variety of media. Most of his ceremonial pieces are in silver or brass. These are strongly modernist creations, under clear Bauhaus influence, featuring an elegant absence of ornamentation, and clear, strong lines. As a craftsman he is the antithesis of Ilya Schor, whose pieces fairly teem with figural embellishments. Wolpert also produced considerable quantities of each design, unlike Schor's unique masterpieces. They tend therefore to be less expensive. Each piece is clearly marked with Wolpert's name, usually together with a formula such as 'Toby Pascher Workshop/ New York'. Some objects were made in limited editions or are even unique, and these are more expensive than the larger product lines. It is advisable to check any major purchases with the Jewish Museum in New York, in order to make certain that they are authentic.

Another major craftsman is Moshe Zabari, born in Israel in 1935 and trained at the Bezalel School in Jerusalem. He went to the Toby Pascher Workshop in 1961 where he still teaches and works as the artist-in-residence. An associate of Wolpert's, Zabari produces a wide range of ceremonial art, primarily in silver. He expresses himself in the modernist vein favoured by Wolpert, but has evolved a distinctively personal, contemporary style, echoing traditional Jewish themes from the Bible and Kabbalah. Zabari excels in the bold interplay of clean, clear surfaces and of well interpreted lettering and other ornamentation. Pieces are stamped with the name of the artist and of the workshop, and are produced in both limited and larger editions, like those of Wolpert. Few of these artists' works appear often in the salerooms, but both men are widely respected and are certain soon to be commercially far

more noticed than they have been until now.

One further artist worth mentioning is the Czech-born Hana Geber, who works in silver, bronze and silvered bronze. She is primarily a sculptor who employs a sculptural technique to build up works of fluid, dynamic ceremonial art. Her complex creations are composed of abstract elements that combine to make rich and satisfying objects.

Many of the craftsmen working today on Jewish ceremonial art are producing pieces which will be no less loved and valued than are the antiques of today. Enquiries concerning their names and whereabouts can be addressed to Jewish museums and institutes of learning, which occasionally organize exhibitions of recent work. The collector of Judaica should not ignore this category of products, which continues traditions established over centuries throughout the Jewish world. The skill of the collector will be revealed here not by his ability to discover who these artists are, but by the taste and discrimination with which he selects the best of their work, and by his skill in commissioning objects that set trends for the future. This is an area in which collectors can actually participate as patrons in the history of their subject. The chance to design and foster a really classic piece should be welcomed by every lover of Judaica.

285

285 Boris Schatz, *Sofer* ('The Scribe'), bronze plaque in original stained-oak frame, 22½ × 16 in (57 × 40.75 cm), excluding frame. Bronze was Schatz's favourite medium, and this work shows how successfully he worked in it. Many small bronze and silvered-bronze plaques exist. The large versions are rarer, and show Schatz's ability to make a powerful emotional and spiritual statement.

286 Boris Schatz, *Evil Thoughts*, oil on panel, in etched brass frame designed by the artist, titled and signed in Hebrew, Bezalel paper label on reverse, 9⅛ × 8½ in (23 × 21.5 cm), excluding frame. Schatz's paintings are usually mounted in Bezalel brass frames. Though primarily a sculptor, Schatz did periodically paint, a versatility typical of many Bezalel artists. This particular work is reminiscent of the Polish-Jewish artist Pilichowski, who specialized in sombre portrayals. The work is painted on two joined wooden boards, a not uncommon feature in early works due to the shortage of materials.

286

287

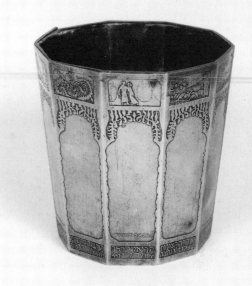

288

289

287 Bezalel brass cachepot, *c.* 1920, *H.* 6 in (15.25 cm).
This tapering, ten-sided piece is etched with a Hebrew inscription taken from the *Song of Songs,* and with vignettes and foliage. An uncommon form with attractive decoration, this piece shows how Bezalel wares extended to non-ceremonial areas.

288 Bezalel brass decorative dish, 1920s, *W.* 12¼ in (31 cm).
Another example of Bezalel etched metalwork, successfully incorporating design and inscription. The stylized foliage and camels in cartouches are classic Bezalel features.

289 Bezalel brass, copper and silver commemorative portrait plaque and stand, *c.* 1910, *W.* of plaque 15½ in (39.5 cm).
This early piece is finely executed on heavy-gauge brass, with complex silver and copper details. Much costlier than the etched work which follows, this inlay, known as 'Damascus work', was adapted from the indigenous metalworking techniques of the Levant. Here Herzl's profile is set in a Star of David. The borders are inlaid with further Stars of David, vignettes of Jerusalem, Herzl's dates, 1860–1904, and the Hebrew word 'Bezalel' at the lower edge of the border in stylized letters – an early form of the signature found on handmade pieces.

290

291

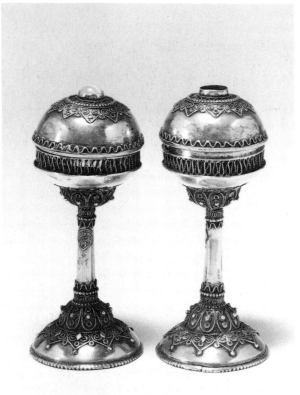

292

290 Bezalel silver *Hanukah* lamp, 1915–20, *H.* 5¾ in (14.5 cm).
The lamp is cast with a titled scene showing the Maccabees cleansing the Temple. It is small, of good weight and pleasing design. The filigree border adds a touch of lightness. The front is set with roundels imitating ancient Judaean coinage and with an applied Bezalel trademark. The latter usually only appears on earlier, better-quality work. The reverse shows the typical 'Bezalel, Jerusalem' stamp in Hebrew, and the silver quality stamp 935, or 93.5 per cent silver, 1 per cent more than Sterling.

291 Bezalel silver *Mezuzah* case, 1920s, *L.* 3½ in (9 cm).
This piece is of heavy-gauge metal, with a hinged upper section for inserting the *Mezuzah* itself – a parchment scroll. The Hebrew inscription refers to the biblical commandment to place the *Mezuzah* on the doorpost of one's house. Such good-quality *Mezuzot* from Bezalel are rare; most surviving examples were stamped from thin silver or copper sheeting, although they are also attractively designed.

292 Bezalel silver spiceboxes, 1920s, *H.* 5 in (12.75 cm).
Each has a spherical upper spice section. The pull-off lids are set with agate, the bodies applied with filigree. Each also has an applied Bezalel trademark plaque on the stem. These pieces are typical of Bezalel work in design and quality.

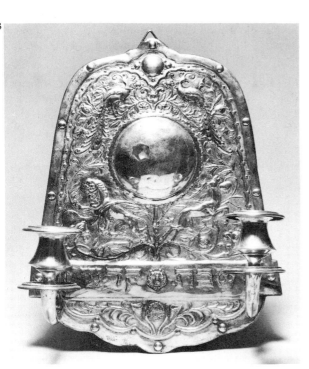

294

הכותל המערבי

עַל זֶה הָיָה רוּחַ לְבֵנוּ. עַל אֵלֶּה חָשְׁכוּ עֵינֵינוּ. עַל הַר צִיּוֹן שֶׁשָׁמֵם שׁוּעָלִים הִלְּכוּ בּוֹ.

293 Bezalel silvered-brass Sabbath wall sconce, *c.* 1920, *H.* 12 in (30.5 cm).
An attractively designed and well-executed wall sconce, decorated with lush foliage, inhabited by peacocks, a lion and a deer – overtones of Persian splendour. The lion's mask and the sconces are Polish in derivation. The Hebrew inscription means 'Holy Sabbath'. The 'Bezalel, Jerusalem' seal in Hebrew is applied below the lion's mask on the lower section.

294, 295 Print from a design by Ze'ev Raban showing the Western Wall, and a Bezalel School print showing the kindling of the Sabbath lights in a synagogue. The second 24½ × 16 in (62.25 × 40.75 cm).
The first print, depicting the Western Wall, is from a portfolio of ten designs issued by the artist in 1931 in Jerusalem. The second was issued in 1916. Both exhibit the stylized motifs that reappear in most of the Bezalel School's works.

293

295

לקראת שבת לכו ונלכה

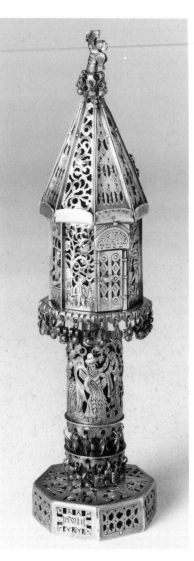

296 Silver spice tower, Ilya Schor, 1948, signed and dated in Hebrew and English, *H.* 8½ in (21.5 cm).
This tower is a masterpiece: hand wrought, pierced and chased by Schor in the full flower of his style and skill. Commissioned by Charles E. Feinberg, a pioneer collector of Judaica, the piece abounds in the folk-art symbolism which the artist shares with Chagall. Collectors responded to the quality and importance of this work when it was sold at Sotheby's in December 1984 for $88,000, a record both for a spice tower and for a piece of twentieth-century ceremonial art. It was interesting to see the record broken by a modern piece, rather than by one noted more for its age than its quality.

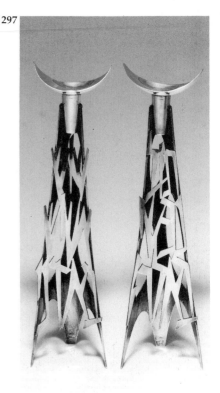

297 American silver Sabbath candlesticks, Ludwig Wolpert, Toby Pascher Workshop, New York, *c.* 1960, *H.* 15 in (38 cm).
This work is typical of Wolpert: Modernist, with clean lines and geometric ornament, the architectural form taking precedence over ornament. These candlesticks are quite simple in design, the bold Hebrew lettering forming an integral part of the construction.

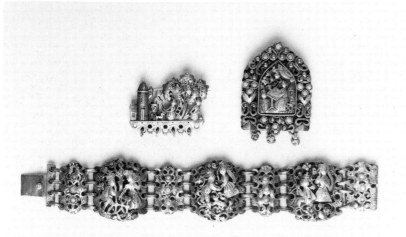

298 Three pieces of silver jewellery, Ilya Schor, 1940s, *L.* of bracelet 6¾ in (17 cm), *H.* of pendant 2 in (5 cm).
These pieces illustrate the enormous detail, especially piercing and engraving, that is typical of Schor's work. They are miniature sculptures that can be viewed from every angle. Most of Schor's pieces, even the smallest, are signed and often dated, and also bear his engraved 'bird' trademark.

299 Gold *Chai* pendant, Ludwig Wolpert, Toby Pascher Workshop, New York, 1976, *H.* 1½ in (3.75 cm).
This 18 carat gold pendant appears in the working drawings from which Wolpert executed the piece. Though later produced in silver, a single and therefore unique gold example was made. The Hebrew word *Chai,* meaning 'life', is a common Jewish talisman, and is often worn as a pendant. Though *Chai* pendants are available in many commercial varieties, not many modern designers of note have given them attention.

300 Silver *Hanukah* lamp, *Hanukia,* by Hana Geber, New York, 16 × 10 in (40.75 × 25.5 cm).
Hana Geber works primarily with the *cire perdue* or 'lost wax' process, creating unique examples in a traditional sculptor's medium. Here the concept of a chain, embracing the lamp link by link, is explored.

301 Silver *Hanukah* lamp, Ludwig Wolpert, 1960s, stamped WOLPERT, 925 STERLING, and with the trademark of Toby Pascher Workshop, *H.* 13 in (33 cm).
A good example of the modern design for which Ludwig Wolpert's work is justly famous. Almost single-handed, Wolpert brought Jewish ceremonial art into the twentieth century. Primarily a metalsmith, Wolpert's work appears in silver and brass, with some gold- and silver-plated pieces. Using traditional motifs such as the lions in this piece, as well as stylized Hebrew inscriptions in modern letterforms, Wolpert's work is distinctive. This piece has a typical vertical axis. The oilpans are quite traditional, while the servant light, fitted for a candle, is completely practical. The silver used in this particular piece is of quite heavy gauge. It can be both free-standing and wall-mounted.

XVIII

Fakes and Forgeries

The field of Judaica suffers no less acutely from faking than any other area of art dealing and collecting. Unlike other fields, however, there are serious problems for the professional as well as the amateur in detecting these forgeries. Firstly, the range of material to be covered by the expert is enormous, and is varied in media, age and place of origin. Secondly, there is a prolonged delay before scholarly publications filter through to the awareness of the collecting public. The person who becomes interested in almost any area of Judaica also has to assimilate a vast amount of information about the non-Jewish arts. It is not surprising that collectors tend to become bewildered. But this feeling should not prevent one from beginning to study one small area in depth. Taking Polish silver spice-towers as an example, one would need to learn something about antique silver in general, slightly more about Polish silver in particular – its marks, alloys and workmanship – and then to study the whole range of spice-towers. One can finally concentrate on one's chosen area, say Polish spice-towers of the nineteenth century. One needs to spend several months studying examples in museums, shops and auction galleries, and only then to venture out and purchase a piece of one's own. In fact, there is no better way of learning about antiques than owning some, and having the opportunity to handle and examine them daily. We learn most from the errors we make – and mistakes are inevitable at this point. It might be time, once this stage has been reached, to move on to another area, perhaps a different part of Polish silver Judaica, such as *Hanukah* lamps or *Kiddush* cups. Constantly check your progress against source books, the views of other collectors and any reliable advisers you may have. It is easy to put oneself in the hands of an adviser. But one then misses the

enjoyment of 'growing up' with a collection, of keeping pace with it and absorbing new information as it is built up and refined. Advice on how to spot forgeries is given in each chapter, but a few general remarks may be useful.

Remember that the aim of forgery is financial gain, and that the greater the potential profit the more effort will be invested in deception. The safeguards against this are not particularly reliable. Most museums will venture an oral opinion on the authenticity of a piece, and auction houses will do the same and also provide an estimate of the value. The thoroughness of the checking will vary with the importance of the purchase. It is almost best to live with a piece for a while before coming to a final conclusion about it, and many dealers are prepared to permit this with very expensive purchases.

The first class of object to avoid is that of biblical subjects. Old Testament art is sometimes presented – quite wrongly – as Judaica. Paintings of Moses striking the Rock and Renaissance plaquettes of the Binding of Isaac cannot be included in an ethnographic and religious category such as Judaica. Biblical art has traditionally been the province of the Christian world, and a piece must be shown to have been commissioned for Jewish use before we can consider it. Remember that Decalogues with Hebrew lettering often appear in altar-pieces.

A more serious trap for the collector is the forged Jewish association. An inscription may quite recently have been added to a sugar-box, for instance, to make it into an *Ethrog* container. Common items are often converted into rare ones, for example by modifying a common gold or silver cigarette-case and selling it as a travelling *Hanukah* lamp. Fancy cane or parasol handles can similarly be cut down to make *Torah* pointers. In the same way, do not be taken in by the so-called Marrano cup. This is a compendium of Jewish ritual articles, including fittings for *Hanukah* candles, an Esther scroll, a spicebox and so on, supposedly made for use by clandestine Jews concealing their faith from the Inquisition. These amusing objects are made in Spain and Israel, and are occasionally exemplary specimens of workmanship. But do not believe a dealer who tells you that they date from the expulsion of the Jews from Spain in 1492, because they were in fact probably made shortly before your visit to the antique shop. Be wary, also, of copies of famous or classic pieces. These are often copied from illustrations in standard reference books. With experience one comes to recognize these instinctively, making it easier to avoid

them. Such fakes are particularly common in tourist shops.

Lastly, there is the problem of a new inscription being added to an old piece in order to increase its value. The object may be Judaic and old, but the inscription is a forgery. Other items may not be Judaic at all. An old goblet, bought for little more than its scrap value, can be sold for many times the price if one adds a quaint Jewish inscription. 'The Cup of Elijah the Prophet' in Hebrew is a current favourite. While a recent Hebrew inscription, sold as such, is completely unobjectionable, especially when the piece dates from the second half of the nineteenth century, earlier pieces are worth more when left plain, in particular when the new engraving is poorly done and is prominently placed on the object.

Fakes are unfortunately a fact of life in this as in all collecting fields, but they are certainly not an insurmountable obstacle to building up a worthwhile collection. If you do your research and are well advised, almost all problems can be avoided. Do not shy away from anomalous pieces. It is the elusive, puzzling object that challenges us to study and know more, and to keep us from feeling jaded and complacent in our search. Spotting fakes is less of a chore than a duty to be enjoyed. Happy hunting!

302

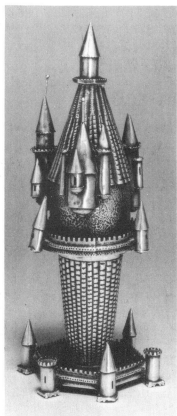

303

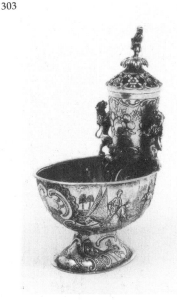

302 Silver spice tower, 20th cent., _H._ 8½ in (21.5 cm). This piece is trying to be medieval, but succeeds in being mere 'Fantasyland'. The proportions and chasing are both bad. The base bears a 'maker's mark' which is also unlikely to be found on a medieval piece, let alone a 'German' one. It happens closely to resemble an American colonial maker's mark.

303 Silver table laver, modern assemblage, _H._ 9 in (23 cm). This piece is made up of several unrelated elements. The bowl is Dutch, Frisian, from around 1900, but in eighteenth-century style. To it has been added a German beaker of the early twentieth century, and new lions, lid and a finial to match. The styles and techniques show glaring dissimilarities – the bowl is chased and the beaker cast. There is an amusing aspect to the effort someone has invested in this pastiche; but, sadly, many people would be taken in.

304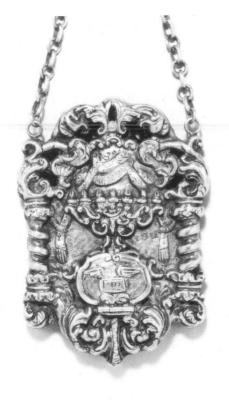

305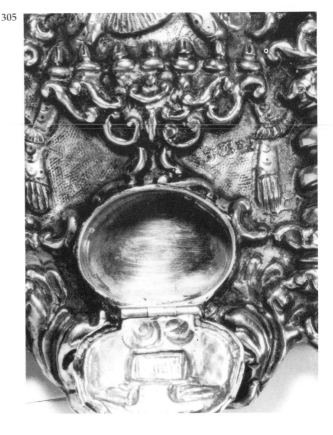

306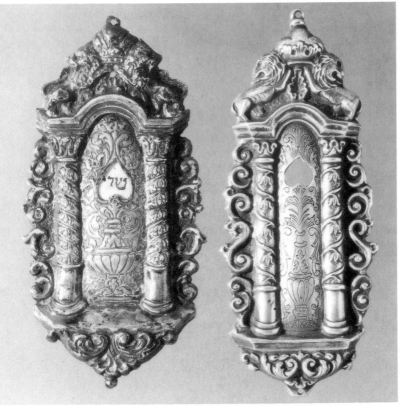

304, 305 Silver amulet, 20th cent., *H.* 4 in (10 cm).
This crudely cast object is intended to resemble an Italian amulet of the seventeenth or eighteenth centuries. An original piece would be finely chased and embossed. This one is too heavy in weight, and the 'chasing' is muddy and uneven. The marks are pseudo-French of the eighteenth century, which are totally inappropriate. The matting is uneven, and the oval compartment for the amulet scroll has a freshly worked interior.

306 Two silver *Mezuzot, H.* 4¼ in (10.75 cm).
The example on the left is genuine, a Polish example dating to the eighteenth century. That on the right is a twentieth-century copy; the side scrolls, the pillars flanking the urn and the urn itself are less complex in the later example, which was cast and minimally hand-finished. The old example is made from very thin sheet silver, and was worked by hand.

229

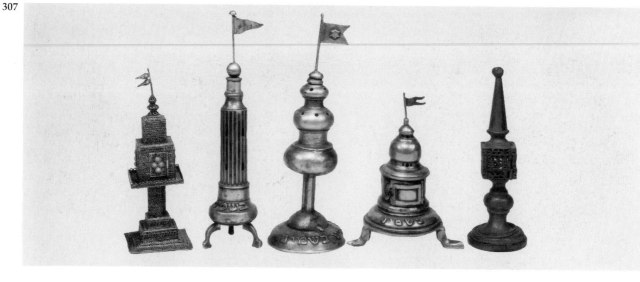

307

308

309

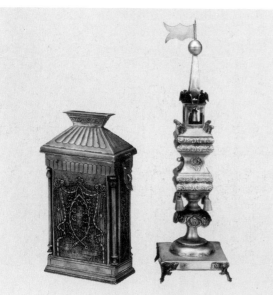

307 Group of silver and brass spice towers, *H.* of example on left, 6 in (15.25 cm).
The example on the right is late nineteenth century, of Polish brass, and is a common type and perfectly genuine. On the left is one in silver filigree, Palestinian, of the early twentieth century and also not meant to deceive. The three in the middle are brass, and are modern examples intended to look old. They all have a uniform blackish patina meant to imitate age.

308 Silver charity box and spice tower, 20th cent., *H.* of charity box 7½ in (19 cm).
The charity box is Persian, but is based on a European original, or on elements from several originals, probably dating to the late nineteenth century. The matting and chasing have a vaguely Persian or Oriental look, and the gauge is much heavier than a nineteenth-century

European piece would be. The spice tower, the original of which was made in Warsaw in the late nineteenth century, was made in Portugal or Israel. It bears pseudo-Russian marks, including a full date, usually 1865, and the *Kokoshnik*, or girl's head, used from 1896 until the Revolution, without the full date mark. The combination of both these marks should arouse suspicion.

309 Two silver spice towers, 20th cent., *H.* of example on left, 11 in (28 cm).
Probably German, these pieces are vaguely medieval and Gothic in inspiration, even ecclesiastical. Though impressive to the untrained eye, their decoration is stamped, with little hand finishing, and is obviously modern. They are amusing pieces, so long as they are not mistaken for antiques.

310

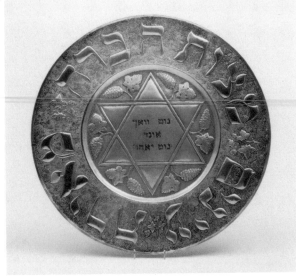

311

312

313

310 Persian silver *Havdalah* plate, 20th cent., *W.* 20 in (50.75 cm).
This piece, finely chased in the Persian manner, is a large, silver version of a smaller, porcelain original produced in Germany. The size is totally out of proportion to its function as an underplate for the *Havdalah* ceremony. It should be a quarter or a third of the width. The Yiddish inscription copied from the porcelain original, saying 'A good week and a good year', is particularly incongruous.

311 Two Persian silver *Torah* breastplates, 20th cent., *H.* of example on left, 11 in (28 cm).
Loosely based on Polish nineteenth-century examples, these breastplates are typically Persian in technique and finish. The quality is as good as that of the *Havdalah* plate in the previous illustration.

312 Silver miniature *Torah* breastplate, modern, in late 18th cent., Polish style, *H.* 6 in (15.25 cm).
A sophisticated copy, made in order to deceive, and difficult to detect for the untrained eye. Complete with a 12 and a maker's mark (which experience would show to be suspicious), the chasing is quite convincing. The wear, the high quality of the silver and the heaviness of the metal, all suggest a well-conceived but entirely fraudulent copy.

313 Silver *Torah* breastplate, 20th cent., *H.* 8½ in (21.5 cm).
Based on a mid-eighteenth-century German model, this piece lacks the vigour of the original; the figures and scroll-work are weak and the matting is bad. It is unfortunately a good enough copy to fool the unwary.

314

315

316

314 Two silver *Torah* pointers, *L.* of lower example, 13 in (33 cm).
The smaller example is Israeli, modern and perfectly acceptable. The other is large and crudely chased with flowers. It is a Spanish or Israeli fake of the 1960s, aimed at lovers of the ornate. The smallness of the hand in proportion to the shaft is a clue to its inauthenticity, as is the crude chasing.

315 Silver *Hanukah* lamp, *c.* 1950, *H.* 11 in (28 cm).
This model originated around 1850 in Germany and has been cast and recast ever since, becoming progressively heavier and coarser in the process. The lions' heads, open to hold the oil, have wide spouts in their mouths. This is a serviceable, sturdy example, but a nineteenth-century piece would cost three to four times as much.

316 Gold miniature *Hanukah* lamp, 1950s, probably made in Israel, *H.* 3 in (7.25 cm).
Pieces like this one rarely deceive, as they are obviously too small for use. The backplate here is made from a cigarette case of about 1930, with added elements loosely based on Polish nineteenth-century models. The Hebrew engraving on the pillars is particularly poor and appears on other freshly engraved converted pieces.

317

318

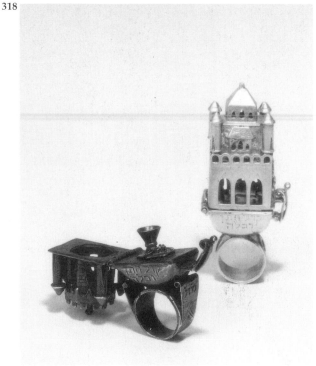

319

317 Silver *Hanukah* lamp, early 20th cent., *H.* 16 in (40.75 cm).
A good quality, convincing piece of very heavy weight, bearing the marks of Orchinikov, the famous Russian maker, and of Moscow, 1892. It is likely that the piece is Polish and was perhaps stamped with the Russian marks to avoid tax in the early twentieth century. Such pieces make the detection of outright fakes and frauds much more difficult. As always, the matching of silversmithing techniques typical of the period and of the region is the only sure guide to authenticity.

318 Two silver marriage rings, 1950s and 1960s, *H.* of closed example, 3½ in (9 cm).
These were once commonly believed to be of the seventeenth century or earlier. Of heavy cast silver, loaded with relevant Hebrew inscriptions, they usually open to reveal a cup and two rings, a torch, or other symbolic articles. There are no early prototypes for these – all such examples are modern. They appear in both silver and silver-gilt.

319 Silver-cased illuminated parchment Esther scroll, 20th cent., *H.* 14 in (35.5 cm).
The scroll is based on seventeenth- and eighteenth-century Italian examples. The freshness of the colours and the lack of wear are clear indications of its recent manufacture. The case is engraved with brickwork, and a close inspection of the lines under magnification reveals little wear as well as the poor quality of the workmanship.

PRICE GUIDE

I have given these prices in dollars. They reflect recent prices and trends at the time of writing, but are intended for general guidance only and to assist in comparing the values of different categories of object.

CHAPTER III *Sabbath Lamps*

Lamps, brass
Plain, Medium Size:
German, 18th c. 500–1500, 19th c. 300–700
Dutch, 17th–18th c. 1000–2500
Italian, 17th–19th c. 1000–2500.
For larger and more elaborate lamps with candleholders etc., add 50–100 per cent.

Lamps, silver
German, late 17th–mid 18th c., marked 50,000+
Dutch, late 17th–mid 18th c., marked 50,000+
Italian, late 17th–mid 18th c., marked 30,000
German, late 18th–early 19th c., marked 20,000+
Dutch, late 18th–early 19th c., marked 25,000+
Italian, late 18th–early 19th c., marked 10,000.
For unmarked examples of above, deduct 25–50 per cent.

Candlesticks, silver
Polish, mid 19th c., medium gauge 800–1500
Polish, late 19th–early 20th c., lighter 1000–1500
Austro-Hungarian, late 19th c., Polish style 500–1000
German, late 19th c., light gauge 500–800.
Modern Designer Examples in Silver:
Ilya Schor 30,000+
Wolpert 1500–5000
Zabari 1500–5000.

Candlesticks, brass
Dutch, 18th c., with inscription 500+ per pair.

Candelabra, brass
Polish:
17th–mid 18th c., massive, ornate 5000+
Late 18th–early 19th c., less massive and ornate 800–2500
Mid 19th c., or later 500–1000
Made to be silver-plated, late 19th c. Warsaw 100–300.

CHAPTER IV *Ceremonial Cups*

Beaker form, silver
German:
late 17th c., plain, and with period Hebrew inscription around rim 2000–5000
As above, with period Hebrew owner's inscription on lip or foot 1000–2000
Kiddush cup, Augsburg, Nuremberg, etc., mid 18th c., period Sabbath inscription 8000–12,000+ Late 18th c., similar inscription 5000–10,000.

With Hebrew inscription and vignettes for Passover, *Shavuoth*, etc. 10,000–20,000+.
Cup by Rimonim of Fürth 12,000–15,000+.
Polish:
Late 18th–early 19th c., with Hebrew Sabbath inscription 1000–3500
Mid to late 19th c. 300–1000.
Beakers, late 18th–early 19th c., with Sabbath inscription 300–1200
Beakers, late 18th–early 19th c., without inscription 200–500.
Late 19th c., Polish and Russian beakers, small, some with foot, uninscribed 50–150.
Lithuanian (Vilna) Footed Cups 1850–1900:
Small 300–500
Large 1000–1500 more for sets.
Silver 'Safed' or Jerusalem Beakers Late 19th c.:
Holy Land vignettes 2000–4000
'Dead Sea Stone' 300–1000.
German Silver Double Cups for Marriage or Circumcision:
18th c., period inscription, barrel-form 10,000–20,000+
Late 19th c., copies 1000–3000.

Burial Society cups
German, Austrian, Bohemian, silver tankards, goblets, beakers (normally covered), with inscriptions of 50–100 years from date of manufacture 15,000–30,000. More if very elaborate.

CHAPTER V *Spiceboxes, Candleholders and Havdalah Sets*
(all in silver)

Spice towers
German:
Late 17th–early 18th c., marked 15,000–25,000+
Late 17th–early 18th c., unmarked 10,000–15,000+
Late 19th c., Berlin type 500–2000
Late 19th–early 20th c., medieval style, cast 300–1500.
Polish:
18th c., ornate piercing with vignettes, unmarked 10,000–20,000+
18th c., filigree 5000–10,000
19th c., simple piercing 500–2000
19th c., filigree 500–2500
20th c., all varieties 200–800.

Fruit form
Polish:
18th–early 19th c., small, no stem 500–2000; on stem 2000–5000
Early to mid 19th c. (Polish and Russian provincial), sunflower type, marked 1500–5000.

Pomegranate form
Italian:
Late 18th–early 19th c., on stem, marked 1500–5000.

Small acorn or egg form
Continental:
Late 18th c., usually unmarked 200–1200.

Fish form
Dutch or German:
First half of 19th c., small, with or without marks, small 500–700; medium 1000–1500
Second half of 19th c., small 300–500; medium 500–700; large 1000–1500.

Locomotive form
Russian, Polish, Austro-Hungarian:
Late 19th c., marked 500–2500.

Box form
German:
Usually marked:
18th c. 1500–5000
Early 19th c. 800–2500
As above, pewter 500–2000.

Vertical candleholder with drawer
German, 18th–early 19th c., marked 2000–10,000.

Havdalah set
(Cup, spicebox, candleholders)
German, late 19th c. Posen 2000–5000
Other makers 1500–2500.

CHAPTER VI *The Torah and its Ornaments*

Torah Scrolls (parchment)
Kasher, Ashkenazi 10,000–15,000+;
Sephardi 8000–12,000
Non-*Kasher* 1000–5000.
Travelling Scrolls
18th–19th c., *Kasher* 10,000–25,000
Non-*Kasher*, fair to poor condition 1000–5000.
Sephardi Case (tiq):
Iraqi, silver-covered wood:
19th c., with non-*Kasher* scroll 5000–10,000
Late 19th–20th c. 3000–5000+.

Torah pointers, silver
Dutch, German, Italian, Austrian, Polish:
18th c., marked 1000–5000; unmarked 800–2000
Early 19th c., marked 800–2000; unmarked 500–1800
Mid 19th c., marked 500–1200; unmarked 300–800
Late 19th c., marked 300–1000
Near Eastern:
Silver 18th–19th c. 500–1000
Brass 18th–19th c. 100–300
Silver late 19th–20th c. 200–500
Brass late 19th–20th c. 50–150
Bone 19th–20th c. 200–500+.

Torah breastplates, silver
Dutch, German, Italian:
Late 17th–early 18th c., marked 15,000–25,000+
Late 17th–early 18th c., unmarked 10,000–15,000+
Mid to late 18th c., marked 10,000–20,000+
Mid to late 18th c., unmarked 5000–10,000+.
Early 19th c., marked 5000–10,000+
Early 19th c., unmarked 2000–5000
Mid to late 19th c., marked 1000–5000+.
Polish:
18th c., usually unmarked, small 1000–3000

18th c., unmarked, large 2500–7000+
First half 19th c., small 500–1500
First half 19th c., large 1500–2800+
Late 19th c., medium to large 1000–2500.

Finials, silver
Italian:
17th c., unmarked, quite large
15,000–25,000+
17th c., marked 25,000–40,000+
18th c., unmarked, large 8000–12,000+
18th c., marked, large 15,000–25,000+
Early 19th c., unmarked, medium
4000–8000
Early 19th c., marked, medium
6000–8000+
Mid to late 19th c., marked 4000–6000
20th c., marked 1500–3000.
German:
17th c., unmarked 10,000–20,000+
17th c., marked 25,000–40,000+
18th c., unmarked 5000–10,000
18th c., marked 10,000–15,000
Early 19th c., unmarked 3000–5000
Early 19th c., marked 5000–7000+
Mid to late 19th c., marked 1000–3000
20th c., marked 500–1500.
Dutch:
17th c., unmarked 10,000–20,000
17th c., marked 25,000–40,000+
18th c., unmarked 8000–12,000
18th c., marked 15,000–25,000+
Early 19th c., marked 8000–12,000
Mid 19th c., marked 4000–8000
Late 19th c., marked 3000–5000
20th c., marked 2000–3000.
Polish;
Late 17th–18th c., usually unmarked
5000–10,000
Early–mid 19th c., marked 3000–5000+
Late 19th c., marked 1500–3000
20th c., marked 500–1500.
Austrian:
Late 18th–early 19th c., marked
5000–8000
Mid to late 19th c., marked 1000–3000
20th c. 500–1500 (more if Art Nouveau
or Deco).
Near Eastern:
18th–19th c., good size and quality
3000–5000+
Late 19th–20th c. 800–1500+.

Finials, brass
Near Eastern:
18th–19th c. 300–1000
20th c. 100–300.

Crowns, silver
Dutch, Italian, German:
Late 17th–early 18th c., unmarked
10,000–15,000+
Marked 25,000–58,000+
Same, later 18th c., unmarked
8000–12,000+
Marked 15,000–25,000+.
Dutch, Italian, German, Austrian:
Early 19th c., marked 8000–12,000+
Mid 19th c., marked 5000–7000+
Mid 19th c., marked 4000–6000+
20th c., marked 2000–5000.
Polish:
18th c., set with stones, usually
unmarked 10,000–25,000+
Early 19th c., marked 8000–12,000+
Unmarked 5000–10,000

Mid-19th c., marked 4000–6000
20th c., marked 2000–3000.
Near Eastern, Usually Moroccan:
In Italian style, 18th–19th c.
3000–8000+
Late 19th–20th c. 2000–3000.

CHAPTER VII *Charity Boxes*

Box form, silver
Continental:
17th–18th c., marked, inscribed for
Burial Society 10,000–25,000+
Late 18th–early 19th c., marked
5000–10,000+
For Burial Society, add 50 per cent
Mid to late 19th c., marked 3000–5000+
Mid to late 19th c., small spool-form
500–700.
**Box form, tin, pewter,
copper, iron or brass**
Continental:
18th c., inscribed 2500–5000; unmarked
500–700
19th c., inscribed 1000–1500; unmarked
200–300.
Bowl form, silver
Continental, Inscribed:
18th c. 4000–6000
Early 19th c. 3000–5000
Later 19th c. 2000–3000.
Fabric
Italian:
19th c., embroidered inscription
500–1200.

CHAPTER VIII *Ethrog Boxes*

Fruit form, silver
Continental (Usually German):
17th c., horizontally set on stem, and
gilt, rare 25,000+
19th c. 1000–2500.
Sugar-box form, silver
Continental:
18th c., marked with period Hebrew
inscription for *Ethrog* container
8000–12,000+
19th c., marked with period inscription
1000–2000+
20th c., plain 250–750; in Art Nouveau
or Deco style 500–1000.
Palestinian:
Early 20th c. Bezalel 800–2000.
Olive wood
Palestinian:
With painted decoration, usually
Bezalel, early 20th c. 300–800.

CHAPTER IX *Hanukah*

Bronze
Franco-German:
14th–15th c., with pierced triangular
backplate, very rare when genuine
25,000+.
Italian:
16th–17th c., with pierced backplate,
Renaissance style 2500–10,000.
Italian:
Sheet-bronze or brass, with applied or
chased 'hand and oil', fine decoration,
lions, etc:
18th c. 2500–7500
Early 19th c. 2000–5000.

Silver
Austrian Region, Backplated:
18th c., marked 15,000–25,000+
Early 19th c., Neo-Classical, marked
5000–7000
Mid 19th c., Rococo, marked 2000–3000
Later 19th c., marked 1500–2500
Gothic, mid-19th c. 4000–6000
Later 19th c. 3000–5000.
Dutch Backplated:
Late 17th–early 18th c., marked 50,000+
Late 18th c., marked 25,000+
19th c., all varieties 3000–5000+.
German:
Late 17th–early 18th c.:
Menorah style, free-standing 75,000+
Later 18th c., free-standing 50,000+
18th c., backplated, large 30,000+
18th c., backplated, small 5000–10,000.
Early–mid 19th c.:
Free-standing 5000–10,000+
Backplated, large 5000–8000
Backplated, small 2500–3500
Later 19th c. 1500–5000
20th c. 500–1500, Art Nouveau, Deco
1500–3000+.
Iraqi, Persian, Moroccan:
18th c. 3000–5000+
19th c. 1500–2500
20th c. 1000–2000.
Italian, Backplated:
17th c., marked 35,000+
17th c., unmarked 20,000+
18th c., marked 25,000+
19th c., marked 5000–15,000.
Near Eastern, Syrian:
Silver, copper or brass:
Late 19th–early 20th c. 2500–5000
Bezalel brass, inlaid and plain varieties
500–5000
Bezalel silver, small backplated
2000–5000+
Large, free-standing 5000–10,000+.
Polish Region:
Backplated, late 18th c., small to
medium, not usually marked
5000–7000+
Baal Shem Tov type with filigree
decoration, early 19th c., marked
5000–10,000+
Backplated first half 19th c., chased
decoration, marked 3000–10,000
Backplated, Warsaw, 2nd half 19th c.,
marked 1500–5000
Same silver-plated, 19th c. 300–800.
Brass
Dutch:
Backplated, sheet metal:
Late 17th c., ornate 5000–7000+
Early 18th c., simpler 3000–5000
Late 18th c., simpler 1000–3000
Backplated, cast: 18th c. 2500–4000
19th c. 1000–1500.
Polish Region:
Menorah type, late 17th–early 18th c.,
free-standing, ornate, massive
8000–12,000
Later 18th c. 4000–6000
Early 19th c. 2500–3500
Mid–late 19th c. 1500–2000.
Backplated, mid 18th c. 2500–5000+
Late 18th c. 2000–3000
Early 19th c., includes 'Prague' type
1500–2500

Mid–late 19th c. 500–1500.
Near Eastern:
Bronze or brass, Italianate, North
African, pierced with *mihrabs*, etc.:
17th–18th c. 2000–4000
19th c. 500–1500
20th c. 100–300.
Pewter
Germany, Bohemia:
Backplated:
18th c. ornate 5000–10,000+
18th c., simple 500–1000
19th c., simple 300–800
Late 19th c., Art Nouveau 500–1500.

CHAPTER X *Purim Objects*

Esther Scrolls (Megillah)
Dutch or Italian:
17th–18th c. ivory or wooden roller, no
silver case:
With fine printed, and or illuminated
decoration, 25,000+
If by famous maker (Shalom d'Italia,
Grisellini, etc.) 50,000+.
Italian, Dutch, Bohemian, etc.:
18th c. ivory or wooden roller, no case:
Much period illumination
10,000–15,000+
Some period illumination 3000–8000+
No illumination, well written, text only
1000–2000
If in ornate silver case of period, add 100
per cent.
Turkish, Balkan, Persian:
19th c., well written, often *Ha' Melech:*
On ivory roller 1000–2500
In silver case 1500–3500.
German, Austrian:
19th c. plain scroll, silver case
1000–2500+.
Polish:
Early 19th c. plain scroll, ornate silver
case 8000–12,000+
Smaller 5000–7000
Later 19th c. 2500–4000.
Near Eastern:
Plain dark skin, leather, wood roller,
primitive, 19th–20th c. 200–500
Bezalel, in filigree silver case with
painted illustrations, early 20th c.,
Narrow scroll 1500–2500
Wide scroll 1000–2000.
Polish or German:
Plain parchment:
18th–19th c. with 20th c. Palestinian
illumination 1000–2000
In silver case 2000–4000.
Purim plates, pewter
*Central European, German, Austrian,
Bohemian:*
Early–mid 18th c., ornately decorated
and inscribed in Hebrew 2500–5000+
Later 18th c., not as ornate 1000–15,000
19th c., still plainer 500–700.
Noise-makers (Greggers)
Wood, 19th–20th c. 100–500
Silver, Polish, early–mid 19th c.
2500–5000+
Silver, 20th c., copy of above 500–1500.

CHAPTER XI *Passover Objects*

Seder plates, pewter

Continental:
Late 17th–mid 18th c., well decorated,
large 2500–5000+
Late 18th–early 19th c., less ornate
1000–2500.
Seder plates, silver
Hungarian:
20th c., large 1500–2000.
Seder plates, ceramic
Franco-German:
Late 18th–early 19th c., simple
decoration 500–700
Ornate, with floral painting 800–1200.
English:
20th c., transfer-printed, etc. 100–150.
**Seder dishes, three-tiered,
silver**
Continental:
18th c., normally German, quite rare
15,000+
Early–mid 19th c. 10,000+
Late 19th–early 20th c., Posen and other
German makers 7500–12,500.
Seder dishes, wood
Palestinian:
Late 19th–early 20th c., painted
olive-wood, some by Bezalel 1000–2000.

CHAPTER XII *Textiles and
Rugs*

Skullcaps
Polish:
19th c., *Shpanyer Arbeit*, gold and/or
silver thread, good condition 500–1500+.
Near Eastern:
18th–19th c., embroidered 250–500+.
Atarot (neck piece for prayer shawl)
Polish:
19th–20th c., *Shpanyer Arbeit*, silver
thread 50–150.
Silver plaques, 19th–20th c., thin gauge
200–400
Gold plaques, 19th–20th c., thin gauge
1000–2500.
Tallit (prayer shawl)
Usually Italian:
18th c., hand-woven, silk-embroidered,
floral decoration 1000–2500
Early 19th c., similar, less ornate
500–1500.
Central European:
Late 19th–early 20th c., wool or linen
50–150.
Velvet bags for Tallit or Teffilin
European:
19th–early 20th c., embroidered 25–150.
Challah covers
Central European:
Late 19th–early 20th c. 50–200.
Matsah cloths
Central European:
Mid–late 19th c. 100–500.
Passover towel and Matsah cloth
German:
Early–mid 19th c., embroidered
3000–5000+
Painted 2500–3500+.
Torah mantles
Central European:
18th c. 500–1500
19th c., velvet 100–200.

Ark curtains
German, Bohemian and Italian:
Late 17th–mid 18th c., profusely
embroidered, good condition, with
Hebrew inscription 10,000–15,000+
Later 18th c., similar to above, less
ornate 3000–5000+
19th c. 300–1000.
Torah binders
Italian:
17th c., quite ornate 2000–5000+
18th c. 1000–2000.
German:
Late 17th–early 18th c., finely
embroidered, good condition
5000–7000+
Later part of 18th c., embroidered, good
condition 3000–5000
Late 18th–early 19th c., painted, good
condition 300–800.
Persian rugs
With Jewish or Biblical scenes and
Hebrew inscriptions, mostly early
20th c.:
Good-quality wool 2500–3500
Fine-quality silk 3000–5000+.

CHAPTER XIII *Ceramics and
Glass*

Festival or Sabbath dish
Central European:
Late 18th–early 19th c. 500–1000
Late 19th c., usually transfer-printed
300–500.
Porcelain or pottery figures
Groups depicting Jewish life, peddlars,
etc., some caricature, most 19th c.
500–1500+.
Glass beakers or goblets
Bohemian:
Mid–late 19th c., with vignettes and
Hebrew inscription 500–1500+
Hebrew inscription alone 200–800+.

CHAPTER XIV *Paintings and
Prints*

Paintings
Maurycy Gottlieb:
Oil on canvas:
Jewish subjects (rarely appear for sale)
25,000–50,000+.
Isidor Kaufmann:
Oil on panel:
JEWISH SUBJECTS:
Small 15,000–25,000
Medium 25,000–35,000
Large 50,000+.
NON-JEWISH SUBJECTS:
Depending on size and subject matter
5000–25,000.
Moritz Oppenheim:
Oil on canvas:
Jewish genre scenes (rarely appear for
sale) 50,000–75,000+.
Ilya Schor:
Oil:
Small 1500–2000
Large 3000–5000+.
Artur Szyk:
Oil and gouache on paper:
Jewish scenes 1000–3000
Public scenes 500–1500.

Prints

Engravings of Jewish Life:
18th c., Picart, Bodenschatz, Kirchner
50–150.
Coloured Prints:
Mostly English or Dutch, 18th–early
19th c., architectural views, costumes,
and political or satirical 50–250.

Etchings

Hermann Struck:
Jewish subjects 100–250.
Joseph Steinhardt, Lazar Krestin, Joseph Budko:
Jewish subjects 100–200.
Ilya Schor:
200–300.

Advertising posters
American, early 20th c. 200–500.
New Year's cards, postcards, formal
Yiddish with amusing photographs,
early 20th c. 10–25+.
Elaborate, pop-up varieties 100–250.

CHAPTER XV *Marriage*

Marriage contracts
Italian:
Parchment, finely illuminated, good
condition, area 12 × 20 in (30.5 ×
50.5 cm):
17th c. 30,000–50,000+
18th c. 10,000–25,000+
Early 19th c. 5000–7000+
Mid 19th c. 3000–5000+
Late 19th c. 1500–3000+.
Near Eastern:
Primarily Persia, Morocco, 19th c.:
Illuminated parchment 1500–5000
On paper 300–1000.
Marriage rings
Italian, German:
15th–17th c., gold, with enamel
15,000–25,000+.
Italian:
17th c., gold, simpler filigree
5000–10,000.
North African:
18th–19th c., silver or silver gilt
500–1500.
Marriage belts, silver
German, etc.:
16th–17th c., no Hebrew inscription
2000–5000.
Marriage buckles, silver
Near Eastern:
18th–19th c., Hebrew inscription
500–2000.

CHAPTER XVI *Amulets, Mezuzot, Teffilin and Watches*

Amulets
Italian (Venice):
17th–18th c., large cartouche-form (add
50 per cent if marked):
Gold 15,000–25,000
Silver, silver gilt 5000–10,000
Simpler, filigree, silver (usually
unmarked) 1500–2500.
German, Bohemian, etc.:
18th–early 19th c., silver, simple
design, usually unmarked 500–1500.
Near Eastern, Usually Persian or Iraqi:
18th–19th c., various shapes, silver:

Large 500–1000
Medium 150–350
Small 75–200.
Late 19th c., gold 500–1000
20th c., silver 50–200.
Mezuzot
Polish:
19th c., silver case 1500–2500+
19th c., wooden case 800–1200+.
Moroccan:
19th–20th c., silver and fabric
500–1000+.
Teffilin
Central European:
Parchment scrolls in leather case:
Late 19th–20th c. 100–200 set of 2
Miniatures 200–500+ set of 2.
Silver cases for Teffilin
Polish:
Early–mid 19th c., marked, plain
2000–3000 per pair
Ornate 5000–7000+ per pair
Simple in cases 50–100 per pair.
Watches with Hebrew dials
Gold pocket watch, early–mid 19th c.
1000–2000
Gold pocket watch, mid–late 19th c.
500–1000
Silver or brass pocket watch with
Moses and Decalogue, c. 1900, 200–400.
Mantle clocks
Austrian (Vienna):
Late 19th c., bronze 800–1200
With musical movements in base
1200–1500.
Yom-Kippur belt buckles
Polish:
Early 19th c., silver 2000–5000
With original belt, usually of *Shpanyer
Arbeit* 3000–6000
Mid 19th c., smaller, coarser 800–1200.

CHAPTER XVII *Bezalel and the Modern Arts*

Jewellery
Small, silver 50–250
Gold 150–500.
Silver objects
Small 200–500
Medium 500–1000
Large 1000–2000
Special commission pieces 3000–5000+.
Brass objects
100–1500+
With silver inlay 500–3000+.
Rugs signed Bezalel or Marvadia
Small 2000–4000
Medium 3000–5000
Large 5000–7000.
Plaques
Bronze:
Small 100–200
Medium 300–500.
Ilya Schor
Small pieces of jewellery:
Silver 1000–5000+
Gold 5000–15,000
Silver ceremonial pieces 10,000+.
Wolpert
Silver ceremonial pieces 500–5000+.
Zabari
Silver ceremonial pieces 500–5000+
Sculpture, silver 3000–5000+.

HEBREW DATES

The Jewish New Year falls in September
or October, according to the lunar
calendar. The years are numbered from
the creation of the world. This
traditionally occurred in 3760 BCE.
Therefore, to convert a Hebrew into a
secular year, 3760 should be subtracted
from a Hebrew year. A more simple
way of doing this is to add 1240 to the
last three numerals of the Hebrew year,
without counting the thousands. For
instance, the year 5660 can be identified
by adding 660 to 1240, which gives a
total of 1900 – the correct year according
to the non-Jewish calendar.

Dates appear as letters of the Hebrew
alphabet, each one of which has a
numerical value. The numerical values
have to be added together to reach the
required total. The thousands are not
usually indicated; this abbreviated form
is identified by the letters *lamed, peh* and
koof following it, written, as are all
Hebrew letters, from right to left. The
date itself consists of between two and
four letters, unless a word or even an
entire sentence is found to contain the
required numerical value. Relevant
letters may be picked out of a quotation
by being starred or underlined, or they
may be written in larger form.

Hebrew contains no capital letters,
but some appear in a different form
when they appear at the end of a word.
These final forms are given in
parentheses in the table below.

The second table contains some of the
more common combinations of Hebrew
letters that appear in Hebrew numerals.
These serve to avoid some either
particularly holy, or other unfortunate,
juxtapositions.

1	aleph	א	30	lamed	ל
2	bet	ב	40	mem	מ(ם)
3	gimel	ג	50	nun	נ(ן)
4	daled	ד	60	samech	ס
5	heh	ה	70	ayin	ע
6	vav	ו	80	peh	פ(ף)
7	zayin	ז	90	tsadeh	צ(ץ)
8	chet	ח	100	koof	ק
9	tet	ט	200	resh	ר
10	yod	י	300	shin	ש
20	kaf	כ(ך)	400	tav	ת

11	אי	18	יח	76	עו
12	בי	19	יט	87	פז
13	גי	21	כא	98	צח
14	די	32	לב	500	תק
15	טו	43	מג	600	תר
16	טז	54	נד	700	תש
17	יז	65	סה	800	תת

GLOSSARY

This glossary includes Hebrew, Yiddish and technical words employed in the text, and some alternative terms that the collector may find in common use. For instance, a *Hanukah* lamp is often referred to as a *Menorah* or a *Hanukiyah*.

Ark The commonly used name for the *Aron Hakodesh*.
Aron Hakodesh The cupboard containing the *Torah* scrolls in the synagogue. Often referred to as the *Aron*, the Ark, or in Sephardi synagogues, as the *Hechal*.
Ashkenazi Jewish cultural milieu including Western, Central and Eastern Europe.
Assay The testing of gold and silver for purity, often controlled by a guild. Acceptable pieces are hallmarked.
Atarah Neckpiece for the *Tallit*, often of *Shpanyer Arbeit*.
Bar (fem. **Bat**) **Mitsvah** Confirmation ceremony, and the person confirmed.
Becher A cup for ceremonial use, usually of silver.
Bema Reading platform in a synagogue.
Besamim Spices for the *Havdalah* ceremony.
Breastplate Common name for a *Tas*, the ornamental plate hung on the front of a *Torah* scroll.
Chai Hebrew word for 'life', often found on amulets.
Challah Plaited loaves, two of which are blessed before Sabbath and festival meals.
Charoset Paste of wine, fruit and nuts, used at the *Seder*.
Crown Common name for a *Keter*.
Ethrog A citrus fruit, used together with a *Lulav* on *Sukkoth*.
Etz Hayim Hebrew for 'Tree of Life'. The roller for a *Torah* scroll.
Finial Decorative terminal, mounted on the end of an *Etz Hayim*. Correctly called a *Rimmon*.
Gregger Rattle used on *Purim*, to 'blot out' the name of Haman in the *Megillah*.
Haggadah The liturgy read at the *Seder*, and the book that contains it.
Ha' Melech A rare type of Esther scroll in which each column, except the first, begins with the word *Ha' Melech*, 'the king'.
Hanukah The mid-winter festival of lights.
Hanukiyah Candelabrum used at *Hanukah*. Also called a *Menorah*.
Hassid Member of a mystic sect founded in Eastern Europe.
Havdalah The ceremony concluding the Sabbath on Saturday evening.
Hechal The Ark in a Sephardi synagogue.
Hevrah Kadishah The Burial Society in a Jewish community.
Judenstern Star-form, oil-burning hanging lamp for the Sabbath.
Kamea Talisman or amulet.
Kappel Yiddish name for a skullcap.

Kasher (Ashkenazi pronunciation *Kosher*) 'Fit for use'. Applied to food, and to objects, such as *Torah* scrolls, which must be complete and undamaged.
Keter 'Crown', usually to fit over the *Torah* when it is not in use.
Ketubah Marriage contract.
Kiddush The prayer recited over wine on Sabbaths and festivals.
Kippa Modern Hebrew name for a skullcap.
Knop Ornamental knob or swelling.
Ladino A Sephardi language, blending Hebrew and medieval Spanish.
Lulav A palm leaf with sprigs of myrtle and willow, used with an *Ethrog* on *Sukkoth*.
Maror Bitter herbs eaten at the *Seder*, symbolizing slavery.
Matsah Unleavened bread eaten at Passover to commemorate the Exodus.
Mazal Tov A greeting on happy occasions, appearing on amulets in the sense of 'Good Fortune'.
Megillah Manuscript *Book of Esther* recited on *Purim*.
Me'il Protective mantle for the *Torah* scroll.
Menorah Hebrew for 'lamp'. Originally the seven-branched candelabrum of the temple. Now the eight-branched *Hanukah* lamp, also called a *Hanukiyah*.
Mezuzah Small scroll fixed to the right doorpost as one enters each door.
Mihrab Islamic arch motif, found on much Near Eastern Judaica.
Parcel-gilt Partial gilding of a silver object.
Parochet Curtain hanging before the Ark in a synagogue.
Passul Invalid for ritual use. The opposite of *Kasher*.
Pessach Hebrew for Passover.
Pointer Common name for a *Yad*, which is hung from the *Etz Hayim* when not in use.
Purim Festival commemorating the events in the *Book of Esther*.
Rimmon (pl. *Rimmonim*) Hebrew for 'pomegranate', applied to a *Torah* finial.
Rosh Hashanah The Jewish New Year.
Seder The ritual meal held at home on Passover eve.
Sephardi Jewish cultural milieu centring on the Mediterranean region.
Sepher Torah Hebrew for '*Torah* scroll'.
Shabat (Ashkenazi pronunciation *Shabbos*) The Sabbath, which begins at sundown on Friday and continues until nightfall on Saturday.
Shammash A ninth light on a *Hanukah* lamp, used to kindle the others.
Shavuoth Pentecost, the first-fruits festival, marking the giving of the Law.
Shlach Manot The gifts of food exchanged on *Purim*.
Shofar A ram's horn, sounded in synagogue on the New Year.
Shpanyer Arbeit (Yiddish for 'Spanish work') Textiles of silver- or gold-wrapped thread.
Shtetl The former Jewish towns of Eastern Europe.

Skullcap Common name for a *Kappel*, *Kippa* or *Yarmulka*.
Sukkah Leafy hut or 'tabernacle' used on *Sukkoth*.
Sukkoth The autumn festival of Tabernacles.
Tallit (Ashkenazi pronunciation *Tallis*) Four-cornered prayer-shawl worn by males for morning prayers.
Tas Torah shield or breastplate.
Teffilin 'Phylacteries'. Two small leather cases containing parchment texts, worn by males at weekday morning prayers.
Tevah The Sephardi name for a *Bema*.
Tiq Near Eastern wood or metal case for the *Torah* scroll.
Torah Hebrew for 'law'. Specifically the Five Books of Moses written on a parchment scroll – *Sepher Torah*, 'Book of the Law' – that forms the focus of synagogue liturgy, and is kept in the *Aron Hakodesh*.
Tsedakah Charity.
Tsitsit Ritual fringe on each corner of the *Tallit*.
Wimpel Fabric binder for when the *Torah* scroll is not in use.
Yad *Torah* pointer.
Yarmulka Russian or Polish name for the skullcap.
Yiddish An Ashkenazi language, blending Hebrew with medieval German.
Yom Kippur Day of Atonement.

MUSEUMS WITH JUDAICA COLLECTIONS

Many museums throughout the world possess collections of Judaica. But those listed here specialize in the field and frequently employ experts who will be pleased to give advice to collectors on their purchases, and may even help trace the origins of puzzling objects.

ARGENTINA
Jewish Museum
Libertad 773, Buenos Aires

AUSTRIA
Jewish Museum
Tempelgasse 2, 1030 Vienna 1

BRITAIN
Jewish Museum
Woburn House, Upper Woburn Place
London WC1

Manchester Jewish Museum
190 Cheetham Hill Road
Manchester M5 8LW

CZECHOSLOVAKIA
Jewish Museum
Jackymova 3, Prague 1

FRANCE
Musée de Cluny, Palais de Cluny, Paris

Synagogue
Rue Hébraique, 84300 Cavaillon, Vaucluse

HOLLAND
Museum of Jewish History
Waagebouw, Nieuwemarkt,
Amsterdam, Noord Holland

HUNGARY
Jewish History Collections
Dohany utca 2, Budapest VII

Medieval Jewish Prayer House
Tancsics utca 26, Budapest I

ISRAEL
Museum of Art
Kibbûtz Ein-Harod, Gilboa District

Dagon Collection
Dagon Silos, Plumer Square, Haifa

Museum of Ancient Art
Municipality Building, Haifa

Museum of Modern Art
Town Hall, 4 Bialik Street, Haifa

Bezalel National Art Museum
P.O. Box 1299, The Israel Museum
Jerusalem

Wolfson Collection
Hechal Shlomoh
King George Avenue
Jerusalem

Museum of the Printing Arts
Kiriat Ha Omanim, P.O. Box 1016,
Safed

Museum of Ethnography and Folklore
Museum Centre, Ramat Aviv, P.O. Box
17068, Tel-Aviv

Tel-Aviv Museum
Helena Rubinstein Pavilion,
6 Tarsat Street
and 27–9 Sd. Shaul Hamelech, Tel-Aviv

ITALY
Museum of the Israelite Community
Campo del Ghetto Nuovo, Venice

POLAND
Museum of Jewish Culture
Ul. Szeroka 24, Krakow

Jewish Museum
Lancut

Museum of the Institute of Jewish
History
Al. Swierczewskiego 79, Warsaw

SOUTH AFRICA
Jewish Museum
Old Synagogue, Government Avenue
Old Hatfield Street, Cape Town,
Cape Province

Jewish Museum
4th Floor, Sheffield House, corner of
Main and Kruis Street, P.O. Box 11180
Johannesburg, Transvaal

SPAIN
Sephardic Museum
Samuel-Ha-Levi Synagogue
Travesia del Transito
Toledo

SWITZERLAND
Swiss Jewish Museum
Kornhausgasse 8, Basel

UNITED STATES
American Jewish Historical Society
2 Thornton Road
Waltham, Massachusetts 02154

Archives Museum
Temple Mikve Israel
20 East Gordon Street
Savannah, Georgia 31401

Harris Swift Museum of Religious and
Ceremonial Art and
Library of Rare Books
526 Vine Street
Chattanooga, Tennessee 37403

Hebrew Union College
Skirball Museum
3077 University Avenue
Los Angeles, California 90007

The Jewish Museum
1109 Fifth Avenue
New York
New York 10028

Judah L. Magnus Memorial Museum
2911 Russell Street
Berkley, California 94705

Judaica Museum of Greater Phoenix at
Temple Beth Israel
3310 North Tenth Avenue
Phoenix, Arizona 85013

Morton B. Weiss Museum of Judaica
1100 Hyde Park Boulevard
Chicago, Illinois 60615

National Museum of American Jewish
History
55 North Fifth Street
Philadelphia, Pennsylvania 19106

Spertus Museum of Judaica
618 South Michigan Avenue
Chicago, Illinois 60605

Synagogue Art and Architectural
Library
838 Fifth Avenue
New York, New York 10021

Temple Museum of Jewish Religious Art
University Circle
Cleveland, Ohio 44106

Yeshiva University Museum
2520 Amsterdam Avenue
New York, New York 10033

SELECT BIBLIOGRAPHY

This bibliography contains essential
general works for collecting Judaica, as
well as basic reference books on
European metalwork necessary for
comparison. All will be found in major
libraries, and can be bought either new
or secondhand.

Judaica in General
ABER, ITA *The Art of Judaic Needlework*,
New York, 1979.

ALTSHULER, DAVID (ed.) *The Precious
Legacy: Judaic Treasures from the
Czechoslovak State Collections*, New York,
1983.

BARNETT, R. D. (ed.) *Catalogue of the
Permanent and Loan Collections of the
Jewish Museum, London*, London and
New York, 1974.

Bezalel 1906–1929, Jerusalem, 1983.
(Exhibition catalogue.)

BIALER, YEHUDA L. AND FINK, ESTELLE *Jewish
Life in Art and Tradition*, Wolfson Museum,
Hechal Shlomo, Jerusalem, 1980.

*Catalogue of the Anglo-Jewish Historical
Exhibition*, London, 1888.

*Danzig 1939: Treasures of a Destroyed
Community*, New York, 1980.

Encyclopedia Judaica, Jerusalem, 1972.

KANOF, ABRAM *Jewish Ceremonial Art and
Religious Observance*, New York, no date.

KAYSER, STEPHEN S. AND SHOENBERGER,
GUEDO (eds) *Jewish Ceremonial Art*,
Philadelphia, 1955.

KLAGSBALD, VICTOR (ed.) *Catalogue raisonné
de la collection juive du musée de Cluny,
Paris*, Paris, 1981.

LANDSBERGER, FRANZ *A History of Jewish
Art*, New York and London, 1946, 1973.

MANN, VIVIAN B. *A Tale of Two Cities –
Jewish Life in Frankfurt and Istanbul
1750–1870*, New York, 1982.

*Monumenta Judaica. Eine Ausstellung im
Kölnischen Stadtmuseum, 15 Oktober 1963
– 15 Februar 1964*, 2 vols.

NARKISS, M. *The Hanukah Lamp*, Jerusalem,
1939. (Hebrew and English text.)

ROTH, CECIL (ed.) *Jewish Art: An Illustrated
History*, Tel Aviv, 1961.

RUBENS, ALFRED *A History of Jewish Costume*,
London, 1967 and 1973.

SCHRIRE, T. *Hebrew Amulets, Their
Decipherment and Interpretation*, London,
1966.

SHACHAR, ISAIAH (ed.) *Jewish Tradition in
Art: The Feuchtwanger Collection of Judaica*,
Jerusalem, 1971 and 1981.

*Synagoga. Kultgeräte und Kunstwerke von
der Zeit der Patriarchen bis zur Gegenwart*,
Städtische Kunsthalle, Recklinghausen,
3 November 1960 – 15 January 1961.

*Towers of Spice: The Tower-shape Tradition
in Havdalah Spiceboxes*, Jerusalem, 1982.

Silver, Gold, Metalwork
BULGARI, CORTALINO G. *Argentieri,
Genamarie e Orafi d'Italia*, 2 vols, 1958.

HERNMARCK, CARL *The Art of the European
Silversmith, 1430–1830*, 2 vols, London
and New York, 1977.

HINTZE, ERWIN *Die Deutschen Zinngiesser
und ihre Marken*, 7 vols, Aalen, 1964.

*Les Poinçons de Garantie Internationaux
Pour L'argent*, Tardy, Paris, 1975 (11th
ed.).

*Les Poinçons de Garantie Internationaux
Pour L'or*, Tardy, Paris, 1975 (11th ed.).

ROSENBERG, MARC *Der Goldschmiede
Merkzeichen*, 3 vols. Frankfurt-am-Main,
1922.

SELING, HELMUT *Die Kunst der Augsburger
Goldschmiede, 1529–1868*, 3 vols,
Munich, 1980.

WYLER, SEYMOUR B. *The Book of Old Silver*,
New York, 1937.

Index